Public Pl~ W9-DJJ-392

RENAISSANCE TO ROCOCO

Renaissance to Rococo

MASTERPIECES FROM THE WADSWORTH ATHENEUM MUSEUM OF ART

edited by Eric Zafran

with contributions by
Joseph Baillio
Edgar Peters Bowron
Hilliard Goldfarb
Ronda Kasl
Cynthia Roman
Amy Walsh

Wadsworth Atheneum Museum of Art
in association with
Yale University Press, New Haven and London

Published in conjunction with the exhibition organized by the Wadsworth Atheneum and shown at:

The John and Mable Ringling Museum of Art, Sarasota, FL
January 29 – April 25, 2004

Kimbell Art Museum, Fort Worth, TX
June 27 – September 26, 2004

Joslyn Art Museum, Omaha, NE
October 23, 2004 – February 27, 2005

Frist Center for the Visual Arts, Nashville, TN
May 19 – August 21, 2005

Mint Museum of Art, Charlotte, NC
September 17, 2005 – January 8, 2006

Copyright © 2004 by Wadsworth Atheneum Museum of Art
Published by Yale University Press, New Haven and London

All Rights Reserved. This book may not be reproduced in whole or in part,
in any form (beyond that copying permitted by Sections 107 and 108 of the
U.S. Copyright Law and except by reviewers for the public press),
without written permission from the publishers.

Editing, design, and production: Sally Salvesen and Emily Winter
Index by Indexing Partners, Annandale, VA
Typeset in Monotype Ehrhardt
Printed in Singapore

Library of Congress Cataloging-in-Publication Data

Renaissance to Rococo : masterpieces from the Wadsworth Atheneum Museum
of Art / edited by Eric Zafran ; with contributions by Joseph Baillio [et al.].
p. cm.
Catalog of an exhibition at the John and Mable Ringling Museum of Art,
Sarasota, FL, Jan. 29–Apr. 25, 2004 and five other locations."
Includes bibliographical references and index.
ISBN 0-300-10205-4 (cl : alk. paper)
1. Art, European—Exhibitions. 2.
Art--Connecticut--Hartford--Exhibitions. 3. Wadsworth Atheneum Museum
of Art--Exhibitions. I. Zafran, Eric. II. Baillio, Joseph. III. John
and Mable Ringling Museum of Art.
ND454 .R45 2003
759.04′074′7463--DC22
2003024440

CONTENTS

ACKNOWLEDGEMENTS

The creation of the Wadsworth Atheneum's extraordinary collection of old master paintings is due to a long list of previous directors and curators, all mentioned in the introductory essay. Their perspicacity is evident in the works included in this exhibition.

To write insightfully about the individual paintings, we were fortunate in assembling a talented team of specialists, which was comprised of Joseph Baillio, Vice-Director of Wildenstein Gallery; Edgar Peters Bowron, Curator of European Painting at the Houston Museum of Fine Arts; Hilliard Goldfarb, Curator of European Art before 1800 at the Montreal Museum of Art; Ronda Kasl, Curator of European Art at the Indianapolis Museum of Art; Cynthia Roman, formerly Associate Curator of European Art at the Wadsworth Atheneum and now Curator at the Lewis Walpole Library; and Amy Walsh, Director of Provenance Research at the Los Angeles County Museum of Art.

We are able to share these paintings now with a wider public thanks to the diligence of many members of the Atheneum's staff. Maura Heffner, Director of Exhibitions, and Mary Schroeder, Chief Registrar, coordinated the arrangements for the tour and the shipping of the art works. Alan Phillips assisted by Natalie Russo and Danielle Mann were responsible for providing and proofing new digital images of the paintings. Some additional photographs were kindly supplied by Professor Craig Felton. Our conservation department, Stephen Kornhauser, Ulrich Birkmaier, and Zenon Ganszinec, prepared and in some instances carried out extensive restorations, so that the paintings and their frames now look their absolute best. The Atheneum Archivists, Eugene Gaddis and Ann Brandwein, as always provided much helpful information and extraordinary editing skills as did Susan Hood, Director of Media Relations; and the museum librarians, John Teahan and William Staples, facilitated research and answered many questions.

Yale University Press with their expert team of Sally Salvesen and Emily Winter has once again overseen the production of a handsome catalogue, which will make our collection more easily accessible to new audiences at the various exhibition locations across the country.

ERIC ZAFRAN
Curator of European Painting and Sculpture

Detail of cat. no. 57

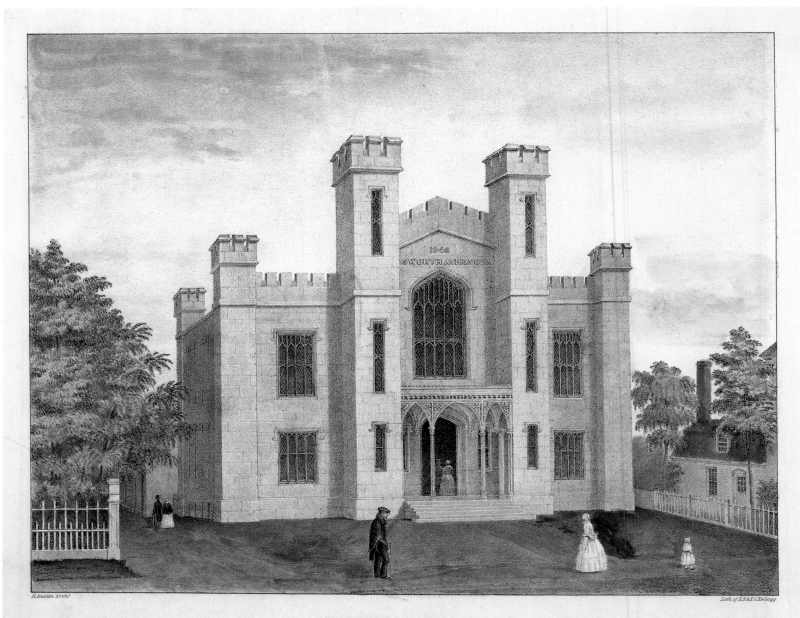

WADSWORTH ATHENEUM,

Hartford, Conn.

FOREWORD

One hundred and sixty one years after its founding, the Wadsworth Atheneum Museum of Art, America's oldest art museum is, for the first time, circulating an exhibition based on its old master collection. As Eric Zafran notes in his illuminating introduction, this remarkable collection has grown as the Atheneum has, organically over a century and a half of incisive acquisitions by a succession of directors and curators, generous gifts from individual patrons and unwavering support from trustees and benefactors through monetary gifts and bequests.

There are few museum collections in America capable of demonstrating either the breadth or individual excellence of the paintings documented in the pages that follow and the exhibition this catalogue accompanies. Its richness stands as a testament to the patronage of the citizens of not only Hartford and Connecticut, but those at greater distance, who have been attracted to the Wadsworth Atheneum by its steadfast commitment over the past century and a half to providing a home for what Daniel Wadsworth, in an 1872 letter to Thomas Cole, called the artist's "spirit of genius".

In his acknowledgements, Eric Zafran thanks all of those connected with this museum who have made this project possible and assisted him so capably in its formation. It is my great pleasure to in turn thank Eric for his leadership, scholarship and tireless efforts on behalf of the Atheneum and this collection and exhibition. As the Atheneum's recently arrived director, only the ninth over the past century and a half, I am not only honored to have inherited the legacy of this wonderful collection of old master paintings, but this, its first touring exhibition and equally, the intelligence of its curator.

WILLARD HOLMES
Director, Wadsworth Atheneum Museum of Art

1 E.B. and E.C. Kellogg, after Henry Austin. *View of the Wadsworth Atheneum*, 1846, lithograph, 10 × 13 ¾ in., gift of Owen Meserve, Jr., 1959.24

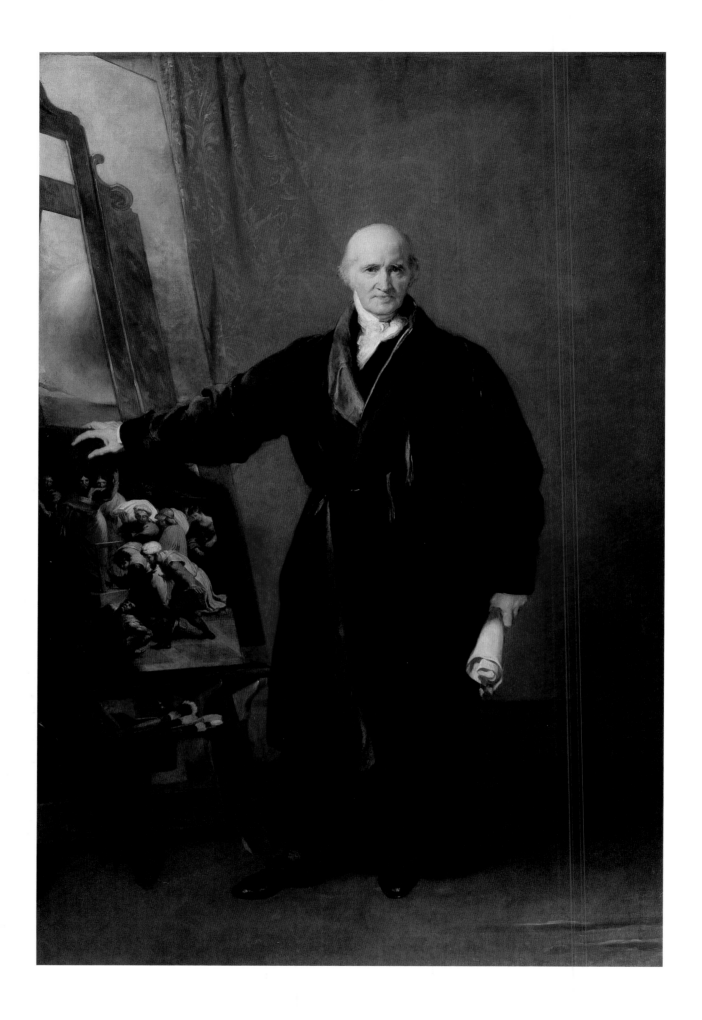

A Passion for Paintings:
The Old Master Collection in the Wadsworth Atheneum

Eric M. Zafran

I. THE EARLY YEARS

When the Wadsworth Atheneum in Hartford, Connecticut, opened its impressive Gothic revival building, designed by Ithiel Town and A.J. Davis, in 1844 (fig. 1), it was one of the first public galleries of fine arts in America. Its creation came as the realization of a vision by Daniel Wadsworth (1771–1848) and encouraged by such leading American artists as John Trumbull. Wadsworth's father, Jeremiah, had been a successful businessman who played a key role in the state during the Revolution. In 1783, he took his son on a yearlong visit to France, England, and Ireland, and young Daniel developed a fondness for art and culture. He became an early patron of Thomas Cole and built the first Gothic revival house for himself and his wife, Trumbull's niece, Faith, outside Hartford in 1809. When the Hartford Gallery of Fine Arts failed in 1840, Daniel Wadsworth provided a site for a new cultural institution through the gift of his family's home on Main Street. It was called an Atheneum, since in addition to housing an art gallery, it also contained a Historical Society, a Natural History Society, and a lyceum with a library.[1]

The art collection comprised nearly eighty paintings. The highlights featured contemporary American artists, but there were also copies by John Trumbull and others after European masters such as Titian, Rubens, and Rembrandt.[2] Of supposedly authentic European works, the first published catalogue listed a Murillo *Boys with Fruit*, *Rubens' Sons* by Rubens, a *St. Peter* by Llorent, and two *Landscapes* by Poussin.[3] These pictures are no longer identifiable, but there was one first-rate European painting still in the collection. This piece, the enormous *Full Length Portrait of Benjamin West* by Sir Thomas Lawrence (fig. 2), had been purchased in 1841 from the defunct American Academy of the Fine Arts in New York. It was a famous image of one of America's leading painters who had achieved renown in London. West was depicted in his role as President of the Royal Academy delivering a lecture, illustrated with a copy after Raphael, on the subject of coloring.[4]

Following the death of Daniel Wadsworth in 1848, his bequest brought many notable American paintings to his namesake institution, but only a lone European – an anonymous Roman seventeenth-century depiction of *Ruth and Boaz*.[5] In a second catalogue of the collection published in 1850, a few new European works bearing distinguished names had been added – most notably a *Head* by Tintoretto; a *Group* by Bonifazio; a *Philip V* by Titian (identified as an "original"); and an unattributed *Christ in the Temple Disputing with the Doctors*,[6] which is most likely the large painting seen in the earliest photograph (fig. 17) of about 1890, showing the Atheneum's galleries.

There were two other noteworthy collectors of art in Hartford during the nineteenth century who owned a great many European paintings. The first was Dr. Samuel Beresford (1805/6–73), a respected physician who had come from Bermuda. He did not leave his collection to the Atheneum, but some of his pictures were later bequeathed by his daughters, Mrs. Digby Marsh and Mrs. Gurdon W. Russell. Among them were a Heda *Still Life* and a Lingelbach *Harbor Scene*, as well as a Michele Pace *Still Life with Flowers*.[7] An even more extensive collection, which was exhibited several times at the Atheneum in the 1860s, was that "imported by" James G. Batterson (1823–1901), founder of the Travelers Insurance Company and a building contractor for such major Hartford structures as the new State Capitol. The printed catalogues of Batterson's collection reveal among the nearly 200 works the names of some impressive and unexpected artists including Jan Steen, Agostino Tassi, G. Dow [sic], Guido Cagnacci, Donducci (a *Magdalen Borne to Heaven* from the Fesch collection), Mola, Caravaggio (*The Fortune Teller* described as "a picture of the first quality and guaranteed original"), and Rembrandt, (*Girl Reading* "a very beautiful sketch").[8] The Atheneum's trustees considered acquiring the collection but did not do so,[9] and thus only a few of Batterson's old masters eventually came to the museum through the estates of his wife's aunt, Mrs. Walter Keney, or of his daughter, Mrs. Charles C. Beach. Among these are a *Portrait of a Young Man* by Thomas de Keyser (fig. 3); *Dead Game* by Hondecoeter; a *Flower Still Life* by Jan Frans van Dael; and a pair of Campidoglio *Still Lives*.[10]

In the late nineteenth century and the first decades of the twentieth century, several gifts added a small number of additional old masters to fill out what was definitely a very modest representation of the great European schools of painting – an unusual Spanish painting, José García Hidalgo's *Death of St. Joseph* from Mrs. Catherine Goodrich Dutton in 1888; an *Adoration of the Magi* by a follower of Sagrestani from Herbert Randall in 1911; a Luca Giordano workshop *Birth of St. John* and Gregorio Lazzarini's *Virgin in Glory with Saints* from Clara Louise Kellogg Strakosch in 1914; a Vito d'Anna, *Hagar and Ishmael*, which came from the estate of Mrs. Charles Dudley Warner as a Sebastiano Ricci in 1921; and a Jan van Goyen *River Scene* from Lyman A. Mills in 1923. George H. Story (1835–1922), a curator of paintings at the Metropolitan Museum of Art and an honorary curator for the Atheneum presented the latter with a painting by Jan Asselijn in 1917.[11]

In terms of quality, however, the most significant addition to the European holdings was not the paintings, but rather the decorative arts. These pieces came through the munificence of J.P. Morgan, Jr., when in 1917 he distributed the "matchless collection" of his Hartford-born father, who had also paid for the construction of a new building at the Atheneum. This Morgan donation consisted of "over a thousand

2 Thomas Lawrence. *Portrait of Benjamin West*, 1820–1, oil on canvas, 107 × 69½ in., purchased by subscription, 1855.1

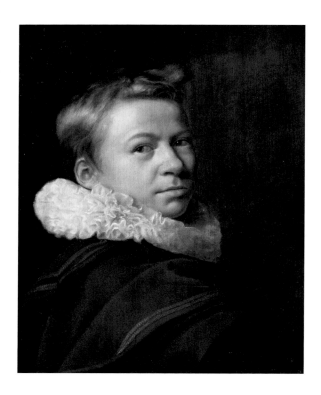

3 Thomas de Keyser, *Portrait of a Young Man with Ruff*, c. 1625, oil on panel, 19¾ × 15¾ in., gift of Mrs. Walter Keney, 1899.5

4 Salvator Rosa, *Landscape with Tobias and the Angel*, 1650, oil on panel, 49⅓ × 79¼ in., the Ella Gallup Sumner and Mary Catlin Sumner Collection Fund, 1934.292

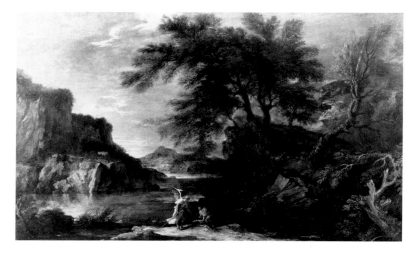

priceless objects – ancient bronzes, Renaissance majolica, baroque ivory and silver-gilt pieces, and rare eighteenth-century porcelains."[12]

II. THE BEGINNING OF THE AUSTIN ERA

It was only with the arrival of A. Everett ("Chick") Austin, Jr. (fig. 9) as director in 1927 that the Wadsworth Atheneum began its process of passionate procurement which would assemble a world-famous collection of European paintings that could equal in quality its collection of decorative arts. Fortuitously, that same year, the Atheneum received a bequest from Frank C. Sumner, a Hartford banker, of an endowment of just over a million dollars for the acquisition of "choice paintings" to create what was to be known as the "Ella Gallup Sumner and Mary Catlin Sumner Collection" in honor of his sister-in-law and wife. This munificent fund would allow Austin to carry out his "ambition," as stated in the *Hartford Times* of October 25, 1927, "to acquire for Hartford over a period of years,

a series of acknowledged and unquestionable art masterpieces . . . not pictures that may simply be popular today but pictures that have stood the test of time."[13] Austin's tastes had been molded by his own extensive travels through Europe and by his education at Harvard University where he worked at the Fogg Art Museum, learning from the cultivated connoisseurs and museum professionals, Edward Forbes and Paul Sachs. In Cambridge he also became familiar with such leading scholars as Chandler Post and Arthur McComb, who were advocates of the then still unpopular Baroque era, which Austin had had a chance to discover first hand when in 1922 he visited the groundbreaking exhibition at the Pitti Palace in Florence.[14]

It was Forbes who recommended his teaching assistant, Austin, to the Atheneum's President, Charles Goodwin, and to assure that his choice would be a success, Forbes was appointed Honorary Director to oversee Austin's first year.[15] Both the new funds for acquisition and the plans for building an addition to the museum spurred the director designate to search for potential purchases during the summer and fall of 1927, as he traveled throughout Europe. He wisely consulted his Harvard mentors about his discoveries, and thus Forbes could write to Goodwin in September 1927:

Austin says in his letter that he has been hunting for pictures among the dealers and he spoke of several fine things he has seen. The one he spoke of particularly as a picture he would like to buy for Hartford was a fine Tintoretto. He is getting photographs of it so that we shall be able to discuss the advisability and feasibility of buying this picture for Hartford in case Austin on maturer reflection decides to recommend it.[16]

Goodwin replied that he was "especially delighted with the idea of the Tintoretto,"[17] and photographs of this work representing *Hercules and Antaeus* (fig. 6) were dispatched from the dealer Durlacher Brothers of London. No less an expert than Bernard Berenson was contacted by Forbes, who after explaining his relationship with the Atheneum wrote:

It happens that the Atheneum has some money to spend for works of art and Austin and I believe that the best picture to begin with is a picture of the High Renaissance, preferably by such a man as Tintoretto. We want something of real quality and something that is striking and effective and will appeal to a public that has not a highly developed taste. We visited Sir Joseph Duveen's and found that he has, of course, some very good pictures, but the pictures we particularly wanted – a fine Rembrandt, for instance were too expensive.

We find that Durlacher has a picture of Hercules and Anteus which comes from an English Collection, which I believe has recently been cleaned, and which is a very effective picture. The color is lovely and the painting of the gods in Olympus of a most delicious and silvery quality. The heads of Hercules and Anteus, as you will see, by the photograph, are a bit crude, but Tintoretto, it seems to me, often was crude. I am having a photograph of this picture sent to you, and write to ask whether you will be willing to drop me a line and tell me whether you believe this picture to be by Tintoretto, for Austin and I are anxious to know what you think, and your opinion would have great weight with the Trustees.[18]

The renowned specialist in Italian art did not reply until December 30 from Edith Wharton's château at Hyeres, France, where he was then residing: "As in the photos, I see nothing that speaks against its being an autograph Jacopo Tintoretto, as on the contrary a great deal speaks for it, I am cabling 'Tintoretto alright.'"[19] In his follow up letter, Forbes confirmed that he had reached the same conclusion and that the museum

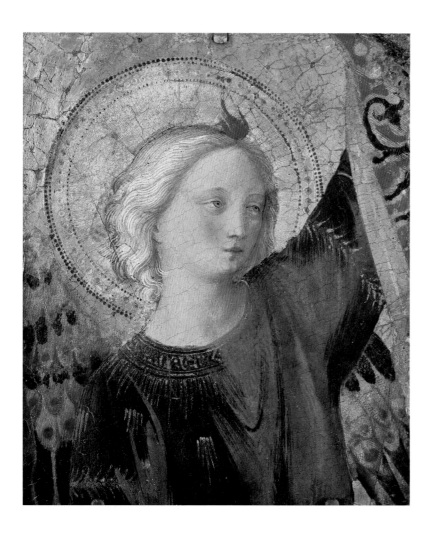

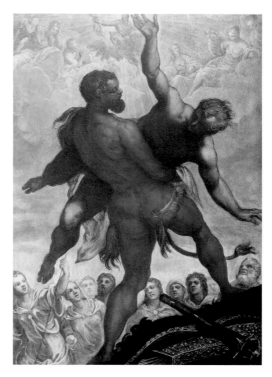

5 Fra Angelico (active
1418–55), *Head of an
Angel*, c. 1440–50,
tempera and oil on panel,
6¾ × 5½ in., the Ella
Gallup Sumner and
Mary Catlin Sumner
Collection Fund,
1928.321

6 Workshop of
Tintoretto, *Hercules and
Antaeus*, c. 1570, oil on
canvas, 60 × 40 in., the
Ella Gallup Sumner and
Mary Catlin Sumner
Collection Fund, 1928.2

had decided to buy the painting.[20] In fact, by cable to Adam Paff, head of Durlacher's New York branch, Austin had already authorized the purchase of the painting for $29,250.[21] Paff had in turn supplied Austin with the following provenance on the painting:

> Your Tintoretto comes from the family of Wolseley of Mount Wolseley; the baronetcy was created in 1744 and the present Baronet is the tenth one. The famous English General, Sir Garnet Wolseley who was created a peer in 1885 was a member of this family. The picture was bought from the widow of Sir Charles Capel Wolseley, the ninth Baronet.[22]

Despite this impressive history and the effusive articles that originally appeared about the painting in the Atheneum's *Bulletin* and in *Art News*, it has in recent times been downgraded to a workshop product.[23] However, at the time of its purchase the picture's size and quality did seem impressive. Hoping to capitalize on its acquisition and eager to show Hartford what he could do, Austin organized around its January 1928 unveiling his first major loan exhibition simply titled *Distinguished Works of Art* (fig. 18). He intended this, as he wrote, to be a "tabloid resume, to some extent, of the whole history of western art."[24] The newspapers referred to it as an exhibition of "acknowledged world masterpieces" with a total value "conservatively estimated at about $3,000,000,"[25] that was "something new for Hartford – new in scope and importance."[26] This exhibition did, indeed, include a wide variety of significant material – ancient bronzes and medieval illuminations, several early Italian panels lent by the Fogg Art Museum, and Impressionist

paintings shared for the first time by Mrs. Theodate Pope Riddle of nearby Farmington. However, the greatest focus fell on the old master paintings, with examples by such names as Bellini, El Greco, and Hals. Among the most publicized loans was a famous Petrus Christus belonging to the New York collector Jules Bache, and from that city's best known dealer, Lord Duveen, came Rembrandt's *The Philosopher*.[27] With characteristic bravado, Austin alerted the local chief of police about the valuable items in the show and requested "protection in the way of plain clothes men" on the night of the opening and for the two weeks of the exhibition.[28] Although brief, the exhibition had what Austin described, in a letter to Adam Paff at Durlacher's, asking for a two-day extension of that gallery's loans, as "an admirable showing" with an "attendance to date of 27,684."[29]

Durlacher's, also on the recommendation of Forbes,[30] had just added to their New York office another young Harvard-trained connoisseur, Kirk Askew, who was a friend of Austin's, and both Paff and Askew journeyed to Hartford to see Austin's inaugural exhibition on January 24.[31] Recognizing the value of this friendship, Paff granted Askew a special commission for every sale he was to make to the Atheneum,[32] and over the following decades Askew (fig. 10) would successfully place many a fine painting in Hartford.

Austin, however, felt by no means tied to only one dealer, and his very next old master purchases revealed this, as well as the breadth of his taste. From the grandiose violence of the big Tintoretto, he turned to the refined beauty of a tiny Fra Angelico fragment *Head of an Angel* (fig. 5). A photograph of this work, said to have been discovered in Russia, was sent to him in September 1928 by the Paris dealer René Gimpel, who had earlier that year presented the museum with a thirteenth-century Italian fresco fragment.[33]

Once again the Harvard advisors were supportive, as Paul Sachs cabled Forbes: "Tell Austin enthusiastic gemlike Angelico fragment Gimpel extends option." And Austin cabled to Sachs in Paris "Gimpel coming America. Am urging him bring Angelico."[34] Gimpel sailed for New York in November with that painting as well as another small work, a fifteenth-

7 Francesco Bacchiacca, *Tobias and the Angel, c.* 1525, oil on panel, 15 ¾ × 13 in., the Ella Gallup Sumner and Mary Catlin Sumner Collection Fund, 1930.79

8 After Salvator Rosa, *Night Scene with Figures*, oil on canvas, 20½ × 15¼ in., the Ella Gallup Sumner and Mary Catlin Sumner Collection Fund, 1930.1

century *Pietà* of the School of Avignon. He sent them on to the Atheneum, expressing to Austin his feeling that "if they were to go into your Museum, I should be the proudest man in the United States." Austin was able by the end of the year to get both paintings from the pliable Gimpel for $40,000.[35] The fragmentary Fra Angelico he would later describe elegantly as an "incomplete statement of the art of one of the purest and most poetic of all masters."[36]

Continuing his stated policy of beginning each year with "an exhibition of distinguished and important examples of some of the world's greatest art,"[37] Austin opened 1929 with *French Art of the Eighteenth Century*, which brought to Hartford outstanding paintings by Fragonard, Chardin, Vigeé Le Brun, and Greuze (fig. 19) lent primarily by the New York gallery of Wildenstein and Co., while Duveen's assisted in securing a Watteau and Boucher from the collector Jules Bache.[38]

Austin's next acquisition was to be of the eighteenth century, but Spanish rather than French – a Goya at Durlacher's. According to Paff, when this overdoor depicting *Gossiping Women* (cat. no. 34) was shown by Austin to three of the Atheneum's trustees, they "literally jumped at it" for the price of $38,250.[39]

III. THE EMERGENCE OF THE BAROQUE

In addition to modern art, which Austin also pursued vigorously, his chief focus, in terms of building the Atheneum's collection was on the Baroque era. In 1929, he acquired two great examples also from Durlacher's: a pair of mythological scenes by Luca Giordano, *The Abduction of Helen* and *The Abduction of Europa* (cat. nos. 19, 20) to represent, as the museum's *Bulletin* said "decoration on a large scale, as practiced in Italy in the seventeenth century."[40] In the cables to the home office, the Durlacher staff used a coded system of animal names for the clients, and so word was sent: "Ferret takes Giordanos."[41]

This initial plunge into the Italian seventeenth century was followed shortly by the purchase from the same dealer of two other works, Francesco Bacchiacca's *Tobias and the Angel* (fig. 7) for $3000, and Salvator Rosa's *Night Scene with Figures* (fig. 8). The latter small work,

which cost only $900, had come from the Holford collection housed at Dorchester House in London. Henry-Russell Hitchcock, Jr., a young but already respected art historian (fig. 10), who was then teaching at Wesleyan University, served as both adviser and mouthpiece for Austin and wrote an article for the Atheneum's *Bulletin* pointing out that the new Rosa "contrasts most interestingly with the decorative Baroque tradition as illustrated by the two paintings of the later Neapolitan, Luca Giordano." Hitchcock praised this painting as "an excellent example of Salvator Rosa's work," and observed, "It carries to us, who have the whole Romantic tradition in literature behind us, perhaps more effectively than it did to his contemporaries."[42] This very overt romanticism, however, has led to the painting's demotion to the status of a pastiche in the manner of Rosa.[43] The two Giordanos have, on the other hand, maintained their place as among that painter's best works in this country.

To show off these first exciting acquisitions, to promote the appreciation of the Baroque period that was being supported by dealers, scholars, and knowledgeable museum directors and curators around the country, and to draw the attention of a wider audience to the Atheneum, Austin decided, on rather short notice, to organize what would be America's first significant exhibition of Baroque paintings and drawings. This was *Italian Painting of the Sei- and Settecento* (fig. 20). As Austin explained in a letter in late December 1929, to Gertrude Hurdle at the Memorial Art Gallery, Rochester, seeking the loan of a Fetti *St. Stephen*:

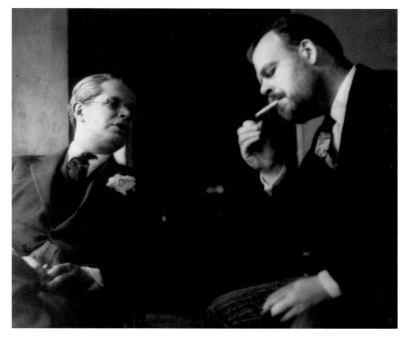

WADSWORTH ATHENEUM DIRECTORS AND ADVISERS

9 Chick Austin in Hartford, 1938. Photograph by Deford Dechert

10 Henry-Russell Hitchcock, at right, and Kirk Askew. Photograph by James Thrall Soby

11 Charles C. Cunningham, *c.* 1966 with Panini's *Interior of a Picture Gallery*, see cat. no. 23

12 Peter Sutton, at right, with the Honorable Mario Bondioli Orso, Chairman of the Italian Commission for Works of Art, on the occasion of the official return of Zucchi's *Bath of Bathsheba*, (see fig. 50), Hartford, 1998

I am planning to hold an exhibition of Italian Baroque painting beginning January 22 which will last for two weeks . . . As you know, in America, it is exceedingly difficult to procure material of this epoch . . . and I want the exhibition to be large enough and important enough to attract as many out of town people as possible.[44]

To aid his pursuit of appropriate paintings, Austin relied on his circle of friends and colleagues. Arthur McComb, who had earlier organized at Harvard the first Baroque painting exhibition in the country, supplied information on a Guercino and a Magnasco in private collections. Kirk Askew, back from a recent tour around America, sent Austin a letter in November commenting on potential loans of Baroque paintings from the museums of Chicago, Minneapolis, and Detroit, and including some postcards of various Baroque pictures that had been assembled by John Ringling in Sarasota, Florida, for his as yet unopened museum there. Askew observed "some of them look pretty magnificent to me."[45] Austin followed up by writing to Ringling, certainly America's leading collector of the Baroque at that time: "I am a great admirer of seventeenth and eighteenth century painting and want to do all I can to change the underestimation in which it has been held for so many years."[46] Ringling and Austin have both been characterized as loving the Baroque because of their taste for spectacle and theater, but Austin's letter, although passed on to Ringling's adviser, Julius Böhler, and a follow-up inquiry went unanswered.[47] Ironically Austin would later become, after Ringling's death, the first director of the museum he founded. The Cleveland Museum, rather huffily declined to loan a Strozzi but did send a Magnasco that was on deposit from another of Austin's art world acquaintances, Harold Parsons, who also supplied several other works.[48] Further receptive responses were forthcoming from other American museum directors, such as Robert Harshe of the Art Institute of Chicago, and W. R. Valentiner in Detroit, who wrote Austin that "an exhibition of Italian Baroque paintings surely would be of the greatest value to the student and to the development of interest in this direction in this country."[49]

Of the New York dealers eager to promote yet more sales, Durlacher's was most helpful with loans from its stock and its clients's including works by Fetti, Magnasco, Solimena, and Stanzione. The dealer Arthur Newton lent a Carlo Dolci *St. John the Evangelist*, which remained in Hartford for two years before Austin finally decided to return it. Wildenstein and Company sent a supposed Caravaggio *Portrait of a Young Boy* (fig. 13) and Poussin's *Ulysses*.[50]

The reception for this exhibition of over sixty paintings and seventy drawings was positive and brought the Atheneum welcome attention. According to the *Hartford Times*, "a large and enthusiastic gathering" of 400 members attended the opening and "because of the increased interest that was shown," the exhibition was "held over for a few days" and closed on Monday February 11.[51]

Austin, as would become his practice, also sought to purchase some of the works lent to the exhibition, and thus a few days before it closed, he cabled Wildenstein and Company to ask the "lowest possible price" for their Caravaggio *Boy*. The answer was $7,500, and he in turn offered $6,500, which Wildenstein's graciously accepted. Austin wrote to Felix Wildenstein:

Thank you very much for your acceptance of our offer. The trustees felt that in comparison to the Fogg Caravaggio the price of this one was somewhat higher than they thought they should pay, but I was so anxious to get the picture that they said they would agree to it if you would reduce the price to this extent.

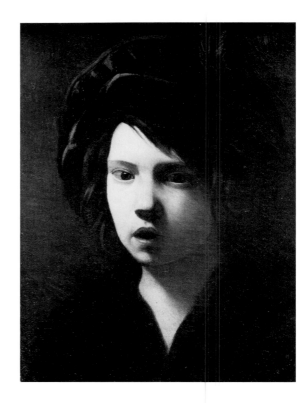

13 French School (17th Century), *Head of a Boy*, oil on canvas, 15 × 11½ in., the Ella Gallup Sumner and Mary Catlin Sumner Collection Fund, 1930.12

14 Bernardo Bellotto, *View of Pirna in Saxony*, 1763, oil on canvas, 18½ × 30 in., the Ella Gallup Sumner and Mary Catlin Sumner Collection Fund, 1931.280

Mr. Wildenstein responded in turn: "I was delighted to have been able to meet your Trustees' views and to have placed this excellent picture in the permanent collection of your Museum. You have made a splendid acquisition."[52] Unfortunately over the years the splendor somewhat diminished, as it became clear that neither the Fogg nor the Atheneum paintings were by Caravaggio. The latter is most likely by a French artist of the seventeenth century sometimes called "The Master of the Open-Mouthed Boys."[53]

The quest for a real Caravaggio would become one of the leitmotivs of Austin's years at the Atheneum. In 1936, he corresponded again with Felix Wildenstein about the possible purchase of the *Lute Player* from the Hermitage in Russia.[54] Then, in 1939, the same dealer wrote that a Caravaggio "had just arrived from abroad." A photograph of this work, *The Chastisement of Love*, was sent, and Austin saw it in March. This is undoubtedly the painting now in The Art Institute of Chicago sometimes attributed to Manfredi.[55] Later that same year the dealer Julius Weitzner sent Austin a handwritten note suggesting that among other things a Caravaggio was "afloat and you will be the first to see it."[56] But that was still in the future and in the meantime the director continued his quest for remarkable pictures from many sources including those in Europe.

IV. COLLECTING AND EXHIBITIONS IN THE EARLY 1930S

In the realm of exhibitions Austin tried to balance his contemporary interests with the old masters and sometimes to combine them. Thus in 1931, he presented both his revolutionary *Newer Super Realism* to introduce the Surrealists and the first of his thematic loan exhibitions devoted primarily to established European masters. The latter, entitled simply *Landscape Painting*, was an extensive chronological survey of over 140 paintings ranging from Sassetta to Matisse. The local newspaper proclaimed it "more magnificent than anything of its kind ever before shown

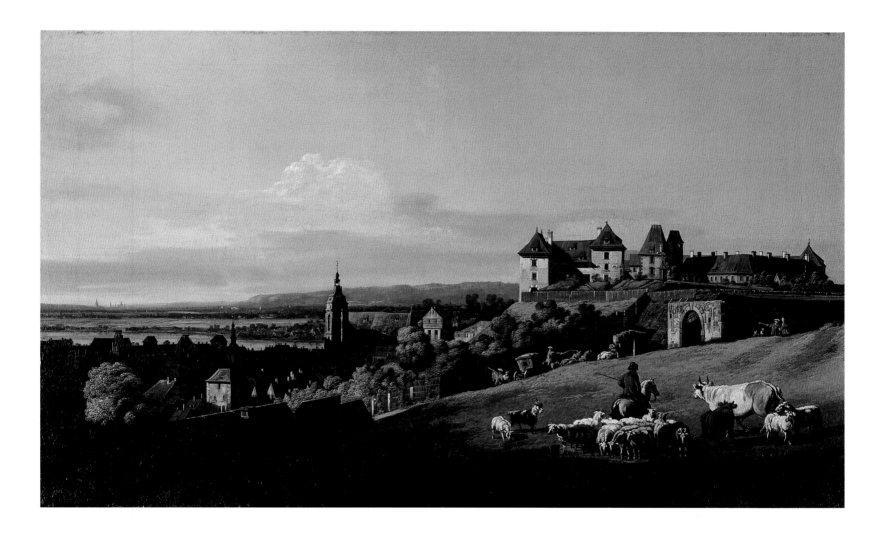

in Hartford" and gave the total value as "conservatively $4,000,000."[57] The many loans again came from collectors, museums, and dealers, and given the most attention were El Greco's *Agony in the Garden* (from Arthur Sachs), Rembrandt's *Landscape with Figures* (from Böhler and Steinmeyer), and a Gainsborough (from Duveen). Also included was a Dossi of a scene from Ariosto's *Orlando Furioso*, lent by Agnew's, which many years later would enter the Atheneum collection (cat. no. 3). In addition, Wildenstein and Durlacher's both lent Claudes, but for the present it was another of the Durlacher's loans that interested Austin – Louis Le Nain's *Peasants in a Landscape* (cat. no. 50).[58] Upon the exhibition's close, it was purchased for $15,000. Austin later provided a fine description of the artist and this work:

> Louis Le Nain emerges as one of the most distinctive personalities of the trio who collaborated to mould the Caravaggesque tradition into Gallic shape. The broad plastic modeling of the Italian master applied to an intimate yet noble interpretation of the genre subject, seen through the inherent classicism of the French mind, clothes here these simple rustic beings with a dignity and a humanity far more moving than when later echoed by Millet.[59]

Also in 1931, Austin was able to purchase, because of what the Munich gallery of Julius Böhler described as "the bad financial condition in Germany," Bellotto's *View of Pirna* (fig. 14) at a very good price.[60] Even more significant was the acquisition that year of one of the greatest of

the Atheneum's Baroque masterpieces, Strozzi's *St. Catherine of Alexandria* (cat. no. 13). This brilliant work had been seen by the director in the 1922 exhibition in Florence. It was owned by the Venetian dealer Italico Brass, and the negotiations for its purchase were carried out by Harold Parsons, an independent agent and consultant to American museums in Cleveland and Kansas City. On February 12, 1930, Parsons wrote to Austin from the Dorset Hotel in New York, with the news that he had just received a cable from Brass "saying that he will accept the minimum price of $16,000." He went on to offer congratulations for "having secured the finest Strozzi I have ever seen; and I think your Trustees ought to feel that you have made a brilliant acquisition, considering the fact that we paid $18,000 for ours in Cleveland." Later that same day Parsons sent a handwritten follow-up note, asking Austin "not to speak of the Strozzi to anyone, particularly our friends at the Durlachers until it has arrived in this country."[61] However, when the painting did arrive in Hartford, Austin immediately recognized that it was not the one he had seen in Florence, but a variant of the composition by Strozzi that was also owned by Brass. The director sent an urgent letter to Parsons:

> My dear Harold, When you came to me with the photograph of the Strozzi "Saint Catherine," which you thought Brass would be willing to sell, I was under the impression, of course, that it was the original which Brass lent to the exhibition at the Pitti Gallery in 1922 and as photographed by Alinari and not the replica, which arrived day before

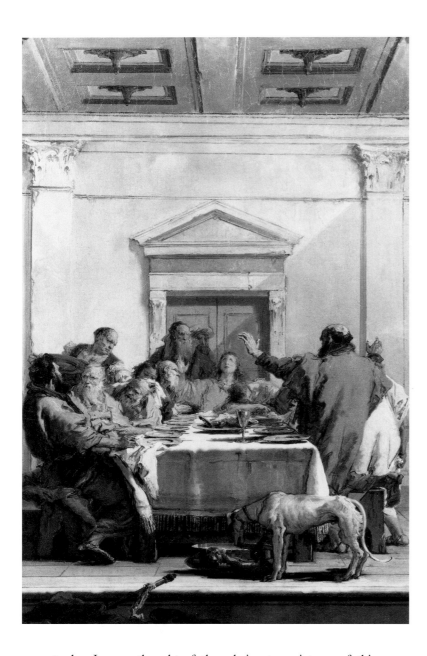

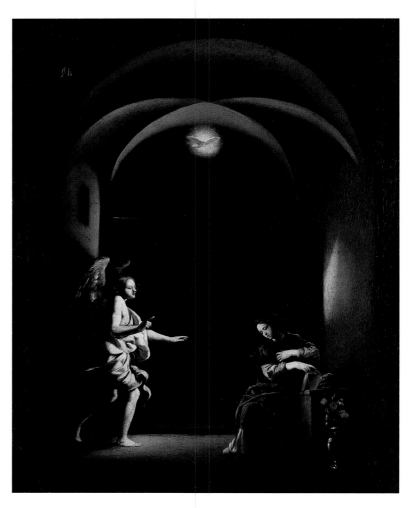

15 Giovanni Domenico Tiepolo , *The Last Supper*, c. 1758, oil on canvas, 26 ³⁄₁₆ × 16 ⅞ in., the Ella Gallup Sumner and Mary Catlin Sumner Collection Fund, 1931.106

16 Giovanni Battista Caracciolo, *The Annunciation*, c. 1615–20, oil on canvas, 24 ⅝ × 19 ¼ in., James J. Goodwin Fund, 1932.292

yesterday. I never thought of there being two pictures of this same subject and a comparison of the photographs even, will show the differences in quality, which is very apparent. Of course under these circumstances, I could not ask the museum to accept the picture which Brass sent and I would be very grateful to you if you will write me a letter clearing up in some way the misunderstanding and telling me what I should do.[62]

Parsons' advice did not come until September in a cable, which said, "Always supposed picture identical one seen in Venice. Would not have recommended unseen picture. Advise refuse, augment materially your offer; confident you will secure picture desired."[63] In fact without an augmentation of the price, an embarrassed Brass arranged to have the correct painting also shipped to Hartford, so that Austin could judge for himself which one he wanted. He rightly chose the somewhat more sumptuous version, which had been exhibited in Florence, thereby separating it from its pendant *St. Cecilia* which Brass later sold to the museum in Kansas City. The rejected second version of the *St. Catherine* eventually found its way into the Bührle collection in Zurich.[64] Henry-

Russell Hitchcock writing in the April issue of the Atheneum's *Bulletin* waxed ecstatic about the new acquisition:

> The Saint Catherine from the Brass Collection, lately acquired by the Wadsworth Atheneum, has for some time been known as a masterpiece by Strozzi . . . The palette is limited and the color acid, electric, with a subtle harmony of whites and rose-mauves against the almost black ground, to which the touch of pale blue border on the outer robe, the edge of gold fringe, the red ribbon at the wrist, and the dull jewels add a rich and delicate contrast. The hair is light golden beneath the deeper gold of the crown, and the flesh clear and fine rather than sturdy and ruddy . . . But the most astonishing element in the picture is the bravura of the painting of the drapery in great broad and crisp folds in which the light glints and is reflected in all directions as from a Baroque glory.[65]

Given the problems over the Strozzi acquisition, Austin may have felt he did better working with his favorite dealer closer to home, as he sought to enhance the museum's holdings, and throughout the 1930s he remained in continuous contact with Kirk Askew. In 1931, he obtained from this dealer Giovanni Domenico Tiepolo's *Last Supper* (fig. 15) formerly in the

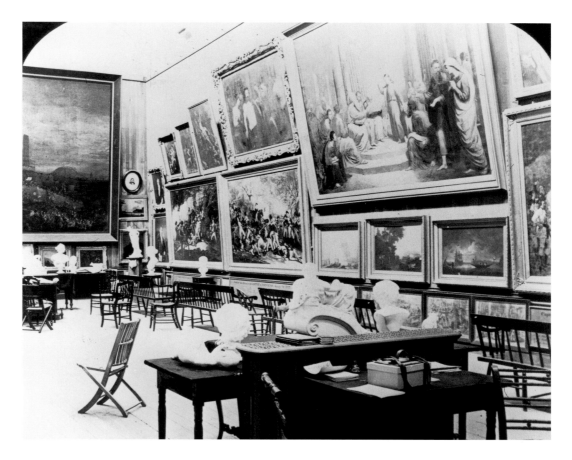

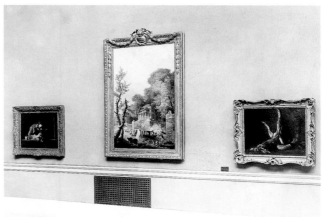

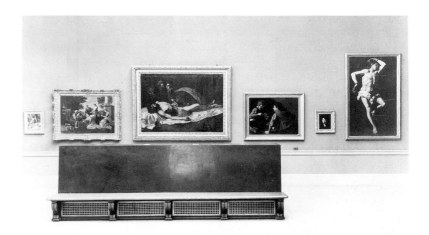

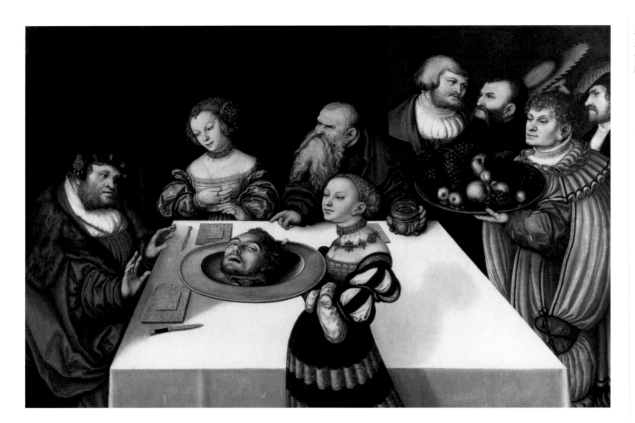

21 Lucas Cranach the Elder, *The Feast of Herod*, 1531, oil on panel, 32 × 47 ⅛ in., the Ella Gallup Sumner and Mary Catlin Sumner Collection Fund, 1936.339

Rothschild collection. Then in November 1932, Askew, who following the sudden death of Mr. Paff, had taken over the operation of the New York branch of Durlacher's, proposed to Austin a group of sculptures and paintings including a Francesco Furini *Adam and Eve* and a Caracciolo *Annunciation* with an authentication from Dr. Herman Voss of the Kaiser Friedrich Museum in Berlin, that described it as "a very fine example of the master."[66] Austin chose the monogrammed Caracciolo (fig. 16) and followed this up in May 1933 by purchasing the great mannerist sculpture of Venus by Francavilla, that the Fogg Art Museum had decided was not appropriate for their courtyard.[67] Also in 1933 Askew sent back to Hartford for consideration the Claude *Landscape with Mill and Goats* previously in the landscape exhibition and a Fetti *Parable of the Sowing of the Tares.* They did not find favor and, Askew reported back to the London office, "[Austin] decided that when he gets a Claude he wants a bigger one."[68] The next year Askew tried with another Fetti of *David with the Head of Goliath*, a variant of one in Dresden, and a Salvator Rosa of a *Landscape with Tobias and the Angel* (fig. 4). The two pictures were priced together at $6000. Austin after, as was his wont, hanging them both in the museum's galleries to study and provide an ever-changing installation, wrote Askew, "I have decided not to get the Fetti at the moment as it seems to look not so well in the Baroque room." The Rosa, on the other hand, he found "magnificent against the red wall and I like it very much."[69] As a single item it cost $3,100. Like the Rosa previously purchased from Durlacher's, this one had a noble English provenance, in this case from the collection of Lord Jersey at Osterley Park, on the outskirts of London, but unlike the other its authenticity has never been doubted.

V. A RENAISSANCE MASTERPIECE

Perhaps fearing that he was paying too much attention to the Baroque era, Austin in late 1931 turned his attention again to the Renaissance and the idea of acquiring one great work each year. The painting which had caught his fancy was a large Piero di Cosimo, (cat. no. 1) actually described by Vasari, that had passed through several distinguished English collections and been shown in the *Exhibition of Early Italian Art* in London during 1930. After consulting with his Harvard associates, Austin decided to purchase the work then identified as *Hylas and the Nymphs* from Lord Duveen for $100,000, the highest price he ever paid for any picture. In the museum's *Bulletin* he revealed his deep fascination with the work, noting how it captured the quintessence of the Renaissance in representing "the discovery of the world and of man;" and he continued, "This most important painting will allow the beholder to share the spirit of joyous paganism which was the Renaissance." It thus provided a perfect contrast to his earlier Renaissance purchase, the Fra Angelico *Angel*, with "its glimpse of Gothic mysticism."[70] As Jean Cadogan has pointed out, the fact that Piero di Cosimo was claimed by the Surrealist artist and writer André Breton as the "spiritual ancestor" of the modern movement that so fascinated Austin may also help explain his enthusiasm for this work with its "disconcerting blend of the real and the fantastic."[71]

When Erwin Panofsky, the eminent art historian and iconographic expert, was invited by Austin to view the Piero di Cosimo at the Atheneum, he firmly informed the director, "You've got the wrong title for this picture. Its subject is not *Hylas and the Nymphs* but *The Finding of Vulcan*." Panofsky proved his point in a 1939 article, which according to Austin's friend and colleague, James Thrall Soby, "was a masterpiece of logic . . . and as exciting to read as the best detective stories of Georges Simenon."[72]

Although never stated as such, it must have been as a reward for this major purchase, that Lord Duveen, who took an avuncular tone with Austin, sent him, anonymously, an entire exhibition in early 1932. The Piero di Cosimo was featured along with eighteen paintings including examples by Pesellino, Giovanni Bellini, Lorenzo Lotto, and Dosso Dossi, as well as bronzes and plaquettes.[73]

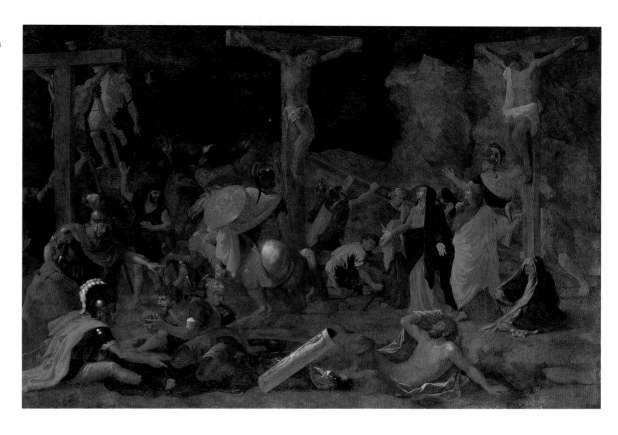

22 Nicolas Poussin, *The Crucifixion*, 1645–6, oil on canvas, 58 ½ × 86 in., the Ella Gallup Sumner and Mary Catlin Sumner Collection Fund, 1935.422

VI. FURTHER GROWTH OF THE COLLECTION IN THE MID-1930S

The new treasure by Piero and all of Austin's other recent purchases received a new suitably grand setting when the Avery Memorial building, the interiors of which were primarily designed by the director, opened in February of 1934. There was a great entrance court with the Francavilla at its center that could serve for special exhibitions (fig. 39), and then as Henry-Russell Hitchcock described, "painting galleries on the upper floor [with] backgrounds of rich textiles suited in general character to the pictures displayed but applied as contemporary taste demands and not in a traditional way."[74] These spaces could accommodate even the grandiose Giordanos (fig. 38), and with this additional room, the process of expanding the collection of old masters continued apace. From Wildenstein, Austin bought in 1934 the small rococo masterpiece *La Paresseuse Italienne (Indolence)* by Greuze (cat. no. 56), which the Metropolitan Museum's curator of paintings, Harry B. Wehle, aptly described in a letter as "a lazy slut" and Glenway Wescott lauded in more literary fashion in the museum's *Bulletin*.[75]

In May 1934, Askew sent to Hartford for purchase consideration works by Castiglione, Maratta, and Magnasco, but none of them was acquired. In 1935–36, however, he succeeded with both Guardi's *View of the Piazzetta, Venice* (cat. no. 27) and Lelio Orsi's *Noli me tangere* (cat. no. 6). To this point Austin had not shown much interest in Northern European art, but when Durlacher's produced a great example of early German painting, Lucas Cranach's *Feast of Herod* (fig. 21), he and the Trustees were "absolutely carried away by it," but because the cost of the Piero had been so great, they had to defer part of the purchase price of $19,000.[76]

In addition to Kirk Askew at Durlacher's, Austin's other favored New York dealer for notable old master paintings was to be Paul Byk (affectionately referred to by the Austin family as Uncle "Sink-So") of Arnold

Seligmann, Rey and Co.[77] Thus it was Byk who in April 1935, sent for the director's consideration information on "the marvelous *Crucifixion* painted in 1645 by Nicolas Poussin for the President Thou." This very large painting sadly in a poor state of preservation (fig. 22) had later passed to the painter Jacques Stella, a friend of Poussin and most recently had been in the collection of the First Marquess of Zetland. Byk added, "After having had extensive correspondence with my partners, I am in a position to confirm to you the special price of $12,500. There is no especial hurry about this transaction." In May he followed up, reporting that Professor [Walter] Friedlaender had discovered the original drawings for the composition by Poussin and "he says that this picture is not only the capital work by Poussin, but the capital work in French painting of all time."[78] Only in October was Austin able to write him: "I have at last persuaded the Trustees that they really should have the Poussin *Crucifixion*. They are willing to purchase it with payment in full immediately for the price made by you, on condition that the payment for the Batoni be delayed for some months."[79] Indeed the Batoni *Portrait of Sir Humphry Morice* as well as Giuseppe Maria Crespi's little portrait of the *Artist in his Studio* (cat. no. 21) were both purchased in 1936 and were followed the next year by a Solimena from Byk, described as a "superb picture . . . representing the foundation of the Dominican Monastery of Monte Cassino,"[80] and an even grander Spanish Baroque masterwork Murillo's *St. Francis Xavier* (fig. 23).[81] Another purchase of note was Magnasco's unusual *A Medici Hunting Party* (fig. 26), offered for $5,500 by M. Knoedler & Co., but sold for a "special price" of $3500. Its acquisition was featured in both the *New York Times* and *Art News*.[82]

To complement the great Poussin, Austin now needed to find a suitable Claude and his wish was fulfilled when Durlacher's in September 1936 had shipped from London to New York the magnificent *St. George Slaying the Dragon* (cat. no. 52). They sent photographs of it to the Frick as well as to the museum directors in New York and Cleveland with an asking price of £3,500. Askew naturally also invited Austin to see it and

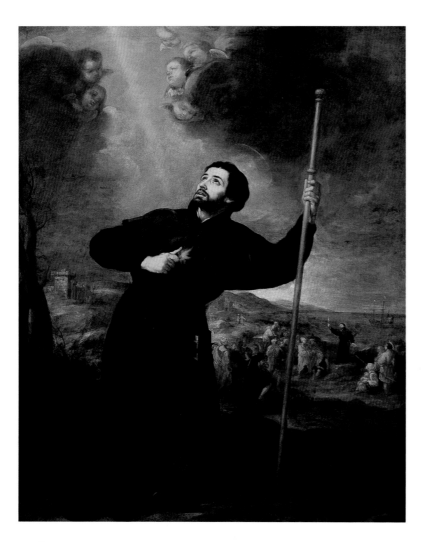

23 Bartolemé Esteban Murillo, *St. Francis Xaviar*, *c.* 1670, oil on canvas, 85 5/16 × 63 7/8 in., the Ella Gallup Sumner and Mary Catlin Sumner Collection Fund, 1937.3

24 Hubert Robert, *Jean Antoine Roucher Preparing to leave his Prison Cell*, *c.* 1797, oil on canvas, 12 5/8 × 15 7/8 in., the Ella Gallup Sumner and Mary Catlin Sumner Collection Fund, 1937.1

25 Gerard Dou, *Still Life with Hourglass*, *c.* 1647, oil on panel, 9 5/8 × 7 in., the Ella Gallup Sumner and Mary Catlin Sumner Collection Fund, 1937.493

26 Alessandro Magnasco, *A Medici Hunting Party*, 1706–07, oil on canvas, 33 3/4 × 46 in., the Ella Gallup Sumner and Mary Catlin Sumner Collection Fund, 1937.84

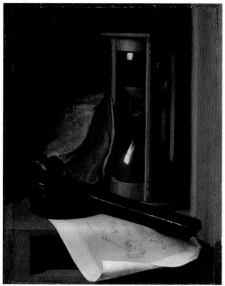

followed up with a detailed letter giving its impressive provenance and an extensive quotation from Smith's *Catalogue Raisonné*. Fortunately Austin acted quickly and purchased it on December 1, 1936, but because he had stretched the acquisition funds so thin, payment had to be deferred until April of the following year. Upon its purchase a photograph of the Claude was published in the *New York Times* with the caption "Masterpiece Acquired by Connecticut Institution."[83]

Additional Italian and Spanish works had come to the museum in 1936 as gifts from Frank Gair Macomber of Boston: Luca Giordano's *St. Sebastian*, which had been on view in the Hartford exhibit of 1930, and the Ribera school *Christ Crowned with Thorns*.[84]

Austin typically spent his summers in Europe, and in 1937 he was in Austria and the Netherlands, searching for works, as his traveling companion, Agnes Rindge, a noted art historian at Vassar, described it "at the source." [85] From Fritz Mondschein of the Galerie Sanct Lucas in Vienna, he made several acquisitions for very modest sums. As a Guido Reni, Austin purchased a bust-length *St. Sebastian* (fig. 27) for $150. It has subsequently been attributed to Bilverti, Carlo Dolci, and Curadi.[86] On this same buying spree in Vienna, Austin actually acquired Dolci's *Christ Child with Flowers* for only $170. An additional work, which clearly appealed to his taste for the bizarre, was Monsu Desiderio's *Belshazzar's Feast*. Of the Northern school, Austin also purchased from the Galerie Sanct Lucas a signed *Still Life with Ham* by Jan Jansz. den Uyl. In Amsterdam he found at the gallery of Pieter de Boer still lifes by Balthasar van der Ast (cat. no. 38) and Gerard Dou (fig. 25), plus a characteristic street scene by Jacobus Vrel.[87]

VII. THE EXHIBITIONS OF 1936–38

The end of 1936 brought to Hartford an extraordinary two-day exhibition. Organized by the French expert Louis Carré, it was entitled *Paintings by Georges de La Tour and the Brothers Le Nain*, and was set to open on November 23 at Knoedler Galleries in New York and then go on to the Art Institute in Chicago and the museums in St. Louis and Detroit. Since Austin was lending the Atheneum's prized work by Le Nain, Carré had already written to him in August that he "hoped that there may be some way to arrange to let you have the exhibition."[88] Then in October with the assistance of Eleanor Howland, Austin's former assistant, who was now working for Knoedler's, it was found possible that after closing in New York on December 13, the exhibition could be shipped to Hartford and exhibited there on Wednesday and Thursday, the 16th and 17th, before going off to Chicago late on Thursday. Best of all the Atheneum had only to pay the expenses for the shipping from New York to Hartford.[89] There were in all twenty-four paintings, which according to the newspaper accounts were hung in the court, to be "more easily and readily available," and special evening viewing hours were set.[90]

After visiting the Atheneum and being entertained at the Austins' home, Louis Carré wrote to thank Mrs. Austin and asked her to, "Please tell Mr. Austin that I think he hung the exhibition magnificently."[91] It was reported that the exhibition "broke attendance records both days,"[92] and the only worry arose when the pictures did not arrive on schedule in Chicago, having been transferred to another train because of an axle accident.[93]

Immediately on the heels of this triumph, Austin organized for January 1937 his next thematic exhibition, *43 Portraits* (fig. 39). The newspaper reported the value of the loans was "approximately $5,000,000," and among the great works displayed in the main court of the Avery Memorial borrowed for the occasion were the Boston Museum of Fine Art's Andrea Solario, a Hans Holbein from Jules Bache, and

27 Florentine, *St Sebastian*, seventeenth century, oil on canvas, 25 × 20 in., the Ella Gallup Sumner and Mary Catlin Sumner Collection Fund, 1937.468

Chauncey Stillman's *Halberdier* by Pontormo (now in the Getty Museum).[94] Lord Duveen was unable to lend Rembrandt's *Aristotle* (now in the Metropolitan Museum), which he had just sold, but he did send another Rembrandt, a *Portrait of an Accountant* (which is now assigned to Drost).[95] Also featured in the exhibition was another unusual recent purchase from Wildenstein – a Hubert Robert then believed to represent *Camille Desmoulins in Prison* but now more correctly identified as the poet Antoine Roucher (fig. 24), who did encounter Robert in prison before being executed.[96]

The exhibition's mix of periods and types of portraits was well received. The local newspaper observed: "It is not often that Hartford, or for that matter any other city, has an exhibition like this . . . The collection on exhibition is one of the finest to have been shown in this country in several years."[97]

The popularity of this type of "retrospective exhibition," as it was called,[98] led Austin to mount another the following January. Devoted to a favorite subject of the director's, it was called *The Painters of Still Life*. The theme allowed him to freely combine old and modern paintings, including many he had purchased. In addition to the van der Ast, Dou, and den Uyl, there were two still lifes of musical instruments by Evaristo Baschenis (now called by followers), one purchased from the Dutch dealer Pieter de Boer and the other from Julien Levy, Austin's ally in nurturing the Surrealist school. Some of the highlights on loan were the

Kress collection's Caravaggesque *Still Life with Watermelon*, the great van Huysum *Vase of Flowers* from the museum in Kansas City, and Chicago's Velázquez of a *Maid Servant*. Also of the Spanish school was a *Still Life* by Luis Meléndez (cat. no. 33), that the catalogue listed as belonging to the Atheneum. The bill for this in the amount of $950 was received in May 1937 from the Amsterdam dealer D.A. Hoogendijk & Co., but only paid almost a year later in April 1938.[99]

VIII. ACQUISITIONS OF THE LATE 1930S

Following this exhibition, yet more purchases of still lifes were made, most notably the Chardin *Kitchen Table*, which had been lent by Wildenstein. Then in October of 1938, Kirk Askew wrote that he was shipping to the museum several pictures, including a Valdés Leal *Vanitas* (cat. no. 32) for $3000 and for $1600 a large *Fruit Stall*, which Dr. Hermann Voss had attributed to Vincenzo Campi; both were purchased in 1939 in addition to the two school of Archimbaldo representations of *Spring* (fig. 28) and *Summer* from Parisian dealer Renou and Colle,[100] which certainly appealed to Austin's interest in the surreal.

Another of the director's great loves was Venice, and he furnished his Palladian style Hartford home with fabrics, furniture, and panels of the Venetian rococo. His chief source of these items was the dealer, Adolf Loewi, who had transferred his business from Venice to Los Angeles, and from him Austin was also able to acquire some works for the museum such as in 1931 Pietro Longhi's *The Temptation* and in 1939 a modest early Canaletto of a *Landscape with Ruins*.[101] Then in April of that year, Felix Wildenstein wrote Austin that he could now give him a price on "the large painting by Carlevarijs 'The Feast of the Redeemer in Venice,' which I had occasion to show you . . . I had to get in touch with its owner who lives in Paris. I am now in a position to quote you the very best price of $3500 on it." Austin cabled on May 4, "Am authorized to offer $3000 immediate payment Carlevarijs," which Wildenstein accepted the next day.[102]

The late 1930s also witnessed several major acquisitions of the Northern European school. From the unlikely source of J.B. Neumann, a New York dealer in modern art, came in 1938 a major example of the *bamboccianti*, *Carnival in the Piazza Colonna* by Jan Miel (cat. no. 41), and from Durlacher's that same year the large but mainly shop treatment of Rubens' *Return of the Holy Family*. Of finer quality was the Bernard van Orley *Crucifixion* purchased the following year.[103]

Several other notable works were acquired in 1939. Representing the French school was Sebastian Bourdon's painting on copper, *The Smoker* (fig. 29), bought from the New York dealer Julius Weitzner for a mere $450, and from Seligmann, Rey and Co. came "the great dramatic seascape" by Claude Joseph Vernet for $2,500.[104] Likewise there also entered the collection that year the first example of Italian Baroque portraiture, a depiction of an otherwise unknown Marcus Viari by the Venetian painter Tiberio Tinelli. It came from the Viennese dealer Fritz Mondschein, who in May of that year visited Hartford bringing with him "the well known Austrian art expert" Wilhelm Suida to see the collection and meet Austin.[105] Suida was one of the several European experts at that

28 Archimbaldo School (17th Century), *Spring*, oil on canvas, 38 ½ × 55 in., the Ella Gallup Sumner and Mary Catlin Sumner Collection Fund, 1939.212

29 Sebastian Bourdon, *The Smoker*, c. 1635, oil on copper, 9 × 11 ⅝ in., the Ella Gallup Sumner and Mary Catlin Sumner Collection Fund, 1939.622

30 Jan Sanders van Hemessen, *Loose Company*, 1543, oil on panel, 33 × 46 ½ in., the Ella Gallup Sumner and Mary Catlin Sumner Collection Fund, 1941.233

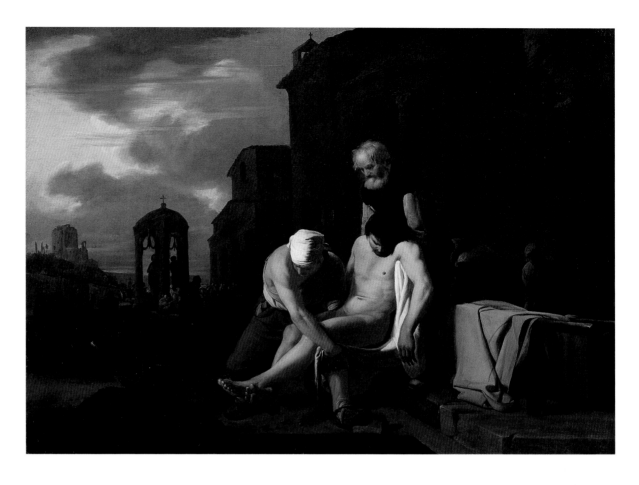

31 Michael Sweerts, *The Burial of the Dead*, c. 1650, oil on canvas, 29 ⅛ × 39 in., the Ella Gallup Sumner and Mary Catlin Sumner Collection Fund, 1941.595

time widely used for authentication and identification especially of Baroque paintings. He would later be entrusted with preparing a catalogue of the Ringling collection in Sarasota.

Highly finished and evocative Northern pictures continued to intrigue the director, and in the early 1940s from Seligmann, Rey, and Co., he purchased the *Head of a Boy* by Michael Sweerts (cat. no. 45) and the small Cornelis van Poelenburgh *Feast of the Gods* formerly in the collection of the Counts Schönborn at Pomersfelden (cat. no. 35). Austin described the first as "reminiscent of Vermeer," and the latter as the painter's "certain masterpiece," going on to note, "This Feast of the Gods is surely a feast for the eyes of mortals, so luscious and fresh is its color, so enchanting the composition with its extraordinary landscape below, which appears to act as a sort of toboggan for the excursion of the cloud-cushioned Olympian assemblage."[106] Of the earlier Netherlandish period, the same dealer also provided Jan van Hemessen's large panel painting of the so-called *Loose Company* (fig. 30) and similar subject in Cornelisz van Haarlem's *The Prodigal Son*.[107]

Austin's willingness to buy unusual paintings, which caught his fancy, was best illustrated by his purchase in 1941 of a second canvas by the rare Flemish painter Michael Sweerts. This haunting work, sold by David Koetser for $1200, was titled "The Entombment of Lazarus," but later correctly identified as *The Burial of the Dead* (fig. 31) from Sweerts' dispersed series of *The Seven Acts of Mercy*.[108]

IX. THE CARAVAGGIO QUEST, PART I

Perhaps the director's reason for liking this second Sweerts may be discovered in his description of the picture: "This subject betrays the influence of Caravaggio in the spotlight illumination of the central

group and characteristic manipulation of the plastic and broad modeling of both figures and draperies."[109] As will be remembered, one of Austin's chief desires was to find an authentic Caravaggio for the Atheneum's collection. The first revived hint of this possibility came in a letter of November 9, 1939, from Paul Byk. He wrote inviting "Mr. Austin," as he addressed him, "to come to the gallery when next you are in New York, as I have a *great surprise* in store. I know in advance that you will share my enthusiasm." Austin, perhaps inured by now to such blandishments by dealers apparently did not respond, so Byk wrote again on the 27th, "Something very exciting and absolutely in your line has turned up. When may I have the pleasure of your visit to have you share my enthusiasm?" The source of Byk's excitement was the now famous Caravaggio, *The Ecstasy of St. Francis* (cat. no. 7), and the dealer followed up Austin's visit by sending him the history of the painting, which had been shown in Naples in 1938. He reported further that the director of the Brera in Milan, Antonio Morassi, had wanted to acquire it but had no funds and that the work was "most emphatically indorsed (sic) by Roberto Longhi, who is after all the greatest connoisseur of the master."[110] Although we have no firm evidence, it must have been Austin's desire to get this picture for Hartford that became the *raison d'être* for one of his most original exhibitions. As he wrote to Dr. Valentiner in Detroit on January 18, 1940, "I am very much involved in getting together (rather hurriedly, I am afraid) an exhibition of Paintings of Night Scenes."[111] Presented in February and March of that year, *Night Scenes* was a typically wide-ranging Austin show. From among his Atheneum purchases were works by Bassano, Caracciolo, Monsu Desiderio, Rosa, Orsi, Poussin, and Honthorst. Significant loans included paintings by or attributed to Rembrandt, El Greco, and Albert Pinkham Ryder. Perhaps the greatest specialist in candle-light scenes

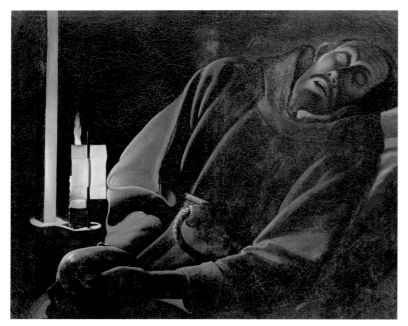

32 Georges de La Tour (after), *St. Francis in Ecstasy*, c. 1645, oil on canvas, 26 × 31 in., the Ella Gallup Sumner and Mary Catlin Sumner Collection Fund, 1940.166

33 Workshop of Guercino (Giovanni Francesco Barbieri), *St. Sebastian with Armor*, c. 1625, oil on canvas, 46 × 56 ½ in., the Ella Gallup Sumner and Mary Catlin Sumner Collection Fund, 1943.100

inspired by Caravaggio was the recently rediscovered French master Georges de La Tour, and he was represented by three examples. One of these, a *St. Francis in Ecstasy* (fig. 32), was lent anonymously by Dr. Vitale Bloch of Paris and would be purchased later that year for $4,800 through Durlacher's. Although now identified as a fragmentary copy after a lost original, at that time Dr. Hermann Voss identified it as "unquestionably by the master."[112] The Caravaggio itself was specially packed for shipment by February 8, since according to the dealer, "as you know the picture is a very valuable one and the frame extremely fragile."[113] The exhibition catalogue gave a full-page illustration to the painting, and the text, which we can assume to be Austin's prose, stressed the painter's "revolutionary" contribution, praised "the miraculous chiaroscuro of his plastic forms," and noted rather grandly that this picture "is related to the *Rest on the Flight* of the Doria Gallery and the *Story of St. Matthew* in S. Luigi dei Francesi in Rome."[114]

On the exhibition's closing Byk wrote, now addressing the director as "Chick,"

I see on the calendar that your show is closing today. I think a few of the pictures coming from us aroused great interest with you personally, especially the Caravaggio. I told you that I would be willing to make terms at mutual convenience. Suppose that the picture stays with you for some time more, to allow you ample time for study and discussion with the trustees.[115]

In April of that year Byk followed up:

I am sorry that I have no hint at all as to what you are willing to do on the Caravaggio. I feel more and more that this is a picture, which fits into your collection with such perfection that you just cannot miss it. The World's Fair made me an offer to get the picture, but I don't feel like accepting it, because I think that its real place and home is Hartford. I made you, I think, a very liberal proposition and I sincerely hope to hear from you soon.[116]

Austin paid a visit on April 10 to Byk and must have expressed his desire to retain the picture, as the latter wrote to him on the 11th that he was "glad to have seen that the picture is as dear to you as it is to myself." He also sent copies of the letters from Walter Pach, the organizer of the World's Fair's *Masterpieces of Art*, requesting the painting for that exhibition to assist in helping to convince the trustees of its importance.[117] A decision by the Trustees was delayed, however, until their September meeting, and Byk wrote in late August hoping that "if the Caravaggio should be the chosen picture I would be delighted," since he rather desperately needed the money.[118] This meeting too never took place and so in October Byk wrote Austin a serious letter:

I have long and carefully thought over the matter of the CARAVAGGIO. You know well enough the personal pride and satisfaction I derive from having recommended to you pictures which are today not only the glory of your collection but also the envy of other executives without the discriminating taste and the daring spirit of enterprise so characteristic of you.

I know that sharing your enthusiasm about the Caravaggio and recommending you this picture I was following my policy to recommend only the best. The picture is not only most attractive, but marvelously documented and recognized by the only authority, Professor Longhi. . . . I told you already that I am perfectly willing to reconsider the price of the picture . . . However, should you after all that I pointed out to you be against its acquisition, I may feel like recalling the picture, much to my regret, not for commercial reasons, but for the reason that I think that it could not find a better, more dignified and worthy surrounding than in the museum you created.[119]

As a further prod, Byk soon wrote again, "I have just had word from Ventura from Italy asking me if we are still free for the Caravaggio and telling me that if and when the War is over he would have a great client in Italy for fine Baroque pictures and especially for this picture, which is so highly praised by Longhi all over the country."[120] Nothing was resolved

that fall, and on December 3, Byk had to suggest, "if Mahomet does not come to the Mountain, I may come up for a brief visit between Christmas and the New Year."[121] Things dragged on into 1941 with Byk writing in January to say, "I suppose that you have a meeting on Saturday and I hope that when I come you will give me a definite answer about the Caravaggio."[122] Then later in the year repeating his "attachment to you and your Institution comes before any other consideration," he noted "you are my oldest and truest and most appreciated client." Taking another tack, he wrote again to point out that an exhibition of Baroque paintings in San Francisco included the Chicago *Chastisement of Love* as a Caravaggio "notwithstanding that Longhi did not recognize the picture." But, he continued, "Ours which you have is recognized by everybody, and especially by Longhi, who bases his judgement on old documents about our picture and which make it undoubtedly an original, authentic work by the master." He goes on to propose, "I would very much like to consider a plan to approach the problem of acquiring this picture, and I would be happy to discuss the matter with you in coming up to Hartford any time convenient."[123]

Still no decision was made so in June Byk sent two more letters. The first "just to confirm having shown you a telegram of Ventura's from Florence, telling me that Longhi wanted to know the name of the definite proprietor of the Caravaggio for publication in his book," and insisting, " I would feel very much obliged if you would consider the problem connected with this picture and discuss it with me in the fall at leisure." The second contained the following information: "I just came back from Cleveland, where I was for the Silver Jubilee. Francis told me that if he ever comes into money he would like to buy the Caravaggio, because he thinks it is the only surely established picture by this master beyond any doubt in America. I told him that you were still seriously considering this picture."[124] Since no solution could be found to the purchase impasse, the painting was returned to New York in May 1942.

X. FINAL AUSTIN ACQUISITIONS

Other more positive activities also transpired during 1942. The Schaeffer Galleries in New York City had organized from a private collection the exhibition *Gems of Baroque Painting*, and Austin was invited to present a talk on Baroque Art at the opening reception. Included in this exhibition was a fine small Salvator Rosa *The Tribute Money*, and it must have been with Austin's encouragement that it was purchased at this time by Henry T. Kneeland of Bloomfield, Connecticut, in whose memory the work was eventually given to the museum. Also from the Schaeffer exhibition, Austin acquired for the Atheneum a *Still Life with Fish* attributed to Giuseppe Recco.[125] An even more significant still life had appeared at the New York gallery of David Koetser in late 1941. This was, as the dealer wrote Austin in November of that year, attributed by Dr. Suida to the Milanese painter Fede Galizia and priced at $2500 (cat. no. 15). Perhaps no other work acquired by Austin has undergone so many attributions. Widely exhibited, it has gone from being by or after Caravaggio or one of his collaborators, such as Prosperino delle Groteschi, to its general appellation as by the Hartford Master.[126]

Also in 1941 Austin purchased from Durlacher's for $2,800 another significant representative of the Neapolitan Baroque, Bernardo Cavallino's *Flight into Egypt*, (cat. no. 16). It had been in the collection of Kenneth Clark and shown at the major 1938 London exhibition of *17th Century Art in Europe* at The Royal Academy in Burlington House.

The last flowering of Austin's tenure was in the years 1943 and 1944. In regard to the Baroque came the acquisition in April 1943 of the supposed Guercino *St. Sebastian with Armor* (fig. 33) from Lord Caledon's

34 Orazio Riminaldi, *Daedalus and Icarus*, 1625–30, oil on canvas, 52 ⅛ × 37 ⅞ in., the Ella Gallup Sumner and Mary Catlin Sumner Collection Fund, 1944.38

collection. Paul Byk had first brought this to Austin's attention in April 1941, noting that the conservator "Mr. Picchetto has virtually put the picture aside for Mr. Kress . . . With all the interest you always have shown in my Firm, I don't want you to miss this picture because it is the only well identified Guercino, and as such, a worthy addition to your permanent collections. I had asked you originally $7,500 for the picture, but would now take $6,500."[127] Austin acquired the painting and made it the centerpiece of his exhibition *Men in Arms*, which ran from February 2 to March 4, 1943. The work was even reproduced on the cover of *Art News* that February, but as Denis Mahon later reported "this painting may be an old copy of a lost original by Guercino or an independent work of a close follower . . . My guess, for what it might be worth, would be the latter."[128]

XI. THE CARAVAGGIO QUEST, PART II

With the acquisition of a work by "Guercino," master of the Bolognese Baroque, Austin turned his attention again to the greatest of Roman Baroque painters, Caravaggio, and Byk's still tantalizing but expensive *St. Francis*. It was sent back to Hartford for renewed consideration in October 1942. On November 30, Byk wrote to Austin, "I trust you will decide this week about the Caravaggio, as I would very much like to see

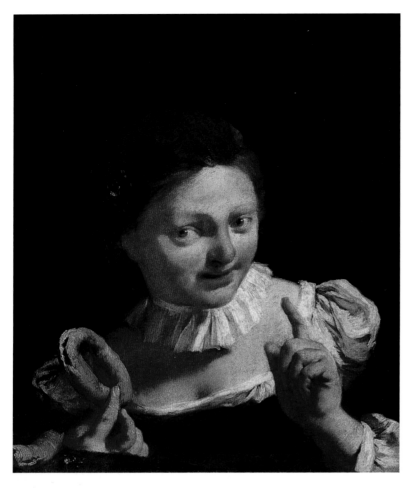

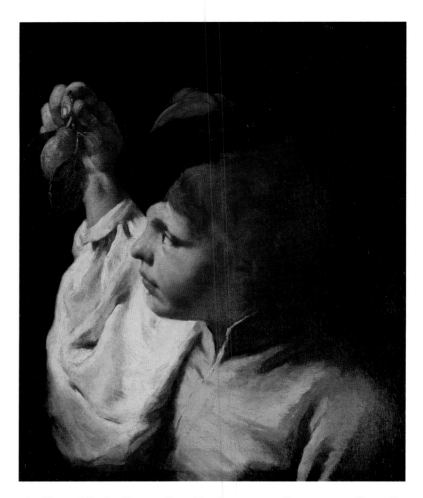

35 Giovanni Battista Piazetta, *Girl with a Ring Biscuit*, *c.* 1740, oil on canvas, 17 ⅛ × 14 ⅟₁₆ in., purchased with funds raised in honor of Jean K. Cadogan, the Ella Gallup Sumner and Mary Catlin Sumner Collection Fund, 1997.22.1

36 Giovanni Battista Piazetta, *Boy with a Pear*, *c.* 1740, oil on canvas, 17 ¾ × 14 ⅝ in., the Ella Gallup Sumner and Mary Catlin Sumner Collection Fund, 1944.34

this picture in Hartford, where after all it belongs as far as my very incompetent judgment is concerned." Austin in one of his rare direct responses to a dealer answered on December 2 that "I shall speak to you about the Caravaggio at the earliest possible moment." What was said is unknown, but on December 11 Byk sent to the museum a transcript of enthusiastic endorsements of the painting by the leading Italian experts Longhi, Morassi, and Fiocco.[129]

Clearly Austin had encountered a multitude of troubles with the Atheneum's Trustees, and a six-month sabbatical for the director had been scheduled to begin in July, so he may have sought to make his last stand over the Caravaggio. On June 10 he wrote a detailed letter to Robert Huntington, chairman of the trustee acquisition committee, who had already departed Hartford for his summer residence in Maine:

> You will surely remember the picture which we had first in Hartford in the exhibition of Night Scenes some years ago and which is reproduced in the catalogue of that show . . . At that time the picture was being held for a very high price, – over fifty thousand dollars as I remember it. It is the only authentic Caravaggio in America and yet at that time I did not feel, important as the picture was, that we should spend that much money on it. . . . During the years that ensued, however, the price of the painting was gradually lowered, and . . . Arnold Seligmann, Rey & Co., finally offered us the picture for seventeen

> thousand dollars, which represents a figure below their actual cost price (because of certain tax difficulties which they wished to straighten out in their own business). In the meantime I have thought a great deal about the painting and have asked many scholars about their feelings in connection with the work. They have all admired it very much and all agree that it is by Caravaggio . . .

> Now as you know, the greatest strength of the Atheneum collections lies in the field of seventeenth century art which have now become, I am sure, the greatest in this country. Both in Italy and in the other countries of Western Europe, Caravaggio was the greatest single influence on that century, and for that reason it has always been most essential that we have a work by this great master as a pivot to the many wonderful pictures we have bought. But since the purchase many years ago from Wildenstein of the so called Caravaggio "Head of a Boy" (which is almost certainly a French picture and a very handsome one, but not by the master), I wanted to be quite certain in my own mind that our next essay would be undisputed. Of this I am now convinced. At seventeen thousand the price not only represents a sensational buy for a Caravaggio, but as well protects us in the future against any reversal of authorship, since the painting is a very beautiful one and would be worth the amount in any case . . .

> I am therefore writing to ask you for your approval for its purchase. We have now about twelve thousand dollars in the bank and will have

ample during the first weeks of July to cover the full payment with some thousands left over. I shall be leaving during the first weeks of July and want very much to have the matter settled as soon as possible, as I should like to arrange an exhibition in the court for the summer around the St. Francis, including some of our other pictures which stem from Caravaggio, and a few to be borrowed from New York. It should be a very handsome one.[130]

Austin's impassioned appeal won the day, and a new invoice for the painting was sent on June 15, and by the end of the month he opened in Avery Court a special exhibition boldly called *Caravaggio and the Seventeenth Century* in which, according to the typewritten checklist, forty works, including the Caravaggio *Ecstasy of St. Francis*, were all those, beginning with the pair of giant Giordanos that Austin had acquired during his directorship. Seven other paintings were lent by New York galleries. The *Hartford Times* reported, "The court is a glamorous scene, which again goes to prove the inspired judgement that has gone into the selection of paintings for the Atheneum's collection . . . This is one of the most elegant and stimulating exhibitions the Atheneum has hung in a long time."[131]

This was not quite the end of the Caravaggio matter, as in June of 1943 Byk, who must by now have been well aware of Austin's continuing disagreement over policy with the Trustees, sent him a handwritten note expressing concern for his health and inviting him to join him as his guest at the celebrated Garden of Allah hotel in Los Angeles. Ever the businessman, he ended by asking, "When do you think the money for the Caravaggio is due? I am somewhat in need of it."[132] Austin apparently arranged for the payment of the new bill for $17,000, which was sent to the Atheneum on June 15 and then did accept the invitation to go to California, remaining in Los Angeles from July 1943 to May 1944. The Caravaggio exhibition ran until January 16, 1944, and Austin's sabbatical was extended until January 1945, when he resigned the directorship.[133]

XI. THE FINALE OF CHICK AUSTIN

Austin's departure, however, did not completely end his influence on acquisitions and exhibitions at the Atheneum. A large number of works, which he had requested be sent by several dealers for possible purchase were, much to the ire of the Trustees, discovered in the museum basement and had to be reviewed. Austin was asked in November of 1943 to choose the ones he favored, and then Mr. Huntington and the acting director, Florence Berger, who had been the general curator since 1918, worked out the purchase details.[134] Of the paintings lent to the 1943 exhibition, the most impressive still at the museum was a *Daedalus and Icarus* attributed to Cavallino from Arnold Seligmann, Rey & Co. This was purchased by the Atheneum in 1944, and in 1966 Roberto Longhi made the now accepted attribution to the rare Pisan painter Orazio Riminaldi (fig. 34).[135] In May of 1943, the dealer A. F. Mondschein had sent to the museum a painting described as "*La Casa dell'Mareschalco*" with an attribution to the obscure Genoese painter Sinibaldo Scorza. As the price for this attractive work was only $850, its purchase was approved in February 1944. Later it was more aptly identified as one of the collaborations between Viviano Codazzi and Michelangelo Cerquozzi. Likewise a painting of *Thistles in a Dune* from Durlacher's that was attributed to Roeland Roghman was purchased for $1500 and was later discovered to be signed by Reinier van der Laeck.[136]

Finally to be dealt with was a work by the popular eighteenth-century master, Giovanni Battista Piazetta. Adolf Loewi of Los Angeles on a New York visit in April of 1943 had offered Austin a pair of works by the

37 Anthony van Dyck, *Robert Rich, Second Earl of Warwick*, c. 1635–40, oil on canvas, 87 ¼ × 52 ¾ in., bequest of J. Pierpont Morgan, Jr., 1944.8

painter representing a young girl and boy for $5500, or either one for $2800. Austin chose the *Head of a Young Boy* (fig. 36), and after some negotiations on the price, it was purchased for $2600 in March of 1944. The pendants were thus separated, and the *Head of a Girl* (fig. 35) appeared later in sales in New York before finding a home in a San Francisco collection. This enforced separation was a wrong that was righted with the Atheneum's acquisition of the young girl in 1997.[137]

Two significant gifts also enhanced the old master collection in 1944. Mrs. Stanley Richter presented the Andrea Previtali *Madonna and Child with a Donor*; and from the estate of J. Pierpont Morgan, Jr., arrived the large Van Dyck *Portrait of Robert Rich, Second Earl of Warwick* (fig. 37), which had been acquired by his father, the great financier of the same name, sometime before 1907.[138]

The Austin era was not, however, entirely over, for surprisingly, as he was in Hartford writing texts for a never-to-be-published catalogue of the Sumner Fund purchases, he was invited to bring his organizational skill and superlative eye to bear one last time. This occurred in April 1945 when the Atheneum joined with the rest of Hartford in celebrating "Netherlands Week," to honor the country then just emerging from Nazi domination. *Dutch Seventeenth Century Masters* combined some twenty works from the museum's collection with another twenty-five borrowed from New York dealers. Many of these, including a Bloemaert from Koetser, a Cuyp and van Goyen from Knoedler's, a great Hals *Portrait of a Man* and a van der Helst from Wildenstein, and a van de Capelle and Leyster from Seligmann, Rey and Co., were delivered to Hartford in a special truck belonging to the Royal Dutch Navy.[139] The greatest interest, as Austin himself pointed out in a radio broadcast from the museum, however, attached to the three borrowed Rembrandts – *Laughing Self-Portrait* from Schaeffer Galleries, *Zacharias in the Temple* from Seligman, and *Hendrikje Stoeffels* from Duveen.[140] Austin also supervised the hanging in the grand Tapestry Court and this gave the local critics a chance to make the appropriate valedictory remarks about the former director's talents. T.H. Parker wrote most eloquently in the *Courant*:

> The arrangement must stand as another example of Mr. Austin's taste in the selection of pictures. His eye for elegance and stylishness has been unerring and interestingly enough is nowhere more manifest than in the Dutch art which he himself bought for the Atheneum. It is unhappy that the exhibition will be on view but a week. It will, however, always be pleasant to recall that Mr. Austin's swan-song was so resplendent an occasion.[141]

XII. THE CUNNINGHAM YEARS – ITALIAN AND SPANISH STARS

The next director of the Atheneum, who began his twenty-year tenure in January of 1946, was the distinguished connoisseur of European art, Charles C. Cunningham (fig. 11). Educated at Harvard, like Austin with whom he was on friendly terms, Cunningham had been for a number of years the assistant to the renowned W. G. Constable in the Department of European Paintings at the Museum of Fine Arts in Boston. Constable had actually been employed as a consultant by the Atheneum in the interim period, and by October of 1946 he felt, gentleman that he was, that he should resign from this role at the end of the year, for, as he wrote to the Atheneum's president, Charles Goodwin, "not only is Charles [Cunningham] firmly in the saddle, but my being there might create a feeling of obligation to consult with me, which would hamper him."[142] It was, however, agreed that W.G. would continue to serve as an honorary consultant, and the extensive correspondence in the files of both Hartford and Boston make it clear how often and on what friendly terms Cunningham and he exchanged ideas and opinions about works of art that were on the market. Although more conservative in outlook than Austin, Cunningham shared his predecessor's fondness for fine paintings and even collected them for himself. He was continuously following the art market and began his purchases auspiciously in 1947 with Austin's beloved eighteenth-century Venice, finding at the Schoeneman Galleries in New York a classic Canaletto, *View of Venice* (cat. no. 22), which had been in the Hugo Moser sale the previous year. Justifying his purchase, Cunningham wrote, "One of the policies of acquisition of this museum has been and still is to build up its collection of seventeenth and eighteenth century painting, rather than to compete with museums with larger resources in the earlier periods of art of the middle ages and

the Renaissance." His philosophy of collecting for the museum, he continued, was going to be to seek out what he called "stars,"[143] and the times were propitious for making some truly stellar purchases. Following the Canaletto, he had an amazing run, especially of Italian and Spanish works, from the late 1940s into the early 1950s, with notable paintings by Panini, Traversi, Dosso Dossi, Tintoretto, Rosa, Gentileschi, Zurbarán and Tiepolo.

The Traversi (cat. no. 24) was first recommended to Cunningham in early 1948 by the distinguished art historical couple, Hans and Erica Tietze, who described it as "one of the most brilliant paintings in its class," and reported it was then owned by another art historian Lili Fröhlich-Bume in London.[144] But by the time Cunningham got to it, the painting was already with Kirk Askew at Durlacher's, and he had to pay $4,000. He wrote to Fröhlich-Bume for information on the work, and she replied that she was "happy that this magnificent painting had found a definite home and would be enjoyed by many visitors." About the painting's history she informed him:

> Nothing is known of it earlier than that Sir Montagu Meyer of Avon castle, one of the leading timber merchants in this country, owned it some thirty or forty years. The picture was never published or reproduced and it was only exhibited the three or four days proceeding the sale at Sotheby's, where a few of us, interested in Italian baroque pictures, recognized it as Traversi. It was called "Hogarth" in the collection . . . I forwarded a photograph of the picture to Roberto Longhi, who had been the discoverer of nearly all pictures by Traversi, and he said in his answer, "La sono molto grato per la splendida fotografia del nuovo Traversi. Pare anche a me uno dei quadro piu belli del maestro, che caratteri e che regisseur."[146]

More than Austin, Cunningham frequented the dealers in London, and there at Thomas Agnew & Sons in 1950 he found the Tintoretto of *The Contest Between Apollo and Marsyas* (cat. no. 4) for £6,000 ($16,820). Unlike Austin's earlier attempt, this was an authentic Tintoretto, which, as Cunningham wrote the dealer, Geoffrey Agnew, was "a magnificent picture" that "should add great distinction to our collection."[147] However, it needed to be cleaned and this task was entrusted to Mr. Vallance at the National Gallery, London, who reported he removed the discolored varnish and dirt, repaired the old damages, and applied a thin coat of varnish. He also pointed out "an interesting artist's alteration – namely Apollo's musical instrument which has been lengthened by many inches."[148]

In 1956, Cunningham went back to Agnew's to purchase two more Italian Baroque works. The first, as described on the invoice, was "the picture by Salvator Rosa *La Ricciardi, Mistress of the Artist as a Sybil*" (cat. no. 17). It was the pendant to the *Self-Portrait*, which had also formerly been in the Lansdowne collection, but had been presented to the National Gallery, London. As Geoffrey Agnew wrote Cunningham, he was, as promised "when you dined with us last year," giving the Atheneum "first offer" on this.[149] Nowadays the subject is tentatively given as *Lucrezia? As the Personification of Poetry*. The other work was a *Holy Family* on panel from the Farnese collection attributed to Ludovico Carracci, that, according to Agnew, had been in the Ashburnham sale of 1953 and "went straight to a client of mine, where it has been ever since. I have now taken it back from him in part-exchange for a Constable landscape . . . so that the picture has not been on the market at all." Then on April 19 Agnew wrote again:

> The Carracci is in first-class condition. With regard to the Salvator Rosa . . . the picture, is still being cleaned. When you saw it some years

GALLERIES AT THE WADSWORTH ATHENEUM

38 View of Avery Galleries, 1934

39 *43 Portraits*, 1937

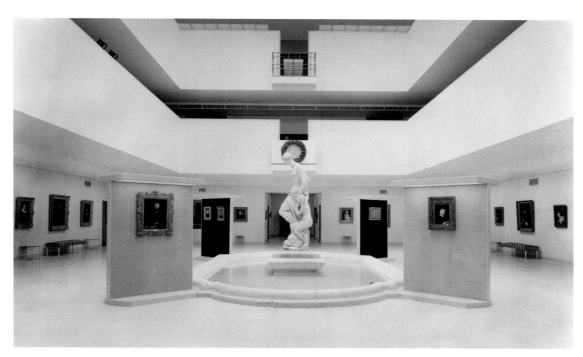

40 *Caravaggio and his Italian Followers*, 1998

41 *Michael Sweerts*, 2002

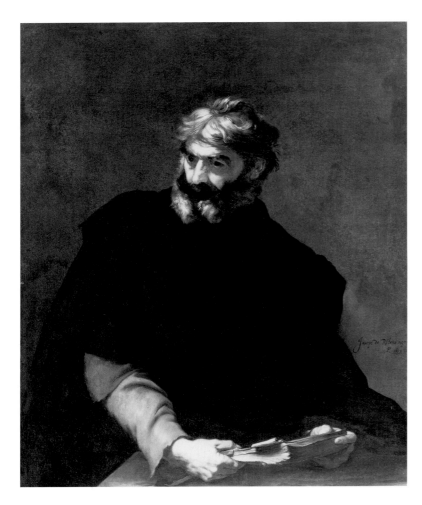

42 Jusepe de Ribera, *Protagoras*, 1637, oil on canvas, 48 ⅞ × 38 ¾ in., the Ella Gallup Sumner and Mary Catlin Sumner Collection Fund, 1957.444

ago it was exactly as it came from the Lansdowne House and the background was almost green with old varnish. I have now had the picture relined . . . the background is enormously improved as it has now a light broken grey which sets off the figure most effectively . . . You ask me if I could make you a better price if you bought the two pictures together. I would take £3300 for the two . . . I would love to see them both at Hartford.[150]

The paintings were flown by Pan Am to America in May and shown in June to the trustees, who were "enthusiastic about both pictures and decided to acquire them."[151]

They were included in a press release and then in an exhibition entitled *Acquired in Three Years* of 1957. Shortly thereafter Cunningham received a letter from one of Italy's greatest connoisseurs, Roberto Longhi, expressing his belief that the Carracci was actually by Sisto Badalocchio. The director followed up by putting the question to a leading young English specialist in Italian Baroque art, Denis Mahon, and he confirmed that his own research had found proof that the *Holy Family* was indeed a rare work by the then little-known Parmese artist Badalocchio.[152] Nevertheless, Cunningham informed Agnew that he was still "delighted with the picture whether it is Carracci or Badalocchio," and Geoffrey Agnew answered half in jest, " I am sorry that I sold it to you under the wrong name. On the other

hand, I should be very pleased to have it back, but I fear you will not want to do this."[153]

Yet another important dealer who had dealt with the museum in the Austin days and continued to shuttle between New York and London before he ultimately settled in Zurich producing extremely fine paintings was David Koetser. First in late 1948 for $16,000, the Atheneum obtained the large Panini, then thought to represent the *Interior of the Colonna Gallery*, but subsequently rightly identified as *The Picture Gallery of Cardinal Silvio Valenti Gonzaga* (cat. no. 23). The next year Koetser sold Cunningham for what the dealer described as a "reduced price of $12,500," Orazio Gentileschi's *Judith and her Maidservant* (cat. no. 12), which had been identified by Voss as an important lost work and was called by Alfred Frankfurter, editor of *Art News*, "the finest Baroque painting to come on the market for several years."[154] Koetser was also to supply the museum in 1951 with what is arguably the brightest of all the starry old masters acquired by Cunningham, Zurbarán's *St. Serapion* (cat. no. 31). According to the dealer, this signed work had been recorded at a convent in Seville in 1800, and was then acquired by the English consul, Julien Williams, who imported it to England, where it passed into the collection of Sir Montague Hugh Cholmeley of Euston Hall. It had only been recently published as a rediscovered work in a Spanish periodical, and was proclaimed by one of the leading Spanish art historians, Dr. López Rey, to be "the most beautiful Zurburán in America." Thus it still seems a bargain at only $15,000![155]

Another London dealer specializing in Spanish and Italian painting, Tomás Harris, sent Cunningham a group of photographs in 1950 including one of the very large Giovanni Domenico Tiepolo of the *Trojan Horse* (cat. no. 28). He followed up with the information that it "is said to have been painted in Venice for Prince Pignatelli" and was later mentioned as "being in the Château de Fervoz. It was exhibited at the Grovesnor Gallery in 1880 and was illustrated in color in *Life* July 29, 1940, and the oil sketch was is in the National Gallery, London."[156] Harris wanted $40,000 for it, but the museum's committee offered only $35,000, which price the dealer cabled from Mallorca he would accept. As he did not want to dismantle the frame, it was sent in a "monster case" aboard the Queen Mary to America.[157] Two years later in 1952, another of Austin's favorite dealers, Adolf Loewi of Los Angeles, supplied for $3,500 a further work by the younger Tiepolo, *The Miracle of Christ Healing the Blind Man* (cat. no. 25).

Still another dealer, based first in New York and later in London, with whom Cunningham enjoyed doing business, due to his flexibility in arranging deals for the museum and willingness to bid at auction, was Julius Weitzner. He acted in this latter role in 1949 when at the New York sale of the late Viennese collector, Oscar Bondy, whose possessions had been seized by the Nazis but returned to the family after the War, he acquired for the Atheneum Dosso Dossi's *Combat Between Roland and Rodomonte* (cat. no. 3). A decade later Weitzner was still busy supplying significant works to the Atheneum, such as the Jacopo Bassano *Mystic Marriage of St. Catherine*, from the Duke of Westminster's collection (cat. no. 5).

Likewise in 1957, when Cunningham was seeking to add more Spanish pictures of high quality to the collection, he effected a trade with Weitzner to obtain the remarkable Ribalta of *St. Francis's Vision of the Musical Angel* (cat. no. 30), which so well complemented the Atheneum's Caravaggio. According to the dealer, the painting

was privately owned in London by a queer character (who owns a famous Palace in Venice). My friend Dr. Xavier de Salas residing in

43 Domenico Fetti, *Martyrdom of Saints Fermus and Rusticus*, oil on wood, 25 × 31 ¾ in., gift of Hans F. Wriedt, 1955.151

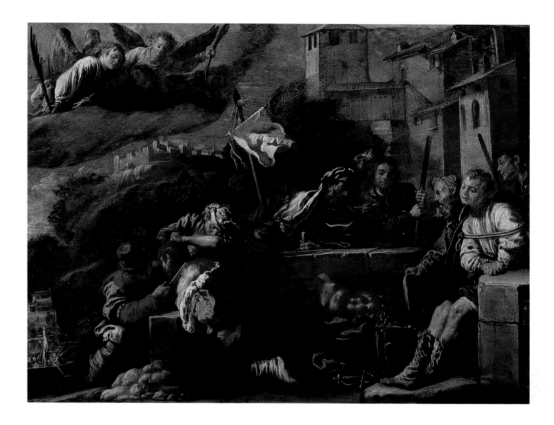

London had for years been telling me about the painting. Partly on his advice and because I liked it I bought it with David Koetser (to keep the price down).[158]

Also in 1957, an important signed Ribera of the philosopher *Protagoras* (fig. 42) was purchased from Newhouse Gallery. It belonged to a series of ancient philosophers once in the Prince of Liechtenstein's collection.[159]

Gifts to the Atheneum also helped to enrich the Italian holdings. In October of 1953, a Mr. Paul Porzelt, who had homes in Sharon, Connecticut, and New York City, wrote to Cunningham that he wished to donate "a painting entitled 'Lot and his Daughters' by the Venetian master Girolamo Forabosco." This work, which had formerly been in the collection of the Savigny family and came with authentications by both Hermann Voss and Hans Tietze, was accepted by an "enthusiastic" Art Committee.[160] Then in 1955, the museum finally obtained a work by Fetti (fig. 43), when Hans Wriedt gave the painting he had acquired in Bremen, Germany, in the 1920s which was then at his home in Westport, Connecticut. The subject, a martyrdom of saints, is, as was noted by Pamela Askew, the step-daughter of Kirk Askew who became a distinguished art historian in her own right, comparable to works Fetti painted after his trip to Venice in 1621, but the exact subject matter proved puzzling. Cunningham, therefore, turned to Professor Panofsky at Princeton. This scholar first suggested it was the martyrdom of Saints Simon and Jude in Persia, but in an old inventory Askew then found a reference to a work by Fetti of the martyrdom of the less well known saints Fermus and Rusticus that fits the subject better.[161] When informed of this, Panofsky wrote to Cunningham, that he had "looked up the *Acta Sanctorum*" concerning these saints, and found that "like all good Christian martyrs, they refused to sacrifice to the pagan gods and were put to death after an alternation of torture and kind persuasion . . . So if Fetti is on record as having depicted the martyrdom of those two worthies, I have no objection to your identifying your painting with this recorded work."[162]

XIII. THE CUNNINGHAM YEARS — NORTHERN, ENGLISH, AND FRENCH PAINTINGS

Although the showiest of his purchases came from the Italian and Spanish schools, the director certainly did not ignore the Northern ones, and in 1951 when Cunningham organized one of the few major old master loan shows of his tenure, he focused on *Life in Seventeenth Century Holland*. There were a mixture of paintings from both museums and dealers, including the Detroit Institute of Art's Sweerts of *Artists in the Studio*. He was also able to include his own most important Dutch acquisition to that point, Jacob van Ruisdael's *View of the Dunes near Bloemendaal* (cat. no. 46) purchased from the English dealer Eugene Slatter in 1950 for $10,250.

Just as Austin had sought to add a Caravaggio to the collection, so Cunningham was eager to find a Rembrandt, but unfortunately he proved less successful. His first attempt occurred in 1954, when he bought from Duits and Koetser the *Portrait of a Young Man* (fig. 44), about which he wrote to the noted Rembrandt scholar, W.R. Valentiner, "Almost every year when I have been in London, I have gone to see the picture and been haunted by it. To me it is an extraordinarily moving work."[163] Both Valentiner and Harvard's Dutch expert, Jakob Rosenberg, concurred in acknowledging the authenticity of the painting, which was thought to possibly portray the painter's son, Titus,[164] and its acquisition was announced with great fanfare in the museum's *Bulletin* and several other art periodicals.[165] Then in 1961, Cunningham sent out a news release with the rather startling information that when the "Titus" had been purchased, "Atheneum officials believed that this portrait would be their only Rembrandt painting. Now, three more come to the museum from three different sources."[166] These newest alleged examples by the great Dutch master were a *Portrait of Saskia* (fig. 45) signed and dated 1636, presented by John E. Rovensky of Newport and New York in memory of his wife, a native of Wethersfield Connecticut;

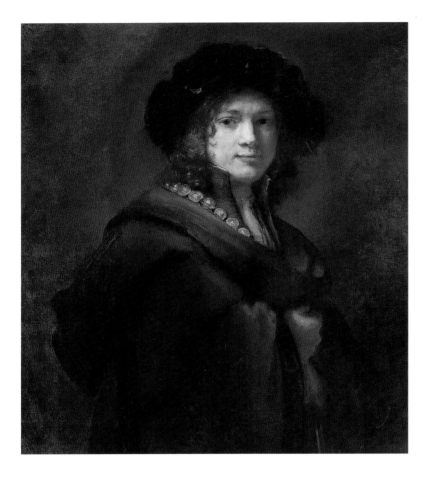

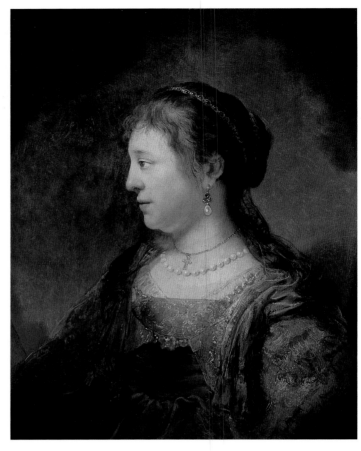

44 Rembrandt School, *Portrait of a Young Man (Titus?)*, 1655, oil on canvas, 38 ¾ × 33 in., the Ella Gallup Sumner and Mary Catlin Sumner Collection Fund, 1954.83

45 Rembrandt School, *Portrait of a Woman (Saskia?)*, 1636, oil on oak panel, 27 × 20 ¾ in., gift of John Rovensky in memory of Mae Cadwell Rovensky, 1961.191

46 Paulus Moreelse, *Shepherdess*, c. 1630, oil on panel, 29 × 22 in., gift of Louis S. Kaplan, 1959.25

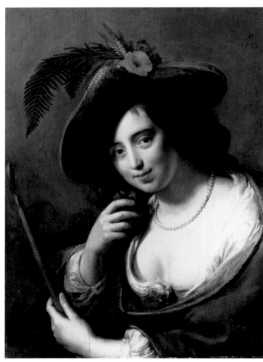

Landscape with a Cottage given by Judges Samuel and Irwin E. Friedman and Mr. Herman Katz, all of Fairfield, Connecticut; and from Robert Lehman of New York and formerly in the J. Pierpont Morgan collection, *Portrait of an Artist*. Although noted scholars had in the past both accepted and rejected one or the other of these works, when the Atheneum's official catalogue of its Dutch paintings was published in 1978, all of the so-called Rembrandts were definitively demoted: the *Landscape* and *Titus* were called "style of Rembrandt"; the Saskia "circle of"; and the *The Portrait of an Artist* tentatively attributed to Samuel van Hoogstraten.[167]

Given these Rembrandt *faux pas*, it is a relief to report that Cunningham had much better luck with another of the greatest seventeenth-century Dutchmen, Frans Hals. To general acclaim in 1958 he purchased for $95,000 the splendid 1644 *Portrait of Joseph Coymans* (cat. no. 40) from the New York collector Louis Kaplan, who was selling it and a Pieter de Hooch because he and his wife were moving into a smaller apartment. As a gift from the Kaplans, the Atheneum received Paulus Moreelse's *Shepherdess* in 1959 (fig. 46).[168]

The ever-active Julius Weitzner also helped enrich the Northern collection. Having been trained as a chemist, he liked to do his own cleaning of the paintings he purchased, and in 1949 he made a lucky discovery when a work bought as a Vinckboons revealed after treatment the signature of Frans Post. The Atheneum promptly purchased this *Brazilian Landscape* (cat. no. 44), which Cunningham told the dealer was "a swell picture and it will help build up our Dutch collection which needs strengthening."[169] At a 1958 sale in Paris, Weitzner also purchased Gerbrand van den Eeckhout's *Daniel Proving the Innocence of Susanna* sold in turn to the Atheneum. Apparently, in gratitude for all this business, Weitzner in 1958 donated another Old Testament subject – a large Jan Victors of *Joseph Telling his Dreams* that in the nineteenth century had been at William Beckford's Fonthill Abbey and more recently in Lady Richmond's collection.[170]

Cunningham was especially interested in British art of all periods, and

47 Joseph Mallord William Turner, *Van Tromp's Shallop at the Entrance of the Scheldt*, c. 1832, oil on canvas, 35 × 47 in., the Ella Gallup Sumner and Mary Catlin Sumner Collection Fund. Endowed by Mr. and Mrs. William Lidgerwood, 1951.233

among the older examples he acquired in the 1950s were Turner's *Van Tromp's Shallop at the Entrance of the Scheldt* (fig. 47) in 1951 from Vose Gallery of Boston;[171] the Gainsborough *Woody Landscape* (cat. no. 60), formerly in the Lenox Collection of the New York Public Library, from the John Nicholson Gallery of New York in 1957; and most spectacularly the Joseph Wright of Derby *The Old Man and Death* (cat. no. 58) that in 1953 was consigned by Lady Wilmot to the London frame and picture dealer H. J. Spiller from whom it was bought for only £200.[172] From the bequest of Mrs. Clara Hinton Gould of Santa Barbara, the Atheneum obtained a substantial number of American paintings, including the Benjamin West *Saul and the Witch of Endor* (cat. no. 59).

Cunningham also broadened the Atheneum's collection of old masters when he snared some unusual French Baroque works, most notably Claude Vignon's *Banquet of Antony and Cleopatra* from the Parisian dealer François Heim in 1956; and in the following year Jacques Stella's *Judgment of Paris* (cat. no. 53) from Julius Weitzner. The latter work, as the museum's news release noted, was of particular interest to the Atheneum, since Stella had been the owner of its grandiose Poussin.[173]

XIV. FINAL CUNNINGHAM YEARS

From 1960 until 1966 and his departure from Hartford to be Director of the Art Institute of Chicago, Cunningham continued to add major old master works to the collection. No grander Renaissance painting perhaps could be found than the Sebastiano del Piombo *Portrait of a Man in Armor* (cat. no. 2) that was with F. Kleinberger and Co. Its manager, Harry Sperling, wrote to Cunningham that this work was probably the one mentioned in Vasari and had been brought over to England from Italy for the first Duke of Chandos.[174] After a year and a half of negotiat-

ing, by late April 1960, Sperling was able to convince his partner to reduce the price for the museum from $45,000 to $35,000. Thus in late May the *Courant* could announce the painting's first public display in more than 200 years.[175]

Of the Dutch school the outstanding addition was Nicolaes Berchem's *A Moor Presenting a Parrot to a Lady* (cat. no. 48), obtained in 1961 from the dealer Hans Schaeffer, who had transferred his business from Berlin, where he had previously sold the painting, to New York. Another dealer who had also made the transition from Europe was Fritz Mondschein, who had also changed his name to Mont and from him came in 1964 the splendid example of the Flemish school, Anthony Van Dyck's *Ressurection* (cat. no. 37). Mont had already also been the source in 1961 for a stunning pair of early Vouet saints, which had arrived rather mysteriously from Spain. The first one – *St. Ursula* – Cunningham saw at Mont's residence in the Ritz Tower and after obtaining the opinion of the collector-scholar Robert Manning that it "is undoubtedly one of the finest examples by the master in this country and I must confess that I would have given an 'eye tooth' to have been able to acquire it for my collection. I can think of no place where I would rather see it go then the Wadsworth Atheneum,"[176] it was acquired that June. Then later in the year Mont let it be known that there was a mate, a *St. Margaret*, that was being restored and fortunately the museum acquired this in November for the same price of $12,000.

Also sometimes attributed to the early career of Vouet is the *Young Man with the Sword* (cat. no. 48) bought from Edward Speelman in 1964. When Cunningham first saw the work in London, it was called a Sweerts,[177] but by the time it was sent to the museum for consideration, it had been dubbed a Eustache Le Sueur. At the same time the Atheneum

48 Giovanni Benedetto Castiglione, *An Allegory*, c. 1660, oil on canvas, 28 × 31 ¼ in., the Ella Gallup Sumner and Mary Catlin Sumner Collection Fund, 1970.2

purchased from Speelman the large *Aurora* (cat. no. 43) from the Arundel collection at Wardour Castle where it was attributed to Jan Gerritsz. van Bronchorst. It has subsequently been identified as the masterpiece by his son Johannes.

In 1963, Cunningham brought to Hartford a major exhibition of Genoese paintings and drawings. Key works included in this were the Atheneum's Strozzi and the Magnasco *Hunt*. Also prominent by its size and brilliance was a Valerio Castello of *The Legend of St. Geneviève of Brabant* (cat. no. 18), lent by Walter P. Chrysler, Jr., that would one day also enter the collection.[178] The director proudly reported to Denis Mahon that this exhibition was "a tremendous success with close to 3000 visitors."[179]

Two major Baroque works were also acquired from New York dealers in 1963. The museum's *Bulletin* identified these paintings "of the Caravaggio school" as "Pietro Novelli's *Sense of Taste* and Carlo Saraceni's *Holy Family in St Joseph's Workshop*,"[180] but both attributions have undergone revision. The most significant is that of the supposed Novelli of a man eating squid (cat. no. 29) on which Cunningham got Mr. and Mrs. Fowles, now managing Duveen's, to lower the price to $10,500. They sent an elaborate brochure giving the provenance as Prince Youssoupoff's collection and an article by Martin Soria about Novelli. But a handwritten letter to Cunningham from Roberto Longhi provided the dramatic revelation of the great scholar, that "my opinion is that the author is not at all Pietro Novelli, but the Spanish painter Ribera." He went on to rightly identify it as *Taste* of the *Five Senses*

Ribera was recorded to have painted in Rome before leaving for Naples.[181]

Somewhat different is the issue with the Saraceni (cat. no. 14), which some art historians, especially those from France, assign to Guy François.[182] *The Holy Family in St Joseph's Workshop* had, in fact, been purchased from a private collection in France by Fritz Mont, who reported to Cunningham that Longhi, Bloch, Sterling, and Zeri had all greatly admired it. On December 24 the dealer's wife, Betty Mont, having received by telephone the good news of the purchase, wrote to the director, "nothing could delight us more than to see this great and unusually outstanding painting go to the Hartford Atheneum. It will be, we trust, a star in your firmament and one that will bear the name of the Atheneum everywhere and will have success both with connoisseurs and the naïve public." As if following her lead, Cunningham decided to have the picture exhibited immediately, since its subject was so in keeping with the Christmas spirit.[183]

The 1960s also brought a number of old master gifts. The brother judges, Samuel and Irwin Friedman donated in 1960 a *Portrait of a Cardinal* (fig. 49) believed to be by Jacopo Amigoni, but later correctly identified by Anthony Clark, Director of the Minneapolis Institute of Arts, as Domenico Corvi's *Portrait of Cardinal York*.[184] Also over the years several pictures had been donated by Mr. and Mrs. Arthur Erlanger of New York and the most significant of these came in 1964 with the Abraham Bloemaert *Neptune and Amphitrite* (cat. no. 36), now fully restored for the present exhibition.

XV. LATER DIRECTORS TO THE PRESENT

Following Cunningham's departure, his successor, James Elliott, who served as director from 1966 to 1976, added a few notable Baroque works to the Atheneum's collection. In November 1967, Frederick Mont sent photos of a Mazzoni *Hagar and the Angel* and a Mola *Barbary Pirate*. The latter was acquired in the fall of 1968, but research has determined that, despite Charles Sterling's verbal attribution of it to Mola, as conveyed in a letter from Mrs. Mont to the Atheneum's new curator, Peter Marlow, it is not, like the Louvre's painting of a similar subject, by this artist, but perhaps, as John Spike suggested in 1979, by Giuseppe Antonio Petrini.[185] Another painter not previously represented was the Genoese master Giovanni Benedetto Castiglione, and from Agnew's in 1970 came what the Castiglione specialist, Ann Percy, described as "an unusual and important painting," which had long been in the Worsley family collection and is an allegory representing either Medea or Melancholy (fig. 48).[186]

In 1976 Peter Marlow was acting director and presented an exhibition organized by his former professor, Edgar Munhall, a curator of the Frick Art Collection, the first ever devoted to Jean-Baptiste Greuze. The museum's painting was reunited with over one hundred paintings and drawings from around the world by this master and the well received show also toured to San Francisco and Dijon.[187]

In keeping with the spirit of this exhibition, the next old master acquisitions made by the Atheneum, now under the directorship of Tracy Atkinson (1977–87), were of French rococo paintings – Boucher's *The Egg Seller* (cat. no. 54) from the well known French dealer Paul Cailleux in 1977, and Carle van Loo's *Offering to Love* from Heim Gallery, London in 1979.

In 1978, the Harvard-trained Jean Cadogan had been appointed Curator of the European Paintings, and as her speciality was in Italian art, she soon made some notable additions in that area. In 1981, she secured from the Heim Gallery in London the museum's first Baroque altarpiece, a large painting by Domenico Corvi depicting a *Miracle of St. Joseph Calasanz* (cat. no. 26). The following year brought an equally rare but intact early Italian devotional altarpiece by Giovanni dal Ponte acquired from Rosenberg and Stiebel in New York.[188] In 1985, the London dealer, Patrick Matthiesen, was the source for a beautiful Scarsellino of *Fame Conquering Time* (cat. no. 11), which he wrote the curator, "Burton Fredericksen was very keen to acquire for the Getty Museum."[189] Also shown that year in both Hartford and Sarasota was the major traveling exhibition *Baroque Portraiture in Italy*.

A few select gifts also helped further enrich the museum's holdings. The year 1986 was marked by receipt of the two paintings, Rosa's *The Tribute Money* and Giuseppe Maria Crespi's *Way to Calvary*, acquired in the 1940s by Henry Kneeland of Bloomfield, Connecticut and presented by his widow in his memory. The same year Mr. and Mrs. Leonard Greenberg, originally from West Hartford and now living in Florida, donated a second Castiglione, *God Appearing to Abraham*, which they had acquired from Agnew's in 1983.[190]

In 1988, the Australian-born Patrick McCaughey became director (serving until 1996), and he supported Cadogan's efforts to further expand the breadth of the Italian holdings. Two works were purchased from the Piero Corsini Gallery – Alessandro Allori's 1574 *Portrait of Isabella de'Medici and her Son* in 1988 and Domenico Puligo's *Virgin and Child with the Young St. John the Baptist and Two Angels* in 1991. Also added was Cosimo Rosselli's *The Visitation*, which came from Colnaghi's in 1989. Then in 1992, negotiations were successfully completed with the independent New York dealer Roy Fisher to acquire the key work selected by Cadogan for the celebration of the Wadsworth Atheneum's

49 Domenico Corvi, *Henry Stuart, Cardinal Duke of York*, c. 1760, oil on canvas, 51 ³/₄ × 37 ³/₄ in., gift of Judge Samuel E. Friedman and Judge Irwin E. Friedman, 1960.286

50 Jacopo Zucchi, *Bath of Bathsheba*, oil on panel, 44 ⁷/₈ × 114 in., formerly Wadsworth Atheneum, now Galleria Nazionale di Palazzo Barberini, Rome

51 Louis Léopold Boilly, *La Moquerie, c.* 1787, oil on canvas, 17 ¾ × 14 ¾ in., European Paintings Purchase Fund, 2001.3.1

150th Anniversary Year. This was the large Cigoli altarpiece of the *Adoration of the Shepherds* (cat. no. 8), which had been commissioned by the Martelli family about 1602.

In the 1990s two impressive Northern European paintings were also added to the collection. The first, purchased at auction was the David Teniers' *Mass in a Grotto* (cat. no. 42), which had been seized by the U. S. government from the Imelda Marcos collection. Then in 1996 Aelbert Cuyp's *A Road Near Woods* (cat. no. 39) was acquired from Robert Noortman of London.

A new era dawned at the Atheneum when Peter C. Sutton (fig. 12), a true connoisseur of European paintings in the tradition of Austin and Cunningham, who had previously been a curator at the museums of Philadelphia and Boston, was appointed director in September 1996. Despite his specialization in the field of seventeenth-century Dutch art, his first acquisition for the Wadsworth Atheneum was wisely a powerful Italian Baroque masterpiece, il Morazzone's *Agony in the Garden* (cat. no. 9). This previously unknown early work by the Lombard master

appeared that December in auction at Christie's, London, and since the sale was public, the local newspapers could report the purchase price was $135,129.[191] As the director wrote of the new painting, Morazzone's work "is exceedingly rare outside Italy, since he painted primarily frescoes. The work complements the museum's baroque paintings, especially those by Caravaggio and his followers."[192] The same was also true of the splendid, large Valerio Castello (cat. no. 18) formerly in the Walter P. Chrysler, Jr. collection acquired in 1999 from New York dealer Adam Williams.

A veritable two-year festival of the Baroque in Hartford also resulted from Sutton's successful negotiations with the Roman authorities to return to the Galleria Nazionale a painting by Jacopo Zucchi of *The Bath of Bathsheba* (fig. 50) purchased in 1965 from the Heim Gallery in Paris, but which had been subsequently discovered to have been stolen from the Italian embassy in Berlin during the war years. In exchange the Atheneum received in the spring of 1998, the exhibition *Caravaggio and His Followers*.[193] There were twenty-nine baroque paintings from Rome including Baglioni's *St. Francis in Ecstasy* and two Caravaggios, *Narcissus* and *St. John the Baptist*. Hung to complement these works were many of the Atheneum's own Baroque paintings and additional works were also borrowed, most notably Baglioni's *St. Sebastian* from New York collector Mary Jane Harris and the greatest of American Caravaggios, the *St. John the Baptist* from Kansas City (fig. 40). When the director and the present curator visited Rome for the ceremonies surrounding the return of the Zucchi, it was learned that the Capitoline Museum would soon be closing for renovations. This presented a unique opportunity to bring to Hartford the highlights of that museum's collection. Among the twenty-nine works that thus came to the Atheneum in April of 1999 by Savoldo, Domenichino, Guercino, and Dossi was also the one other Caravaggio depicting *St. John the Baptist*.[194]

Following on the success of the Italian Baroque exhibitions, the Atheneum has presented two more distinguished old master exhibitions, which made full use of Peter Sutton's expertise in Northern European painting. *Pieter de Hooch* (shared with the Dulwich Picture Gallery, London) and *Michael Sweerts* (co-organized with the Rijksmuseum of Amsterdam). The cultural historian Simon Schama described the Hartford installation (fig. 41) of the latter, which reunited the Flemish painter's *Seven Acts of Mercy* as a "dazzling show" and opined that, "if there is any justice in the world, there should be traffic jams on I-84 [the highway between New York and Hartford]."[195]

The most recent museum purchases of older paintings have been made to enrich the holdings of the French eighteenth century with three exquisite works. Both the Nöel Hallé *Holy Family* (cat. no. 55) and Louis Léopold Boilly's *La Moquerie* (fig. 51) were formerly housed by the Basle banker Ernest Gutzwiller in his Parisian *Hôtel particulier*, and after being sold at Sotheby's were purchased from John Mitchell and Son in London.[196] Lastly, Vigée Le Brun's *Portrait of the Duchesse de Polignac* (cat. no. 57) appeared in 2002 for the first time in many years at the New York Art Fair with the dealer Jack Kilgour. With the enthusiastic support of Kate Sellers (director 2000–2002), it was quickly reserved and purchased, providing a fitting up to the moment acquisition of high quality to stand with those of the past and launch the Atheneum into the twenty-first century.

CATALOGUE

1. Piero di Cosimo

Italian (Florentine), 1462–1522

The Finding of Vulcan on the Island of Lemnos

c. 1490

Piero di Cosimo, a pupil of Cosimo Rosselli (1439–1507), whose Christian name he adopted as a surname, is the subject of one of Giorgio Vasari's most colorful biographies.[1] According to Vasari, he was a peculiar and reclusive genius who lived on hard-boiled eggs that he prepared fifty at a time while boiling the glue for making size and was frightened of noise. His religious paintings exerted a powerful role on the formation of a number of important Florentine painters in the first quarter of the sixteenth century such as his pupil Andrea del Sarto (1486–1530), and one art historian has described "his whimsical Madonnas, Holy Families, and Adorations" as "a welcome relief from the wholesale imitation of Raphael in early Cinquecento Florence."[2]

The paintings for which Piero di Cosimo is best known today are his imaginative and unorthodox mythological inventions, inhabited by fauns, centaurs, and primitive men. In three panels – the *Hunting Scene* and *Return from the Hunt* (Metropolitan Museum of Art, New York) and the *Forest Fire* (Ashmolean Museum, Oxford) – he represented successive stages in the evolution of early man. What is striking about his mythological pictures – which often served to decorate *cassoni*, or chests, as well as rooms in the private houses of prominent Florentine families – is their highly individual subject matter, coupled with features that range from the elegiac to the pathetic. One of his most poignant and tender creations is the *Death of Procris* (1500–5; National Gallery, London). Piero di Cosimo was a marvelous painter of animals, and the mournful dog in the foreground of this picture is one of his most memorable creations.

The *Finding of Vulcan on the Island of Lemnos* is among the artist's best-known paintings, in large measure due to an article in 1937 by the legendary art historian, Erwin Panofsky, who recognized the subject of the painting as an episode in the myth of the Roman god Vulcan, keeper of fire who taught its uses to man.[3] According to Panofsky, the Atheneum painting depicts the moment when as a child Vulcan

was thrown from Mount Olympus by Zeus who intended to punish Hera for her intervention in the Trojan War, as related in Homer's *Iliad* (Book 1, lines 590–4). He landed on the island of Lemnos, where he was raised by its inhabitants, the Sintians. Here, Vulcan is shown awkwardly on the ground; the prominent hole in the cloud through which he was thrown from Mount Olympus is still visible. He is helped to his feet by a nymph, while her amused companions look on.[4]

The *Finding of Vulcan* has long been recognized as the pendant to a painting known as *Vulcan and Aeolus* in the National Gallery of Canada, Ottawa (fig. 1A).[5] In the companion picture, Vulcan is shown at his forge fashioning a horseshoe on an anvil, while Aeolus, the God of the Winds, works a pair of bellows to fan Vulcan's fire. Vulcan thus serves as the guiding force of human progress through his instruction of the use of fire – with the rudiments of technology gained from Vulcan and his control of fire, men construct a rough house in the background, enabling a family group to gather comfortably and a youth to sleep peacefully in the foreground. Whatever the precise subjects of the Hartford and Ottawa canvases – and each has been examined and discussed at great length – the paintings "can rightly be claimed to be the first significant manifestation of the Vulcan myth in Italian Renaissance art."[6]

The chronology of Piero di Cosimo's work is problematic, and as the paintings are not dated or documented, most writers have established the approximate date of the Hartford and Ottawa paintings in the late 1480s or early 1490s on the basis of style and handling. *Vulcan and Aeolus* was almost certainly painted after December 1487, when a famous giraffe – depicted prominently at the right of the composition – was presented by the sultan of Egypt to Lorenzo ("the Magnificent") de'Medici.[7] Thus, the pair of canvases are creations of an artist still in his late twenties and quite probably Piero di Cosimo's first important statements as a mythological painter.

Piero di Cosimo's original patron for the commission of the paintings is not known, and their original destination is still a matter of debate, although it has been noted that the idyllic subject matter of each would have been more appropriate to a country villa than to a city palace. Originally, the paintings probably served as *spalliere*, a type of decoration popular in Florence between 1470 and 1520. The canvases or panels were either set into the wall paneling of an interior at the height of the shoulders (*spalle*) above the back rest of a piece of furniture, or separately framed and freely hanging as they are today.[8] These paintings were almost invariably narratives, with subjects often drawn from

classical authors or from medieval romance. Both the Hartford and Ottawa paintings have frequently been linked to a series of secular paintings described by Vasari in the Florentine house of the wool merchant Francesco del Pugliese as filled with buildings, animals, costumes and other "fanciful things that came into his head," although recently doubt has been cast upon Vasari's textual justification for this provenance for the pair.[9]

EPB

Fig. 1A. Piero di Cosimo, *Vulcan and Aeolus, c.* 1490, oil and tempera on canvas, 61 ¼ × 65 ½ in. National Gallery of Canada, Ottawa

Oil and tempera on canvas, 61 × 68 ¾ in.

The Ella Gallup Sumner and Mary Catlin Sumner Collection Fund, 1932.1

Provenance: Possibly Francesco di Filippo del Pugliese (*c.* 1487–1519), Florence, *c.* 1487–1519; Micheli family, Florence, prior to the mid-1860s; William Blundell Spence, Florence, by 1861; William Graham, London, 1882; sale, London, Christie's, April 8, 1886, lot 216 (as *Triumph of Chastity*, by Signorelli); P. & D. Colnaghi, London; Robert and Evelyn Benson, London, 1914–27 (as *Hylas and the Nymphs*); Joseph Duveen, London and New York; Duveen Brothers, New York, from whom purchased in 1932.

References: Panofsky, 1939, pp. 33–67; Cadogan, 1991, pp. 122–5 (with earlier references); Fermor, 1993, pp. 77–8; Forlani Tempesti and Capretti, 1996, pp. 97–100, no. 7a; Franklin, 2000, pp. 53–65; Barclay, 2000, pp. 67, 70.

Selected Exhibitions: London, 1893, no. 118; London, 1930, no. 235; New York, 1938a, no. 3; Ottawa, 2000.

2. Sebastiano del Piombo

Italian (Venetian), c. 1485/6–1547

Portrait of a Man in Armor

c. 1512–13

Giorgio Vasari, the sixteenth-century Italian painter, architect, and biographer, considered portrait painting to be Sebastiano del Piombo's proper vocation because his likenesses were so well executed that they seemed to be alive. The *Portrait of a Man in Armor* is one of the artist's earliest portraits and is perhaps identical with one mentioned by Vasari "of a captain in armor, I know not who, which is in the possession of Giulio de' Nobili at Florence."[1] The sitter wears expensive armor that is north Italian in origin – probably Venetian or Milanese – from the second half of the fifteenth century, and holds in his left hand a war-hammer or war-axe.[2] The armor is depicted with a sophisticated, even virtuoso, handling of oil paint; the passages capturing the play of light and shade on the metal rendered with a "liquid smoothness" and delicate and subtle shifts of black, ochre, and off-white.[3] The rhetorical grandeur with which Sebastiano imbued his later, more monumental portraits – *Portrait of a Man* (c. 1518–20; National Gallery of Art, Washington); *Anton Francesco degli Albizzi* (1525; Museum of Fine Arts, Houston); *Andrea Doria* (1526; Palazzo Doria-Pamphilj, Rome); *Pope Clement VII* (c. 1526; Museo e Gallerie Nazionali di Capodimonte, Naples) – that established him as one of the major figures of High Renaissance painting, is only hinted at in the Atheneum's portrait. The simpler, bolder, and more energetic treatment of the *Portrait of a Man in Armor* is explained in part by its early date of about 1512–13 and in part by its more modest function. Sebastiano's portrayal of grand sitters, such as the Pope, obviously required an altogether more formal style and different compositional arrangements than the *capitano* in the present portrait.

Vasari explained that "portraits from life could be obtained with ease from Sebastiano, because he could finish these with more facility and promptitude,"[4] suggesting that at least early in the painter's career he was comfortable depicting his sitters simply and informally "from life"; that is, directly without the trappings of formal portraiture. The Atheneum portrait may even belong to a class of paintings that is not strictly a portrait in the conventional sense as Michael Hirst, commenting on the "sheer energy and expressed vitality of the soldier", has suggested. The sitter, portrayed in isolation and on the move, appears caught up in some activity which extends beyond the picture space.[5]

Before Sebastiano left Venice in 1511 for Rome, where he collaborated with Michelangelo on various projects, he was strongly influenced by the paintings of the legendary Giorgione (1477/8–1510) – Vasari even referred to Sebastiano as Giorgione's student. Thus, although the *Portrait of a Man in Armor*, given its presumed date of about 1512–13, is one of Sebastiano's earliest Roman portraits, it is a painting that nonetheless reveals his Venetian heritage. Several writers have commented on the striking Giorgionesque character of the Atheneum's portrait – the parapet on which the sitter's arm rests, his full head of hair and gleaming armor, and the energetic pose and slightly dreamy expression – particularly its debt to Giorgione's "over-the-shoulder" *Self-portrait as David* (Herzog Anton-Ulrich Museum, Braunschweig).[6]

When the Hartford portrait was cleaned in 1982, a head of a black page or servant was revealed that had been laid in by Sebastiano with underpainting but was subsequently covered by the thick layer of brilliant green defining the background. Whether in fact Sebastiano "suffered a failure of nerve" and covered the head of the page, or abandoned Venetian portrait conventions as he became more aware of the formal Roman style, the inclusion of the second figure evokes the influence of another of Giorgione's pictorial inventions around 1500 – a double-portrait type featuring a man in armor with his page.[7] An example of such a Giorgionesque precedent is the painting of a man in armor with his page in the Uffizi, the so-called *Portrait of Gattamelata*, formerly attributed to Giorgione, which shares several elements with the Atheneum's portrait.[8]

A copy of the painting in the Magazzino degli Occhi in the Palazzo Pitti, Florence, suggests that the Atheneum painting has been slightly cut on the left.[9]

EPB

Oil on canvas, 34 ½ × 26 in.

The Ella Gallup Sumner and Mary Catlin Sumner Collection Fund, 1960.119

Provenance: Possibly Giulio de' Nobili, Florence;[10] James Brydges, 1st Duke of Chandos, by 1723; sale, Cock's, Covent Garden, London, May 17, 1747, lot 68 (as Giorgione); Sir Thomas Sebright, Beechwood Park, Hertfordshire, by 1857; by descent to Sir Giles Sebright; sale, Christie's, London, July 2, 1937, lot 118; F. Kleinberger & Co., New York; from whom purchased in 1960.

References: Anderson, 1979, p. 155; Hirst, 1981, p. 97, pl. 65; Cadogan, 1991, pp. 197–200 (with earlier references); Sheard, 1994, p. 87 (as c. 1510).

Exhibitions: Los Angeles, 1979–80, no. 12; Paris, 1993, no. 39.

3. Battista Dossi

Italian (Ferrarese), 1490/5–1548

The Battle of Orlando and Rodomonte

c. 1527–30

Dosso Dossi (c. 1490–1542) and his young brother Battista were the leading painters at the court of Ferrara under Alfonso I d'Este and Ercole II d'Este. Their activities were typical of Renaissance court artists: decorating palaces and villas with frescoes and canvases; providing designs for tapestries, theatre sets, festival decorations, banners, coins and tableware; painting portraits and small-scale devotional works; gilding their employer's furniture and decorating and varnishing carriages and barges; and devising court entertainments.[1] Dosso Dossi is well known for his independent religious, mythological, and allegorical paintings, and he was important as a landscape painter in continuing the romantic pastoral vein of Giorgione and Titian. The artistic identity of Battista, however, has been obscured by that of his brother, under whom he worked for most of his career. Even in those works in which Battista is known to have had a hand, the nature of his contribution is not easily identified, and scholars have remained sharply divided over the paintings thought to be his. Not a single picture exists that is known with certainty to have been painted solely by Battista, except for those made after his brother's death in 1542.[2]

These difficulties notwithstanding, in the recent international exhibition devoted to the Dossi brothers, a small group of five pictures was brought together as by Battista that included the Atheneum's *Battle of Orlando and Rodomonte*. Although frequently given to Dosso Dossi in the past, as early as the end of the nineteenth century certain critics found the handling of the picture incompatible with his style – for some the pictorial execution of the picture is too precisely descriptive; for others it displays "a pedantic tightness of the paint handling;" and for other observers there is an evident effect of refinement and preciosity that suggest a Flemish influence. The painting has recently been published as "undoubtedly" by the hand of Battista and one of the artist's fundamental works and this seems to represent the current consensus of scholarly opinion on the attribution.[3]

The subject of the Hartford painting is drawn from *Orlando Furioso*, the romantic epic by the Italian poet and playwright Lodovico Ariosto (1474–1533), first published in 1516, that deals with the wars between Christians and Saracens at the time of Charlemagne. Ariosto's supervision (1526–33) of the ducal theatre at Ferrara enabled him to collaborate with, among others, Dosso and Battista Dossi, who designed sets for several of his comedies and whom he mentioned in the final 1532 edition of the poem in a list of the great artists of the modern age.[4] The story of the battle between Orlando and Rodomonte is drawn from Canto 29, lines 39–48, of Ariosto's poem. Rodomonte, the Saracen king of Algiers, had previously converted an abandoned chapel in the south of France into a mausoleum for Isabella, a Castilian princess with whom he had fallen in love and inadvertently slain when she rejected him. Beside the mausoleum he ordered a tower built for himself and this he defended against all comers by means of a narrow bridge. If a knight approached, pagan or Christian, Rodomonte jousted with him on the bridge

and when he prevailed, hung the beaten man's shield and weapons on the walls of the mausoleum. One day the Christian hero Orlando, naked and mad (*furioso*) with grief and jealousy for Angelica, a daughter of the king of Cathay who had become the lover of Medoro, a Moor, arrived at the bridge. Disdaining to attack a naked and unarmed man with a weapon, Rodomonte attempted to prevent Orlando's advance by wrestling with him on the bridge, but both warriors tumbled into the river below and were forced to swim to safety.[5]

Dossi's painting follows the poem closely. The chapel-tomb is seen in the middle distance, adorned with the armor of fallen knights. One of the shields is inscribed with the name of its owner, as related in the poem. The tower to the left is still under construction; at the door, a moor with a lance stands guard and a page holds the bridle of Rodomonte's horse, which is still dripping from having tumbled with its master into the river during a previous contest. On the narrow bridge, Rodomonte, fully armed, wrestles with the naked Orlando. In the distance a magnificent panoramic landscape with a medieval city is visible with a glimpse beyond of the Mediterranean Sea, on which Rodomonte planned to sail home to Algiers. As Peter Humfrey has written, "the picturesque, even comic mixture of style and modes – for instance, the contrast between a neomedieval knight in shining armor and a heroic nude *all'antica*, and that between the Renaissance architecture of Rodomonte's tower and the spiky Gothic city in the background – is completely in the spirit of Ariosto's poem."[6]

EPB

Oil on canvas, 32 ¼ × 53 ⁷/₁₆ in.

The Ella Gallup Sumner and Mary Catlin Sumner Collection Fund, 1949.81

Provenance: Possibly Francesco I d'Este (1610–58), 8th Duke of Modena and Reggio, Palazzo Ducale, Modena, by 1657[7]; possibly Cesare Ignazio d'Este, Palazzo Ducale, Modena, 1685 inventory; possibly Galleria Ducale, Modena, before 1720 inventory; William Graham, London, by 1882; his sale, London, Christie's, April 10, 1886, lot 477; possibly B. T. Clifford; Earl of Brownlow, Belton House, Grantham, by 1894–1929; sale, London, Christie's, May 3, 1929, lot 4 (as Battista Dossi); F. Howard; Thos. Agnew and Sons, London, 1931; Oskar Bondy, Vienna, 1933; his estate sale, New York, Kende Galleries, March 3, 1949, lot 92; from whom purchased at the auction by Julius Weitzner in 1949.

References: Cadogan, 1991, pp. 137–41 (as Dosso Dossi, with earlier references); Ballarin, 1994–5, vol. 1, pp. 335–6, no. 429 (as Battista Dossi); Lucco, 1998, p. 270 (as Battista Dossi); Humfrey, in Ferrara–New York–Los Angeles, 1998–9, pp. 250–3 (as Battista Dossi).

Selected Exhibitions: Ferrara, 1933, no. 207; Ferrara–New York–Los Angeles, 1998–9, no. 50 (as Battista Dossi).

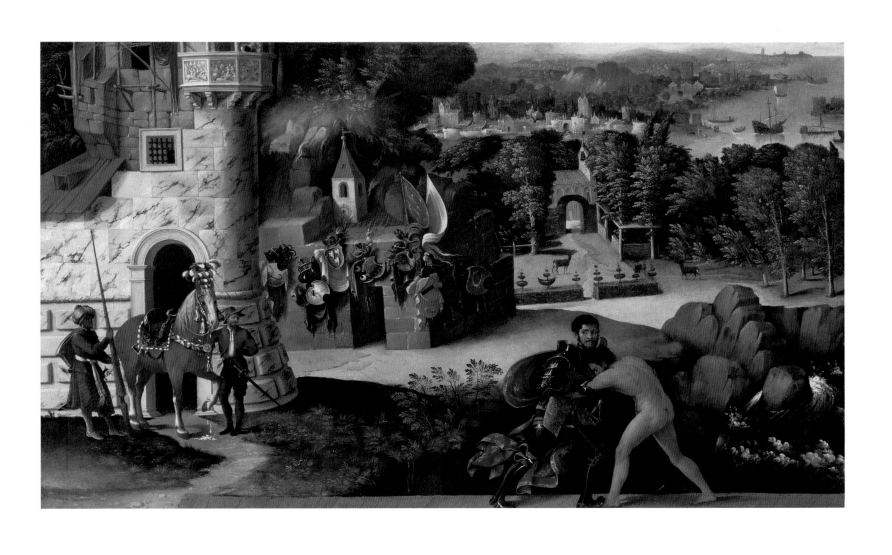

4. Jacopo Robusti, called il Tintoretto

Italian (Venetian), 1519–94

The Contest Between Apollo and Marsyas

c. 1544–5

Tintoretto, along with Titian, Veronese, and Jacopo Bassano (cat. no. 5), was among the greatest painters in Venice's so-called Golden Age of Painting in the Renaissance and the most prolific painter working in the city in the later sixteenth century. Almost all of his life was spent in Venice and most of his work is still in the churches or other buildings for which it was painted. His greatest paintings are the vast series of biblical scenes he did for the Scuola di San Rocco from 1565 to 1588 in which the complex poses and extreme foreshortening of the figures, dazzling effects of light and color, and unorthodox rough brushwork are unlike anything heretofore produced in Venice. In his mature years Tintoretto worked extensively on decorations for the Doge's Palace and for the meeting-house of the Scuola Grande di S. Rocco, on which he was occupied from 1564 until 1567 and between 1575 and 1588. In addition to his religious and mythological works, Tintoretto also painted many portraits of prominent Venetians.

The *Contest between Apollo and Marsyas* is generally thought to have been one of two ceiling paintings Tintoretto produced for one of the most engaging literary figures of the Italian Renaissance, the art critic, writer, poet and collector, Pietro Aretino (1492–1556). The famous Tuscan man of letters settled in Venice after the Sack of Rome in 1527 and became friendly with Titian and other artists working in the city and collected their art. He commissioned a pair of elongated oval ceiling paintings by Tintoretto depicting *Apollo and Marsyas* and *Mercury and Argus* (untraced) for his residence in the Ca' Bollani, but left the canvases behind in 1551, when he moved to his much grander quarters of the Ca' Dandolo on the Grand Canal.[1] In a letter of February 15, 1545, Aretino wrote to Tintoretto thanking him for the painting and its now lost pendant, *Mercury and Argus*: "All connoisseurs agree that the two fables, that of Apollo and Marsyas and the tale of Argus and Mercury, are beautiful, lively and effortless, as are the attitudes adopted by the figures therein: these, you, so young, have painted to my great satisfaction and indeed to everyone else's for the ceiling of my house, in less time than normally might have been devoted to the mere consideration of the subject. Certainly the brevity of the execution depends upon knowing exactly what one is doing; so that one sees, in the mind's eye, exactly where to place the light colors and where the dark."[2] Aretino referred to the paintings in another letter of January 1551 as "*le figure del soffitto.*"[3]

Most writers on Tintoretto have concurred with the identification of the *Contest between Apollo and Marsyas* as one of the ceilings painted for Aretino, and there is a consensus that the spirited brushwork; dynamic, curving contours; and numerous *pentimenti*, or changes in design that have been overpainted by the artist and become visible again over time, reflect the rapid execution – "*la brevità del fare*" – mentioned by Aretino.[4] The date of about 1544–5 implied by Aretino's letter corresponds to Tintoretto's known works around this time and marks the end of the artist's youthful phase when he was strongly

influenced by the Dalmatian painter Andrea Schiavone (*c.* 1510–63): the free manipulation of paint and the spindly figure types with long limbs and small heads especially recall the manner of the older artist, with whom Tintoretto is said to have collaborated in this period.[5]

Tintoretto reverted here to a type of composition common in central Italian ceiling painting in which the design is arranged frontally, instead of illusionistically foreshortened and seen *di sotto in sù*, or from below upwards, with the figures appearing to float, suspended in space, above the viewer as in the Venetian tradition.[6] He may have done so to present more effectively the narrative details of the contest between Apollo and Marsyas recorded by the Latin poet Ovid in his *Metamorphoses* (VI, 382–400), a retelling of the myths and legends of ancient Greece and Rome, and *Fasti* (VI, 696–710), a poetic treatment of the Roman history, and other ancient writers.

Marsyas, a satyr whose prowess with the flute was legendary, presumed to challenge the god of music, Apollo, to a competition. The god agreed, with the stipulation that the winner could impose on the loser any penalty he chose. The contest was judged by the Muses, who granted the victory to Apollo. His choice of punishment was to flay the satyr alive, a separate episode often depicted by Renaissance artists. Here, Apollo, crowned with laurel, plays on his instrument, a *lira da braccio*, while Marsyas, holding a *shawm*, an early double-reed instrument, listens. Athena, goddess of wisdom and protectoress of the arts, is seated to the right of center, while three male onlookers, or judges, sit at the right. In the background the twin peaks of Mount Helicon, the home of Apollo and the Muses, are visible.

The contest between Apollo and Marsyas was a popular tale in both classical and postclassical art including the paintings and drawings of the sixteenth-century Italian artists Raphael, Cima da Conegliano, Perugino, Bronzino, Parmigianino, Luca Cambiaso, Paris Bordone, Veronese, and Tintoretto, each of whom depicted the subject.[7] The theme presumably held moral and didactic implications for contemporary Venetian observers and has been related to Pietro Aretino's professional ambitions and self-image and to his mastery of two modes of poetry, the encomiastic mode, which praises the ideal qualities of humanity, and the realistic mode, which exposes its baseness. The three male figures at the right of the composition have also been related to Aretino and his profession, and the figure at the extreme right, shown leaning forward with his head in profile as if he just arrived to judge the contest, has been identified as an idealized portrait of the writer himself.[8]

EPB

Oil on canvas, 55 ¼ × 94 ½ in.

The Ella Gallup Sumner and Mary Catlin Sumner Collection Fund, 1950.438

Provenance: Pietro Aretino (1492–1556), Venice, by 1545; Sir Dudley Carlton (1573–1632), The Hague, London, and Oxfordshire; Duke of Abercorn; Rev. Walter Davenport Bromley (1787–1863), Wootton Hall, Staffordshire, and/or London; by descent to his son, Sir William Bromley-Davenport (1862–1949), Capesthorne, Macclesfield, Cheshire; his sale, London, Christie's, July 28, 1926, lot 149; Thos. Agnew & Sons, London; Stephen Courtauld, London; Thos. Agnew & Sons, London, 1949; from whom purchased in 1950.

References: Pallucchini and Rossi, 1982, vol. 1, pp. 143–4, no. 82; Cadogan, 1991, pp. 244–7 (with earlier references); Fehl, 1992, pp. 167–9, 172–3; Nichols, 1996, p. 5; Nichols, 1999, pp. 6, 17, 38.

Selected Exhibitions: London, 1892, no. 117; Toronto, 1960, no. 6; London, 1983–4, no. 100.

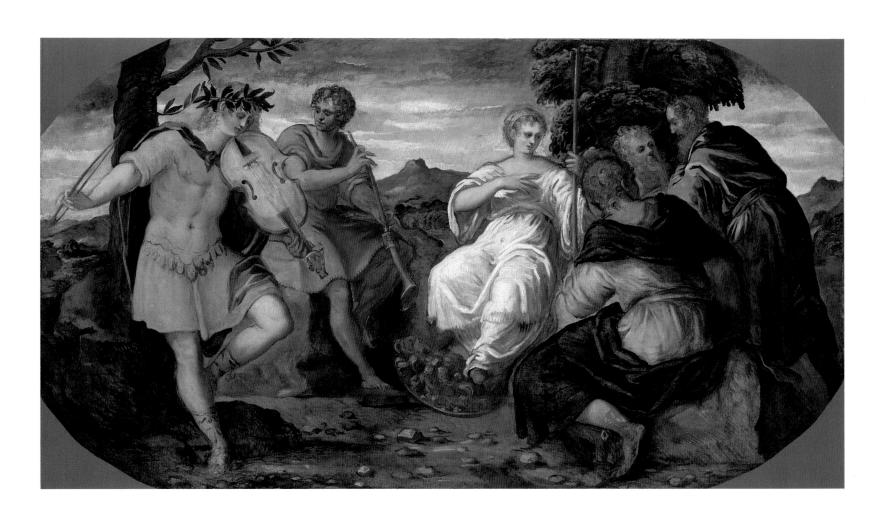

5. Jacopo Bassano

Italian (Venetian), c. 1510–92

The Mystic Marriage of Saint Catherine

c. 1552–3

Jacopo Bassano was the most celebrated member of a family of painters who took their name from the small town of Bassano del Grappa, about forty miles from Venice. Its members were active in Venice and the Veneto from the early sixteenth century to the early seventeenth and acquired the surname "dal Ponte" because their workshop in Bassano was close to a bridge. Jacopo Bassano produced a wide range of work over his career that included altarpieces and other public commissions as well as a remarkable variety of easel paintings. His style changed continually and was influenced by sixteenth-century Venetian and North Italian painters as various as Bonifazio de'Pitati, Titian and Pordenone, Moretto and Lorenzo Lotto, Veronese and Tintoretto, but his paintings have in common an interest in naturalistic description and luminous, often novel, effects of light, color, and atmosphere such as night scenes. Today he is best known for his paintings of biblical themes treated in the manner of rustic genre scenes, using rural types, and portraying animals with real interest. These pastoral pictures became popular with Venetian collectors, and helped to develop the taste for paintings in which the genre or still-life element assumes greater importance than the ostensible biblical subject. To meet the demands of collectors from about 1575 Jacopo had many copies of his works made by apprentices and by his sons, Francesco (1549–92), Leandro (1557–1622), and Gerolamo (1566–1621).

Although once attributed to Jacopo Tintoretto (cat. no. 4), the *Mystic Marriage of Saint Catherine* is unanimously accepted by modern scholars as a work by Jacopo Bassano from the early 1550s. One of two versions of this composition painted by the artist around 1553, Roger Rearick has observed that many passages of the painting have been left in a sketchy, even unfinished, state.[1] This is particularly evident in the saint's drapery and the landscape, where the painter's spontaneous and rapid handling is visible. None of the passages appears to have been completely finished with the final glazes applied, although the heads seem to have been brought closest to completion. Bassano's handling hints at the exaggerated search for novel effects of light common to his work from about 1560, when his paintings took on something of the iridescent coloring of Tintoretto. The canvas has been cut by about seven inches at the bottom edge and one and a half at the right.[2]

A resourceful artist, Bassano studied a wide range of graphic material from which he often derived compositional and figural motifs. Rearick has noted that the Hartford composition is a free conflation of two contemporary Italian woodcuts, Niccolò Vicentino's *Virgin and Child with Saints* of about 1550 and Antonio Campi's *Rest on the Flight into Egypt*, dated 1547. Moreover, Bassano adopted, in reverse, the figures of the Virgin and Child, Saint Joseph, and the *putto* from his own *Adoration of the Magi* (formerly Caggioli Collection, Venice).[3]

The fourth-century Saint Catherine, daughter of King Costus of Alexandria, was persecuted for her Christianity and martyred by Emperor Maxentius because she was a "bride of Christ" and refused to marry him (cat. no. 13). Her tortures consisted of being broken on a spiked wheel but a thunderbolt from heaven destroyed it before it could harm her and she was beheaded. Her body was carried by angels to a monastery on Mount Sinai which still claims to possess her relics. However, because of her uncertain historicity – no ancient cult devoted to the saint, no mention in the early Martyrologies, no early works of art – Catherine was removed from the Catholic Church Calendar in 1969.

Nonetheless, the cult of Saint Catherine, which strongly appealed to the imagination of artists, flourished throughout Europe in the Middle Ages under the influence of the Crusaders and of the *Golden Legend*, a thirteenth-century compilation by Jacobus de Voragine of the lives of the saints, legends of the Virgin, and narratives relating to the Church's feast days.[4] The subject of Catherine's mystic marriage to Christ was found in Italian painting by the fourteenth century, in which the infant Christ appears to her and places a ring on her finger. The Atheneum's painting shows the Child seated on the Virgin's lap accompanied by Saint Joseph and a *putto* bearing a basket of fruit.

EPB

Oil on canvas, 35¼ × 44 in.

The Ella Gallup Sumner and Mary Catlin Sumner Collection Fund, 1959.254

Provenance: Welbore Ellis Agar, London, 1806 (as by Tintoretto); Robert, Earl Grosvenor, London, 1806; by descent to William Grosvenor (died 1963), 3rd Duke of Westminster; sale, Sotheby's, London, June 24, 1959, lot 2; Julius Weitzner, New York; from whom purchased in 1959.

References: Cadogan, 1991, pp. 58–60 (with earlier references); Ballarin, 1995, vol. 1, pp. 125, 135, 136, 174; vol. 2, pp. 247, 249, 387, 395; Ballarin, 1996, vol. 2, fig. 590 (as c. 1553 and a fragment).

Selected Exhibitions: Fort Worth, 1993, no. 22.

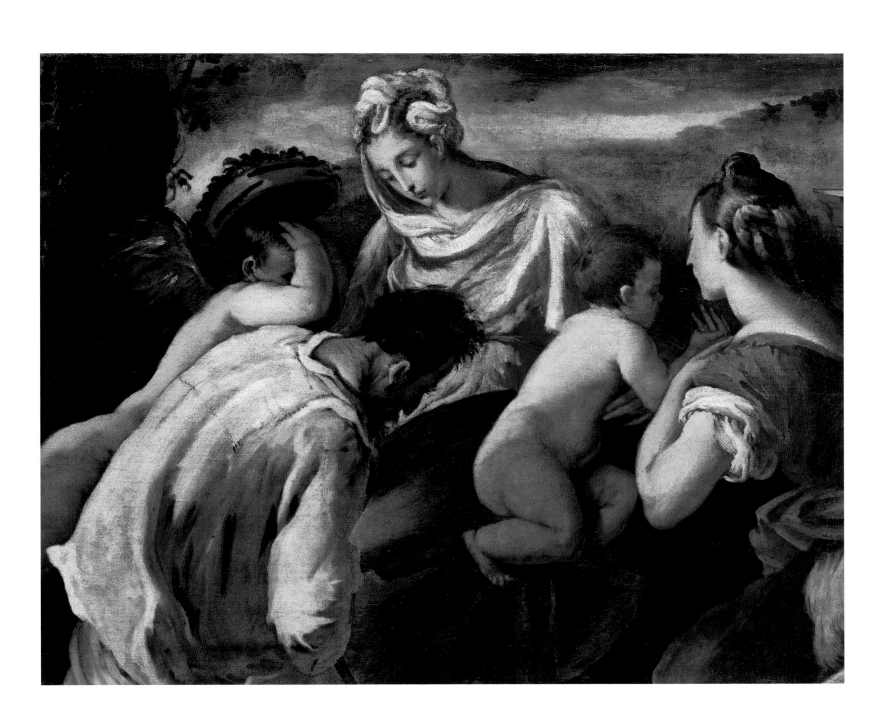

6. Lelio Orsi

Italian (Emilian), 1508/11–87

Noli me tangere

c. 1575

Lelio Orsi was a prominent Emilian painter and draftsman who worked mainly in his birthplace, Novellara, and in Reggio Emilia, although he travelled to Venice in 1553 and to Rome in 1554–5. Little remains of his large-scale decorative work, mainly interior palace decorations and illusionistic façades such as *Apollo and the Chariot of the Sun* on the Torre dell'Orologio, Reggio Emilia, 1544, and he is known today largely on the basis of his easel paintings of religious subjects and his drawings (more than 170 are known). Looking to a variety of sixteenth-century artists for inspiration – Correggio, Parmigianino, Primaticcio, Giulio Romano, and Michelangelo – Orsi created a highly distinctive, if peculiar, style marked by great energy and expressiveness and often bizarre figural motifs and drapery patterns. His handling of oil paint is often rich and exuberant and his best-preserved canvases glow with a colorful iridescence. Although Lelio Orsi was the subject of several studies in the 1980s, many aspects of his work remain to be clarified.[1]

The subject of Christ's appearance to Saint Mary Magdalene outside the tomb after the Resurrection is known in art as "*Noli me tangere*" ("touch me not"). The episode is described in the Gospel of Saint John 20: 14–18 as follows: ". . . she turned round and saw Jesus standing there, though she did not recognize him. Jesus said, 'Woman, why are you weeping? Who are you looking for?' Supposing him to be the gardener, she said, 'Sir, if you have taken him away, tell me where you have put him, and I will go and remove him.' Jesus said, 'Mary!' She knew him then and said to him in Hebrew, '*Rabbuni*!' – which means Master. Jesus said to her, 'Do not cling to me because I have not yet ascended to the Father. But go and find the brothers, and tell them: I am ascending to my Father and your Father, to my God and your God.' So Mary of Magdala went and told the disciples that she had seen the Lord and that he had said these things to her."[2]

The Atheneum's *Noli me tangere* is one of Orsi's many highly refined paintings done on a small scale for collectors. It has in recent years been understood by scholars as a late work by the artist that exemplifies his enthusiasm for the bold and inventive art of Correggio (*c.* 1489–1534) and that belongs to the general revival of Correggio's ideas and modes throughout Emilia and elsewhere.[3] The entire composition is suffused with an animated light and soft tonality that derives from the great Emilian master, and figural details – Christ's and the Magdalen's delicate facial types and the urgency of their gestures, notably his hand, viewed against the light with the soft Correggesque surface of the palm delicately shaded – underscore particularly the influence of Correggio's art. The influence of Michelangelo is equally evident amidst the recollections of Correggio; for instance, the pose of Christ is inspired by the Saint John the Baptist in the *Last Judgment* of the Sistine Chapel as is the turbulent, sharply-carved drapery of both Christ and the Magdalen.[4]

Lelio Orsi had a predilection for dramatically lit landscapes and the evocative landscape here – described as "bristling with rocky crests only partially revealed by a light that filters through an opening in the cloud-filled sky, and populated by bushes with minutely drawn leaves"[5] – provides an imaginative foil for the religious drama taking place in the foreground. Typical of Orsi's style are the fanciful scenery, restlessly flickering chiaroscuro, and the bizarre flow of drapery. In fact, the painting encapsulates Vittoria Romani's enumeration of the special qualities of Lelio Orsi's art; namely, "the interest in effects of light and illusionism, the urgency of expression, and a restless formal dynamism."[6]

EPB

Oil on canvas, 37 ¾ × 30 ⅞ in.

The Ella Gallup Sumner and Mary Catlin Sumner Collection Fund, 1936.500

Provenance: Achillito Chiesa, Milan, 1926; Ehrlich Galleries, New York, 1932; Durlacher Bros., New York; from whom purchased in 1936.

References: Cadogan, 1991, pp. 181–2 (with earlier references).

Selected Exhibitions: Sarasota–Hartford, 1958, no. 59; Notre Dame–Binghamton, 1970, no. 12; Bologna–Washington–New York 1986–7, no. 54; Reggio Emilia, 1987–8, no. 194.

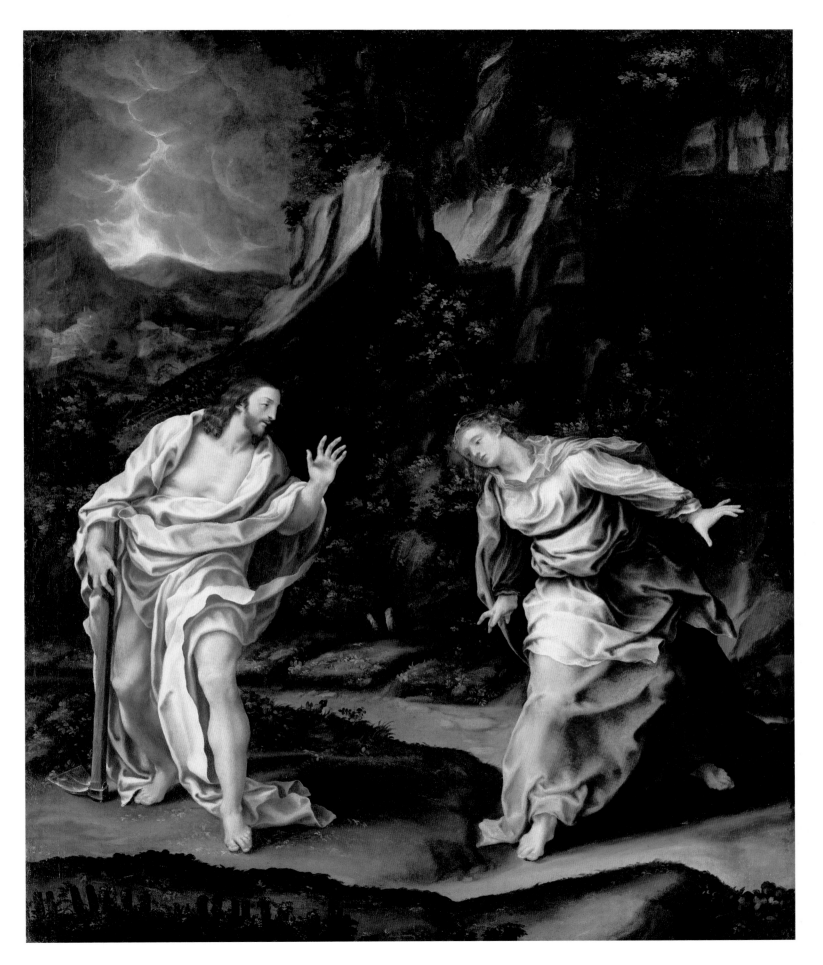

7. Michelangelo Merisi da Caravaggio

Italian (Lombard), 1571–1610

Saint Francis of Assisi in Ecstasy

c. 1594–5

Caravaggio is generally considered the most original and influential Italian painter of the seventeenth century. After an early career as a painter of portraits, still-life and genre scenes he became the most persuasive religious painter of his time. His bold, naturalistic style flattered the aspirations of the Counter-Reformation Church, while his vivid chiaroscuro enhanced the mystery of the scenes he portrayed. His "militantly realistic agenda," his naturalistic ambitions, and revolutionary artistic procedure attracted a large following from all over Europe.[1]

In Italy, Caravaggio has long resided in a mythic pantheon of artistic giants – his portrait and details of two of his works graced the 100,000 *lira* Italian banknote since the 1980s – but in the Anglo-American world, too, his popularity has soared in past decades. Art historians primarily account for the flood of books, dissertations, and articles – four biographies, two full-scale monographs, numerous other publications, and half a dozen exhibitions just since 1998. But literary and film critics, philosophers, and psychoanalysts also write prolifically about Caravaggio and his life and work, which have inspired a steady stream of novels, plays, and films as well as calendars, coffee mugs, CD-ROMs, and framed illustrations of his more sensational paintings such as the *Head of the Medusa* (*c.* 1597–9; Galleria degli Uffizi, Florence).

Caravaggio's life is well documented, at least by the standards of the seventeenth century. There are records of his court appearances for assaults, criminal damage, libel, and homicide; accounts of his patrons; and several contemporary biographical sketches. It is not quite true that Caravaggio's art and reputation languished entirely after his death in 1610, but the resuscitation of his art from the oblivion to which Italian Baroque art generally was consigned in the eighteenth and nineteenth centuries did not occur until three centuries after his death. In 1905, the English critic and painter Roger Fry noted "that there is hardly any one artist whose work is of such moment as [Caravaggio's] in the development of modern art ... he was, indeed, in many senses the first modern artist; the first to proceed not by evolution but by revolution; the first to rely entirely on his temperamental attitude and to defy tradition and authority. Though in many senses his art is highly conventional ... he was also the first realist ... his force and sincerity compel our admiration, and the sheer power of his originality makes him one of the most interesting figures in the history of art."[2] A number of German and Italian art historians were beginning to reconsider the painter's work about the same time, but none played a greater role in advancing the appreciation of Caravaggio's art than Roberto Longhi (1890–1970), who realized the painter's importance in the history of Italian painting upon seeing several paintings by the nineteenth-century realist painter Courbet in the Venice Biennale

of 1910 and who grasped the relationship between his paintings and the dominant art of the twentieth century – film.[3] Longhi, the most important and influential Italian art historian, connoisseur, and critic of the twentieth century, possessed an extraordinary capacity to perceive a work of art keenly and to convey his perceptions in words. It was he who first brought the artist international renown with his historic exhibition of the painter's work at Milan in 1951.

That exhibition sparked a torrent of scholarship that has since occupied itself with every conceivable question regarding the style and content and dating and attribution of Caravaggio's paintings, their relationship to the Catholic Reformation and the world of Copernicus, Giordano Bruno, Teresa of Avila, and Galileo, and of course the artist's life, presumed psychological makeup, and sexual orientation. Indeed, as Ellis Waterhouse once dryly observed, "So much fancy ink has been spilled about Caravaggio ... and he has been credited with roles of such extravagent importance in the history of art ... the innocent reader of art-historical literature could be forgiven for supposing that his place in the history of civilization lies somewhere in importance between Aristotle and Lenin."[4]

Francis of Assisi (1181–1226), founder of the Order of Friars Minor, or Franciscans, has always had a widespread cult, beginning in the Middle Ages, when at least four biographies were written by his contemporaries. One of the most famous incidents of the saint's life was his experience of the impression of the Stigmata on Mount La Verna in the Apennines in 1224. The event occurred when he had gone up the mountain to pray in the company of Brother Leo and saw a vision of a crucified seraph, or six-winged angel, who imprinted on his body the stigmata, or wounds, that Christ received during the Crucifixion from the nails of the cross and the lance.

Caravaggio explicitly referred to the stigmatization of Francis by the wound in the saint's chest, setting the scene on a hilltop, the presence of Brother Leo (the hooded figure under a tree in the left middle ground of the painting), and the small scene in the distance where shepherds around a fire point excitedly at streaks of light in the sky. But his interpretation of the ecstasy which accompanied Francis's stigmatization is unusual in the absence of the celestial vision of the seraph, the saint's recumbent pose, and the presence of the boyish angel. Most writers agree that Caravaggio intended to emphasize Francis's metaphorical death and spiritual rebirth in Christ's image, and have cited the parallels between the lives of Francis and Christ implicit in the painting: the figures around the fire evoking the annunciation of Christ's Nativity to the shepherds; the angel's supporting embrace modeled upon representations of the Agony in the Garden; and Francis's Pietà-like pose reminiscent of the Dead Christ supported by angels. In the Counter-

Reformation period, the Franciscans occasioned a number of changes in the iconography of Saint Francis including images of his consolation by an angel after his ecstatic stigmatization.[5] The Atheneum's painting may thus have been intended to satisfy the devotional needs of a member of the Confraternity of the Girdle of Saint Francis, a Franciscan reform movement founded in 1585.[6] The gesture of the angel hooking his index finger and thumb around the cord at the saint's waist, turning him to expose his wounds, and his ecstatic swoon of death and spiritual rebirth further underscores Francis's role as an Imitator of Christ.[7]

Nearly every aspect of *Saint Francis of Assisi in Ecstasy* is exceptional and innovative. It is Caravaggio's earliest multi-figured composition, his first religious picture, his first use of a landscape setting, and one of the first instances of his use of light both literally, to illuminate a scene, and figuratively, as a metaphor for divine presence. Of all his achievements, the greatest is his interpretation of Francis's miracle as an internalized experience. Just as he had with his earlier *Penitent Magdalen* (*c.* 1593–4; Galleria Doria Pamphilj, Rome), Caravaggio suggests here that Saint Francis is in the process of conversion, with one eye closed and one fluttering open, and his left hand beginning to feel the imprint of the wound: an image intended to inspire devotion in the beholder.[8]

EPB

Oil on canvas, 37 × 51 in.

The Ella Gallup Sumner and Mary Catlin Sumner Collection Fund, 1943.222

Provenance: Presumably Ottavio Costa, Rome, by 1606[9]; Ruggero Tritonio da Udine, Abbot of Pinerolo, Rome, by 1607; by bequest in 1612 to his nephew, Francesco Tritonio; private collection, Malta; Dr. Guido Grioni, Trieste, by 1929; Arnold Seligmann, Rey & Co., New York, 1939; from whom purchased in 1943.

References: Hibbard, 1983, pp. 55–61; Mahoney in Cadogan, 1991, pp. 84–91 (with earlier references); Gilbert, 1995, pp. 107–10, 125, 153–4, 158; Langdon, 1998, pp. 123, 126–7, 145; Puglisi, 1998, pp. 121–4; Spike, 2001, pp. 55–7; Lorizzo, 2001, pp. 408–9.

Selected Exhibitions: Milan, 1951, no. 17; Cleveland, 1971, no. 14; New York–Naples, 1985, no. 68; London–Rome, 2001, no. 121.

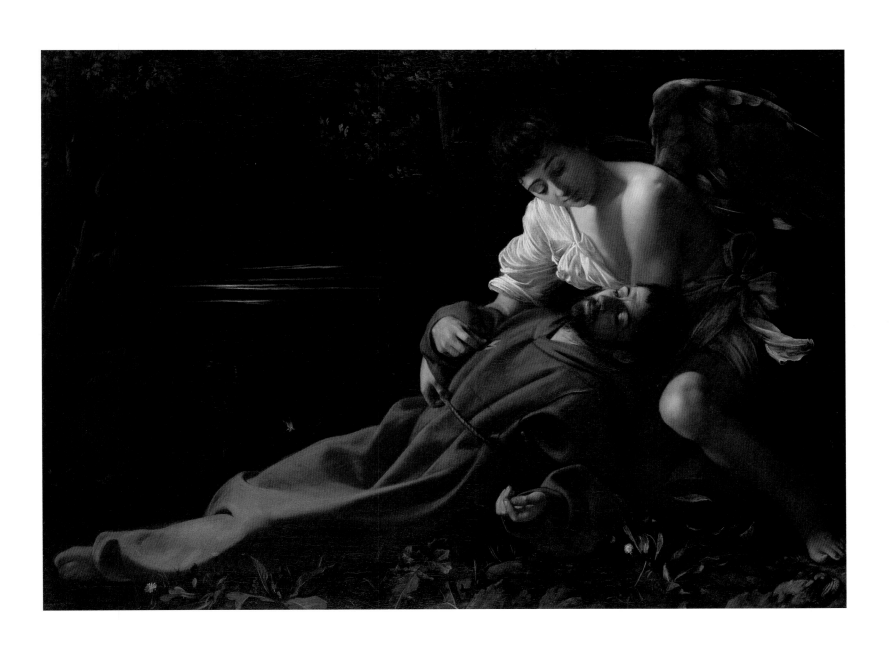

8. Lodovico Cardi, called Il Cigoli

Italian (Florentine), 1559–1613

The Adoration of the Shepherds

c. 1601–2

The Italian painter, draughtsman, architect and scenographer Ludovico Cardi took his name, "Il Cigoli," from his family's ancestral castle near Pisa. One of a circle of forward-looking artists who successfully invigorated contemporary Florentine painting through a close study of nature and a fresh appraisal of the great figures of the High Renaissance, in the opinion of most scholars he was the most eminent Florentine artist of his generation.[1] An eclectic artist active at a moment of great transition in Italian painting, Cigoli was shaped by a variety of influences including the work of such sixteenth-century artists as Andrea del Sarto, Jacopo Pontormo, Michelangelo, Albrecht Dürer and Santi di Tito.[2] But the painters whose works were most influential in helping him to attain a convincing and touching emotional content and a naturalism attuned to the Counter-Reformation and to formulate a distinctively Florentine Baroque style were the Emilian painters Correggio (*c.* 1489–1534) and Federico Barocci (1535–1612). Filippo Baldinucci, the seventeenth-century art historian and writer, characterized Cigoli as "*Il Tiziano e il'Correggio di Firenze*," and largely credited him with the reformation and resurgence of Florentine painting after the artificiality of Mannerism.[3]

Cigoli had numerous patrons throughout Tuscany and in the Medici court, principal among whom were Grand Duke Ferdinand I and Christine of Lorraine, their son, Cosimo II, and his wife, Maria Maddalena of Austria, and Don Giovanni de' Medici. In 1604, Pope Clement VIII summoned Cigoli to Rome to paint an altarpiece for Saint Peter's, and he was active in the Eternal City until his death in 1613. He was predominantly a religious painter, and he produced half a dozen paintings on the theme of the Adoration of the Shepherds (Luke 2:8 ff.) in the years around 1600. Among the finest of these are the *Adoration of the Shepherds with Saint Catherine of Alexandria*, signed and dated 1599 (Metropolitan Museum of Art, New York); and the *Adoration of the Shepherds* of 1602 (or 1604) in the church of San Francesco, Pisa.[4]

The New York and Hartford paintings are particularly close in composition; each is divided into a celestial aura with *putti*, cherubim, and seraphim above, and an earthly realm in which a radiant Christ Child is presented by the Virgin to solid and real shepherds below, the immediacy of which is heightened by such concrete details as the saddle, trussed lamb, and basket of eggs in the foreground. The Atheneum's version of the theme particularly evinces Cigoli's feeling for space and atmosphere, color and light, naturalistic form, and religious sentiment, and it underscores why, in Rudolf Wittkower's words, "he went further on the road to a true Baroque style than any of his Florentine contemporaries."[5] The exceptional state of preservation of the Atheneum's *Adoration* reveals Cigoli's dexterous, delicate handling of paint in passages such as the rough yellow undergarment worn by the shepherd kneeling at the lower right of the composition.

The Hartford *Adoration of the Shepherds* was commissioned by Ilarione Martelli, a member of one of Florence's most distinguished families of collectors and patrons, presumably as the altarpiece for a chapel under his patronage. By 1682 it was documented in a chapel in the family palace in Florence; in 1767, Senator Niccolò di Marco Martelli loaned the painting to the annual Saint Luke's Day exhibition organized by the Accademia del Disegno at the cloister of the Santissima Annunziata in Florence. In 1777 the picture was recorded in the Martelli family palace in a "conversation piece" painted by Giovanni Battista Benigni (1736–after 1786) depicting Senator Martelli and other members of the family gathered in one of their picture galleries.[6] The lower left corner of the Atheneum's *Adoration* can be seen at the extreme right of the composition hanging beside one of the most celebrated works in the Martelli collection, Donatello's *Saint John the Baptist as a Youth* (*c.* 1455; Museo del Bargello, Florence).

A measure of the contemporary admiration for Cigoli's *Adoration of the Shepherds* and an indication of his profound influence on seventeenth-century Florentine art is suggested by the fact that the composition exists in several contemporary copies, including one in a reduced format by the young Cristofano Allori (1577–1621).[7]

EPB

Oil on canvas, 98 ½ × 61 in.

The Douglas Tracy Smith and Dorothy Potter Smith Fund, 1992.75

Provenance: Commissioned by Ilarione di Tommaso Martelli (1549–*c.* 1620), possibly for the chapel in Palazzo Martelli, Florence, and there until 1952[8]; given by Paola di Carlo Martelli (1886–1975) to the monastery of Civitella San Paolo, near Rome; Baron Basilio Lemmerman, Rome; his sale, Christie's, Rome, December 9, 1976, lot 12; private collection, Bergamo, 1980[9]; private collection, Switzerland; M. Roy Fisher Fine Arts Inc., New York; from whom purchased in 1992.

References: Cardi, 1628, p. 28 (described as a *Presepio*); Bonsi, 1767, p. 17; Repetti, 1841, p, 426; Fantozzi, 1842, p. 491; Borroni Salvadori, 1974, p. 153; Matteoli, 1980, pp. 130 (as in the 1767 exhibition and as lost), 325, no. 11. A.; Chappell, 1981, pp. 69–70; Cantelli, 1983, p. 35; M. Chappell, in Florence, 1986–7, vol. 2, p. 122, under no. 2.69; Civai, 1990, pp. 43–4, 49, fn. 84–7.

Exhibition: Florence, 1767 (lent by Senator Niccolò di Marco Martelli).[10]

9. Pier Francesco Mazzucchelli, called il Morazzone

Italian (Lombard), 1573–1625/6

The Agony in the Garden

c. 1608–12

Pier Francesco Mazzucchelli, called il Morazzone, along with Giovanni Battista Crespi, called Cerano (*c.* 1575–1632), Giulio Cesare Procaccini (1574–1625) and Tanzio da Varallo (1575/80–1635), was among the leading Lombard painters of the early seventeenth century. His style of painting is typically Milanese, and like many of his contemporaries, he was strongly affected by the piety and mysticism of the teachings of the great religious reformer and writer Saint Carlo Borromeo (1538–84) that inspired deeply-felt devotional images such as this *Agony in the Garden*. Milanese art at this period is marked by an extraordinary religious intensity, which has deep roots in the spirit of popular devotion epitomized in the pilgrimage churches of the *Sacri Monti* of Lombardy.[1] The *Sacri Monti*, or "holy mountains," are chapels and sanctuaries adorned with illusionistic sculptural tableaux vivants depicting religious events, usually episodes in the life of Christ or a saint. Life-sized terra-cotta figures, naturalistically carved and painted, fitted with glass eyes and real hair, and posed before frescoed backgrounds, presented the events of the life of Christ to the pious with terrifying realism.[2]

Morazzone was thoroughly steeped in the tradition of these collective enterprises, in which the spirit of the medieval miracle plays was revived and to the decoration of which a whole army of artists and artisans contributed between the sixteenth and eighteenth centuries.[3] Much of his career was taken up with large decorative frescoes and illusionistic backgrounds complementing the realistic figures in painted wood or terracotta that make up the main protagonists in the narrative cycles of sacred events. His greatest achievements were the "Ascent to Calvary" Chapel of the Sacro Monte, Varallo (1605); the "Flagellation" Chapel of the Sacro Monte near Varese (1608–9); and the "Ecce Homo" Chapel at Varallo (1609–13). In 1614 he finished the frescoes of the "Condemnation to Death" Chapel of the Sacro Monte at Varallo, and between 1616 and 1620 he executed those of the "Porziuncola" Chapel of the Sacro Monte at Orte.[4]

The *Agony in the Garden* was unrecorded from 1818 until it appeared on the London art market in 1996, where it was purchased by the Atheneum.[5] Morazzone's private devotional paintings are relatively rare, so this canvas provides an important addition to his known works. Hugh Brigstocke, who identified the painting as the work of Morazzone, has suggested that from stylistic evidence the painting appears to have been created early in the artist's career, perhaps from *c.* 1608–12.[6] The most distinctive features of the picture – the golden tresses of the angel's hair; tense expressive poses of Christ and the angel; detailed highlights of the landscape background with its meticulous treatment of rocks and plants; and relaxed naturalism of the sleeping apostles in the foreground – are all found in the artist's works of the period. Especially comparable are Morazzone's frescoes in the Chapel of the Flagellation at Varese of about 1608–9 and the Collegiata of San Bartolomeo at Borgomanero of 1611–12; and an oil painting, *The Trinity with Angels* (*c.* 1610; SS. Trinità, Como).[7]

The Garden of Gethsemane at the foot of the Mount of Olives was where Christ and his disciples went after the Last Supper and where he was captured. He had taken Peter, James, and John with him, and then moved apart from them. When he returned to the disciples he found them asleep and rebuked them for their lack of resolve. The subject is described in three of the four Gospels, but Luke (22: 39–46) is the only one which mentions the angel: "And he came out, and went, as he was wont, to the mount of Olives; and his disciples also followed him . . . And he was withdrawn from them about a stone's cast, and kneeled down, and prayed, Saying, 'Father, if thou be willing, remove this cup from me: nevertheless not my will but thine be done'. And there appeared an angel unto him from heaven, strengthening him. And being in an agony he prayed more earnestly; and his sweat was as if it were great drops of blood falling down to the ground . . ."

Morazzone depicted the angel before Christ in shimmering white robes, bearing a chalice and cross. The three sleeping disciples appear in the lower third of the composition: Peter, gray-haired with a curly beard, at the left; John, the youngest, reclining on his red cloak; and James, at the far right. The nature of Christ's vision came to take two distinct forms in the period of the Counter-Reformation, both of which Morazzone combines in the Hartford painting: the angel appears bearing both a cross (an instrument of the Passion and standard iconographical element of the scene), illuminated in a shaft of light as in a vision, and a chalice and wafer. The convention of representing Christ as if he were about to receive communion seems to have arisen from the gospels' metaphorical reference to the cup – "My Father, if it is possible, let this cup pass me by" (Matthew 26: 40) – and refers both to Old Testament references to a cup, or chalice, as a symbol for the judgment of God and to the chalice filled with wine, symbolizing Christ's blood, described in the biblical accounts of the Last Supper (Matthew 26: 27–28).[8] The splashes of blood on the ground in the painting refer to the blood shed by Christ at the Crucifixion. This is the blood which Christ himself described at the Last Supper as his blood, "the blood of the covenant, which is to be poured out for many for the forgiveness of sins" (Matthew 26: 28–30). The painting thus contains a Eucharistic reference, since according to the Catholic theology, the wine in the chalice and the bread held by the priest during the rite of Holy Communion become the actual blood and body of Christ through the miracle of transubstantiation. This medieval doctrine, rejected by the Protestant faith, was reaffirmed at the Council of Trent in 1551–2 and promoted during the Counter-Reformation in artistic images such as Christ in the Garden of Gethsemane.[9]

EPB

Oil on canvas, 43 ¾ × 33 ⅝ in.

The Ella Gallup Summer and Mary Catlin Sumner Collection Fund, 1997.1.1

Provenance: Possibly Anguissola Visconti, Milan;[10] sale, London, Christie's, December 13, 1996, lot 115; from whom purchased.

References: Stoppa, 2003, p. 208, no. 31, fig. 31a.

10. Sisto Badalocchio

Italian (Parmesan), 1585–after 1619

The Holy Family

c. 1609–10

Sisto Badalocchio is a painter whose appreciation today is confined, unfairly, to a handful of scholars and specialists in Italian seventeenth-century painting. He is thought to have trained briefly in Bologna in the academy of the Carracci family, the brothers Agostino (1557–1602) and Annibale (1560–1609) and their cousin Ludovico (1555–1619). In their teaching the Carracci laid special emphasis on drawing from life, and Badalocchio developed the strong and clear draughtsmanship associated with the artists who studied in their circle. According to contemporary sources, Badalocchio was a pupil of Agostino and returned with him to Parma in 1600 when his master entered the service of Ranuccio I Farnese, Duke of Parma. After Agostino's death in 1602, Badalocchio was sent by the duke with his fellow pupil Giovanni Lanfranco (1582–1647) to Rome in order to complete his training in the studio of Annibale Carracci, who was then working in the Palazzo Farnese. Badalocchio remained with Annibale until his death in 1609, and participated in most of the projects that occupied the studio assistants during those years such as the frescoes on the walls of the famous Gallery in the Palazzo Farnese. A number of his paintings are variations on originals by Annibale, and Badalocchio himself acknowledged the importance of his master in the dedication (1607) to a series of etchings he made after Raphael's frescoes in the Vatican Logge and the antique sculptures in the Vatican.

In 1609 Badalocchio returned to Parma where his style was invigorated by a renewed study of the art of the sixteenth-century Emilian master, Correggio, and of the contemporary painters, Ludovico Carracci and Bartolomeo Schedone (1578–1615). Indeed, the Atheneum's lyrical *Holy Family*, painted in about 1609–10, has been described as uniting "the clarity and grandeur of Annibale with the colors and soft light of Correggio and Schedone."[1] Badalocchio's powerful, firmly-constructed composition – strengthened by the force and precision of drawing that define Mary, Joseph, and the Christ Child – reveals the profound influence of his direct association with Annibale Carracci.[2] Annibale is generally regarded as the father of the "ideal" landscape, and Badalocchio's manipulation of the landscape in the background of the *Holy Family* into a formalized setting suitable for the figures is another indication of his attention to his master's paintings.

Although Badalocchio was commended by contemporary critics for his artistic ability and especially his talent for drawing, his biographers often noted that he "lacked application."[3] The careful composition, grandeur of form, vivid draftsmanship, and bright colors of the Hartford *Holy Family* belie such criticism, however, and the fact that it was recorded in various Farnese inventories in the seventeenth century suggests that the painting was one of the artist's most admired creations.[4] Nonetheless, the identity of its authorship by Badalocchio was lost at an early date and throughout its history the work has been attributed variously to Annibale and Ludovico Carracci and to Giovanni Lanfranco.[5] Denis Mahon, one of the scholars responsible for the resurgence of interest in Italian Baroque painting in Europe and the United States following World War II, discussed the correct authorship of the painting in the *Wadsworth Atheneum Bulletin* in 1958. The painting exists in a remarkable state of preservation on the original, unthinned panel. Recently cleaned, Badalocchio's fine handling and sensitive touch is particularly evident in the treatment of Saint Joseph's hands, beard, and hair; the flesh tones of the Virgin and Child; and the foliage behind the figures.

The scene appears to be a straightforward devotional representation of the Holy Family resting in a landscape. The presence of Joseph's staff, however, suggests that the Holy Family may be resting on its flight into Egypt, an event described briefly in the Gospel of Matthew (2: 13–15). The angel of the Lord warned Joseph in a dream that King Herod, hoping to destroy the child called the King of the Jews, had ordered the murder of all the infants in Bethlehem. Joseph departed that night with the infant Jesus and Mary for Egypt, where they stayed until Herod was dead. No further mention of the journey appears in the Bible, but the tale was elaborated in the rejected biblical writings that form what is called the New Testament Apocrypha and appeared again, in the Middle Ages, in the *Golden Legend*. Here, Badalocchio has eliminated allusions to the miraculous literary accounts of the Flight into Egypt such as the donkey and angels who frequently accompany the Holy Family (see cat. no. 16). That a copy of this painting in horizontal format, extended at the left to include two angels, once hung in the Farnese collection in Rome (now in the Museo e Gallerie Nazionali di Capodimonte, Naples) suggests that Badalocchio conceived the Hartford scene as a pause during the flight into Egypt without the presence of angels.[6] The exquisite still-life of a basket of fruit in the center of the composition may refer to the fruit (usually dates) given to the Holy Family by angels in various accounts.

EPB

Oil on wood, 31 ⅞ × 22 ½ in.

The Ella Gallup Sumner and Mary Catlin Sumner Collection Fund, 1956.160

Provenance: Palazzo Farnese, Rome, 1644 (inv. no. 2862)[7] and 1653 (as Giovanni Lanfranco)[8], until 1662; transferred to Parma and in 1671 installed in Palazzo del Giardino (listed in 1680 as by Sisto Badalocchio and in 1708 as by Lanfranco); presumably inherited in 1731 by Charles III (1716–88), King of Spain, and later Charles VII, King of Naples, and possibly seized by the French in 1799; John Udny (1727–1800), Livorno and London; sale, London, Christie's, April 25, 1800, lot 52 (as Ludovico Carracci), bought by Colonel Murray; John, 2nd Earl of Ashburnham (1724–1812) or George, 3rd Earl of Ashburnham (1760–1830), Ashburnham House, Westminster; sale, London, Sotheby's, July 20, 1850, lot 70 (as Annibale Carracci, bought in); by descent to Lady Catherine Ashburnham, Ashburnham Place, Sussex; sale, London, Sotheby's, June 24, 1953, lot 39; David Koetser, New York; Sir John Heathcoat Amory, Tiverton, Devon; Thomas Agnew & Sons, London; from whom purchased in 1956 (as Ludovico Carracci).

References: Mahon, 1958, pp. 1–4; Cadogan, 1991, pp. 50–2 (with earlier references); Negro and Pirondini, 1995, p. 92, pl. 140; Tuyll van Serooskerken, 1996, p. 33 (as 1609).

Exhibitions: London, 1950–1, no. 146 (as Lodovico Carracci); Bologna–Washington–New York, 1986–7, no. 120; London–Rome, 2001, no. 40.

11. Ippolito Scarsella, called lo Scarsellino

Italian (Ferrarese), c. 1551–1620

Fame Conquering Time

c. 1610–15

Scarsellino appeared at a moment when the great age of Ferrarese painting, established by the painters Dosso and Battista Dossi (cat. no. 3), Girolamo da Carpi, and Garofalo, began to decline with the death of the latter in 1559. He remained not only the last of the important painters active in Ferrara in the sixteenth century, but also perhaps the only artist of major talent to paint there in the following century. Working in the atmosphere of the Counter-Reformation, Scarsellino spent most of his long career painting religious subjects. Modern taste, however, has recognized the artist's representation of landscape and his excursions into classical mythology as his most congenial and sympathetic works.

Scarsellino was born in Ferrara and first trained in the shop of his father, Sigismondo Scarsella (from whom the diminutive lo Scarsellino was derived), a painter and architect. Girolamo Baruffaldi, the eighteenth-century biographer of Scarsellino, and all later writers on the artist emphasize the consequences of his journey to Venice about 1570 and of his subsequent stay of several years in the ambience of Paolo Veronese. Scarsellino's appropriation of the manner of Veronese, which led to the epithet "Paolo dei Ferraresi," is but one example of his wide-ranging eclecticism and the contemporary Venetian painters who inspired him including Titian, Tintoretto (cat. no. 4), and Jacopo Bassano (cat. no. 5).

Therefore, one of the difficulties, and delights, encountered in the experience of Scarsellino's painting is his extraordinary ability and willingness to absorb the manner of other artists. Writing in the eighteenth century, the antiquary and art historian Luigi Lanzi describes his visits to Roman palaces in the company of others to examine the artist's paintings and how those present commented on Scarsellino's attention to the sixteenth-century painters Veronese, Parmigianino, Titian, Dosso, and Girolamo da Carpi.[1] Scarsellino's synthesis of the Venetian, Lombard, Emilian, and Bolognese traditions of painting have led modern writers on Fame Conquering Time to invoke the influence of individual artists as diverse as Veronese, Annibale Carracci (1560–1609), Guido Reni (1575–1642), Guercino (1591–1666), and Carlo Bononi (1569–1632).[2]

Whatever his sources of inspiration, Scarsellino forged a distinctively personal style and his pictures have been aptly described as "hearty and easily understood."[3] Here, a winged female figure of Fame soars over Father Time, whom the artist has shown as an old man cowering on the ground, nude except for a loin-cloth, and clutching an hourglass. Fame bears her usual attribute in Renaissance and later art, a trumpet, and with a long stick points to the hourglass. These personifications with their attributes generally follow the descriptions of the standard reference work for Italian artists of the time, Cesare Ripa's Iconologia.[4] Scarsellino conceived a particularly memorable figure in the personification of Fame, and her complex pose and elaborate, fluttering draperies suggest a date for the picture in the last decade of the painter's life.

Fame Conquering Time combines a number of elements traditional to Ferrarese painting in general such as the blue-green sky shot with faded pink and yellow and to Scarsellino's own manner such as the landscape gently rolling to the cool blue mountain on the horizon, which subtly frames the figure of Time in the foreground. Another stamp of Scarsellino's individuality is the effect of the last streaks of sunlight lingering in the sky before night falls, which, as Sir Denis Mahon observed, is echoed in almost every early Guercino background landscape.[5]

Surprisingly, no references relating this important and dramatic painting to contemporary Emilian art collections have been found, although it was almost certainly painted for a private collector. Allegories by Scarsellino are rare, but he was sufficiently highly considered as a master of the genre to receive the commission to paint a lost Allegory of Ferrara Extending her Hand to the River Po in chiaroscuro for the triumphal entry of Pope Clement VII to Ferrara in 1598.[6]

EPB

Oil on canvas, 67 ³⁄₈ × 51 ½ in.

The Ella Gallup Sumner and Mary Catlin Sumner Collection Fund, 1985.50

Provenance: Private collection, Europe; Matthiesen Fine Art, London; from whom purchased in 1985.

References: Cadogan, 1991, pp. 222–5; Ruggeri, 1996, vol. 28, p. 39, repr. (as c. 1610).

Exhibitions: London, 1984, no. 56; Bologna–Washington–New York, 1986–7, no. 75.

12. Orazio Gentileschi

Italian (Roman), 1563–1639

Judith and Her Maidservant with the Head of Holofernes

c. 1610–12

The exploits of the Jewish heroine Judith have occupied Western artists from the Middle Ages through to the Baroque period. For example, Donatello's bronze *Judith* was set up outside the Palazzo della Signoria in Florence as a symbol of civic liberty and Michelangelo in 1508–12 painted four scenes of divine deliverance in the Sistine Chapel, pairing Judith and Holofernes with Esther and Haman. The story of Judith, "the glory of Israel," is told in the Old Testament Apocrypha. The Assyrian army had laid siege to the Jewish city of Bethulia (probably an imaginary city) and when the inhabitants were on the verge of surrender, Judith, a beautiful young widow, devised a plan to save them. She adorned herself "so as to entice the eye of any man who might see her" (Judith 10: 5), and with her maid Abra set off for the camp of the Assyrian commander, Holofernes, to whom she proposed a fictitious plan to overcome her city. Enamored with Judith's beauty, Holofernes invited her to a banquet with the intention of seducing her. Overcome with liquor, he passed out and Judith beheaded him with his sword and returned with Abra to Bethulia in triumph with his head in a sack. The discovery of the commander's death threw the Assyrian forces into disarray and they abandoned their siege, fleeing the Israelites. Apart from its own inherent dramatic possibilities, the story of Judith was a popular subject in Counter-Reformation art because she was regarded by the Church as a prefiguration of the Virgin Mary.[1]

Judith and Her Maidservant with the Head of Holofernes is one of the most refined and elegant masterpieces of Orazio Gentileschi, a friend and important Roman follower of Caravaggio (cat. no. 7). The Atheneum's picture belongs to a relatively short phase around 1610 when Gentileschi was acutely conscious of Caravaggio's pictorial vision and its conception, lighting, and format derive from the Lombard master's works.[2] Like Caravaggio before him, Gentileschi chose subjects that required few figures and placed them close to the picture plane. The upturned heads of Judith and her servant are typical features of his heroines, and the rendering of their sumptuous draperies anticipates the increased elegance of his later paintings. The solid young women are typical of Gentileschi's physical types, and he gracefully combines them within a simple triangular design that incorporates the severed head of Holofernes yet allows each to play her respective role in the drama.[3] Gentileschi delighted in such details as hands, feet, and faces, and the exquisite finish and meticulous handling of the women's drapery, skin, and hair are a signature of the artist.

Gentileschi has depicted Judith and her servant in the act of placing the head of Holofernes in a basket at the moment before their successful escape from the Assyrian camp. A noise has caused the women to start, and they look out of the picture to the left and right, listening before they begin their escape through the night. The strong illumination on the figures intensifies their isolation amid the surrounding darkness, both enhancing the drama of the scene and intensifying the features of the protagonists and the red and gold brocade of Judith's blouse and Abra's blue drapery.

The Hartford *Judith and her Maidservant* has been the subject of many iconographic, narrative, formal, and psychological interpretations and readings. Recently, Judith Mann has discussed the powerful dramatic effect of the composition, and compared the two women in operatic terms – Judith as the soprano to Abra's dusky contralto. She raises an interesting analogy between Orazio's composition and a drama by Federico della Valle, *Iudit*, written about 1600 and published in Milan in 1627. In one scene the two women have retired to pray and Abra confides her doubts and fears to Judith: "I confess my fear . . . but often my soul, trembling, turns back, or lingers or stays fast." Judith responds: "Raise your soul, dear Abra, or if you cannot do that, then raise your eyes. Look at those stars in the sky. . . . And shall you fear that . . . the great and pious God who rules and governs them does not fight for us. . . . ?"[4]

Art historians have discussed extensively the relationship between the Hartford *Judith and Her Maidservant with the Head of Holofernes* and the several versions of the subject by Orazio's daughter, Artemisia Gentileschi (1593–1652/3), a legendary figure in recent years, celebrated particularly by feminists and women artists, whose name has come to be associated with the image of Judith slaying Holofernes.[5] The date of Orazio's painting has also sparked a debate among scholars; one group has suggested a relatively early date around 1611–12; more recently, the painting has been seen as characteristic of Orazio's work in the early 1620s, when he was in Genoa.[6]

EPB

Oil on canvas, 53 ¾ × 62 ⅝ in.

The Ella Gallup Sumner and Mary Catlin Sumner Collection Fund, 1949.52

Provenance: Possible Pietro Maria I Gentile, Palazzo Gentile, 1640–1; thence Gentile collection, Genoa, until 1811–8 (1811 inventory as by Valentin) or, alternatively, Carlo Cambiaso, Palazzo Brignole, Genoa, by 1780 – *c.* 1805;[7] Sir Hugh Cholmondeley, London; David Koetser, New York 1948–9; from whom purchased in 1949.

References: Bissell, 1981, pp. 153–4, no. 25 (as *c.* 1611–12); Mahoney, in Cadogan, 1991, pp. 148–51 (with earlier references); Harris, 1996, p. 305; Bissell, 1999, pp. 13, *passim*; Mann, in New York–Saint Louis, 2001–2, pp. 186–190, *passim*.

Selected Exhibitions: Detroit, 1965, no. 6; Cleveland, 1971, no. 30; New York–Saint Louis, 2001–2, no. 39.

13. Bernardo Strozzi

Italian (Genoese), 1581/2–1644

Saint Catherine of Alexandria

c. 1615

Trained in Genoa and active there for more than thirty years, Bernardo Strozzi was one of the leading artists in the city's golden age of painting in the first half of the seventeenth century. During Strozzi's lifetime, Genoa occupied a privileged position among the major artistic centers of the Italian peninsula. Because of its location, the city served not only as an important port but also as a vital link between the southern and northern states of Italy and to northern European countries. Genoa was open to foreign artistic influences, and as a result Strozzi drew inspiration from a variety of diverse sources such as Mannerist paintings and prints, the paintings of Caravaggio (cat. no. 7), contemporary Milanese painting (cat. no. 9), and the presence of Flemish painters and pictures in Genoa. As a young man Strozzi entered the Capuchin monastery of San Barnaba in Genoa, earning him the nickname "*Il Cappuccino*" (as well as another, "*Il Prete Genovese*," the Genoese priest). He eventually left the Capuchin order, and in 1633 traveled to Venice where he won widespread recognition as a painter.

Although in the late 1610s Strozzi received important commissions for frescoes in the palaces of the Genoese nobility and for altarpieces and frescoes in churches, his earliest works appear to have been easel paintings, mostly of religious subjects, for private clients. The *Saint Catherine of Alexandria* was one of these private commissions and is presumed to have been painted for Giovanni Carlo Doria (1576/7–1625), a member of the powerful Genoese noble family in whose collection the work was recorded. Giovanni Carlo was an enthusiastic patron

of the arts – he and his brother Marc'antonio (1572–1651) owned numerous paintings by such contemporary artists as varied as Caravaggio, Simon Vouet, Sir Peter Paul Rubens, and Giulio Cesare Procaccini – and of Strozzi in particular.

Saint Catherine of Alexandria is one of the highlights of Strozzi's Genoese career, and the work reflects his earliest style of painting. The simple composition, the crowding of the figure into a confined space, the exotic and iridescent palette, and the upward gaze of the saint are typical features of his early style. Both the highly spiritual atmosphere and Strozzi's dazzling painterly technique reveal his admiration for the work of Federico Barocci (*c.* 1535–1612), whose *Christ on the Cross with the Virgin and Saints* was placed in Genoa cathedral in 1599. Another likely inspiration for Saint Catherine's elongated head, her eyes rolled upward in ecstasy, and her "faceted, frenetic draperies" are the elegant and mystical prints of the French painter and etcher, Jacques Bellange (active *c.* 1580–1638).[1]

The cult of Catherine of Alexandria flourished throughout Europe in the Middle Ages under the influence of the Crusaders and of the *Golden Legend*, a thirteenth-century compilation of the lives of the saints and legends of the Virgin.[2] Believed to have been executed by the Roman emperor Maxentius early in the fourth century, Catherine was venerated as a Christian saint and virgin martyr and a patron of education and learning. Strozzi has thus depicted the saint with the palm of martyrdom, sword of execution, and her special attribute, a piece of a wheel studded with spikes upon which she was to have been tortured until a thunderbolt from heaven destroyed it before she could be harmed.

Saint Catherine of Alexandria is generally thought to have been paired with another of Strozzi's most memorable works now in an American collection, *Saint Cecilia* (fig. 13A, 1620–5; Nelson-Atkins Museum, Kansas City), also owned by Giancarlo Doria.[3] Eliot Rowlands has suggested that the two paintings of seated female saints were intended to function as allegorical representations of "the muses of Christian poetic art": Saint Catherine as patron of letters, her foot resting prominently on a book representing literature and philosophy; Saint Cecilia, a third century virgin martyr, as patron of music, symbolized by an organ, violin, and lute in the Kansas City painting.[4] The paintings were likely intended for a library or study.

Although the Hartford and Kansas City paintings share the same dimensions and the same size and placement of figures, the *Saint Cecilia* is more naturalistically proportioned, evenly lighted, and broadly painted and is thought to have been painted

later. It was, moreover, apparently conceived originally as an image of Saint Catherine and subsequently transformed by Strozzi at the request of his patron into a figure of Saint Cecilia.[5] Understandably, in light of the fact that each painting is among the finest that Strozzi ever produced in a long and active career, several versions exist of each composition.[6]

EPB

Fig. 13A. Bernardo Strozzi, *Saint Cecilia*, 1620–5, oil on canvas, 67 ¾ × 48 ⅛ in. Nelson Atkins Museum of Art, Kansas City

Oil on canvas, 69 ⅛ × 48 ½ in.

The Ella Gallup Sumner and Mary Catlin Sumner Collection Fund, Endowed in Memory of A. Everett Austin, Jr. by Mrs. A. Everett Austin, Jr., 1931.99

Provenance: Possibly commissioned by Giovanni Carlo Doria (1576/7–1625), Palazzo Doria di Vico di Gelsomino, Genoa; bequeathed to his son Agostino Doria (*c.* 1620–44), Genoa; thence to his uncle, Marc'antonio Doria (1572–1651); by descent to Marc'antonio III Doria, Palazzo Doria di Vico di Gelsomino, Genoa, as of 1766[7]; Marcello Tozzi, Genoa; sale, Milan, Galleria Geri-Boralevi, 11–14 February 1920, lot 60; Italico Brass (1870–1943), Venice; from whom purchased in 1931.

References: Mortari, 1966, pp. 137–8; Mahoney in Cadogan, 1991, pp. 229–33 (with earlier references); Mortari, 1995, p. 108, cat. no. 115; Rowlands, 1996, pp. 260, 264–7; Boccardo, 1995, pp. 867, 868 (*c.* 1615); Lukehart, 1998, p. 11.

Selected Exhibitions: Florence, 1922, no. 156; New York, 1932, no. 11; San Francisco, 1941, no. 107; Baltimore–Saint Louis, 1944, no. 6; Baltimore, 1995, no. 3.

Italian School * 65

14. Carlo Saraceni

Italian (Venetian active in Rome), c. 1579–1620

The Holy Family in Saint Joseph's Workshop

c. 1615

The subject of the Holy Family in Saint Joseph's workshop is not found in the Bible, and it may have been taken from one of the early apocryphal texts or later biographies of the saint. The emergence of Joseph as a significant figure in ecclesiastical literature, and as an important subject in art, did not occur until the Catholic Counter Reformation. As part of the Church's new efforts to combat Protestantism and propagate the Catholic faith, as articulated at the Council of Trent (1545–63), images of saints and holy figures were humanized and made more psychologically accessible to the faithful. The theme of the young Jesus in his father's woodworking shop – Christ was referred to as "the carpenter's son" in Matthew 13: 55 – belongs to the seventeenth-century tradition of depicting Joseph as the foster father of Christ and husband of the Blessed Virgin Mary. In his profession as carpenter, Joseph was also viewed as an exemplar of humility. The subject undoubtedly appealed to painters for the opportunity it presented to include genre details such as the display of woodworking tools and anecdotal and sentimental elements such as the Virgin's admonition to her Child, as here, to be careful with the gouge he holds. (The implements also bear a symbolic significance: Jesus holds what appears to be a wooden nail, one of the angels bears a piece of wood reminiscent of the Cross carried by Christ to Calvary.) The trend toward representing religious subjects in a mundane manner – "the secularization of the transcendental," in Walter Friedlaender's phrase – heightened the empathy between viewer and image and made the depiction of religious iconography more natural and convincing.[1]

The *Holy Family in Saint Joseph's Workshop* has been acclaimed as one of Carlo Saraceni's finest paintings – indeed, as among the most beautiful paintings of the early Seicento – for its delicate combination of naturalism and mood of poetic innocence.[2] Until the last year of his life, Saraceni worked mainly in Rome where, from about 1600 to 1610, he was a prolific painter of small cabinet pictures on copper with biblical and mythological themes indebted to Adam Elsheimer (1578–1610), the German painter, printmaker, and draughtsman. In the following decade, Saraceni produced a number of monumental altarpieces for churches in and around Rome that reverted to a style that owes as much to paintings by Titian, Tintoretto (cat. no. 4), Veronese, and Jacopo Bassano (cat. no. 5), whose art he had absorbed in his native Venice, as to the influence of Caravaggio (cat. no. 7) and his followers. The most memorable of these, and the most Caravaggesque, is a *Saint Benno Recovering the Keys of Meissen* and the *Martyrdom of Saint Lambert* in Santa Maria dell'Anima in Rome, dating from 1610–8. The best known of Saraceni's large-scale compositions is the *Death of the Virgin* commissioned in about 1610 for the Cherubini Chapel in Santa Maria della Scala, Rome, as a replacement for Caravaggio's famous painting of the subject (Musée du Louvre, Paris), which the church had rejected in 1606 for reasons of decorum.

According to the contemporary Italian painter and writer Giovanni Baglione, Saraceni was a Francophile who adopted a French mode of dress, "though he had never visited France nor knew a word of the language," and had several French students and followers.[3] Among these were Jean Leclerc of Lorraine (c. 1587–1633), possibly Philippe Quantin (c. 1600–36), the anonymous Pensionante del Saraceni ("boarder of Saraceni") and Master of the Open-Mouthed Boys (active in Rome c. 1615–1625, see fig. 13), and Guy François (c. 1578–1650), who was in Rome from 1602 until 1613. So close in style was the work of these painters to Saraceni's that the *Holy Family in Saint Joseph's Workshop* has in the past been attributed to both Jean Leclerc and, more plausibly and often, to Guy François, notably by Pierre Rosenberg in 1982.[4] (The discussions on the authorship of the Atheneum's painting have relied mainly upon stylistic analysis and connoisseurship, but if the work is compared to the most securely attributed works by Saraceni and François, it is unlikely that either painter will ever be established beyond doubt to be its creator.[5])

The art historian Richard Spear noted the lucid design, tranquil figures, and quiet harmony of the *Holy Family in Saint Joseph's Workshop* and Saraceni's delicate feeling for color and tone: "The rotund faces of the *putti* and unblemished complexion of the Virgin in the Hartford painting, as well as the strength of her red robe, the clarity of the colors, and the simplified forms, establish an unusual accord between Caravaggesque naturalism – so apparent in the carefully observed and rendered tools – and an ideal classicism, which undoubtedly in part attracted French artists to Saraceni. Especially noteworthy are the violet and soft blue robes on the Child at the left, contrasted with the deep blue of the sash around his waist and with the garments of the adjacent *putto*. The silver blues and greyed whites of the feathers, enlivened by passages of dark blue and yellow, are coloristically among the most most beautiful passages in all of Saraceni's work."[6]

EPB

Oil on canvas, 44 5/8 × 33 3/16 in.

The Ella Gallup Sumner and Mary Catlin Sumner Collection Fund, 1963.496

Provenance: Private collection, near Ardèche, France, c. 1960 (as Guy François); Frederick Mont, New York; from whom purchased in 1963.

References: Ottani Cavina, 1968, pp. 48–9, 103, no. 20 (as Saraceni); Mahoney in Cadogan, 1991, pp. 220–2 (as Saraceni and with earlier references).

Exhibitions: Cleveland, 1971, no. 60 (as Saraceni); Paris–New York–Chicago, 1982, no. 29 (as Guy François).

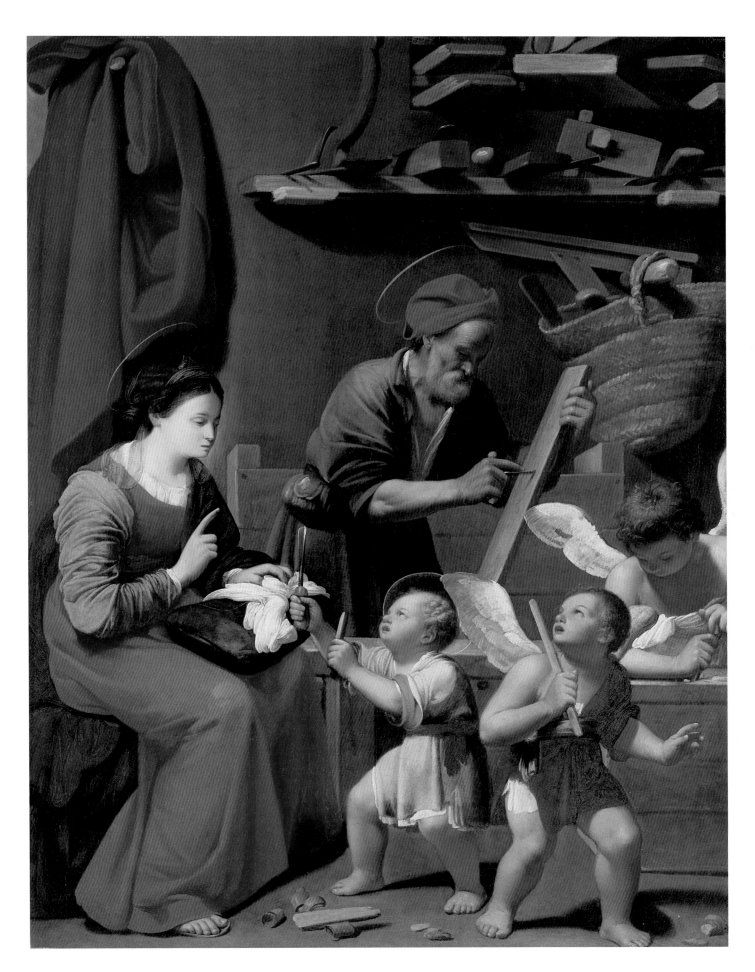

15. Master of the Hartford Still-Life

Italian (Roman), active *c.* 1600

Still Life with Flowers and Fruits

c. 1600–10

The designation "Master of" is a term used by art historians to label the author of anonymous works for convenience in discussing them. The use of invented names began in Germany in the nineteenth century for the description of early Netherlandish paintings. The choice of names was often quite imaginative, although today anonymous masters are usually named after a particular picture or the collection to which it belongs. The name "Master of the Hartford Still-Life" is the label given to an unidentified painter active in Rome about 1600 whose work has traditionally been associated with the circle of Caravaggio (cat. no. 7). Surprisingly little is known about still-life painting in Rome during the first two decades of the seventeenth century and written sources provide the names of few genuine fruit and flower painters active at the time. Inventories of Roman collections in the first two decades of the seventeenth century contained very few examples of still-life painting, and what was listed was often anonymous. For example, in the *Nota de' quadri*, an inventory of the painter Cavaliere d'Arpino's (1568–1640) property drawn up in 1607 at the time it was confiscated and given to Pope Paul V's nephew, Cardinal Scipione Borghese, artists' names were not given and of the 129 paintings recorded only seven were still-lifes.[1]

Art historians have attempted to identify the work of anonymous still-life painters on the basis of specific stylistic characteristics and compositional features and have thus assigned names such as the "Master of the Acquavella Still-Life," "Pensionante del Saraceni," and, even, "Pseudo-Master of the Hartford Still-Life" to supposedly homogenous groups of paintings.[2] Just how unconvincing these efforts have been is underscored by the number of individual painters to whom the Atheneum's painting has in the past been attributed. Acquired in 1942 as the work of the Lombard still-life painter Fede Galizia (1578–1630), the painting has at various times been given to the young Caravaggio (cat. no. 7), Giovanni Battista Crescenzi (1577–1635), Pier Paolo Bonzi (1576–1636), Francesco Zucchi (*c.* 1562–1622), and even the Flemish painter Frans Snyders (1579–1657), who travelled in Italy 1608–9.[3] Most recently, the painting has been attributed to Prospero Orsi, called Prosperino delle Grottesche (*grottesche* are interlinked floral motifs, animal and human masks derived from the antique), documented as working in Cavaliere d'Arpino's studio.[4]

The so-called Master of the Hartford Still-Life acquired particular significance for scholars in 1976 when the late Federico Zeri identified him as the young Caravaggio working in the Roman studio of Cavaliere d'Arpino after his arrival in Rome in 1593. Caravaggio has always been considered a central figure in the development of Italian still-life painting, although he painted only one genuine still-life, the *Basket of Fruit* (*c.* 1595–8; Pinacoteca Ambrosiana, Milan), so Zeri created a stir when he identified the Hartford painting with an unattributed still-life listed as number 47 in the 1607 inventory of the Cavaliere's sequestered possessions: "*Un quadro pieno di frutti, et fiori con due Caraffe,*" a painting full of fruit and flowers with two carafes, and inferred that it was the work of the young Caravaggio. Zeri assembled a group of eight paintings – most with glass carafes and flowers – as by the Master of the Hartford Still-Life, including two additional still-lifes seized from the Cavaliere d'Arpino that are now in the Borghese Gallery, Rome.[5]

Even if few writers today accept the attribution of the Hartford *Still Life with Flowers and Fruits* to Caravaggio, most have noted its author's dependence on Caravaggio's innovative naturalism and the still-lifes in his paintings – evident here in the reflective glass vases filled with flowers and basket of fruit perched on the edge of the table; single pieces of fruit strewn across the table's surface seen from above; the compositional effect of deep space achieved by the receding triangle formed by the two vases and the basket; the transparency of the cast shadows; and the dark background lit by a diffuse, luminous light – and a consensus has been reached that the painting is a work by one of his early seventeenth-century Roman followers aspiring "to paint flowers and fruit so realistically that they began to attain the extraordinary beauty that delights us so much today," in the words of the seventeenth-century writer Giovanni Pietro Bellori touting the young Caravaggio's own prowess in this field.[6]

In style and composition, *Still Life with Flowers and Fruits* represents the initial stage of still-life painting in seventeenth-century Rome, a simple arrangement of fruits and vegetables in horizontal rows on a flat surface in a fairly restricted foreground space. Although archaic in comparison with later Italian still-life painting, the treatment of the individual elements displays a remarkable technical competence and an assertive naturalism that has led several scholars to suggest that this anonymous artist, although influenced by Caravaggio, possessed familiarity with the work of the first generation of Dutch still-life painters in Rome such as Floris van Dijck (1575–1651), who lived near the studio of Cavaliere d'Arpino.[7] Zeri observed the remarkable "botanical erudition" of the Master of the Hartford Still-Life, the result of which is an extraordinary variety and display of flowers (gladioli, sun flower, yellow asters, a sprig of rosemary, a red camelia, jonquils, and forget-me-nots) and fruits (figs, cherries, apricots, melon, grapes, plum, peaches). The butterfly and flies on the wall at the left and the yellow butterfly on a flower in the center of the composition add a distinctive touch of realism. Although the direct and simple presentation of the fruit and flowers on a table derives from the religiously significant still lifes of Caravaggio's Lombard contemporaries, it is doubtful whether the Atheneum's painting possesses a symbolic meaning.[8]

EPB

Oil on canvas, 28 ⅝ × 39 ½ in.

The Ella Gallup Sumner and Mary Catlin Sumner Collection Fund, 1942.353

Provenance: Koetser Gallery, New York and London; from whom purchased in 1942.

References: Zeri, 1976, pp. 92–103; *La natura morta in Italia*, 1989, vol. 2, p. 691; Mahoney in Cadogan, 1991, pp. 92–7 (with earlier references); Berra, 1996, pp. 130–1; Markova, 2000, pp. 53, 54; Laureati, 2001, pp. 71, 72, 73, 87.

Selected Exhibitions: Paris, 1952, no. 66; Sarasota–Hartford, 1958, no. 31; New York–Tulsa–Dayton, 1983, no. 10; London–Rome, 2001, no. 18; Munich, 2002–3, p. 138.

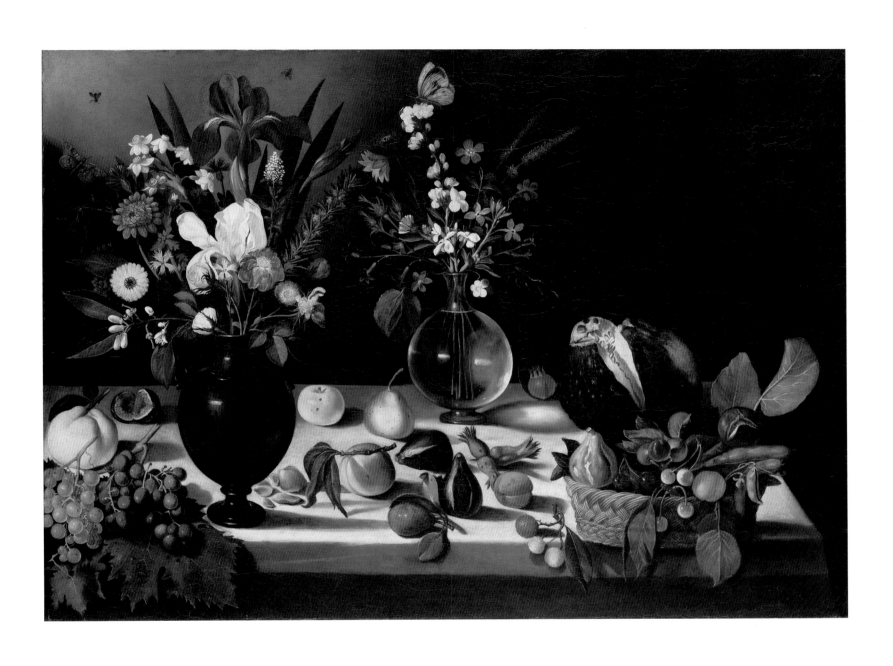

16. Bernardo Cavallino

Italian (Neapolitan), 1622–c. 1656

The Flight into Egypt

late 1630s

Bernardo Cavallino has been acclaimed as "the most individual and most poetic painter active in Naples during the first half of the seventeenth century."[1] Yet, he remains enigmatic and elusive as an artist – documentary evidence for his life and work is almost non-existent; his creative activity was confined to about twenty years; only eight of his eighty-odd known works are signed, initialed or inscribed; and only one, an altarpiece of 1645, is dated. Cavallino painted small cabinet pictures on canvas or on copper for dealers and private patrons, but he had few public commissions and apparently never painted any large-scale decorations for private or ecclesiastical patrons. In spite of the great progress that has been made in understanding the complexities of Neapolitan painting between the death of Caravaggio in 1610 and the plague that devastated the city in 1656, uncertainties surrounding Cavallino's life and art persist.

For these reasons, a convincing chronology is not easily established for Cavallino's paintings, and the attribution of works to him is based almost entirely on an appreciation of his striking characteristics as a painter. Because of its dark tonality, strong naturalism, and stiff and slightly awkward figural arrangement, the Atheneum's *Flight into Egypt* has generally been recognized as an early example of Cavallino's effort to create his own highly personal style from a variety of sources. The contemporary Neapolitan painters most often cited as providing inspiration at this date include Massimo Stanzione (c. 1585–1656), Jusepe de Ribera (cat. no. 29), Aniello Falcone (1607–56), and the Master of the Annunciation to the Shepherds (active c. 1620–40). The straightforward figures of Mary and Joseph, for example, have been thought to reflect Stanzione's physical types.[2] The handling of paint and the naturalistic rendering of surface textures (skin, hair, fur, leather, wood, sheepskin, and feathers), on the other hand, reveal the influence both of Ribera and the anonymous Master of the Annunciation to the Shepherds.

Ann Percy, who has written perceptively on Cavallino's art, identified another element that transformed his early naturalistic, even Caravaggesque manner into the highly individual and idiosyncratic style of his maturity – the graphic work of late sixteenth- and early-seventeenth-century Netherlandish and French Mannerist artists such as Hendrick Goltzius (1558–1617) and Jacques Callot (1592–1635). The most vivid example of such inspiration in the *Flight into Egypt* is the extraordinary angel at the left who displays, in Percy's view, "the elegantly mannered grace combined with an intense and precise naturalism that distinguishes Cavallino's work from his contemporaries."[3]

Cavallino's eighteenth-century biographer, Bernardo de Dominici (1683–1759), praised the painter's "numerous works done in such a delicate manner and with such life-like coloring, correctness, and naturalness that the figures seem not painted but alive; using a minimum of light sources, contrasts, and reflections, [and] manipulating light with such

smoothness, he sweetly deceives the eye of anyone who looks at his pictures."[4] Even for such an early moment in Cavallino's career, the *Flight into Egypt* anticipates the individuality of style that led de Dominici to admire the artist's "beauty of coloring" (the contrast between Joseph's purple robe and his yellow cloak), "great understanding of illumination" (the strong contrasts of light and shade between the figures and their surroundings), and "noble conceptions" (the exquisitely elegant and refined angel who evokes a feeling of tender fragility).[5]

Cavallino's paintings have generally not survived in good condition, and his early works in particular have proven vulnerable to change, damage, or harsh cleanings.[6] He typically used a dark ground in these youthful works, toned with brown or red earth colors, that has become accentuated with time. Here, he employed a red ground on a fairly coarse canvas support, and on this he set out shadowy background figures formed up from thin glazes and played these against brightly illuminated foreground forms rendered opaquely and with more substantial impasto. But in many passages the overlying paint layers have become transparent – and the red ground prominent – so that the figures and their relationship to the landscape setting have become difficult to read. It is not immediately evident, for example, that there are three angels in the Holy Family's entourage. Moreover, the darkened varnish has suppressed the middle tones in many areas, and the balance between the landscape and the sky has also been lost. Many passages have suffered in the overall abrasion following the use of strong solvents during past cleanings. Nonetheless, in spite of such obstacles, enough of Cavallino's brilliance remains to understand why Rudolf Wittkower could write that "his work is in a category of its own; a great colorist, his tenderness, elegance, gracefulness, and delicacy are without parallel. . . ."[7]

The scene depicted here derives from the apocryphal stories of the infancy and childhood of Christ, attributed to the Pseudo-Matthew and probably written in the twelfth century. The Holy Family's flight into Egypt was described briefly in the Gospel of Matthew (2: 13–15). The angel of the Lord warned Joseph in a dream that King Herod, hoping to destroy the child called the "King of the Jews," had ordered the murder of all the infants in Bethlehem. Joseph departed that night with the infant Jesus and Mary for Egypt, where he stayed until Herod was dead. No further mention of the journey appears in the Bible, but the tale was elaborated in the rejected biblical writings that form what is called the New Testament Apocrypha and appears again later, in the Middle Ages, in the *Golden Legend*.

An amusing iconographic note is Joseph's offer of a handful of grass to the donkey rather than leading the animal, which has been interpreted as an example of divine intervention – the donkey, on his own, finds his way with the help of an angel.[8]

EPB

Oil on canvas, 40 1/2 × 49 7/8 in.

The Ella Gallup Sumner and Mary Catlin Sumner Collection Fund, 1942.348

Provenance: Sale, London, Christie's, May 8, 1931, lot 102 (as "Bassano"); Kenneth Clark (1903–83), London and Saltwood Castle, Kent, 1930s; Durlacher Bros., New York; from whom purchased in 1942.

References: Mahoney in Cadogan, 1991, pp. 104–5 (with additional references); New York, 1989a, pp. 32–3, figs. 5, 6 (detail).

Selected Exhibitions: London, 1932–3, no. 22; London, 1938, no. 312; Detroit, 1965, no. 161; Cleveland–Fort Worth–Naples, 1984–5, no. 8.

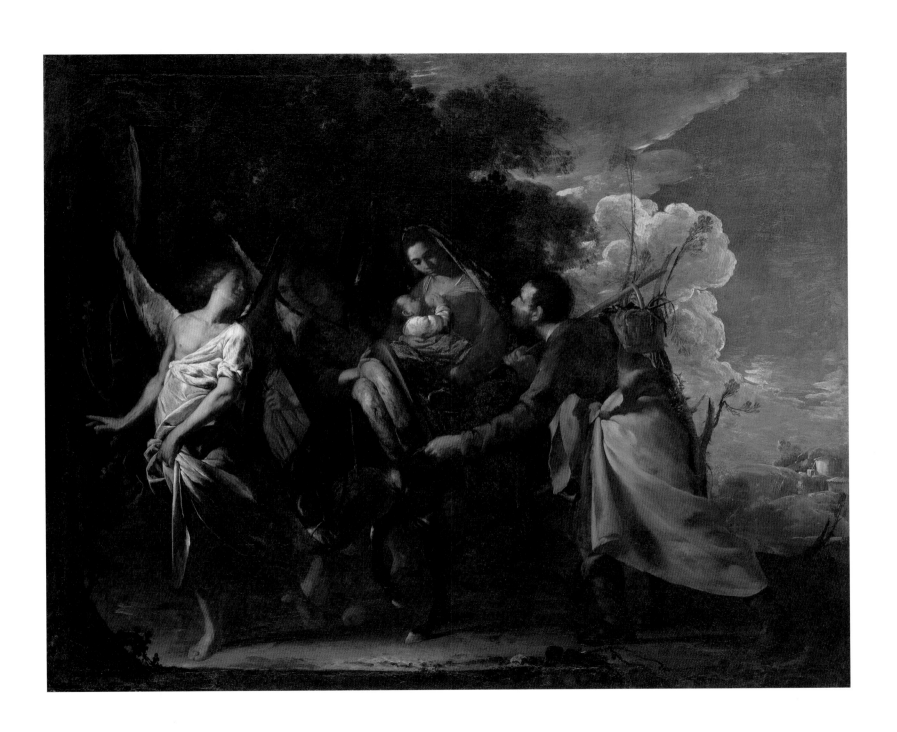

17. Salvator Rosa

Italian (Neapolitan), 1615–73

Lucrezia as Poetry

c. 1640–1

The Neapolitan painter and etcher Salvator Rosa is one of the best-known seventeenth-century Italian artists, as famous for his colorful life and extravagant personality as for his art. He possessed a restless and fiery temperament that found expression in poetry, drama, music, philosophy, and art. Trained in Naples, he visited Rome in 1635, was back at Naples in 1637, and returned to Rome two years later. In the 1640s he lived mainly in Florence at the invitation of Prince Giovanni Carlo de'Medici, younger brother of Ferdinand II, Grand Duke of Tuscany, after he insulted Gianlorenzo Bernini (1598–1680), the most powerful artist in Rome. He returned to Rome in 1649 and remained there until his death in 1673. His colorful personality, scorn for society, and unswerving belief in his own genius made him a prototype for the Romantic artist and his fame was enormous, particularly in England, in the eighteenth and nineteenth centuries.

Rosa was acclaimed as a painter of landscapes, marines, and battle-pieces, and he also produced scenes of witchcraft, and of hermit saints and bandits in the wilderness. He himself, however, strove to be remembered for his large, intellectually complex history paintings such as *Democritus in Meditation* and *Diogenes Throwing away his Cup* (1650 and 1652; Statens Museum for Kunst, Copenhagen) and *Human Frailty* (*c.* 1657; Fitzwilliam Museum, Cambridge).[1] Moralizing historical subjects were ranked higher in seventeenth-century academic art theory than landscapes, and for Rosa these erudite philosophical allegories provided the means to compete as a history painter with the Renaissance masters Raphael, Giulio Romano, and Michelangelo and his contemporary, Nicholas Poussin. Rosa was an indefatigable graphic artist – roughly 800 drawings by his hand survive and

more than 100 etchings – and his figural motifs had a lasting impact on painters such as Panini (cat. no. 23) well into the eighteenth century.

Lucrezia as Poetry is one of Rosa's most memorable paintings, both for its brilliant handling of paint and its vibrant image of an enigmatic, defiant muse. The painting attains its force, as the Rosa scholar Luigi Salerno observed, from the juxtaposition between the realism of the model and the abstract associations of her characterization as Poetry.[2] The half-length standing female figure who turns her head to look over her left shoulder out of the picture – brow furrowed, eyes glaring, and disheveled hair spilling from under a headscarf entwined with laurel leaves – is at once intensely real yet also an abstraction. The model has generally been thought to represent Lucrezia Paolini del fu Silvestro, whom Rosa met shortly after his arrival in Florence in 1640, lived with for the rest of his life, and married in 1673, eleven days before his death. (She bore him several children, all but two of whom were placed in orphanages.)[3] Rosa certainly used Lucrezia – described by a contemporary writer as being of "*bello aspetto*" and "*buona qualità*" – as a model and she probably provided the likeness for another personification of poetry in the Galleria Nazionale d'Arte Antica, Roma.[4]

Although Lucrezia has been identified as representing both a sibyl and a muse, rather than a personification of poetry, the Atheneum's painting is clearly linked with Rosa's role as the most significant satirical poet of the Italian seventeenth century.[5] The pen, book, and laurel crown are among the traditional attributes of poetry described in Cesare Ripa's *Iconologia*, the standard reference work for seventeenth-century artists needing descriptions of allegorical figures of the arts, virtues and vices, seasons, and parts of the world. Moreover, the picture was exhibited in Florence in 1767 as a female figure representing poetry together with Rosa's famous *Self-Portrait* in the National Gallery, London (fig. 17A). In the companion-piece Rosa has depicted himself against a cloudy sky, his expression dark and sinister and wearing a scholar's cap and gown. He holds a tablet inscribed in Latin that admonishes the viewer to "Either be silent or say something better than silence."[6] Although the Hartford and London paintings may not have been produced as actual pendants, they share similar plain backgrounds, silhouetted poses, and dark, handsome figures confronting the spectator with intense gazes. Lucrezia's role as a personification of poetry complements Rosa's depiction of himself as a painter-philosopher, her cool gray, blue, and lilac coloring contrasting with the rich brown of the cloak in the *Self-Portrait*.[7]

Lucrezia as Poetry belongs to a tradition of depicting allegorical female figures that was quite popular in seventeenth-century Florentine painting in the 1640s.[8] Lorenzo Lippi (1606–65), Giovanni Martinelli (1600/4–59) and Cesare Dandini (1596–1657), for example, each painted similar three-quarter-length female figures personifying Music, Comedy, Painting, Sculpture, Architecture, and Poetry.

EPB

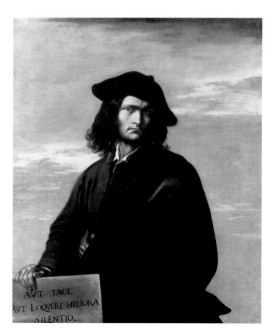

Fig. 17A. Salvator Rosa, *Self-Portrait*, *c.* 1645, oil on canvas, 45 ¾ × 37 in. National Gallery, London

Oil on canvas, 45 ¾ × 37 ¼ in.

The Ella Gallup Sumner and Mary Catlin Sumner Collection Fund, 1956.159

Provenance: Niccolini family, Florence; from whom bought by the Reverend John Sanford (1777–1838), by July 1832; Marquis of Lansdowne, Bowood House, Wiltshire, 1838, and thence by descent at Lansdowne House, London; Thomas Agnew & Sons, London; from whom purchased in 1956.

References: Salerno, 1963, pp. 35, 108, 116–17; Roworth, 1989, pp. 139–41; Mahoney in Cadogan, 1991, pp. 213–16 (with earlier references); Leuschner, 1994, p. 282; Scott, 1995, p. 64, col. pl. 78; Langdon, 1996, p. 151.

Selected Exhibitions: Possibly Florence, 1729 (lent by Filippo Niccolini); Florence, 1767 (lent by Marchese Lorenzo Niccolini); London, 1925, no. 41; London, 1938, no. 301; London, 1973, no. 10; Sarasota–Hartford, 1984–5, no. 57.

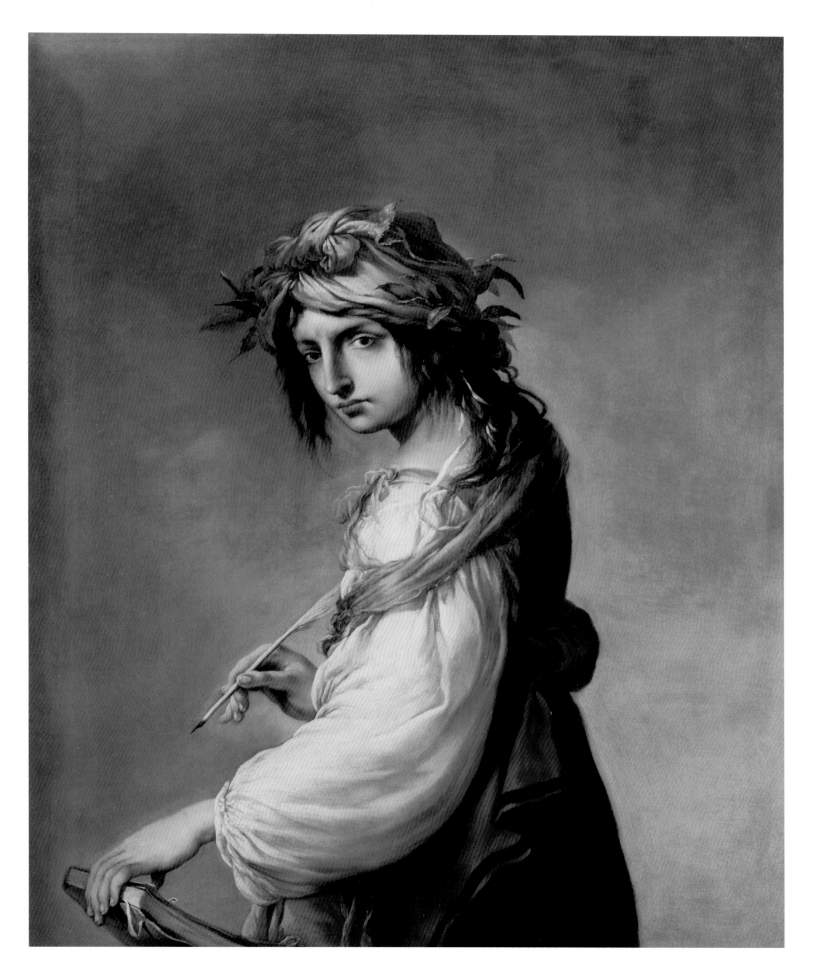

18. Valerio Castello
Italian (Genoese), 1624–59
The Legend of Saint Geneviève of Brabant
1652

The *Legend of Saint Geneviève of Brabant* is a striking example of Valerio Castello's talent, exemplifying his taste for dramatic and sweeping compositions populated with large, elegant figures. The placement of the figures close to the picture plane and their vigorous movement and emotional intensity are characteristic of Castello at the height of his brief career. His lively, flickering brushwork – in the words of a biographer, "Valerio so easily manipulated his brush that it appeared he was doing it as a game"[1] – suffuses the surface of the canvas with an energy that epitomizes Baroque painting in Genoa. The coloring is typical of Castello's vibrant palette, especially the warmth and brilliance of the red, blue, and yellow drapery worn by the principal figures. Castello reveled in fine silks, and the fluttering garments worn by the principal male figure as he strides through the landscape is almost a signature of the painter. The painting has always been admired as one of Castello's most impressive works and is one of his best-known, having appeared in a number of exhibitions devoted to Genoese Baroque painting when it was owned by the celebrated American art collector, Walter P. Chrysler, Jr. (1909–88).

Valerio Castello, the son of a Genoese painter, Bernardo (*c.* 1557–1629), rose to become one of the leading painters in his native town. Like Bernardo Cavallino (cat. no. 16), he achieved his own distinctively personal style of painting from the study and synthesis of the work of others – in this instance of sixteenth- and early seventeenth-century North Italian painters as various as Correggio, Parmigianino, Veronese, Rubens, Van Dyck, and Giulio Cesare Procaccini, whose paintings he saw on a trip to Milan and Parma, probably between 1640 and 1645. His early biographers hailed his original manner and "new style which encompassed the taste of his predecessors and yet had a certain grace which might be called Valerian."[2] Although he died aged thirty-five, Castello was enormously productive, and the graceful imagery of pictures like the *Legend of Saint Geneviève of Brabant* not only inspired the next generation of Genoese painters, but, in the words of a recent writer, proved "instrumental in contributing to the lyrical splendor of Italian art in the late seventeenth and early eighteenth centuries."[3]

Castello's contemporary biographer, Raffaele Soprani, noted in 1674 that his easel paintings were expensive – in fact, owing to their popularity with foreign collectors, were "too high for words" – and the Hartford painting suggests the appeal of these large, decorative works.[4] The painting has been linked to a set of eight large-format canvases commissioned by Pietro Fenoglio of Ventimiglia in 1652.[5] This may explain the traditional identification of a so-called pendant of similar dimensions depicting episodes of Diana and Actaeon and Pan and Syrinx (Norton Museum of Art, West Palm Beach; fig. 18A); the iconographical relationship between the two compositions is in fact more plausible in the context of a wider (and as yet unexplained) literary program and large ensemble of paintings representing various subjects.[6]

The depiction of a scene from the medieval German legend of Saint Geneviève of Brabant is highly unusual in Italian painting.[7] A daughter of the duke of Brabant and faithful wife of Siegfried of Trier, Geneviève was falsely accused of adultery by an evil household courtier, Golo, and sentenced to death. Her executioner, however, took pity on her and permitted her to flee with her infant son to a cave in a forest in the Ardennes where they lived for six years, nurtured by a roe deer. Siegfried, while hunting, chanced to follow the deer, which led him to Geneviève's hiding place. Realizing his mistake and the treachery of Golo, Siegfried restored Geneviève to her former place of honor.

The tale is said to be based on the history of Marie of Brabant, wife of Louis II, Duke of Bavaria and Count Palatine of the Rhine, who had been tried by her husband and beheaded in 1256 for her alleged adultery. The heroine's name, Geneviève, probably derives from the better-known Saint Geneviève (died *c.* 500), patroness of Paris, whose cult flourished in south-west Germany in the Middle Ages. Although Geneviève was never canonized or listed in the official Church calendar, her story circulated in seventeenth-century Europe by means of an edificatory text by the Jesuit R. P. René de Cerisiers, *L'Innocence Reconnue, ou, Vie de Sainte Geneviève de Brabant* (Paris, 1638), that in turn inspired additional literary versions of the legend. Reminiscent of the banishment of Hagar and Ishmael (Genesis 21: 9–21), the tale of Geneviève became a frequent theme in popular visual imagery of the seventeenth and eighteenth centuries and, in the nineteenth century, in German Romantic verse, music, and painting.

Few of Castello's drawings relate to known paintings, but Mary Newcome Schleier recently discovered a pen, wash, and red chalk sketch in the Palazzo Rosso, Genoa, that served as an initial sketch

for the composition with clear indications of Siegfried and his men on the left following the deer and finding Geneviève with her son in a cave at the right.[8]

EPB

Oil on canvas, 65 ¼ × 101 ⅛ in.

The Ella Gallup Sumner and Mary Catlin Sumner Collection Fund, 1999.12.1

Provenance: Possibly Pietro Fenoglio, Ventimiglia, 1652[9]; private collection, London; Julius Weitzner, London; from whom purchased by Walter P. Chrysler, Jr., in December 1953; sold by the estate of Walter P. Chrysler, Jr., New York, Sotheby's, June 1, 1989, lot 60; bought by Newhouse Galleries, Inc., and Adam Williams Fine Art Limited, New York; from whom purchased in 1999.

References: Manzitti, 1972, pp. 49, 216, fig. 125; McCorquodale, 1979, pp. 72–3; Newcome Schleier, 1997, pp. 149–50.

Exhibitions: Portland, 1956, no. 40 (attributed to Castello by William Suida); Dayton–Sarasota–Hartford, 1962–3, no. 19; New York, 1964–5, no. 60; Norfolk, 1967–8, no. 43; Nashville, 1977, no. 16; New York, 1978, no. 5; New York, 1989, no. 5; Frankfurt, 1992, no. 76; Monte Carlo, 1997, no. 18.

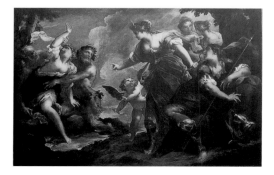

Fig. 18A. Valerio Castello, *Diana and Actaeon with Pan and Syrinx*, 1652, oil on canvas, 65 × 99 in. Norton Museum of Art, West Palm Beach, Florida.

19, 20. Luca Giordano

Italian (Neapolitan), 1634–1705

The Abduction of Helen of Troy

c. 1685–90

The Abduction of Europa

c. 1685–90 or later

One of the most celebrated European painters around 1700, Luca Giordano was also one of the most versatile and prolific. His vast output included altarpieces, mythological paintings, and decorative fresco cycles in both palaces and churches. He began his career in Naples in the circle of Jusepe de Ribera (cat. no. 29), but he was able to imitate other artists' styles with ease and during his extensive travels he absorbed the influence of painters as various as Veronese and Titian, Pietro da Cortona and Mattia Preti. He worked mainly in Naples, where he was the leading artistic personality in the second half of the seventeenth century, but he also painted extensively in Florence and Venice. His rapid manner of working and enormous output were proverbial, earning him the nickname "*Luca Fa presto*" (Luca works quickly). Giordano's greatest achievements reside in his large decorative programs, for which he attained enormous renown. Among his most successful projects was the decoration of the Palazzo Medici Riccardi in Florence in the 1680s. It is impossible to overestimate Giordano's influence upon painting in Italy and in Spain, where he was invited by King Charles II and painted in Madrid, Toledo, and the Escorial from 1692–1702. His open, airy compositions; light, luminous colors; and free, painterly technique are generally cited as heralding the Rococo style of the early eighteenth century.

In Greek mythology, Helen of Troy was the daughter of Leda and Zeus and the wife of Menelaus, king of Sparta. Famous for her great beauty – Homer (*Iliad* 3: 157–8) described her as "dreadfully like immortal goddesses to look upon" – Helen was loved by the Trojan prince Paris, son of Priam, king of Troy. When Menelaus was away from Sparta, Paris forcibly abducted Helen, thus bringing about the Trojan War and fulfilling the prophecy made at his birth that he would bring ruin to Troy; specifically, in Ovid's (*Metamorphoses* 12: 5) phrase, that he would cause "a long-continued war upon his country with his stolen wife." Giordano has depicted the scene of abduction before a rocky seashore. Paris holds the compliant Helen in his arms while his companions ward off the Greeks with their swords at the right of the composition. At the entrance to the harbor on the left, the Trojan boats are visible.

The theme of the Rape of Europa was popularized by the Roman poet Ovid, whose *Metamorphoses* (2: 836–75), written at the turn of the first century, is a retelling of the myths and legends of Greece and Rome.[1] In Greek mythology Europa is a beautiful Phoenician princess, the daughter of Agenor, king of Tyre. Jupiter falls in love with her and disguising himself as a white bull, comes to where she plays by the seashore with her attendants. Seduced by the animal's pleasant appearance, Europa bestows a garland of flowers upon him and climbs on his back.

Suddenly, Jupiter plunges into the sea and abducts the princess to the island of Crete. Upon resuming his godlike form, Jupiter then seduces her. Giordano's picture shows Europa and her attendants just prior to the actual abduction, as they naively decorate the bull with garlands of flowers. The direct gaze of the bull toward the viewer is the equivalent of a wink, as if to remind us that we can guess the outcome of this ostensibly innocent scene.

The myth of the Rape of Europa was especially popular with painters in the Renaissance and its aftermath, the most famous treatment of the theme being Titian's picture in the Isabella Stewart Gardner Museum in Boston. The life of Helen, on the other hand, appeared much more frequently in literature than the visual arts, although certain seventeenth-century Italian painters such as Guido Reni depicted her abduction by the Trojan prince (1630–1; Musée du Louvre, Paris). Thus, the thematic relationship between the two Hartford paintings is not quite clear beyond the fact that each depicts a scene of abduction. Moreover, despite their common dimensions, the Atheneum's pictures are not especially complementary, either thematically or formally. As Michael Mahoney has noted: "The relationship of figures and space in the *Helen*, with large figures pulled up close to the picture plane, is quite different from that in the *Europa*, where moderately-sized figures are set back into the picture space."[2] In fact, as Mahoney has speculated, the two large, decorative canvases may have been brought together at a later date for convenience in satisfying the requirements of a commission rather than specifically conceived as a pair from the outset.[3]

Luca Giordano possessed a legendary ability to imitate other artists – Dürer, Titian, Veronese, Rubens – and the Hartford paintings reflect his scrupulous attention to the styles of other painters. The *Rape of Helen* appears strongly indebted to Pietro da Cortona (1596–1669), with whom he may have studied and whose works he saw in Florence and Rome, especially in 1680–5 when he was in Florence to execute the gallery and library frescoes in the Palazzo Medici-Riccardi and the dome of the Corsini Chapel in the church of the Carmine.[4] On the other hand, Giordano frequently turned to sixteenth-century Venetian painters for inspiration, and several writers have recognized the powerful "neo-Venetianism" evident in the *Rape of Europa*, notably the analogies with Veronese's treatment of the theme in the Palazzo Ducale, Venice.[5]

Since Giordano could easily adapt his manner to fit a given subject and paint "in the manner of" a given artist, the stylistic disparities between the two compositions raise additional concerns about their complementariness. Although the *Rape of Helen* and *Rape of Europa* have been generally dated in the

literature to 1686, the signatures and dates of both pictures have been badly abraded and the interpretation of the date of the *Helen* as 1686 is entirely conjectural.[6] Only the first digit is clear on each canvas, and the second digit has been read as a 7. The flying putti in the *Rape of Europa* have been linked to Titian; specifically to those in his treatment of the theme in the Gardner Museum. The Boston painting was in the Spanish royal collections until 1704 where Giordano could have seen it after 1692 when he accepted the invitation of Charles II of Spain to the court of Madrid. He made a drawing of a figure of Europa (Art Institute of Chicago) that is reminiscent of Titian's composition that strongly suggests he had studied the painting in the Alcazar during his sojourn in Madrid.[7] The stylistic differences between the two Atheneum paintings could then be explained by their having been painted, respectively, at different moments in Giordano's career.

EPB

Oils on canvas, 89 ³⁄₈ × 76 ³⁄₁₆ in. and 89 ⁹⁄₁₆ × 76 ¹⁄₈ in.

Signed and dated on the face of the rock in the lower right corner: *Giordanus/ F 1* (19); Signed and dated on a stone block in the left foreground: *Giordano F 17* (20)

The Ella Gallup Sumner and Mary Catlin Sumner Collection Fund, 1930.2 and 1930.3

Provenance: Leger & Sons, London; Durlacher Bros., New York; from whom purchased in 1930.

References: Ferrari and Scavizzi, 1966, vol. 2, p. 145, vol. 3, figs. 283 and 284; Mahoney in Cadogan, 1991, pp. 153–6 (with earlier references); Ferrari and Scavizzi, 1992, vol. 1, pp. 107, 194, 245, 292, 319, 371, cat. no. A 413a and A 413b (as signed and dated 1686); vol. 2, figs. 543 and 544.

Selected Exhibitions: Hartford, 1930, nos 12 and 13; New Haven–Sarasota–Kansas City, 1987, no. 12 (as signed and dated: "*L. Jordanus F. 1686*") (20); Los Angeles, 2001–2, nos 137a and 137b.

21. Giuseppe Maria Crespi

Italian (Bolognese), 1665–1747

An Artist in his Studio

1730s

Giuseppe Maria Crespi is most admired today for his genre scenes, generally set in a dark monochrome brown atmosphere relieved by carefully studied effects of light and color. His paintings of common people, peasants, and laborers going about their business; fairs, markets, religious missions, and similar public gatherings in the out-of-doors; and other activities of everyday life distinguish him as one of the first Italian painters of high standing to devote serious attention to the depiction of contemporary life. Paintings such as *The Flea Hunt* (1720s; Musée du Louvre, Paris) and *Woman Washing Dishes* (1720–5; Galleria degli Uffizi, Florence) offer straightforward glimpses of daily life in images that are startlingly novel for the period and look forward to the art of the nineteenth century.[1]

An Artist in his Studio is among the most captivating – and best-known – images of a painter at his easel. Concentrating intensely on the canvas before him, the artist is seated before his easel, palette and mahlstick in hand, surrounded by the paraphernalia of his profession. Plaster casts hang on the wall and rest on the bookcase; a lute rests on a nearby table; well-thumbed, vellum-bound books line the shelves. The prominence of Crespi's own copy of the *Ecstasy of Saint Francis and Saint Benedict* (c. 1690; Bologna, Boni-Maccaferri Collection) by Guercino (1591–1666), intended for an important Turinese patron, on the rear wall of the studio has led to the traditional interpretation of the Atheneum painting as a self-portrait in which the artist depicted himself as a young man at the easel.[2] The simple, uncluttered studio, with a cat dozing by the hearth, has thus been understood as reflecting Crespi's lack of pretension in the practice of his art. Indeed, one scholar has written of the picture that "Crespi, native son of Bologna and speaking the flinty Bolognese dialect, has consciously embodied in his characterization a certain air of domesticity, as if determined not to assume the airs of a cosmopolite."[3]

Mira Merriman challenged this identification, however, noting that although the artist's youthful appearance would signal a date early in Crespi's career, the Atheneum's painting is executed in the artist's late style and could not have been produced before the second decade of the eighteenth century.[4] Moreover, arguing that the carefully calculated cultural atmosphere of the studio, with its books, lute and display of plaster casts better fits the image that Crespi entertained for his son Luigi than the populist image he projected of himself in his early years, Merriman rejected the Hartford painting as a self-portrait, proposing instead an identification of the sitter as one of Crespi's sons, Luigi (1709–79) or Antonio (1712–81), each of whom was a painter, and a date for the painting in the 1730s.[5]

John Spike, on the other hand, maintained that the late style of *An Artist in his Studio* lends persuasiveness to its identification as the small painting by Crespi of "his person in the act of painting at the easel in his room" that was sent in 1742 as an unsolicited gift by the artist to Carlo Vincenzo Ferrero, Marchese d'Ormea, minister and art advisor to Charles Emmanuel III, Duke of Savoy and King of Sardinia. The passage is excerpted in a letter of December 1742 to the Marchese from Paolo Salani (1688–1748), the Olivetan Abbot of the monastery of S. Michele in Bosco, Bologna, relating to paintings commissioned from Crespi that were being sent to the court of Turin: "In the same carton your Eminence will find two other small pictures made by Crespi, and I confess that I was reluctant to take them for fear that you might think that his idea, although wise, was instigated by me. But the fantasy of a painter of such distinctive images is not easily contained, and he persuaded me to concede to his genius and wishes. He desires too much, he says, that his person in the act of painting at the easel in his room should be in the hands of your Eminence. . . ."[6] Crespi enclosed the painting of an artist at his easel and an *Adoration of the Shepherds* (1742; Galleria Sabauda, Turin) in the packing case as gifts for the Marchese d'Ormea and the king, respectively. This, Spike suggests, was a stratagem often employed by Crespi – such "gifts" to patrons and other important persons were usually recompensed, or at least resulted in subsequent patronage.[7]

A nearly identical version of the Hartford painting is at the Walpole Gallery, London.[9]

EPB

Oil on canvas, 22 5/8 × 16 15/16 in.

The Ella Gallup Sumner and Mary Catlin Sumner Collection Fund, 1936.499

Provenance: Possibly given by the artist in 1742 to Carlo Vincenzo Ferrero, Marchese d'Ormea, Turin;[8] Carlo Foresti, Milan, 1935; Adolfo Loewi, Venice; Arnold Seligmann, Rey & Co., New York; from whom purchased in 1936.

References: Merriman, 1980, p. 299, no. 222; Marandel, 1990, pp. 17–18; Cadogan, 1991, pp. 126–9 (with earlier references); Borys, 2001, p. 71, fig. 4 (as c. 1735).

Selected Exhibitions: Bologna, 1935, no. 20; New York, 1937, no. 8; Baltimore–Saint Louis, 1944, no. 15; Chicago–Minneapolis–Toledo, 1970, no. 46; Fort Worth, 1986, no. 29; Ottawa, 2001.

22. Giovanni Antonio Canal, called Canaletto

Italian (Venetian), 1697–1768

The Square of Saint Mark's and the Piazzetta, Venice

c. 1731

For Canaletto, as for Luca Carlevarijs (1663–1730), Michele Marieschi (1710–43), Francesco Guardi (cat. no. 27), and other eighteenth-century Venetian *vedutisti*, the Piazza San Marco was the quintessential view of the city, and he painted the square dozens of times from a variety of vantage points. The piazza may well have been the subject of both Canaletto's first view of Venice, around 1720–1, before the gray and white stone pavement was re-laid by Andrea Tirali in 1723, and his last, in 1763.[1] In the Atheneum's sweeping panorama of the square and its environs, Canaletto has created a dramatic view from an elevated vantage point near the Torre dell'Orologio. He has employed two predominant vanishing points: one, at the left, converging on the Isola San Giorgio Maggiore in the distance across the Bacino di San Marco; the other, at the right, on the west end of the piazza to the right of the church of San Giminiano, which was demolished in 1807 to make space for the ballroom of the Palazzo Reale. The overall pictorial effect, as Charles Beddington has observed, depends on considerable distortions, notably a considerable reduction in the height of the Campanile, which, if it were shown in proportion, would be cut by the upper edge of the painting.[2]

The main façade of the basilica of San Marco, its mosaics gleaming softly in the afternoon sunshine, is shown sharply in perspective, with the Doges' Palace beyond on the right. Immediately in front is the Piazzetta leading to the Molo and the columns of Saint Mark and Saint Theodore, beyond which lies the Bacino di San Marco, upon which several three-masted vessels are moored. The center of the composition is dominated by the Campanile and the Loggetta, a wooden booth at its base, flanked by the elegant rhythms of the Procuratie Vecchie. Along the extreme right edge of the composition the façade of the Procuratie Vecchie encloses the square on the north.

The fascination with daily life in so many of Canaletto's pictures is evident here. Figures from all walks of life—magistrates in full wigs and gowns, fashionable women, gentlemen in contemporary costume of cape and three-cornered hat, laborers, and vendors—wander about the square. In the foreground, the large shade umbrellas of the cloth merchants have been set beside the three flagstaffs rising upon their elaborate bronze pedestals cast by Alessandro Leopardi (1465–1522/3) in 1505. Canaletto, who had a sharp eye for the particulars of the scene before him, has noted a beam with a pulley wheel projecting from the last bay of the first story of the palace, a detail that he first recorded around 1726 in a drawing at Windsor.[3]

The Hartford view has never been dated with precision, but as Charles Beddington has recently noted, a pen-and-ink drawing that corresponds closely to the composition bears the date 1731, which seems acceptable on grounds of style.[4] This early date raises the possibility that the canvas may have belonged to one of Canaletto's most important patrons, Johann Matthias, Graf von Schulenburg (1661–1747), the German military commander and collector. The

marshal acquired from Canaletto two views of the Piazza San Marco, recorded as of approximately this size, in March and April 1731, and they have been untraced since 1775. Beddington has further noted that the inventory number in red paint in the lower left corner is similar to those found on paintings owned by Schulenburg: "The marshal owned relatively few view paintings, but those which have been identified are all of exceptional quality and they included one of the supreme masterpieces of the genre, Canaletto's view of the Riva degli Schiavoni, looking east, executed in the mid-1730s and now in Sir John Soane's Museum, London."[5]

The period between 1730 and 1742 was the most productive of Canaletto's career; it was in these years that almost all of the paintings of Venice, for which he is best known, were completed and during which he produced much of his best work. In this, the second period of his career, Canaletto aimed to present in views such as the *Square of Saint Mark's and the Piazzetta* an accurate and detailed record of a particular scene, and he captured the light, the life, the buildings and the expanse of Venice with a perception and luminosity that established his reputation as one of the greatest topographical painters of all time.

EPB

Oil on canvas, 26 ¼ × 40 ⅞ in.

Inscribed at lower left in red: *13/45*

The Ella Gallup Sumner and Mary Catlin Sumner Collection Fund. Endowed by Mr. and Mrs. Thomas R. Cox, Jr., 1947.2.

Provenance: Possibly Johann Matthias von der Schulenburg (1661–1747), Venice; Martin H. Colnaghi, London; Louis Costa Torro, Chateau des Iris, Lormont, Gironde, France; sale, Anderson Galleries, New York, January 20, 1927, lot 36, bought by Knoedler & Co., New York); Gaston Neumans, Paris, 1928; Julius Böhler, Munich, 1929 (as Bellotto); Rosenbaum, Berlin; Mr. and Mrs. Hugo Moser, Berlin, Amsterdam, and New York, *c.* 1929–30; sale, Parke-Bernet, New York, April 20, 1946, lot 32[6]; bought by Schoenemann Galleries, New York; from whom purchased in 1947.

References: Constable 1989, vol. 1, pl. 20, vol. 2, pp. 209–10, no. 54; Cadogan, 1991, pp. 78–81 (as "around 1740" and with earlier references); Baker 1994, pp. 120–1, col. pl. 45; Links 1994, p. 229, col. pl. 200; Links 1998, pp. 42–4, fig. 21; Beddington, in San Diego, 2001, pp. 28, 52–3 (with additional references).

Selected Exhibitions: Toronto–Ottawa–Montreal, 1964–5, no. 25; San Diego, 2001, no. 11.

23. Giovanni Paolo Panini

Italian (Roman), 1691–1765

Interior of a Picture Gallery with the Collection of Cardinal Silvio Valenti Gonzaga

1749

The earliest paintings depicting the interior of private art galleries, or *Kunstkammern*, were produced in the southern Netherlands, especially in Antwerp, in the seventeenth century. Several variations on this genre developed, notably "portraits" of collections that can be identified along with their owners, the most famous of which are probably the dozen or so works that David Teniers II painted in Brussels after 1651, as court painter and keeper of the collections of Archduke Leopold Wilhelm, showing the collector among his treasures.[1] The *Interior of a Picture Gallery with the Collection of Cardinal Silvio Valenti Gonzaga* is Panini's first undertaking on the theme of "pictures within a picture" and is immediately distinguished from his northern seventeenth-century predecessors both by the size of his canvas and by the scale and complexity of his composition. Next to anything of the type that preceded it, the painting is unrivalled for its grandiose architecture, dazzling use of perspective, and combination of descriptive exactitude and trompe l'oeil bravura.

Silvio Valenti Gonzaga (1690–1756) was created cardinal in 1738, appointed secretary of state in 1740 by Pope Benedict XIV, and later made Camerlengo of the Holy Roman Church and prefect of the Propaganda Fide in 1745. An important collector of books, scientific instruments, drawings, sculptures, and, above all, paintings, he played a powerful role in Roman artistic affairs, helping to found the Pinacoteca Capitolina, administer the Accademia di San Luca, and establish the Accademia del Nudo, the life drawing academy on the Capitoline in 1754.[2] In about 1749 the cardinal's collections were installed in an old villa near the Porta Pia in Rome that had been refurbished for the purpose by Panini, Paolo Posi (1708–76), and Jacques-Philippe Maréchal (d. 1756). Valenti also commissioned Panini to make architectural designs for a compact casino on the grounds of the villa intended to house his vast library and scientific instruments and his works of ancient and modern art. His great collection of pictures—he owned well over 800 paintings at one time—must have been displayed in the villa and casino as well, but their actual arrangement is unknown. The grand architectural setting in the Atheneum's painting is entirely imaginary, although Panini appears to have been loosely inspired by the picture gallery of the Palazzo Colonna in Rome.

Valenti, as he was called, is portrayed in the center of the composition, standing beside Panini with his palette and brushes before an enlarged copy of Raphael's *Madonna della Sedia* (*c.* 1514; Palazzo Pitti, Florence); the cardinal's coat of arms, supported by an allegorical figure of fame, decorates the arch at the top of the picture and further underscores the identification of the interior as his gallery. At the left, a group of young men surrounded by prints after compositions by Raphael and Titian examines the plans for the cardinal's new villa; at the right, various items suggesting the range of Valenti's interests are displayed, including zoological and botanical texts, scientific books, maps, instruments, paintings, drawings, and sculpture. Several figures in the interior

have been identified as the cardinal's contemporaries including, at the left of center, his dwarf Giovan Battista Mamo.

Although Panini's grand basilica-like setting for Valenti's collection is imagined, the paintings, in the form of individual canvases framed uniformly in the so-called "Salvator Rosa" style frames popular in eighteenth-century Rome and displayed without regard to school, chronology, or category as within an actual picture gallery, are not.[3] Panini has depicted about one-quarter of the cardinal's pictures, which range from the sixteenth to the eighteenth century. Following the cardinal's death in 1756, some of the paintings entered the Torlonia collection and subsequently the Galleria Nazionale of Rome. In 1763 about 300 pictures were sent to Amsterdam, where they were sold at auction. In 1951, Harald Olsen, in a fundamental study of the Atheneum painting using a posthumous inventory of Valenti's collection, traced many of his paintings to public collections in Copenhagen, Dresden, The Hague, Leningrad, London, Rome, and Stockholm.[4] More recently, Seymour Slive has observed the interest and variety of Valenti's Dutch seventeenth-century paintings, which included the earliest known work by Jacob van Ruisdael in an Italian collection, *The Great Oak* (1752; Los Angeles County Museum of Art), displayed prominently in the lower left corner.[5]

The variety of figures painted in Panini's compositions relieves what otherwise would have been unenlivened architectural records. For the staffage, the artist depended upon a large repertory of human types and figures which he created around 1730 and which he and his workshop assistants continued to exploit for the next thirty years. The principal sources for these models are a sketchbook in the British Museum and a group of figure drawings formerly in the collection of the Roman sculptor Vincenzo Pacetti (1746–1820) and now in Berlin. From these sources Ferdinando Arisi identified preparatory drawings for a number of figures; for example, one of the youths examining the plan of the villa in the foreground and the prelate at the very rear of the gallery.[6]

A possible oil *bozzetto*, or sketch, for the composition is in the Musée des Beaux-Arts, Marseille; a copy with variations and dated 1761 is in the Casita del Principe at the Escorial; another appeared on the New York art market in 1996.[7]

EPB

Oil on canvas, 78 3/16 × 105 3/8 in.

Signed and dated with initials on a book on the floor at lower left: *I.P.P/ Romae/ 1749*

The Ella Gallup Sumner and Mary Catlin Sumner Collection Fund, 1948.478

Provenance: Cardinal Silvio Valenti Gonzaga (1690–1756), Rome; by descent to Cardinal Luigi Valenti Gonzaga (1725–1808), Rome; purchased in Rome in 1822 by Sir George Howland Beaumont (1753–1827)[8], Coleorton Hall, Leicestershire; by descent to Sir George Beaumont [George Howland], Coleorton Hall, Leicestershire; sale, Sotheby's London, June 30, 1948, lot 42; bought by David Koetser, New York; from whom purchased in 1948.

References: Olsen, 1951, pp. 90; Arisi, 1961, pp. 194–5, no. 209; Arisi, 1986, p. 430, no. 400; Slive, 1987, pp. 169–76, figs. 1, 2, 4–6; Mahoney in Cadogan, 1991, pp. 184–91 (with earlier references); Kiene, 1990, pp. 262, 279–99, figs. 3, 7, 10, 16; Kiene, in Paris–Piacenza–Braunschweig, 1992–3, p. 77, fig. 85; Mitchell and Roberts, 1996, p. 209, pls. 209 and detail; Marshall in Turin–Montreal–Washington–Marseille, 1999–2001, p. 426.

Selected Exhibitions: Hartford, 1949, no. 34; Rome, 1959, no. 422.

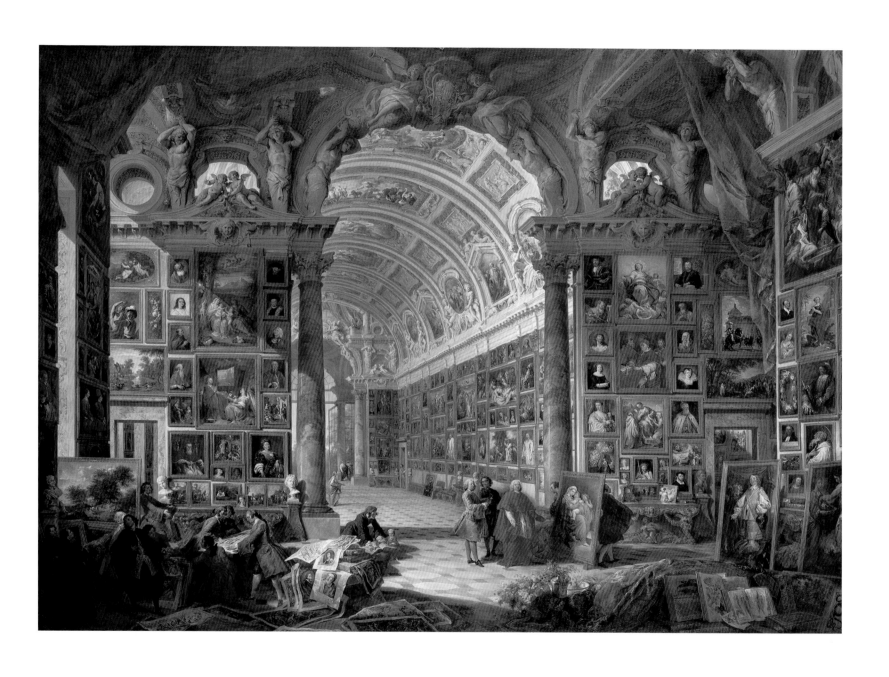

24. Gaspare Traversi

Italian (Neapolitan), *c.* 1722–70

A Quarrel over a Board Game

c. 1752

Although Gaspare Traversi is unquestionably one of Italy's most important eighteenth-century painters, to the average American art museum visitor he remains virtually unknown. Even for historians, documents regarding his life and career are infuriatingly scarce.[1] His activity in his native Naples, for example, is documented only by three canvases of scenes from the *Life of the Virgin* (Santa Maria dell'Aiuto, Naples), one of which is signed and dated 1749. He appears to have received his initial training in Naples from Francesco Solimena (1657–1747) and Francesco de Mura (1696–1782), who had assumed control of Solimena's large workshop in 1747 and was probably Traversi's actual teacher. Within a few years Traversi's style matured with astonishing speed, incorporating the naturalism of seventeenth-century Neapolitans such as Jusepe de Ribera (cat. no. 29), Francesco Francanzano, the Master of the Annunciation to the Shepherds, and Mattia Preti. Traversi's new manner is evident by 1752, the year in which he settled in Rome and painted six large canvases with biblical and apocryphal subjects that are today in the Roman basilica of San Paolo fuori le Mura. Traversi appears to have remained mostly in Rome until his death in 1770, and he supplied sacred paintings to the religious orders including the Carmelites and Observant Franciscans, furnished profane pictures for various Roman and Emilian patrons, and regularly sent works back to Naples. His reputation vanished after his death, and almost all that is known of his life and work—which numbers around seventy paintings—is due to the efforts of twentieth-century art historians beginning with an article by the great Italian critic Roberto Longhi in 1927.[2]

Traversi's most significant contributions to eighteenth-century Italian painting are "his lucid, often irreverent reflections on the mores and conflicts of his time"[3]—his genre paintings—and it is these canvases that are most admired by modern audiences. Longhi assigned most of Traversi's genre paintings to the painter's last years in Naples about 1750–2, although others have dated them to the entire decade of the 1750s. These bourgeois genre scenes are characterized by elegantly dressed figures engaged in "polite" social activities such as card parties and cultural pursuits, music-making and drawing lessons. Some of Traversi's paintings revive popular Caravaggesque themes; for example, fortune telling. Most observers have seen in these lively scenes the artist's attempts to satirize the social aspirations of the emergent middle class in southern Italy. The humor Traversi imparts to his subjects has been likened to the moralizing narrations of William Hogarth (1697–1764), with which he may have been familiar.[4] Traversi's psychological insights into human expression and sharp characterization of individual figures belie his interest in portraiture—his small group of extant portraits, which contains such penetrating likenesses as the famous *Portrait of a Man* (1760; Museo e Gallerie Nazionale di Capodimonte, Naples), remains under-appreciated.

The *Quarrel over a Board Game* is a vivid example of Traversi's depictions of the apparent daily activities of the middle classes and their social pursuits. The three-quarter-length-figures are shown typically close-up in a narrow foreground space, an arrangement that allows Traversi to focus on a range of emotions—from concern to fear to anger. His expressive figures are carefully delineated by incisive drawing, bright color, and pronounced lighting that seems to have been inspired by another Neapolitan painter, Giuseppe Bonito (1707–89), whose own genre pictures became especially famous in Naples beginning in the 1730s.[5] The apparent subject in the Atheneum's picture is a fight between two well-dressed gentleman that has erupted over a gaming board—described as both chess and checkers[6]—the presumed cause of which is an accusation of cheating. The theme was well-known in seventeenth-century Dutch painting—Jan Steen's *Card Players Quarreling* (*c.* 1664–5; Gemäldegalerie, Berlin), for example—although precisely what Traversi's intentions are in the Hartford painting are not immediately evident. Many depictions of gamblers quarreling in northern seventeenth-century art were intended as straightforward, moralizing denunciations of human weakness—loss of self-control, anger, and violence—fueled by alcohol and gambling.[7] Too little is known about Traversi's patrons and contemporary audience, however, to speculate about the purpose of his pictorial narratives.

The theatrical and anecdotal qualities of Traversi's compositions as well as their stylish staging have captured the attention of critics who have raised the possibility that his subjects derived from stage figures and theatrical situations in contemporary theater and opera, notably the Neapolitan comic opera, or *opera buffo*, with their "stories full of ridiculous situations, of complications and entanglements, of disguises, love plots and unfortunate love combinations."[8] Thus, a painting such as the *Quarrel over a Board Game* may have been intended as comedy—light entertainment with a moral lesson—meant to appeal to a specific audience.

EPB

Oil on canvas, 50 ½ × 71 ¼ in.

The Ella Gallup Sumner and Mary Catlin Sumner Collection Fund, 1948.118

Provenance: Sir Montague L. Meyer, Avon Castle; sale, London, Sotheby's April 3, 1946, lot 131, bought Wengraf; Lili Fröhlich-Bum, Vienna, until 1948; Durlacher Bros., New York; from whom purchased in 1948.

References: Mahoney in Cadogan, 1991, pp. 249–51 (with earlier references); Rave, 2003, p. 161, no. 27, ill. p. 33 (with additional references).

Selected Exhibitions: Naples, 1979–80, no. 107; Detroit and Chicago, 1981–2, no. 49.

25. Giovanni Domenico Tiepolo

Italian (Venetian), 1727–1804

The Miracle of Christ Healing the Blind Man

1752

Giovanni Domenico Tiepolo was the eldest surviving son of Giovanni Battista Tiepolo (1696–1770), the famous eighteenth-century Venetian painter. He entered his father's studio in the early 1740s, where he learned his art by copying his father's drawings and etchings. From 1750 to 1770 Domenico (as he later signed himself) was both his father's assistant and associate as well as an independent artist, although at times the roles merged. From 1750 to 1753 the Tiepolos were preparing and executing the fresco decorations in the Würzburg Residenz, and it was in these years Domenico came into his own as an artist and began producing his own creations such as *The Miracle of Christ Healing the Blind Man*. In 1757, working with his father on the decoration of the Villa Valmarana, outside Vicenza, Domenico also served as both associate and independent artist, painting lyrical scenes of oriental fantasies, courtly promenades and rustic pleasures. In 1762 Domenico accompanied his father and his brother, Lorenzo (1736–76) to Spain, working primarily with Giovanni Battista on the three allegorical ceiling frescoes in the Royal Palace, Madrid. When his father died in 1770, Domenico returned to Venice and produced some of his most remarkable work such as the large *Building of the Trojan Horse* (cat. no. 28).

Domenico's early work centered on religious themes—his first independent painting commission was a cycle of fourteen canvases depicting the *Stations of the Cross* for the Oratory of the Cross annexed to the Venetian church of San Polo, one of which is dated 1747. His first etched series was after the *Via Crucis* paintings in San Polo, testifying to the popular success of this cycle. In 1753, he published in Würzburg a highly original series of twenty-four etchings on the theme of the *Flight into Egypt*, dedicated to Carl Phillip von Greiffenklau, Prince-Bishop of Würzburg. The years in Würzburg were a period of frenetic activity for Domenico Tiepolo, for in addition to the frescoes on the ceilings and walls of the Kaisersaal of the Residenz and his graphic activity, he produced some of his most evocative and impressive easel paintings.

Some of these early works may have been painted for the Prince-Bishop or members of his entourage and the majority are biblical in subject; for example,

the *Apparition of the Angel to Hagar and Ishmael* (c. 1751; Nelson-Atkins Museum, Kansas City).[1] Domenico favored scenes from the life of Christ in his early years, and for these paintings chose a horizontal format that could accommodate the presentation of a large number of figures in a dynamic composition: *Christ Cleansing the Temple* (c. 1752; Museo Thyssen-Bornemisza, Madrid); *Christ in the House of Simon the Pharisee* and *Institution of the Eucharist* (1752; Alte Pinakothek, Munich); and *Institution of the Eucharist* (1753; Statens Museum für Kunst, Copenhagen).[2] Thus, *The Miracle of Christ Healing the Blind Man* is important as one of the early signed and dated works by Domenico Tiepolo, significant proof of the young painter's increasing maturity as well as his growing independence from his father.

In 1910, the Atheneum's painting was paired in the Wilhelm Laporte collection with a pendant *Christ and the Woman Taken in Adultery* (fig. 25A) that appeared recently on the New York art market.[3] Both paintings are marked by Domenico Tiepolo's animated and lively brushwork, boldly applied with rich impasto, and brilliant coloring derived from his father's work in the Würzburg period. The exotic figures and their poses—the turbaned man seen from behind at the left, for example—preserve the traditional values of Venetian painting from Veronese to his father Giambattista, whose figural types and costumes dominate his son's earliest works; for example, the male figure at the right leaning into the group of disciples to witness the miracle. Oil sketches for both compositions are known—that for *The Miracle of Christ Healing the Blind Man*, formerly with Didier Aaron, New York, and now in a French private collection, and the *bozzetto* for the companion in the collection of Baroness von Essen, Rome, 1929, now untraced.[4]

During the period of the Counter Reformation, the subject of *The Miracle of Christ Healing the Blind Man* was sometimes interpreted as an allegory of the revelation of true faith. The Atheneum's painting shows Christ, surrounded by his disciples, performing the miracle under a palm tree on a man kneeling before him. The account in Matthew (20: 29–34) describes the scene as taking place outside the walls of Jericho, depicted at the right of the composition, and includes the healing of a second blind man, perhaps the figure kneeling just to the left of Christ.

EPB

Fig. 25A. Giovanni Domenico Tiepolo, *Christ and the Woman Taken in Adultery*, 1752, oil on canvas, 18 ¼ × 40 ¾ in. Private collection (Courtesy of Sotheby's, New York)

Oil on canvas, 28 ¾ × 40 ⅞ in.

Signed and dated lower left: *Domo Tiepolo Fe/ 1752*[5]

The Ella Gallup Sumner and Mary Catlin Sumner Collection Fund, 1952.289

Provenance: Dr. Forcke, Hildesheim; from whom purchased in 1868 by Wilhelm Laporte, Linden (near Hanover), Germany, thence by family descent until 1910; Julius Böhler, Munich; Adolf Loewi, Los Angeles; from whom purchased in 1952.

References: Sack, 1910, p. 307, fig. 322; Mariuz, 1971, p. 120, figs. 51, 52; Knox, 1980, vol. 1, p. 300, no. P74; Cadogan, 1991, pp. 241–2 (with earlier references).

Selected Exhibitions: Venice, 1951, no. 116.

26. Domenico Corvi

Italian (Roman), 1721–1803

The Miracle of Saint Joseph Calasanz Resuscitating a Child in a Church at Frascati

1767

Domenico Corvi was one of the champions of classical painting in Rome in the second half of the eighteenth century.[1] Admired particularly for his graceful handling of color and light and his strong draughtsmanship, Corvi's early career was largely devoted to the decoration of churches in and around Rome. But even as a relatively young artist his reputation was such that on a visit to Rome in 1765, about the time he produced the *Miracle of Saint Joseph Calasanz Resuscitating a Child in a Church at Frascati*, the Frenchman Joseph Lalande praised him as one of the best painters in the city after Pompeo Batoni (1708–87) and Anton Raphael Mengs (1728–79).[2]

The Atheneum's painting depicts an episode from the life of the Spanish saint Joseph Calasanz (1558–1648), founder of the Clerks Regular of the Christian Schools. Ordained a priest in Spain, and later appointed vicar-general of Lérida, he believed that he was called to the work of educating the urban poor and in 1592 resigned his office and prospects for advancement and departed for Rome. There he nursed the sick and the dying during the plague of 1595, but he returned to educating children, especially the homeless and neglected. As other religious orders were unable or unwilling to help, he started a free school with three other priests in 1597 that eventually expanded to a *palazzo* near Piazza Navona in Rome with 1,200 pupils. In 1669, Calasanz's congregation was made into a religious order, called the Scolopians, or Piarists, which flourished particularly in Italy, Spain, and South America. In 1948 Pius XII declared him patron of Christian schools.[3]

Calasanz was one of several saints canonized by Pope Clement XIII Rezzonico on July 16, 1767, in St. Peter's. On this occasion, the upper register of the interior was decorated by the architect Carlo Marchionni (1702–86) with simulated statues of female virtues painted in monochrome by Corvi; moreover, the Scolopian Fathers commissioned a picture from Corvi recorded as a "Miracle of Saint Joseph Calasanz Resuscitating a Child in a Church at Frascati," which they gave to the pope in commemoration of the event. Fiorella Pansecchi has convincingly suggested that this painting is to be identified with the present canvas of the same subject.[4]

There is a rich vein of dramatic naturalism that runs through Settecento Roman painting and explains why, for instance, in the realm of sacred painting, scenes from the lives of little-known saints of the period appear so convincing to a modern audience. Roman eighteenth-century painters devoted considerable skill and effort toward making the drama of the fictive scene a real and present event before the observer. Corvi, too, in Stella Rudolph's words, "visualized the miracle as a contemporary *tableau vivant* of historical exactitude in the costumes and extraordinary precision of details such as the hanging lamp and veritable 'still life' of the altar with candles, crucifix, Mass cards, lace and brocade trappings, veined marble column and gilt-framed icon of the *Virgin and Child*."[5]

Corvi encouraged the emotional involvement of the observer by presenting the sacred drama in a convincing narrative manner. He carefully manipulated the composition to suggest to the beholder the illusion that Saint Joseph's miracle is being enacted before his eyes: the sharp illumination leaves the kneeling figure at the left in shadow while the mother in colorful local dress and the saint and the child he rescues are thrown into prominence. Especially convincing is the entry into the scene of the animated Scolopian father with his pupils, one of whom, the boy in blue dress, is depicted with such immediacy that he must have been an actual child known to the artist. Intimacy between spectator and painting is the norm in Roman eighteenth-century painting, and Corvi is typical of the finest sacred painters of the period in underplaying swarms of angels, hosts of airborne saints, and dramatic shafts of golden light in favor of more matter-of-fact representations with a relatively limited cast of characters.[6]

EPB

Oil on canvas, 87 ¼ × 69 ¼ in.

The Ella Gallup Sumner and Mary Catlin Sumner Collection Fund, 1981.24

Provenance: Probably Pope Clement XIII Rezzonico (1693–1769), Rome, 1767; private collection, Rome; Heim Gallery, London, 1980; from whom purchased in 1981.

References: Rudolph, 1982, pp. 35–6; Rudolph, 1984, pl. 213; Pansecchi, 1989–90, pp. 343–5; Cadogan, 1991, pp. 120–1; Rudolph, in Philadelphia–Houston 2000, pp. 350–1, no. 203.

Exhibitions: London, 1980, no. 20 (as "St. Philip Neri invoking the Madonna to revive a Dead Child"); Philadelphia–Houston, 2000, no. 203.

27. Francesco Guardi

Italian (Venetian), 1712–93

View of the Piazzetta Looking toward San Giorgio Maggiore, Venice

1770s

Francesco Guardi is the best-known member of a family of artists that included his brother, Giovanni Antonio (1699–1761). Although Francesco spent his earliest years assisting his brother as a figural painter, it is his views of Venice, which he began to paint in the mid-1750s, that have made him, along with Luca Carlevarijs (1663–1730), Canaletto (cat. no. 22), and Michele Marieschi (1710–43), one of the city's most celebrated view-painters. In spite of the enormous modern appreciation of Guardi's *vedute*, however, he never attracted the attention of foreign visitors in the way Canaletto did, and his work seems to have been purchased mainly by middle-class Venetians and English visitors of modest means.[1] Like other view painters, Guardi also painted depictions of Venetian festivities such as Mardi Gras; events connected with the visits of foreign dignitaries; and landscape and architectural capriccios, fantasy subjects in which real buildings are combined with imaginary ones or shown with their locations rearranged. Guardi had little immediate following and died in relative neglect. Only in the late-nineteenth century, with the advent of Impressionism, when his vibrant and rapidly painted views were seen as having qualities of spontaneity, bravura, and atmosphere lacking in Canaletto's sharply defined and deliberate works, did he achieve widespread appreciation. Enormously prolific, with more than one thousand canvases attributed to him, Guardi's paintings are plentiful in the major public collections of Europe and North America.

In the Atheneum's painting, Guardi focused his attention on the Piazzetta, the square leading from the Piazza di San Marco toward the south, bounded on the east by the Palazzo Ducale and on the west by Jacopo Sansovino's Libreria. Between these two buildings the Column of Saint Mark and the Column of Saint Theodore are visible, beyond which lies the Bacino di San Marco, upon which various vessels are moored. In the distance at the left may be seen the church of San Giorgio Maggiore and the adjoining Benedictine monastery; in the background at the right is the island of the Giudecca with the sixteenth-century church of Le Zitelle.

The fascination with daily life in so many of Guardi's pictures is evident here. His innumerable small figures in contemporary dress—the staffage—are extremely charming and convey the liveliness of the Venetian scene. Figures from all walks of life—magistrates in full wigs and gowns, fashionable women, gentlemen in the typical costume of cape and three-cornered hat, laborers, and vendors—wander about the Piazzetta. Guardi was in the habit of making rapid abbreviated sketches of such accessory figures—*macchiette*, as they are called—which he used as the source for the figures animating his compositions.[2] The base of the Column of Saint Theodore was a traditional gathering place for sellers of poultry and wild birds, and Guardi has taken some care in depicting this scene. Like Canaletto before him, Guardi has noted the beam with a pulley wheel projecting from the last bay of the first story of the Doges' Palace. In fact, he often adopted compositions from others—for instance, from the etchings of Marieschi—and he almost certainly borrowed this detail from one of Canaletto's compositions painted years before.[3] (Canaletto's art influenced his style so powerfully that is has been thought that Guardi may have learned topographical view painting from Canaletto himself, who had returned from England in 1755.)

Guardi represented this view of the Piazzetta from slightly varying vantage points several times throughout his career.[4] Most authorities have dated the painting to the 1770s when the artist's brushwork became increasingly loose, his palette lighter and cooler, and the forms enveloped in a shimmering, magical atmosphere. In this period, Guardi also began to modify the proportions of his buildings and to take liberties with their location and perspective, with the result that his late work was often criticized for its poor technique and carelessness in the depiction of specific topographical sites. In the Atheneum's painting, for example, the Libreria is unnaturally opened out. After Francesco's death, his son Giacomo (1764–1835) and numerous followers and imitators produced paintings of inferior quality in his late style that were sold as by "Guardi" to less demanding clients which continue to present complicated questions of attribution and authorship.

A pen-and-ink drawing by Guardi that corresponds closely to the composition, and includes some of the same figures, is also in the collection of the Wadsworth Atheneum (fig. 27A).[5] The drawing has been identified as both a preliminary sketch for the painting and a *ricordo*, or record, that Guardi utilized for the preparation of other versions of the composition.[6]

EPB

Fig. 27A. Francesco Guardi, *The Piazzetta, Venice,* pen and ink over black chalk, 9 ¾ × 15 ½ in. Wadsworth Atheneum, 1936.336

Oil on canvas, 18 ⅝ × 30 ⅜ in.

The Ella Gallup Sumner and Mary Catlin Sumner Collection Fund, 1935.62

Provenance: Private collection, England; Durlacher Bros., New York, 1934; from whom purchased in 1935.

References: Morassi, 1973, vol. 1, p. 379, no. 366; Cadogan, 1991, pp. 162–4 (with earlier references).

Selected Exhibitions: New York, 1934, no. 25; Springfield, 1937, no. 26; Sarasota–Hartford, 1958, no. 39; Allentown, 1971, no. 27.

28. Giovanni Domenico Tiepolo

Italian (Venetian), 1727–1804

The Building of the Trojan Horse

c. 1773–4

Domenico Tiepolo returned to Venice from Madrid on November 12, 1770, where he had accompanied his father Giovanni Battista in 1762 at the invitation of King Charles III of Spain and where he and his father had executed a series of fresco decorations for the throne room in the Royal Palace in Madrid (1762–6). Giambattista had died seven months before, and Domenico was now the head of the Tiepolo family workshop. The decade following his return to Venice was extremely productive and a period in which many of his finest pictures were painted. Among these is the enormous *Building of the Trojan Horse*, the only survivor of a set of three pictures which are known through sketches and that has been considered among the artist's masterpieces, one in which he continued the tradition of monumental Venetian painting.[1]

This large canvas must have been part of a series illustrating scenes from the fall of Troy. There exists a finished oil sketch for the composition at the National Gallery, London (fig. 28A), which shows minor differences in the details of the workmen around the horse, the architecture, and in the placement of the two figures at the left further in the distance than in the Atheneum painting.[2] Two other oil sketches depict additional episodes in the legend of the Greeks capture of Troy with the wooden horse—*The Procession of the Horse into Troy* (National Gallery, London) and *The Greeks Emerging from the Horse inside the Walls of Troy* (Private collection, Paris)[3]—and all three scenes show quite careful adherence to the textual details of the story.

The story of the Trojan Horse, and the part played by Odysseus in the scheme, is referred to in the *Odyssey* (books 3 and 8), but the most detailed account of the Fall of Troy is related by Aeneas in the second book of Virgil's *Aeneid*.[4] The Greek forces had laid siege to Troy, and in order to penetrate the city's walls they fashioned a large wooden horse in which they concealed their troops. In the Atheneum's painting, the Greeks are shown industriously constructing the wooden horse, while groups of figures look on. The two prominent figures at the left have been interpreted alternatively as Agamemnon, the Greek commander, and Odysseus disguised as an old man in Oriental costume; the pointing figure may be Epeius, the builder of the horse. The significance

of the dry stream or riverbed that separates the foreground group from the two left figures is uncertain.[5]

The *Building of the Trojan Horse* displays both Domenico Tiepolo's virtuoso brushwork as well as his use of the airy, clear, light colors typical of eighteenth-century Venetian painting. The figure wrapped in a luminous yellow mantle at the left, thought to represent Epeius, is typical of the painter's handling, the folds of his drapery edged with brown that in turn is a mixture of cream, ochre, and brown. Throughout the composition Tiepolo juxtaposes a palette of brilliant, high-key yellow, salmon, blue, and red drapery to enliven and animate the surface of the painting. An especially vivid accent of color is provided by the crumpled striped robe thrown on the ground in the center foreground of the composition.

The Tiepolo scholar, George Knox, published several preparatory red chalk studies for the *Building of the Trojan Horse* at the State Hermitage, St. Petersburg, and Museo Correr, Venice, respectively, that enabled him to date the painting to about 1773–4. These drawings, moreover, serve to underscore the care with which Domenico Tiepolo prepared the various figural details of the enormous composition, including the man wielding a hammer at the extreme top right-hand corner of the composition; the man painting the flank of the horse; the right foot of the standing man at the lower right; the arm of the man by the neck of the horse; a detail beneath the back leg of the horse; the hands holding the ladder by the rump of the horse; and the boy holding a basket in the lower right corner.[6]

EPB

Fig. 28A. Giovanni Domenico Tiepolo, *Building the Trojan Horse, c.* 1760, oil on canvas, 15 ¼ × 26 ¼ in. National Gallery, London

Oil on canvas, 75 ⅞ × 140 ⅞ in.

The Ella Gallup Sumner and Mary Catlin Sumner Collection Fund, 1950.658

Provenance: Prince Pignatelli, Venice; Comtesse de Romrée de Vichenet, Château de Fervoz, Namur, about 1765; Galerie Sedelmeyer, Paris, 1911; possibly Demotte, Paris; Lennie Davis Gallery, Paris, 1923; sale, Paris, Galerie Charpentier, December 17, 1938, lot 6; Tomás Harris of the Spanish Art Gallery, London, by 1940; from whom purchased in 1950.

References: Levey, 1971, pp. 238–9; Mariuz, 1971, p. 120; Knox, 1980, vol. 1, p. 78; Cadogan, 1991 (with earlier references), pp. 240–1.

Selected Exhibitions: San Francisco, 1940, no. 169.

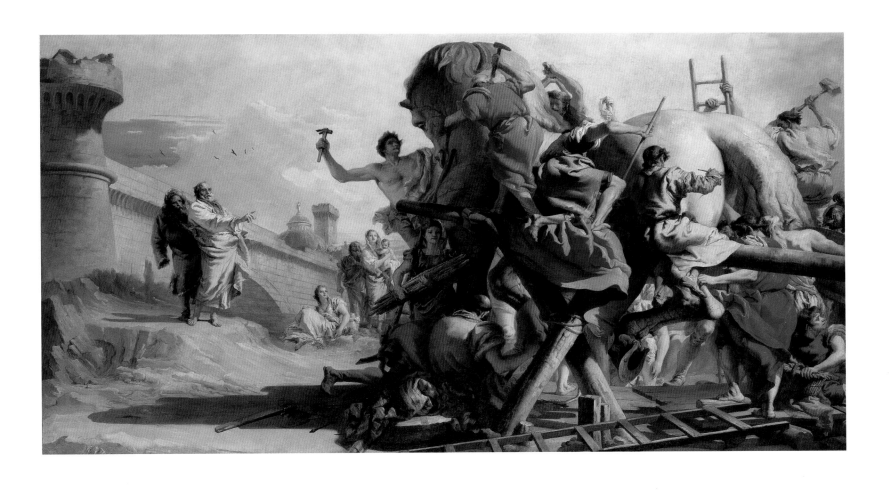

29. Jusepe de Ribera

Spanish, 1591–1652

The Sense of Taste

c. 1614–16

Jusepe de Ribera, born in the Valencian town of Játiva, spent his entire career in Italy. He frequently asserted his Spanish nationality by adding the qualifying inscription "*español*," "*hispanus*," or even "*valentinus*" to his signature in what may have been an attempt to gain an advantage with Spanish clients. He is first recorded in Italy in 1611, when he painted an altarpiece dedicated to *St. Martin* (lost) for a Parma church. Ribera quickly established himself as the leading painter in Naples, enjoying patronage of the Spanish viceroys, as well as the local nobility and religious institutions. In 1618, the year Ribera received his first commission from the Spanish viceroy, Ludovico Carracci wrote with admiration of the "young Spaniard working in the manner of Caravaggio." Over the course of the next decade, the Caravaggesque naturalism of Ribera's work was enhanced by his technical development and the achievement of a pronounced sense of tactile physicality through the use of more thickly textured brushwork. Beginning in the 1630s his early tenebrist style was tempered by the apparent influence of Venetian and contemporary Flemish painting, resulting in a more luminous palette and more loosely applied paint. Nor was he exempt, during the 1640s, from the influence of Roman-Bolognese classicism and its greater formal complexity. His inspired synthesis of these stylistic trends was enormously influential for the next generation of painters in Naples, including Giordano, Stanzione and Vaccaro. In Spain, the circulation of Ribera's prints and the presence of paintings imported by the viceroys and other Spanish Neapolitan officials, proved important for painters as diverse as Zurbarán, Cano, and Pereda.

Ribera's *Five Senses* series can be counted among a handful of works painted during the artist's early years in Rome. Four of the five paintings that originally comprised the series have been preserved: *Taste* (Hartford, Wadsworth Atheneum), *Sight* (Mexico City, Museo Franz Mayer), *Touch* (Pasadena, Norton Simon Foundation) and *Smell* (Madrid, Juan

Abelló collection) (figs. 29A–C). The fifth painting in the series, *Hearing*, is known only through a copy (fig. 29D).[1] The paintings are first recorded by Giulio Mancini, who saw them in the home of an unnamed Spaniard sometime between 1614 and 1621: "He made many things in Rome, and in particular for . . . , the Spaniard, those having five half-figures representing the five senses, very beautiful, a Christ Deposed and another, which in truth are things of most exquisite beauty."[2] It is not known for whom Ribera painted the Five Senses, although it may well have been the Spanish diplomat Pietro Cussida, a patron of the Dutch Caravaggesque painters Dirck van Baburen and David de Haen.[3]

In a highly original departure from the usual practice of depicting the *Five Senses* by means of female allegorical figures, Ribera represents them with ordinary, even vulgar, physical types. Such crude characterization of the basic human faculties implies that knowledge gained by the senses rather than the intellect is mundane, pertaining only to the material world. At the same time, there is clearly an acknowledgement of the traditional hierarchy of the senses. *Sight* (fig. 29B), the sense most sympathetically portrayed by Ribera, was also believed to be the most noble. An ordinary man with the appearance of a laborer, possesses a dignified bearing and a keen gaze. He holds a telescope in his hands, while other symbolic objects, including spectacles and a mirror, lie on the table in front of him. The open window behind him, unique in the series, may signal the pre-eminent role of sight in perceiving the world. *Hearing* (fig. 29D), next in the hierarchy, is known only through a copy, but appears to be a more conventional image of a man playing a lute. *Smell* (fig. 29C) is represented by a tattered old man, brought to tears by the cut onion in his hands. A flower, the usual symbol of the sense of smell, another onion and a head of garlic lie in front of him. *Taste*, near the bottom of the hierarchy of senses, may be the most uncouth figure in the series. A corpulent, ruddy-complexioned

man, traditionally identified as a gypsy, in a soiled shirt sits before a generous serving of what appears to be squid. He lifts a full wine glass with one hand and holds an uncorked bottle in the other. A piece of bread and a paper cone of olives compliment the rustic meal. A connection between the sense of taste and the vice of gluttony was probably intended, along with a more general reference to the relationship between the senses and moral behavior. The final image in the series, *Touch* (fig. 29A), is a blind man holding an antique head, whose features he perceives by running his coarse fingers over its face. A painting lies unperceived beside him.

The formal and conceptual starting point for the gritty naturalism of Ribera's *Five Senses* is the work of Caravaggio. His early secular paintings, such as *Boy with a Basket of Fruit* (Rome, Borghese Gallery), may have provided the basic formal model for dramatically lit half-length figures, but his slightly later religious pictures are the obvious source for the direct and unidealized portrayal of models from everyday life. Ribera's Northern European contemporaries in Rome were responding to the same revolutionary achievement and, though their influence upon him is often cited, it has probably been overestimated. Works such as Ribera's *Sense of Taste* reveal a direct understanding of both Caravaggio's naturalism and his tenebrism, much more closely linked to the master than to his followers in its rough and compelling immediacy.

RK

Oil on canvas, 44 13/16 × 34 3/4 in.

The Ella Gallup Sumner and Mary Catlin Sumner Collection Fund, 1963.194

Provenance: Prince Youssoupoff, Moscow and Saint Petersburg (before 1917); Duveen Brothers, New York, by 1953; from whom purchased in 1963.

References: Mancini, 1614–21 (ed. of 1956–57), vol. 1, p. 251; Milicua, 1952, pp. 309, 312, 315; Longhi, 1966, pp. 74–8; Schleier, 1968, pp. 79–80; Paoletti, 1968, pp. 425–6; Felton, 1969, pp. 2–13; Spear, 1971, pp. 149–53, no. 55; Spear, 1972, pp. 149–50; Volpe, 1972, pp. 72–3; Konečný, 1973, pp. 85–91; Felton, 1976, pp. 31, 33; Pérez Sánchez, 1978, p. 91, no. 2; Whitfield and Martineau, 1982, pp. 225–7, no. 119; Felton and Jordan, 1982, pp. 60–4, no. 4; Mallory, 1990, pp. 86–7; Brown, 1991, pp. 180–1; Cadogan, 1991, pp. 320–3; Felton, 1991, pp. 76–80; Pérez Sánchez and Spinosa, 1992, 13–4, p. 32, fn. 5, pp. 92–101, no. 3; Cohen, 1996, pp. 81–2, fig. 19; Brown, 1998, pp. 147–9; Papi, 2002, 25, 34, 42–3, fig. 23a.

Selected Exhibitions: Cleveland, 1971, no. 55; London–Washington, 1982–3, no. 119; Fort Worth, 1982–3, no. 4; New York, 1992, no. 3.

Fig. 29A. Jusepe de Ribera, *Sense of Touch*, oil on canvas, 45 1/4 × 34 2/3 in. Norton Simon Foundation, Pasadena

Fig. 29B. Jusepe de Ribera, *Sense of Sight*, oil on canvas, 44 1/2 × 34 3/4 in. Franz Mayer Collection, Mexico City

Fig. 29C. Jusepe de Ribera, *Sense of Smell*, oil on canvas, 44 3/4 × 34 2/3 in. Madrid, Juan Abelló colletion

Fig. 29D. Copy, after Jusepe de Ribera, *Sense of Hearing*, oil on canvas. Europahaus, Vienna

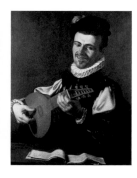

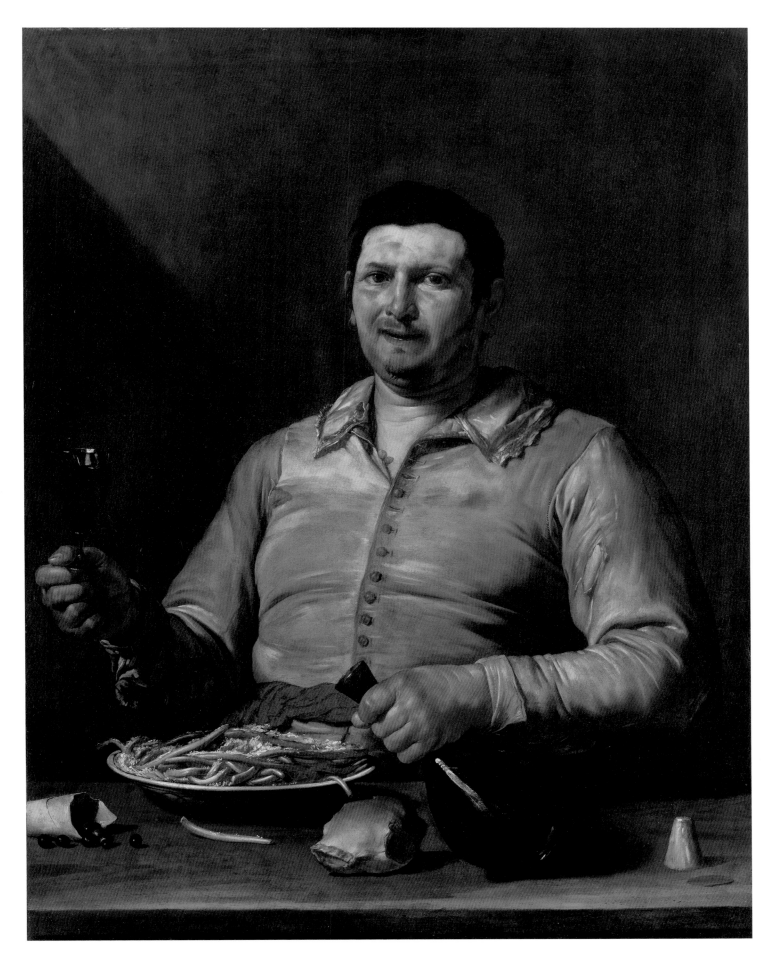

30. Francisco Ribalta

Spanish, 1565–1628

The Ecstasy of St. Francis: The Vision of the Musical Angel

c. 1620–5

Francisco Ribalta was born in 1565 in the Catalan town of Solsona, moving at an early age to Barcelona, where he is likely to have received his initial training as a painter. He was active in Madrid by 1582, the year in which he signed and dated his earliest surviving work, *Preparations for the Crucifixion* (St. Petersburg, Hermitage).[1] Philip II had moved the court from Toledo to Madrid barely twenty years before and Ribalta, like many artists, almost certainly went to the thriving new capital in search of work. Artistic activity at court was dominated by the ongoing decoration of the Escorial, the vast monastery, mausoleum and palace complex built by the king in the Sierra Guadarrama northwest of Madrid. Ribalta's early paintings are unmistakably informed by the late mannerist style practiced there by Italian artists such as Luca Cambiaso, Federico Zuccaro, and Pelegrino Tibaldi, all of whom were called to the Escorial during the 1580s. He was similarly receptive to the work of the Italian-trained Spaniard, Juan Fernández de Navarrete, whose Venetian-inspired naturalism would have a more durable influence.

Following the death of Philip II in 1598, Ribalta left Madrid and settled permanently in Valencia, where he continued to work in an eclectic style indebted to the Escorial painters. He soon attracted the patronage of the powerful Patriarch Juan de Ribera (1532–1611), archbishop and viceroy of Valencia, for whom he undertook a series of important works at the Colegio de Corpus Christi. Ribera, a post-Tridentine reformer who was archbishop of Valencia for more than forty years, had a profound effect on the spiritual life of the city. Paintings such as Ribalta's two versions of the *Ecstasy of St. Francis* (Wadsworth Atheneum and Museo del Prado) are properly viewed in the context of the Patriarch's influence, in particular, his fomentation of new devotions and his pursuit of monastic reform. Two of Ribalta's most remarkable paintings, the Prado *Ecstasy of St. Francis* and *St. Francis Embracing the Crucified Christ* (Valencia, Museo de Bellas Artes) were painted around 1620 for the Capuchin monastery of Sangre de Cristo.[2] Juan de Ribera was responsible for bringing the Capuchins, a reformed branch of the Franciscan Order, to Valencia and the monastery of Sangre de Cristo, which he helped found in 1596, is one of the first in Spain.

It is not known for whom the Hartford *St. Francis* was painted, but like the Prado painting of the same subject, it was probably commissioned for a Capuchin foundation. The unusual subject of the painting is taken from St. Bonaventure's life of St. Francis (*Legenda Sancti Francisci*), which narrates the story of an angel sent to comfort the ailing saint with heavenly music.[3] Ribalta stages the mystical event in a monastic cell furnished with little more than the crude bed upon which the haggard saint half-reclines. The traditional attributes of St. Francis are displayed in the foreground: the skull upon which he meditated, an alms basket, a clear glass carafe of water (symbolic of priestly purity), and the lamb of Christ. A printed image of the Crucifixion is attached to the wall above

the bed as a devotional aid, an unusual descriptive detail that may also refer to the saint's imitation of Christ and his experience of the Crucifixion through the stigmatization.[4] The austerity of the setting contrasts with the luminous vision of the angel who bursts into the darkened cell and plays a melody that enraptures the astonished saint and transports him far from the site of his earthly tribulations. The apparition is invisible to Brother Leo, who sits beside the bed of St. Francis and yet requires the light of a candle to read the book on his lap. The striking repoussoir figure of the saint's companion, a compositional device used to establish the foreground plane of the painting, is also used to establish his location outside the realm of mystical experience. Brother Leo wears the distinctive pointed hood believed to be the original form of the Franciscan habit and adopted by the Capuchins as a symbol of their return to the primitive observance of the Rule of the Order.

The Ecstasy of St. Francis exemplifies the heightened naturalism of Ribalta's mature works after 1620. The tendency toward greater naturalism and directness of expression, combined with the pronounced tenebrism of works such as the Hartford *St. Francis*, are suggestive of Caravaggio's inescapable influence. Although Ribalta is not known to have visited Italy, he had access to an Italian replica of Caravaggio's *Martyrdom of St Peter* in Valencia and copied it.[5] The iconographic details of St. Francis's vision of the angel may likewise owe something to Italian precedents.[6] The genesis of his innovative characterization of the subject is, however, to be found in his own drawings.[7] In five sheets of sketches Ribalta's exploration of a variety of poses, gestures and compositional solutions points to a working method that is not dependent upon painted or engraved models. The practice of drawing as a means of pictorial invention is not typical of seventeenth-century Spanish artists and Ribalta may have developed it through contact with the Italian painters at the Escorial. The success of Ribalta's compelling invention is reflected in the existence of several copies.

RK

Oil on canvas, 42 ½ × 62 ¼ in.

The Ella Gallup Sumner and Mary Catlin Sumner Collection Fund, 1957.254

Provenance: Possibly López Martínez, Jérez de la Frontera, by 1812; private collection, London, until 1956; Julius H. Weitzner, New York; from whom purchased in 1957.

References: Cruz y Bahamonde, 1813, 12: 499; Darby, 1938, 285; Darby, 1957, 1–9; Indianapolis, 1963, no. 63; Kowal, 1981, pp. 52–4, no. Fç17, fig. 39; Kowal, 1984, 768–75; Kowal, 1981, pp. 52–4, no. F–17, pl. 35; Benito Domenech, 1987, 166–7; Benito Domenech, 1988, 110–11, no. 27; Benito Domenech, 1990, 295; Cadogan, 1991, 306–8.

Selected Exhibitions: Indianapolis, 1963, no. 63; Jacksonville, 1965, no. 29; New York, 1988, no. 27.

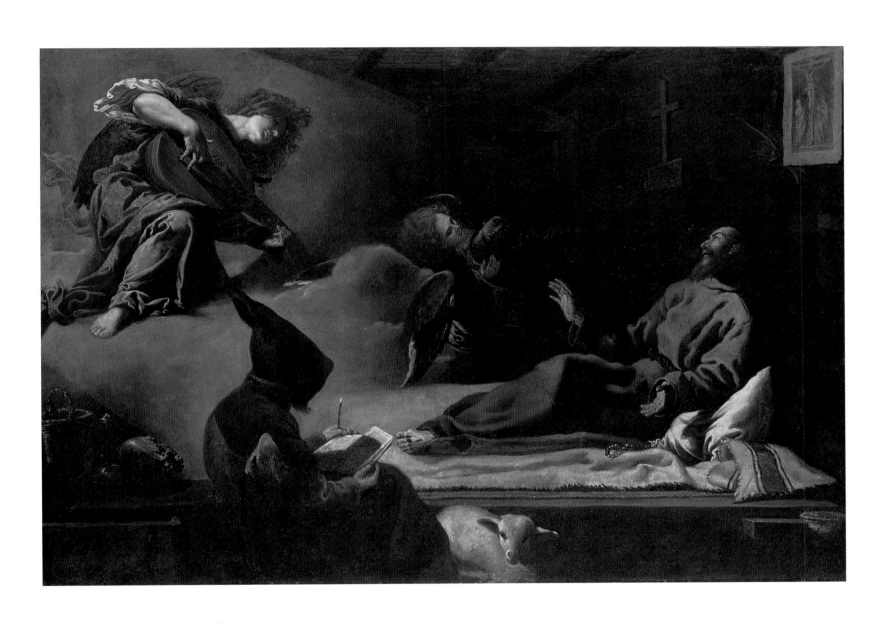

31. Francisco de Zurbarán

Spanish, 1598–1664

Saint Serapion

1628

Francisco de Zurbarán was born in the Extremaduran town of Fuente de Cantos (Badajoz), northwest of Seville. After serving an apprenticeship in Seville between 1614 and 1617, Zubarán established himself as an artist in Llerna, a town not far from his native Fuente de Cantos. No works are known from a decade of activity there. His return to Seville in 1626 was probably motivated by the departure of Diego Velázquez in 1623 and the death of Juan de Roelas in 1625. From the date of his first Seville commission, Zurbarán was a mature artist already in possession of a powerful new style of painting characterized by its compelling fusion of sobriety and drama, palpable realism and intense spirituality. Similarly, he was already the master of an established shop in Llerena, one large enough to accommodate a major commission calling for more than twenty paintings. The success of the San Pablo commission led immediately to others, including one in 1628 from the Mercedarians for twenty-two paintings, and another in 1629 from the *Colegio de San Buenaventura* to complete a cycle of paintings begun by Francisco de Herrera the Elder. His success in Seville led to a royal commission in 1634, perhaps facilitated by Velázquez, to assist in the decoration of the Hall of Realms in the Buen Retiro Palace. Zurbarán provided two battle paintings and a cycle of ten overdoors depicting the Labors of Hercules. The commissions he received after his return to Seville in 1635 mark the high point of his career: the high altarpiece for the Carthusian monastery in Jérez de la Frontera (1638–8) and seven paintings for the Hieronymites of Guadalupe (1639). Zurbarán's fortunes waned after 1640, partly because of a prolonged economic crisis, followed by the plague of 1649. By the late 1640s, with the emergence of a more dynamic and lyrical baroque style in the hands of artists such as Herrera the Younger and Murillo, Zurbarán found fewer clients in Seville and focused increasingly on the American export market.

Zurbarán's *Saint Serapion*, one of his most important early works, was painted for the Seville monastery of *Nuestra Señora de la Merced*. The Order of Merced was founded by Peter Nolasco in 1218 under the patronage of Jaime I of Aragón to ransom Christian captives. Mercedarian brothers, both lay and clerical, procured funds for ransoms through alms and traveled to Muslim Spain and North Africa to negotiate the liberation of captives, often staying behind as substitutes.[1] The Seville monastery was founded in 1249 by Fernando III of Castile and Leon one year after the re-conquest of the city. Between 1602 and 1612 the monastery was rebuilt and the decoration of its interior was entrusted to the leading artists of Seville, including Juan Martínez Montañés, Francisco Pacheco, Juan de Roelas, Francisco de Herrera the Elder, and the newly arrived Francisco de Zurbarán. In August 1628 Zurbarán was commissioned to paint twenty-two scenes from the life of Saint Peter Nolasco for the lower gallery of the monastery's small cloister, called the "Boxwood Cloister." Ten paintings from the series, four of which are considered autograph, have been preserved and it is unclear whether the requisite twenty-two

were ever painted. Likewise unclear, is the relationship between the commission and Zurbarán's *Saint Serapion*, signed and dated in the same year, but not mentioned in the contract. Most likely, it represents an earlier commission, probably his first, from the Mercedarians. The artist had already gained a certain amount of notoriety with his 1627 *Christ on the Cross* for the Dominicans of San Pablo and his powerful *Saint Serapion*, the crucified Mercedarian, is in many ways a direct, formal and spiritual reprise.

Serapion was an English crusader who entered the service of Alfonso VIII of Castile during the reconquest of Spain. A contemporary of Peter Nolasco, he became a member of the Mercedarian Order in 1222, just four years after it was founded. Zurbarán portrays him in an ample habit of rough white wool emblazoned with the insignia of the Order: the red and gold arms of the kingdom of Aragon surmounted by the white cross of Jerusalem. Mercedarian martyrologies give conflicting accounts of Serapion's death; according to the most pertinent one, he was tortured and killed in Algiers in 1240 after surrendering his own freedom to guarantee the ransom of eighty-seven Christian captives. As has often been observed, Zurbarán suppresses the most gruesome details of Serapion's martyrdom, namely his disembowelment and decapitation, and focuses instead on his swollen face and bound, outstretched arms. The rope that binds his right arm to a tree has loosened and his weight shifts in that direction, his head resting heavily on his shoulder. The isolation of the white-robed figure against a dark background enhances the devotional emphasis on spiritual rather than physical anguish in very much the same way as the earlier *Christ on the Cross*. The painting once hung in the monastery's *sala De profundis*, so-named after the opening words of Psalm 129, "*De profundis clamavi ad te Domine* (From the depths I have cried to thee O Lord)," recited in prayers for the dead. Although Zurbarán's *Serapion* is not recorded in the *sala De profundis* until the eighteenth-century, there is little reason to doubt that it formed part of its original decoration.[2] In the context of the *sala De profundis*, the stark image of the Mercedarian martyr would have functioned not as a symbol of death, as has been suggested, but as a powerful symbol of redemption. Saint Serapion, who ransomed captives with his blood, hangs lifeless by his wrists in a pose that explicitly recalls Christ's redemptive sacrifice on the Cross.

RK

Oil on canvas, 47 5/16 × 40 5/16 in.

The Ella Gallup Sumner and Mary Catlin Sumner Collection Fund, 1951.40

Signed and dated on cartouche, at right: *fran^co de Zurbaran fabt./ 1628*

Inscribed: *B[eatus] Serapius*

Provenance: *Sala De profundis*, Monastery of the Merced Calzada, Seville; Alcázar, Seville, 1810; Julian Williams, Seville, until about 1832; Richard Ford, Seville and London, until 1836; Sir Montague John Cholmeley (d. 1874); Sir Hugh Arthur Henry Cholmeley (d. 1904); Sir Montague Aubrey Rowley Cholmeley (d. 1914); Sir Hugh John Francis Sibthorp Cholmeley, Easton Hall, Grantham, Lincolnshire; Koetser Gallery, New York, 1947; from whom purchased in 1951.

References: Ponz, 1794, 9 (1786), pp. 106–7; Cean Bermúdez, 1800, 6, p. 49; González de Leon, 1844, 1, p. 161; Matute y Gaviria, 1887, p. 377; Viñaza, 1889–94, 4 (1894), pp. 71–2; Gómez Imaz, 1896, p. 141; Sánchez Cantón, 1922, pp. 209–16; Guinard, 1947, pp. 172–3; Pemán, 1949, pp. 207–8; Cunningham, 1951, p. 1; Soria, 1953, p. 140, no. 28, pl. 8; Gaya Nuño, 1958, pp. 336–7, no. 2991, pl. 147; Kubler and Soria, 1959, p. 245; Guinard, 1960, pp. 94, 259, no. 411, pl. 9; Madrid, 1964, pp. 68, 107–8, no. 10; Sutton, 1965, pp. 323–5, fig. 2; Frati and Gregori, 1973, p. 88, no. 34, pl. v; Brown, 1974, pp. 68–9, pl. v; Gállego and Gudiol, 1977, pp. 74, 137, no. 9, fig. 13; Baticle, 1987, pp. 102–3, no. 5; Glendinning, 1989, p. 26; Mallory, 1990, pp. 114–5; Cadogan, 1991, pp. 328–31; Caturla, 1994, pp. 54–5, 72; Bean, 1995, pp. 98–9; Fernández Rojas, 2000, p. 141 and pl. 14.

Selected Exhibitions: Madrid, 1964–5, no. 10; New York–Paris, 1987–8, no. 5; Atlanta, 1996.

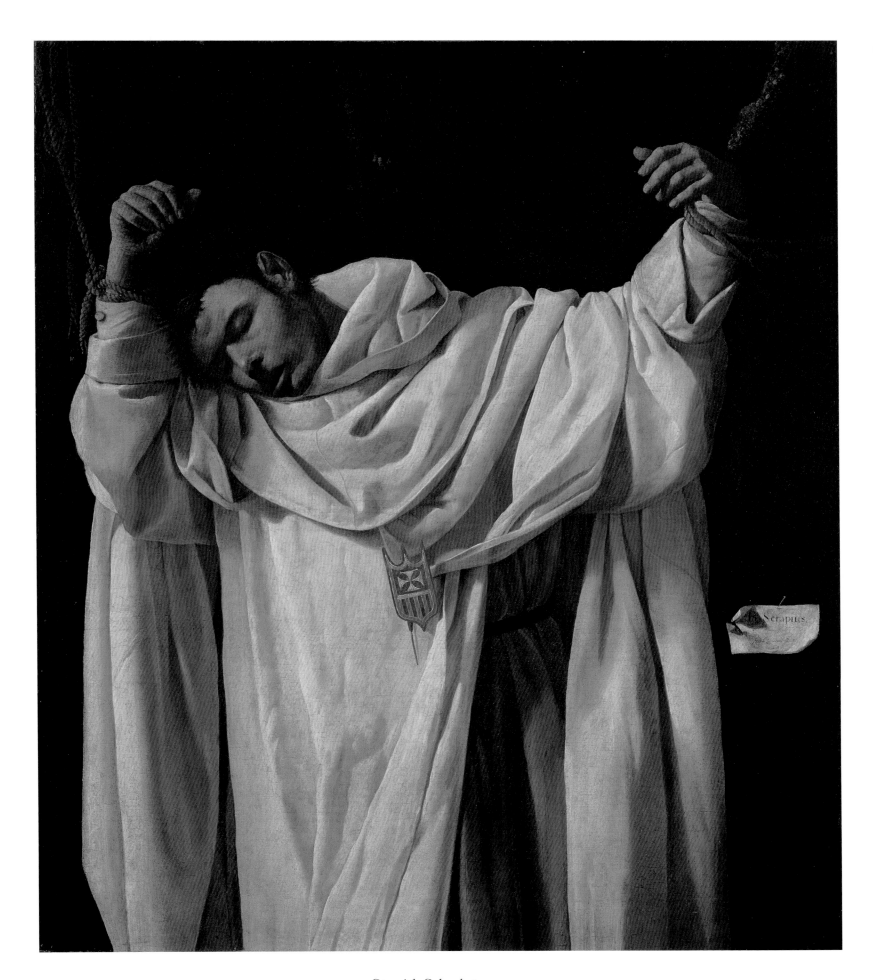

Spanish School ✳ 101

32. Juan de Valdés Leal

Spanish, 1622–90

Allegory of Vanity

1660

During the twenty-five years that separate the date of his birth and that of his marriage in Cordoba in 1647, nothing is known of Juan de Valdés Leal. The coarse immediacy of his early works links them to the distinctive naturalism of painting in Seville and points to his having been trained there in the 1630s under the influence of Francisco de Herrera the Elder. During the next decade he received commissions for work in both Cordoba and Seville, including the high altarpiece for the church of the Shod Carmelites in Cordoba (1655–8). The central image of the *Ascension of Elijah* is among his finest works and is regarded as the first in his mature style, which is characterized by more fluid brushwork, and a lighter, more colorful palette. The change in Valdés Leal's style in the mid-1650s may have been stimulated by a trip to Madrid, when he could have seen paintings in the royal collection by Titian, Tintoretto and Rubens, as well as works by Spanish painters such as Velázquez, Pereda and Herrera the Younger.[1] The return of the latter to his native Seville in 1655, followed by that of Valdés Leal in 1656, promoted the establishment of a dynamic, colorful High Baroque style as the dominant manner in the city. The Hartford *Allegory of Vanity*, signed and dated in 1660, was painted at the height of Valdés Leal's career. In the same year, he was involved in the foundation of a drawing academy in Seville, the first artistic academy in Spain, becoming its president in 1663. By 1665, however, his position had been surpassed by that of Bartolomé Esteban Murillo, whose own mastery of the new style established him as the leading painter in Seville. Murillo's more serene and pleasing manner guaranteed him the most prestigious and lucrative commissions and thereafter

Valdés Leal turned increasingly from easel paintings to murals, ornamental painting, the design of ephemeral decorations, printmaking and polychromy. Arguably his greatest works were created late in his career under the patronage of Miguel de Mañara for the Hospital de la Caridad in Seville. The grim message of the *Hieroglyphs of Death and Salvation*, two large paintings of 1670–2 for the Caridad, is anticipated by the earlier *Allegories of Vanity and Salvation* in Hartford and York.

Valdés Leal was a religious painter, even in his rare excursions into the genres of portraiture and still life. The *Allegory of Vanity* and its pendant, *Allegory of Salvation* (York City Art Gallery) (fig. 32A), expand upon a type of *vanitas* painting first produced in Madrid in the 1630s by Antonio de Pereda. Such paintings are described in seventeenth-century documents as "*desengaños del mundo*" (worldly disillusionments) and contain a fairly standard repertory of symbolic objects.[2] The Atheneum's painting depicts a pile of objects that allude to the possession of worldly riches and the enjoyment of ephemeral pleasures: coins, jewels, playing cards and dice. Emblems of temporal power, including a papal tiara, a bishop's mitre, a crown and scepter, rest on a book that can be identified as Jerónimo Román's universal history, *Las Repúblicas del Mundo*. Other books, treatises on astrology, agriculture, painting, architecture, and perspective, refer to the vanity of intellectual attainments.[3] The open pages of Carducho's *Diálogos de la pintura* contain a more pointed reference to artistic attainments and the potentiality of creative action. The book is illustrated with a plate featuring an image of a *tabula rasa* and a verse that asserts the possibility of acting upon it with a paintbrush.[4] Carducho's book leans against a stack of volumes that includes other treatises on art, including works by Alberti, Vignola, and Serlio, recalling the fact that the Seville academy was founded the same year the canvas was painted. These books and the nearby divider, triangle and brush-holder function as symbols of creative endeavor, whereas the armillary sphere and treatises on astrology, astronomy and agriculture symbolize scientific pursuits. The sense in which such objects are to be understood is clearly indicated by familiar *vanitas* motifs: a timepiece, an extinguished candle, a putto blowing bubbles, and a vase of flowers whose short-lived beauty is emphasized by their falling petals. A skull with a laurel crown rests on the single non-profane book represented in the painting, a work by the recently deceased Jesuit, Juan Eusebio Nieremberg, titled *De la diferencia entre lo temporal y eterno* (*On the Difference between the Temporal and Eternal*).[5] Behind the dense accumulation of symbolic objects in the foreground of the painting an angel lifts

a curtain and gestures towards a painting of the Last Judgment. Juxtaposed with the painting are scientific tools for contemplating the heavens, the armillary sphere and a book containing a cosmological diagram. Below, the *tabula rasa* of Carducho's treatise invites contemplation of the human potential for action and the resulting attainment of Glory or Hell.

The meaning of Valdés Leal's *Allegory of Vanity* can only be fully appreciated when it is paired with its pendant, the *Allegory of Salvation* (fig. 32A). In place of the tokens of pride, transience and death found in the first work, its pendant displays a more orderly assortment of objects associated with prayer, penitence and spiritual merit. A pensive figure once identified as Miguel de Mañara, with a rosary in hand and a penitential flail nearby, reads from one of several religious texts.[6] An angel beside him holds an hourglass in one hand and gestures with the other towards a vision of the Crown of Life, emblazoned with the words: "QUAM REPROMISIT DEUS." The phrase derives from the Epistle of James (1:12): "Blessed is the man that endureth temptation; for when he hath been proved, he shall receive the crown of life, which the Lord hath promised to them that love him." The theme of salvation is further emphasized by a painting of the Crucifixion in the background.

RK

Fig. 32A. Juan de Valdés Leal, *Allegory of Salvation*, 1660, oil on canvas, 49 ½ × 37 ¼ in. York Museums Trust (York Art Gallery)

Oil on canvas, 51 ⅜ × 39 ¹/₁₆ in.

The Ella Gallup Sumner and Mary Catlin Sumner Collection Fund, 1939.270

Signed and dated: *Juº de baldes Leal f Aº 1660*

Provenance: Mr. Wellcome (?), London[7]; Tomás Harris, London, 1938; Durlacher Brothers, New York, 1939; from whom purchased.

References: Borenius, 1938, pp. 146–51, pl. B; Trapier, 1956, pp. 20, 22–5, 28; Gaya Nuño, 1958, p. 312, no. 2752; Kubler and Soria, 1959, p. 293; Nordström, 1959, pp. 127–37; Trapier, 1960, pp. 14, 30–4, 54; Gállego, 1968, pp. 201–2; Bergström, 1970, pp. 77–80; Angulo Iñiguez, 1971, pp. 374, 378, 383, fig. 394; Kinkead, 1978, pp. 402–4; Sullivan and Mallory, 1982, p. 108, no. 44; Valdivieso, 1988, pp. 117–21, 243, no. 79; Mallory, 1990, pp. 262–3; Cadogan, 1991, pp. 324–7; Jordan and Cherry, 1995, pp. 115–17; Cherry, 1999, pp. 44–5; Valdivieso, 2002, pp. 104–7.

Selected Exhibitions: London, 1938, no. 20; Toledo, 1941, no. 78; Princeton–Detroit, 1982, no. 44; London, 1995, no. 45; Bilbao, 1999–2000, no. 37.

33 · Luis Egidio Meléndez

Spanish, 1716–80

Still Life with Pigeons, Onions, Bread and Kitchen Utensils

c. 1772

Luis Egidio Meléndez was born in Naples, the son of the Spanish painter Francisco Antonio Meléndez (1682–after 1758), a specialist in portrait miniatures and manuscript illumination. One year later, in 1717, the elder Meléndez returned to Spain with his wife and four children, all of whom were destined to be artists. Meléndez was among the first to advocate the creation of an Academy of Fine Arts in Madrid and played an active role in its foundation as a member of the Preparatory Junta, sanctioned by the king in 1744.[1] Luis Meléndez ranked first among the students examined for admission to the academy in 1745 and one year later painted his earliest dated work, a supremely confident *Self-Portrait* (Louvre), in which the artist proudly holds up an academic figure study in red chalk. The painting emphasizes his mastery of figure drawing and announces his artistic ambitions. The promising career as a history painter foretold by the *Self-Portrait* was cut short when in 1748 Meléndez's father took offense over a minor breach of protocol and publicly denounced the Academy and its director, complaining bitterly of their failure to duly acknowledge both his genius and his founding role in the institution. As a consequence, he was relieved of his official duties and his son Luis, who had personally delivered the printed diatribe, was expelled. The punishment had devastating consequences for the younger Meléndez, who was henceforth excluded from the privileges and opportunities conferred by the Academy. With only limited access to court patronage, Meléndez would be forced to earn his living as a painter of miniatures and a practitioner of the minor genre of still life painting.

In 1748, immediately after his expulsion from the Madrid Academy, Meléndez traveled to Rome and Naples to complete his training, perhaps with the intention of pursuing a career abroad. The trip was financed by his father, who recalled him to Madrid in 1752 to assist with an important commission for a set of choir books for the chapel of the new Royal Palace, a project that would take five-and-a-half years to complete. Luis Meléndez can be identified as the painter of twelve full-page miniatures and of numerous large initials, some of which are decorated with fruit still lifes.[2] Meléndez's earliest independent still life, dated 1759, was painted one year after the completion of the choirbooks and may indicate a conscious effort to develop an alternative source of income.

Luis Meléndez continued to paint still lifes throughout the 1760s, indeed the only record of his activities during this decade is a handful of signed and dated still life paintings, all of them with royal provenance. On January 6, 1771 Meléndez made a Christmas present of a number of his paintings to the Prince of Asturias (the future Charles IV) and thereby secured a verbal agreement to supply additional ones for Charles III's natural history collection. Within a year Meléndez had supplied between thirty-seven and forty-one paintings out of an eventual total of forty-four. The paintings, which bear dates between 1759 and 1773, were evidently assembled partially from the painter's stock. In 1772, in a second unsuccessful petition for a court appointment, Meléndez describes the program of the projected series as "the four Seasons of the year, or, more properly, the four Elements, with the aim of composing an amusing *Gavinete* with every species of food produced by the Spanish climate in the said Four Elements."[3] Precedents for such a collection, which were undoubtedly known to Meléndez, include a series of twenty-four rustic still lifes by Giacomo Nani for the Palace of San Ildefonso (La Granja) and a famous series of naturalist paintings by Bartolomeo Bimbi for Cosimo III de' Medici at the Casino della Topaia. Meléndez's proposed natural history of Spain was never completed, the commission having been terminated in 1776 over a payment dispute.[4]

The Wadsworth Atheneum's still life, one of more than one hundred painted by Meléndez between 1759 and 1778, is executed in a studied manner that recalls his academic training. Compositional sophistication and flawless technique combine to produce a distinctive, structured realism characterized by powerfully modeled objects against neutral backgrounds, viewed close-up from a low vantage point, and arranged with deliberate equilibrium and clarity. The fall of light is minutely observed and describes the texture of each object: the soft feathers of pigeons, the papery skins of onions, and the porous clay of simple crockery. Meléndez adjusted the carefully constructed composition at a late stage by painting out an onion that had been placed in front of the two pigeons. And yet for all Meléndez's precision and scientific rationalization, such a work is less a natural history of Spanish abundance than a *bodegón* descended from the larders of Sánchez Cotán and the rustic meals of Velázquez. The Hartford still life was probably painted in the early 1770s at a time when Meléndez's short-lived success at court attracted the attention of other clients. Paintings he made for the private market are consistent in quality and subject matter with those produced for the king. Some compositions were repeated with slight variations and certain motifs appear in more than one painting. The two pigeons at the center of the Hartford painting are exactly replicated in a still life in Raleigh (North Carolina Museum of Art), suggesting that Meléndez in some cases worked from model drawings or painted studies rather than life.

RK

Oil on canvas, 25 ⅛ × 32 ⅞ in.

The Ella Gallup Sumner and Mary Catlin Sumner Collection Fund, 1938.256

Signed: *L.ˢ M.ᶻ*

Provenance: Private collection, England; D.A. Hoogendijk & Co., Amsterdam; from whom purchased in 1938.

References: Gaya Nuño, 1958, 235, no. 1787; Tufts, 1969, pp. 60–72; Tufts, 1982, p. 158, no. 55; Tufts, 1985, pp. 95–6, 177, no. 65; Tufts and Luna, 1985, pp. 108–9, no. 28; Mallory, 1985, pp. 358–9; Cadogan, 1991, pp. 299–301.

Selected Exhibitions: Raleigh–Dallas–New York, 1985, no. 28.

34. Francisco Goya

Spanish, 1746–1828

Gossiping Women

c. 1792–6

The long career of Francisco Goya straddled two centuries and bore witness to a period of unprecedented social, political and cultural upheaval in Spain. Goya was painter to four Spanish kings and, during fifty years in Madrid, experienced the enlightened absolutism of Carlos III, the ineffective rule of Carlos IV, invasion and occupation by Napoleonic troops, the bloody Peninsular War and the reactionary despotism of Fernando VII. A prodigious painter, printmaker and draughtsman, Goya was also an artist of uncommon range – he painted portraits, decorated chapels, designed tapestries and famously gave reign to his imagination in his *Caprichos* and in small cabinet pictures.

Goya was twenty-nine years old when he was called to Madrid in January 1775 to paint cartoons for tapestries to be woven at the Royal Tapestry Factory of Santa Barbara. Apart from a short period of study in Italy, Goya's formative years were spent in his native Zaragoza, where he had recently completed an important fresco commission at the basilica of El Pilar and a series of wall paintings at the monastery of Aula Dei. The invitation to Madrid doubtless resulted from the intervention of Goya's brother-in-law, the court painter, Francisco Bayeu, who was also active as a designer of tapestries. The work of preparing cartoons for the numerous tapestries that decorated royal apartments at the Escorial and the Pardo palace was not highly esteemed and Goya became increasingly reluctant to paint them as his artistic reputation grew. By June 1792, when Goya delivered his last tapestry designs, he had painted a total of fifty-seven cartoons.[1]

Goya's *Gossiping Women* and its pendant, *Sleeping Woman* (fig. 34A), were once thought to have been cartoons for tapestries that were never woven.[2] Whether they were meant to be woven or not, the narrow horizontal format and low viewpoint of both paintings clearly indicate that they were conceived as overdoor decorations. The subject matter is likewise consistent with such a function and can be associated with the cartoons designed in 1780 for the Pardo bedroom antechamber. The Pardo tapestry depicting a sleeping laundress and the overdoor of a half-reclining girl waiting for her lover (*The Rendevous*) are

very much in the spirit of Goya's discreetly erotic *Gossiping Women*.

It is possible, though by no means certain, that the painting belonged to Sebastián Martínez, the wealthy Cádiz merchant in whose home Goya recuperated during the winter of 1792–3 from the devastating illness which left him deaf. During his six-month-long convalescence in Cádiz, Goya had access to Martínez's extraordinary art collection, one of the finest in Spain at the end of the eighteenth century. At the time of his death, Martínez owned 743 paintings, including works attributed to Titian, Rubens, Velázquez, Murillo and Zurbarán, as well as thousands of prints, drawings and books.[3] Martínez owned at least four paintings by Goya, including his own splendid portrait (New York, Metropolitan Museum of Art)[4] and three "caprichos or overdoors," first described by Nicolas de la Cruz, conde de Maule, in 1813[5]. The overdoors have long been identified with three paintings of reclining women: *Gossiping Women* (Hartford, Wadsworth Atheneum), *Sleeping Woman* (Madrid, MacCrohon collection) and *The Dream* (Dublin, National Gallery).[6] It should be noted that the Dublin painting, which can be more securely connected to the Martínez collection than the other two, has different dimensions and appears to be painted in a somewhat later style.[7] All three paintings, including the mildly suggestive *Gossiping Women*, are perfectly compatible with the taste for erotic art that earned Martínez the unwanted attention of the Inquisition in 1788–9.[8]

Martínez probably helped Goya obtain a commission from the Oratory of the *Santa Cueva* in Cádiz for three large lunettes depicting New Testament subjects. The paintings, which may have been ordered as early as 1792–3, were probably not painted until shortly before the Oratory was consecrated in early 1796.[9] Goya seems to have spent much of that year in Seville and its environs and, although he is documented in Cádiz in December and January of 1796–7, the exact purpose of the visit is unclear. Initially at least, he once again appears to have been convalescing at his friend's home.[10] The Hartford and Madrid overdoors, if indeed they were painted for Martínez's home in Cádiz, may be

connected with Goya's stay in the city during the winter of 1796–7. It is perhaps significant in this regard that the pose of the reclining woman in the Hartford painting is virtually identical to that of a reclining Apostle in the foreground of Goya's *Last Supper* for the Santa Cueva.[11]

RK

Oil on canvas, 23 ¼ × 57 ½ in.

The Ella Gallup Sumner and Mary Catlin Sumner Collection Fund, 1929.4

Provenance: Possibly Sebastián Martínez (1747–1800), Cádiz[12]; Marchioness of Bermejillo del Rey, Madrid; Kurt M. Stern Inc., New York; Viscount Bernard d'Hendecourt, Paris; Durlacher Brothers, New York, 1929; from whom purchased in 1929.

References: Cruz y Bahamonde, 1813, vol. 13, p. 340; Mayer, 1923, p. 213, no. 631, pl. 22; Desparmet Fitz-Gerald, 1928, vol. 1, p. 215, no. 179; 1950, vol. 3, pl. 141; Sambricio, 1946, p. 173; Trapier, 1964, pp. 8–9; Gudiol, 1970, vol. 1, p. 287, no. 321, vol. 3, figs. 454–5; Gassier and Wilson, 1971, p. 100, no. I.307, and p. 106; Angelis, 1974, p. 104, no. 243; Pemán, 1978, p. 56; Camón Aznar, 1980–2, pp. 2, 90, 207; Sullivan, 1982, pp. 50–1, no. I.5; Zueras Torrens, 1989, p. 77; Cadogan, 1991, pp. 288–9; Tomlinson, 1991, pp. 59, 61–2; Tomlinson, 1992, p. 123; Morales y Marín, 1994, p. 222, no. 214; Luna and Moreno de las Heras, 1996, pp. 355–6, no. 77; Lee, 2001, pp. 6 and 10; Tomlinson, 2002, pp. 214–15, no. 48.

Selected Exhibitions: New York, 1936a, no. 2; The Hague, 1970, no. 4; Dallas, 1983, no. I.5; Madrid, 1996, no. 77; Washington, 2002, no. 48.

Fig. 34A. Francisco Goya, *Young Woman Asleep*, *c.* 1792, oil on canvas, 23 × 56 ⅔ in. MacCrohon Collection, Madrid

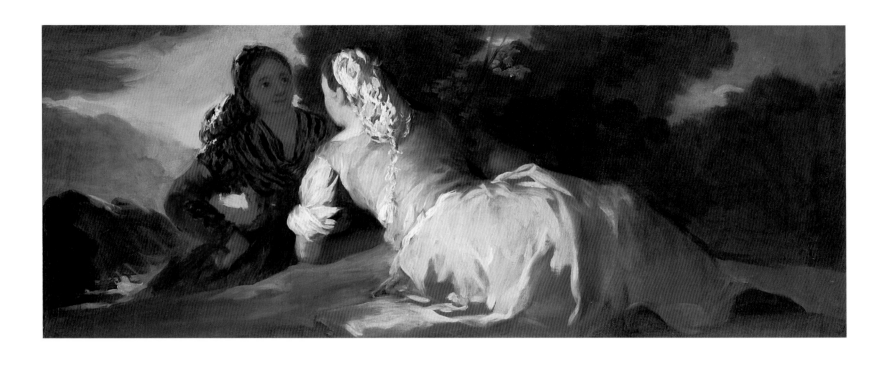

35. Cornelis van Poelenburgh

Dutch, 1594–1667

The Feast of the Gods

1623

Poelenburgh (or sometimes Poelenburch) was born and died in Utrecht where his father was Canon of the cathedral. But a great deal of his career was spent away from Holland, and he was in fact one of the leading members of the first generation of Dutch Italianate painters. After receiving early training from Abraham Bloemaert in Utrecht and the Pre-Rembrandists in Amsterdam, he was documented in Rome by 1617 and remained in Italy until 1626. In Rome he was one of the founding members in 1623 of the Dutch and Flemish artists' brotherhood. While there Poelenburgh was much influenced by the landscapes of Paul Brill and the small detailed works of Adam Elsheimer. The style that Poelenburgh perfected, primarily also in small format, for genre subjects as well as religious and mythological ones was of delightful, detailed landscapes, sometimes interspersed with classical ruins, and highly finished, rather squat figures in poses often taken from antique prototypes. These precious, polished works brought him employment with eager noble patrons, first in Italy at the Medici court of Cosimo II and then later in his life, between 1637 to 1641, at that of Charles I in London.

Of mythological subjects one of Poelenburgh's favorites was *The Feast of the Gods*,[1] and this example, formerly in the distinguished Schönborn collection, is one of the finest. It was Frits Duparc who first noted the hidden date, which places it early in the artist's career and while he was still in Italy. The composition, with the gods of antiquity arranged around a table, is clearly derived from Raphael's fresco of *The Marriage of Cupid and Psyche* at the Farnesina in Rome. As to its specific content, it appears that this is a moment of great importance for both mythological and human beings during the marriage of Peleus and Thetis when the goddess of Discord, angered at being excluded, threw an apple marked "for the fairest" on to the table. Jupiter accompanied by his eagle is seated at the head of the table at the right and points with his scepter toward the apple of dissension, making his proclamation that it will be awarded according to the choice of the Trojan youth Paris to one of the three prominent goddesses, each identifiable by her attribute: Juno next to Jupiter with her peacock, the nude Venus seen from the back with Cupid, and standing at the end of the table, Minerva in full armor. Also in attendance are Mars wearing armor, Apollo with his lyre, Diana with the crescent moon on her brow, Neptune with his trident, Saturn with the scythe, Hercules with his club, Bacchus with a cup of wine, and Silenus with a wine jug.

The lineup of fleshy deities supported only on fluffy clouds seems a miraculous accomplishment and provides a marked contrast to the delicate landscape vista glimpsed below.

EZ

Oil on panel, 12 ½ × 19 in.

Monogrammed and dated on the scythe: *CP 1623*

The Ella Gallup Sumner and Mary Catlin Sumner Collection Fund, 1940.24

Provenance: The Counts Schönborn, Pommersfelden, by 1719–1867; sale Hôtel Drouot, Paris, May 17–24, 1867, no. 90; Paris art trade; Harry G. Sperling, New York; Arnold Seligmann, Rey, and Co., New York, 1940; from whom purchased.

References: Haverkamp-Begemann, 1978, p. 173, no. 115; Sluijter-Seijffert, 1984, pp. 82, 84, 92, 131–2, 227, no. 32, fig. 5.

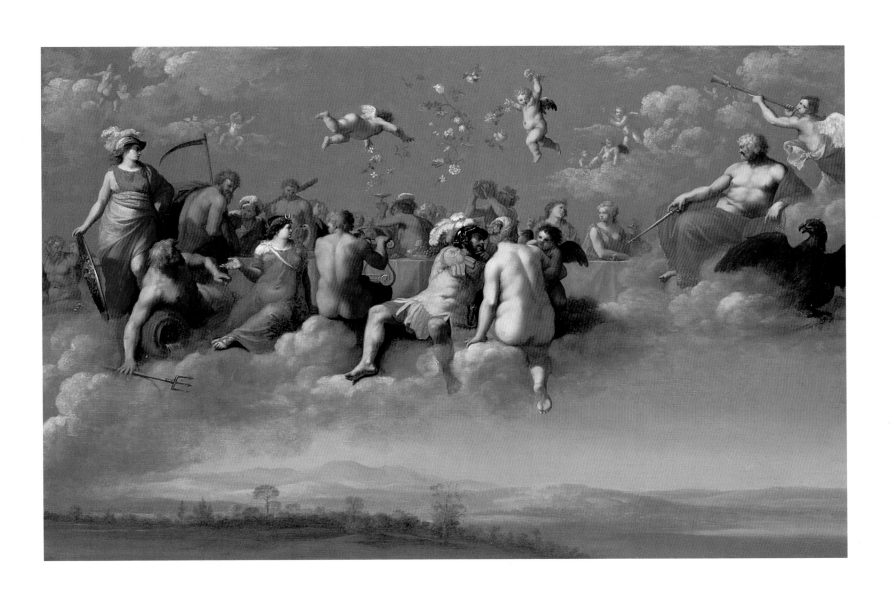

36. Abraham Bloemaert

Dutch, 1564–1651

Neptune and Amphitrite

c. 1630–5

Born in Gorinchum, south of Utrecht, in 1566, Bloemaert travelled to Paris and spent two formative years in Amsterdam before settling in Utrecht. He was essentially self-taught. His early work was strongly influenced by the Haarlem mannerists, especially the prints of Hendrick Goltzius and through him the work of Bartholomeus Spranger (1541–1611). Although mannerist forms lingered longer in Bloemaert's work than in that of many of his contemporaries, his later works are more classical in both composition and figure type.

This is the last, and most classical of three paintings of the realm of Neptune that Abraham Bloemaert completed in Utrecht between about 1625 and 1635.[1] In all three the sky is divided into two zones of light: dark clouds on the left, bright, blue sky on the right. In the mannerist Stockholm and Utrecht versions, Neptune stands in the distant right, leaving the right side and the foreground to a writhing sea of nude tritons and nereids. In the Hartford painting, however, Neptune occupies the dramatically lit compositional center, balanced on the left and right by subsidiary figures. Seated sideways on a conch shell, he twists around and stares intensely at the viewer as a nereid, often identified as Amphitrite, steps off of a dolphin and embraces the ancient god of the sea, visually assisted by the diagonal line of the dark storm cloud behind her. She is framed by red and yellow drapery and surrounded by tritons and nereids. Above them, putti suspend a floral wreath and cast flowers down around them, while in the brightly lit sky on the right Cupid readies his arrow to shoot at the amorous couple. To the right and in front of Cupid, the elegant figure of Venus, crowned with a floral wreath and clothed only in a billowing green drapery, stands on a shell, her face turned away from the central group. An oil sketch (art market 1991), which Roethlisberger dates 1645–50, rethinks the basic elements of the Hartford painting, focusing on the central group of Neptune and a nymph.[2]

The subject of the painting has in the past been identified as the triumphal return and betrothal of Amphitrite to Neptune.[3] The nereid Amphitrite had attempted to escape Neptune, but the amorous sea god sent a dolphin to retrieve her. Marcel Roethlisberger, noting the similarity of Bloemaert's

images to a print by Jacob Matham after Bartholomeus Spranger (1541–1611) (fig. 36A), convincingly identifies the subject of Bloemaert's paintings as the "Triumph of Venus in the Realm of Neptune," a theme not explicitly described in a classical text but represented on Roman sculpture.[4] The caption of the Matham print extols the power of Venus over the realm of Neptune and credits her with the ability to quiet storms. The mannerist print, which represents the standing figure of Neptune in the distance, is compositionally closest to Bloemaert's paintings in Stockholm and Utrecht but also explains the prominent placement of the figure of Venus in the Hartford painting, in which she stands against the brightest area of the sky, apparently having quieted the distant storm.

Bloemaert's figures in the Hartford painting are, in general, more classically proportioned than in the earlier examples of the subject. Neptune, whom Spranger/Matham represent with knobby muscles, appears in Bloemaert's painting with classical but not robust physique. He bears familial relationship to that in the Spranger/Matham print, where Neptune is represented with a long, straggly beard and hair. Bloemaert appears, however, to have developed the figure of Neptune from sketches of old men made from life: two views of the head of an old, disheveled man on a sheet of drawings in the Fitzwilliam Museum, Cambridge.[5]

ALW

Fig. 36A. Jacob Matham after Bartholomeus Spranger, *The Triumph of Neptune and Thetis*, engraving, 10 × 15 ¾ in. Private Collection

Oil on canvas, 49 ¾ × 55 ¼ in.

Signed at lower right corner: "*A Bloemaert, fe* [AB in monogram]

Gift of Arthur L. Erlanger, 1964.223

Provenance: Possibly Guérin sale, The Hague, 13 September 1740, no. 63; Anonymous W[illem]. Hekking Fils sale, Amsterdam, Hôtel "De Zon," 20 April 1904, no. 2; Anonymous sale, Brussels, Palais des Beaux-Arts, 27–8 February 1933, no. 150; Private Collection, Amsterdam; Julius Böhler, Munich; Arthur L. Erlanger, New York.

References: Haverkamp-Begemann, 1978, pp. 119–20; de Bosque, 1985, pp. 274–5; Roethlisberger, 1993, vol. I, pp. 277, 299, 328, 350, 413, no. 457, pl. XXII; Seelig, 1997, p. 302, no. B165.

Selected Exhibitions: Poughkeepsie, 1970, no. 7; St. Petersburg, 2001, no. 13.

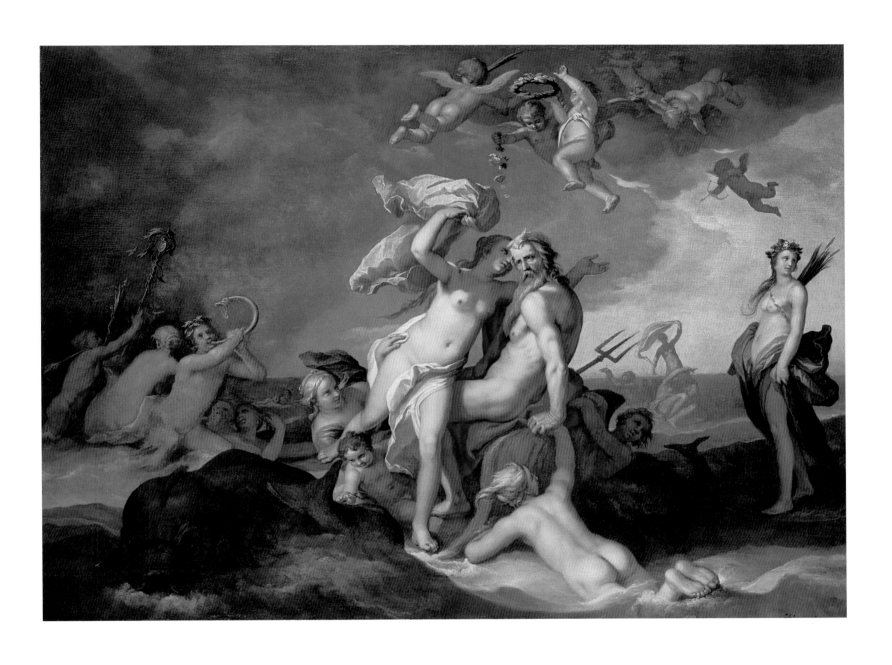

37. Anthony van Dyck

Flemish, 1599–1641

The Resurrection

c. 1631–2

Van Dyck was a painter of the utmost precocity. At the age of ten he became an apprentice to Hendrick van Balen in his hometown of Antwerp and at nineteen was a member of the city's Painters' Guild; and at twenty he became an associate of Flander's leading artist, Peter Paul Rubens, who described the youthful van Dyck as his most talented assistant. In 1621 Van Dyck left Antwerp for a six-year sojourn in Italy where he worked primarily as a portraitist for the noble families of Genoa. After a brief return to Antwerp, he was invited to England in 1632. There he was knighted and made court painter to Charles I. Although he painted some religious and mythological subjects during this time, Van Dyck is best known for his elegant portraits of the royal family and their courtiers, which established a standard of official portraiture for centuries to come.

Van Dyck returned from his Italian sojourn to Antwerp in 1627 and remained there before departing for England in 1632. During much of this so-called Second Antwerp Period, Rubens was abroad carrying out diplomatic missions, so the younger artist benefited by receiving many commissions for religious works, not only for churches, but also for private chapels or homes. It was most likely for this latter purpose that the Atheneum's vivid *Resurrection* was conceived. As Jaffé has pointed out, Van Dyck would have been familiar with Italian baroque prototypes for this subject, but as the Princeton exhibition catalogue commented, it was especially Rubens' depiction of the same theme in the *Breviarium Romanum* of 1612–14 that provided a direct source for Van Dyck. Most effectively he took over the older master's diagonal division of the composition with Christ ascending on one side and the sleeping and distraught soldiers on the other. To this theme, however, Van Dyck brought his characteristic grace and fluidity. Possibly because the work is partly unfinished, there is much less attention paid to background detail or trying to define the tomb. Instead the emphasis is on the contrast of the heavy, earthbound soldiers and the elegant, even marbleized, figure of Christ ascending with an elegant gesture of his hand. Through this contrast, as well as the brilliance of the divine light, Van Dyck made the miracle of the Ressurection convincingly real.

EZ

Oil on canvas, 44 ¾ × 37 ⅛ in.

The Ella Gallup Sumner and Mary Catlin Sumner Collection Fund, 1964.1

Provenance: Cardinal Fesch, Bonn and Rome; sale Palace of Cardinal Fesch, Rome, March 25, 1844, no. 66; M. Moret, Paris; sale Hôtel des Commissaires-Priseurs, Paris, February 12, 1857, no. 4; Adolphe Joseph Bösch, Vienna; sale Villa Bösch, Vienna, April 28, 1885, no. 13; bought in by Mme. Bösch and with her until at least 1892; Carl von Hollitscher, Berlin, by 1910; Camillo Castiglioni, Vienna; sale Frederick Muller and Co., Amsterdam, November 17–20, 1925, no. 58; bought in; Castiglioni sale, Ball and Graupe, Berlin, November 28–9, 1930, no. 44; Marczell von Nemes (?); Ernest Cohn, Bremen and Scarsdale, 1946; Frederick Mont, New York, 1963; from whom purchased.

References: Glück, 1931, pp. 251 and 545; Jaffé, 1964, pp. 1–7; Haverkamp-Begemann, 1978, no. 42; Larsen, 1980, p. 105, no. 719; Larsen, 1988, I, pp. 259, 430, fig. 228 and II, pp. 291–2, no. 733; Moir, 1994, pp. 28 and 92, pl. 23.

Selected Exhibitions: Brussels, 1910, no. 164; Los Angeles, 1946, no. 56; Princeton, 1979, no. 45.

38. Balthasar van der Ast

Dutch, 1593/4–1657

Still Life with Shells and Fruit

c. 1630–40

Born in Middleburg *c.* 1593, Balthasar van der Ast probably studied painting with his brother-in-law, the flower still-life painter Ambrosius Bosschaert the Elder (1573–1621), whose work and technique of using glazes to achieve subtle variations in tone influenced his early work. Following the death of his parents, Van der Ast lived with his sister and Bosschaert in Middleburg before moving with them to Utrecht, where he registered as a master in the painters' guild in 1619, the same year as Roelandt Saverij (1578–1639). The youthful Jan Davidsz. de Heem (1606–39) was Van der Ast's student in Utrecht. In 1632 Van der Ast left Utrecht and registered in the guild at Delft, where he died in 1657. Throughout his career Van der Ast specialized in still life. The majority of his signed works date before 1632.

Still Life with Shells and Fruit is one of a small group of paintings by Van der Ast in which shells are the primary subject and the fruit is incidental; other still lifes of shells are in Dresden, Rotterdam, and The Hague.[1] Although Van der Ast, like Bosschaert, includes shells as accessories in many of his flower and fruit still lifes, such as *Still Life with Fruits and Flowers, c.* 1630 (Pasadena, Norton Simon Museum), the independent still life of shells is Van der Ast's own invention. Neither the Hartford painting, nor the other shell still lifes are dated. The low horizon and the overall tonal quality of the Hartford painting suggest that Van der Ast painted it after his move to Delft in 1632. Typical of his horizontal still lifes, the shells and the few pieces of fruit lie on a table the front edge of which is brought close to the picture plane, so that pieces of fruit hanging over the edge of the table seem to enter the viewer's space. A butterfly flying above the shells animates the still life and contributes to the sense of space also suggested by the subtle variation of the background to indicate the diagonal fall of light on the wall. The large scale of the shells relative to the space and the greater cohesion of the composition in which the overlapping shells form a loose pyramid distinguish the Hartford painting from the Rotterdam painting in which the shells are loosely scattered on the table. The Dresden painting more fully develops the devices of vines and crawling lizards Van der Ast used in the Hartford painting to define space.

Van der Ast renders the shells with naturalistic accuracy that allows the identification of the individual shells. In the Hartford painting the shells are (left to right) *Murex ramosus* (Indo-Pacific), *Lambis Chiragra* (Indo-Pacific), *Cittarium piea* (W. Indies), *Charonia tritonis* (Indo-Pacific), *Trochus marmoratus* (Indo-Pacific), *Cassus tuborosa* (W. Indies), and *Nautilus pompilius* (Indo-Pacific).[2] The reappearance of specific shells in different orientations in Van der Ast's paintings suggests that he worked directly from life rather than from drawings. It is likely that he had his own collection of shells.

The visual accuracy of the shells in Van der Ast's paintings would have appealed to collectors and connoisseurs of the rare specimens of nature.

Admired for both their beauty and scientific interest, shells from the warm waters of the West Indies and South Pacific, souvenirs of distant, exotic lands, were coveted by both princes and scholars during the seventeenth century when a rare shell could cost the modern equivalent of thousands of dollars. The title to an emblem published by Roemer Visscher in 1614 representing shells on a beach refers to the mania for collecting shells: "It's sickening how a fool spends his money." The text continues the theme: "It is surprising that there are people who spend large sums of money on shells and mussels, whose only beauty is their rarity. They do it because they notice that great potentates, even Emperors and Kings, commission people to look for them and pay them well . . . I do not mean to condemn the people who earn their living from this: they are cunning enough to see a profit in this game."

The lizard crawling on the central shell, the butterfly and ripe fruit in Van der Ast's painting are common allusions to transience and thus to the vanity of earthly possessions, however, it is unlikely that contemporaries viewed the painting as a moralizing image counseling against frivolous spending. Rather than condemn, Van der Ast's paintings of beautiful, exotic shells, which were themselves objects of vanity, seem to celebrate the beauty and scientific appeal of the actual objects for which they could, in some ways, substitute

ALW

Oil on panel, 26⅝ × 42 in.

The Ella Gallup Sumner and Mary Catlin Sumner Collection Fund, 1937.491

Provenance: P. Smidt van Gelder, Jr., Amsterdam; sale, Geneva, Galerie Moos, 7 April 1933, no. 2; Friedrich Camphausen, Krefeld; estate sale, Cologne, Lempertz, 8–11 December 1936, part 2, no. 961, pl. 42; Pieter de Boer, Amsterdam; from whom purchased in 1937.

References: Bergström, 1956, p. 301; de Mirimonde, 1964/5, p. 240, fig. 5b; Haverkamp-Begemann, 1978, p. 114; Zafran, 1978, p. 243.

Selected Exhibitions: Hartford, 1938, no. 9; Baltimore, 1971–2, no. 12.

39. Aelbert Cuyp

Dutch, 1620–91

Wooded Landscape with an Artist

c. 1643

One of the masters of the Dutch Golden Age renowned for his light filled land and sea scapes, Aelbert Cuyp, was able to marry well in 1658 and gave up painting in his later years. He had been trained by his father, and although he traveled seeking picturesque motifs along the Rhine, Cuyp made his career wholly in his hometown of Dordrecht. During his lifetime he was little known beyond there, but during the eighteenth century his works became extremely popular, especially in England.

This grand scene is the only known woodland subject by the painter. It is also an unusual work in that it combines the activities of elegantly attired gentry – strolling and riding by the forest – with more humble individuals, most notably the artist, seen at the lower right corner busily sketching the scene before him. One would assume that this is the landscape near to Dordrecht, where Cuyp, in the approved manner of educated seventeenth-century artists would go to make studies from nature. Several drawings by Cuyp of comparable paths and rows of trees do exist,[1] although none is precisely a preparatory study for this painting. This work is so unusual in Cuyp's œuvre, that until the signature was discovered, it was not generally believed to be fully by him.[2] The composition does not present his typical open, sweeping distant vista, but merely hints at such a view by placing a tiny, seated figure at the far left. Here instead he creates a dramatic contrast between the Y-shaped path opening up the foreground and the dense screen of twisting trees into which it leads the eye. This evocation of powerful natural forces calls to mind works by the greatest Dutch painter of forests, Jacob van Ruisdael (cat. no. 46).

EZ

Oil on canvas, 38 ¾ × 53 ⁹⁄₁₆ in.

Signed at lower right: *A. cuyp f.*

The Ella Gallup Sumner and Mary Catlin Sumner Collection Fund; The Douglas Tracy Smith and Dorothy Potter Smith Fund; The Evelyn Bonar Storrs Trust Fund; and by exchange, 1996.26.1

Provenance: Miss P. M. Young, Faringdon, 1942; Thomas Agnew and Sons, London; Professor Singer, London; P. de Boer, Amsterdam, by 1954; Mrs. Morris Dalinon; sale, Sotheby's, March 27, 1968, no. 49; sale, Sotheby's July 13, 1977, no. 15; Noortman Gallery, Maastricht, by 1996; from whom purchased.

References: Stephen Reiss, *Aelbert Cuyp*, New York, 1975, p. 104, no. 69.

Selected Exhibitions: Washington et al., 2001, no. 11.

40. Frans Hals

Dutch, *c.* 1581/5–1666

Portrait of Joseph Coymans

1644

The leading portrait painter in Haarlem during the second quarter of the seventeenth century, Frans Hals was born in Antwerp in 1582 and moved with his family to the Northern Netherlands in 1585; residing in Haarlem by March 1591. Hals studied with Karel van Mander but did not enter the painters' guild of Haarlem until 1610, the year of his marriage to Anneke Harmens. Known for his innovative portraits of the militia companies and regents of Haarlem, Hals was a member of the St. George Civic Guard, between 1616 and 1624, as well as of the rhetorician group "De Wijngaertrancken." In 1617, following the death of his first wife in 1615, Hals married Lysbeth Reyniersdr. In addition to his activity as a painter, Hals was also a dealer and in 1644 became an inspector of the Guild of St. Luke in Haarlem.

Like Hals, Joseph Coymans (1591–1677) was the child of refugees from Antwerp. In October 1592 the family settled in Amsterdam, where his father, Balthasar Coymans (1555–1634), founded the Coymans Trading Company, later joined by his sons Balthasar (1589–1657) and Joan (1601–34).[1] The firm was extremely successful; by 1645 their transactions totaled an incredible 4,140,00 guilders.[2] In 1616 in Dordrecht, Joseph Coymans of Amsterdam married Dorothea Berck (1593–1684), the daughter of Johannes Berck and Erkenraadt van Brederode. By 1619, Joseph was one of the leading entrepreneurs in Haarlem. Among other ventures, he owned a number of bleaching operations in the vicinity of Bloemendaal and Saantpoort, as well as others north of Haarlem on the Jan Gijzenvaart. He was clearly prosperous. In 1650 he and his family lived in two large houses in the Zijlstraat, Haarlem, and when he died in 1677, Joseph Coymans was buried in a grand tomb covered with a large sculpted tombstone in the Brouwerskapel of the Groote Kerk (St. Bavo), Haarlem.

Frans Hals painted pendant half-length portraits of Joseph Coymans and Dorothea Berck (Baltimore Museum of Art; fig. 40A) in 1644. Following portrait convention, Joseph assumes an open pose that suggests a more active personality and social role than his wife. Turned so that he regards the viewer over his right shoulder, his arched eyebrow and fully illuminated face engage the viewer. Joseph Coymans wears the cloak, hat and gloves of a prosperous gentleman about to step out of his home into the busy commercial life of the city. The three cattle heads in the crest that seems to hang on the back wall refer to his name, Dutch for "cow man."

Hals treated the visual impression of the picture as an entirety so that light plays across the forms in a seemingly haphazard way while capturing and animating the facial expression and gloved hand. Hals varies his brushstrokes to emphasize the different personalities of the husband and wife. While blended brushstrokes contribute to Dorothea's stable, refined appearance, lively, independent brushstrokes suggest the dynamic personality of Joseph Coymans. Played off against the subtle gradations of black and white in the massive cloak and collar, the freely rendered brushstrokes used to render the glove, face and hair seem to resonate with light to create a sense of fleeting reality.

Joseph Coymans and his family were part of a close-knit network of prosperous, commercial, regent families, many of whom were portrayed by Frans Hals. Hals also painted portraits of other members of the Coymans family; the year following the portraits of Joseph and Dorothea, Hals painted a portrait of Joseph's nephew Willem Coymans (1623–78) (Washington, National Gallery of Art).[3] In the early 1650s Hals painted two of his most masterful portraits of Joseph's daughter Isabella (Paris, Baron Edouard de Rothschild Collection) and her husband, the Amsterdam merchant Stephanus Geraerdts (Antwerp, Koninklijk Museum voor Schone Kunst), in which the sitters turn and address each other as if in animated conversation.[4] The coincidence of Isabella and Stephanus's marriage in 1644 and the date of the portraits of her parents has suggested to some scholars that Joseph Coymans may have commissioned the portraits as wedding gifts for their daughter. Based on his analysis of inventories made of the possessions of Dorothea Berck in 1681 and following her death in 1684, however, Pieter Biesboer has suggested that the portraits of Joseph and Dorothea actually remained in her collection.[5] In 1681 her collection included as items 64 and 65 two paintings identified only as "Frans Hals." In 1684, the collection, which was then housed in the residence of Balthasar Coymans, where Dorothea was living at the time of her death in 1684, included an unidentified portrait by Frans Hals (item 5) and "2 portretten van de overledene en haer man za:" (item no. 15), which Biesboer assumes are the portraits by Hals. The portraits were already separated in the nineteenth century, when that of Dorothea belonged to Frederick Wollaston, London. Hals's portrait *Willem Coymans*, which was previously identified as Balthasar Coymans, the son of Joseph and Dorothea, was also in the Wollaston collection, raising the question whether the National Gallery's portrait could be the unidentified painting by Frans Hals (item 5) in the 1684 inventory and whether the two paintings could have remained together since the seventeenth century.[6] Both paintings passed through Sedelmeyer, Paris, and then to Rodolphe Kann (d. 1905), Paris, while the portrait of Joseph passed through the collection of James Carnegie (d. 1905) in the 1850s, eventually entering the collection of Rodolphe's brother, Maurice Kann. The brothers lived in adjacent mansions in Paris; the second floor of each house was reserved for the display of their art collections. Connecting doors made it possible to join the areas into a single, large gallery.

ALW

Oil on canvas, 33 × 27 ½ in.

Inscribed and dated at upper right: ÆTA SV Æ 52/1644

The Ella Gallup Sumner and Mary Catlin Sumner Collection Fund, 1958.176

Provenance: Commissioned by Joseph Coymans, probably bequeathed 1677 to his wife; Dorothea Berck, Haarlem (1593–1684) to her son;[7] Balthasar Coymans (1618–90), Haarlem; [William] Forrest, London; sold October 1850 to Sir James Carnegie (d. 1905), Bart., and after 1855 9th Earl of Southesk, Kinnaird Castle, Angus, Scotland;[8] Maurice Kann, Paris; sold 1908 to Duveen Brothers, London, until at least 1909; Dowdeswell, London, 1911; Reinhardt Galleries, New York, 1913; John North Willys, Toledo and New York; by descent to Mrs. Isabel Van Wie Willys, New York; sale Parke-Bernet, New York, 25 October 1945, no. 17; Louis and Mildred Kaplan, New York, by 1950; from whom purchased in 1958.

References: Slive, 1970, vols. I and II, pp. 139, 170, 172, 185, figs. 178, 183, p. 243; Grimm, 1972, pp. 106, 205, cat. no. 125, fig. 140; Slive, 1974, vol. III, no. 160, pp. 81f., 147; Haverkamp-Begemann, 1978, pp. 147–50; Zafran, 1978, p. 243; London, 1989, p. 322–3, fig. 68a; Grimm, 1990, cat. no. 120, pp. 106–7, 193–4, fig. 71a; Wheelock, 1995, p. 78; Biesboer, 2001, pp. 260, 278–80.

Selected Exhibitions: London, 1909–10, no. 36; Toledo, 1913, no. 76; New York, 1939, no. 6; Haarlem, 1962, no. 52.

Fig. 40A. Frans Hals, *Dorothea Berck*, 1644, oil on canvas, 32 ⅝ × 27 ½ in. The Baltimore Museum of Art, The Mary Frick Jacobs Collection, 1938.231

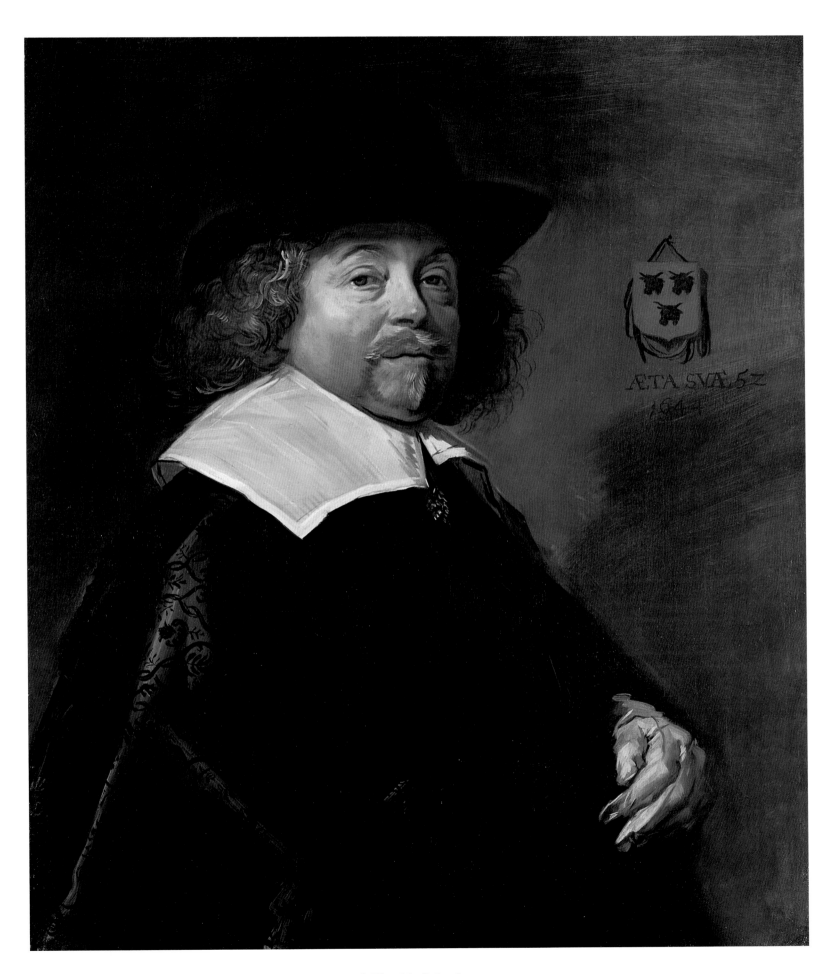

ÆTA SVÆ 52
1644

41. Jan Miel

Flemish, 1599–1663

Carnival in the Piazza Colonna, Rome

c. 1645

Born in Beveren near Antwerp in 1599, Jan Miel probably moved *c.* 1633 to Rome, where he is first documented in 1636. Two paintings dated 1633 depict Roman street scenes (*bamboсciate*) similar to those by the Dutch painter Pieter van Laer, who had been in Rome since 1625/6. Soon after his arrival in Rome, Miel joined the society of northern artists known as the *Schildersbent* and adopted the name "Bieco." In contrast to most of the Netherlandish artists in Italy, who returned to the North after several years, Miel stayed in Italy until his death. While never totally abandoning the painting of *bamboociate*, at mid-career Miel turned increasingly to large-scale history paintings and frescos influenced by Andrea Sacchi and Nicolas Poussin as well as Correggio and Carracci. His reorientation to more classical subjects and style may have been in response to the prevailing taste of his Roman patrons. Miel, who enjoyed noble patronage in Rome, spent the last five years of his life in Turin in the service of Duke Carlo Emmanuele II, who awarded him a knighthood of the order of Saint Maurice and Saint Lazarus in 1663.

Writing in defense of the *bamboociate* Filippo Baldinucci (1625–97) provided important descriptions of pictures he had personally seen or been told about. Among those is a *bambocciati* representing the Corso and the Carnival Masquarade painted by Jan Miel for the Marchese Raggi.[1] The painting was one of a series of five scenes of daily life mentioned in the collection of the heir of the Marchese in 1701 and 1710 and later described in detail in the catalogue of Count Sellon d'Allaman of Geneva, where all five are attributed to Miel.[2] The description of the Carnival painting corresponds exactly to the Hartford painting:

> On canvas, 2 feet 10 inches by 5 feet 6 inches. In a Roman piazza decorated with the Antonine column, innumerable scenes of carnival are represented, Groups of masked figures of all kinds appear with soldiers of the Swiss guard in full costume including one hung from the gallows. The different groups are drawn and composed with great spirit and wit. The main characters are noble and graceful, their manners picturesque. The color and composition leave nothing to desire.[3]

The other four paintings in the series (now lost), had the same oblong format: they are described as "soldiers playing dice near a fountain, beggars and peasants dancing near Roman walls, a fair behind St. Peter's with a view of Monte Mario, and '. . . the most interesting monuments of ancient Rome . . . with picturesque figures."[4]

Tommaso Raggi (1595/6–1679) probably commissioned the group of five paintings in the mid-1640s.[5] The Raggi family from Genoa, were important art patrons in Rome during the 1640s, when both Tommaso's brother and nephew were elected cardinals.[6] The scale and format of the Hartford painting and its companions suggest that they hung as over doors, probably in Raggi's palazzo under the Campidoglio in Rome.[7] A date of *c.* 1645 for the painting is consistent with the family's interest in the Roman Carnival. According to a contemporary

source, the Raggis were sponsors of one Carnival event and participants in others during the second half of the 1640s.

Anticipating later *vedute, Carnival in the Piazza Colonna* represents a specific place. The Piazza Colonne, the traditional center of Rome, is dominated by the ancient Roman column of Marcus Aurelius surmounted by a gilt bronze statue of St. Paul, which was added in 1589 for Pope Sixtus V. Bounded on the east by the Via del Corso, the view is south toward the Palazzo Bufalo-Ferrajoli and the church of Santa Maria della Pietà (later Bartolommeo dei Bergamaschi), which are still standing. The buildings on the east and west sides of the piazza were removed and replaced at the end of the seventeenth century. The sunlit buildings provide the stage setting for the annual celebration of Carnival before the start of Lent. An effigy hanging from the gallows in the middle ground on the left, a ritual of the last day of Carnival, symbolizes the end of winter. Masked and extravagantly dressed carnival revelers on horseback and in carriages pour into the shadowed piazza from all directions, joining the throng of people and animals animated by flickering light. The painting is composed in terms of numerous vignettes. Along the periphery, peddlers, beggars and prostitutes carry out their business as usual while members of the papal Swiss Guard and performers of the *commedia del arte*, including the characters Harlequin and Scaramouche, the Doctor, and Pulcinella, provide anecdotal interest in the center of the large painting. Typical of *bambociatte*, Miel includes children and animals to add to the excitement and activity of the scene, which he introduces and anchors with a man seated in the lower left corner who looks at the viewer and points inward. The opposite corner is likewise anchored by a fortune teller and beggars gambling.

ALW

Oil on canvas, 35 × 69 ¼ in.

The Ella Gallup Sumner and Mary Catlin Sumner Collection Fund, 1938.603

Provenance: Marchese Tomasso Raggi (1595/6–1679), Rome, from *c.* 1650, by descent 1679 to; heirs of Marchese Raggi, until at least 1710;[8] Count Jean Sellon d'Allaman, Geneva and château d'Allaman, in Suisse Pays de Vaud, in 1795; Karl Loevenich Gallery, New York, by 1932 until at least 1936; J.B. Neumann, New Art Circle, New York; from whom purchased in 1938 (as Pieter van Laer).

References: Baldinucci, 1681/1728, vol. VI, p. 367; Waterhouse, 1962, p. 62, fig. 55 (as by van Laer); Haverkamp-Begemann, 1978, pp. 162–4; Zafran, 1978, p. 245, fig. 9; Kren, 1979, vol. 1, pp. 5–6, 94–5, 209, cat. A15; Levine and Mai, 1991, p. 226.

Selected Exhibitions: New York, 1932; Los Angeles, 1936, no. 10; Oberlin, 1952, no. 9; Pittsburgh, 1954, no. 21; Rotterdam–Rome, 1958–9, no. 92; Philadelphia–London, 1984, no. 73.

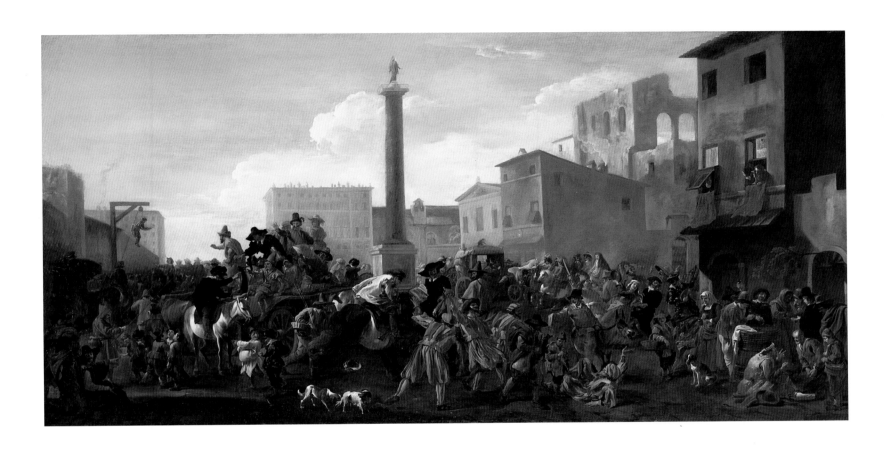

42. David Teniers the Younger

Flemish, 1610–90

A Mass in a Grotto

c. 1645–50

Teniers the Younger was the most talented member of a large family of artists living in Antwerp and he married into another dynasty of painters when in 1637 he wed Anna, daughter of Jan Breughel the Elder. Teniers made his reputation as a painter of genre scenes, at first inspired by the drinkers and brawlers of Adriaen Brouwer but eventually expanding his repertoire to include kermesses, soldiers, alchemical scenes, extensive landscapes, and even some portraits. In 1651 Teniers was appointed court painter to Archduke Leopold William, the Governor of the southern Netherlands, and he soon moved to Brussels where he lived in grand style and was ennobled in 1663. Among his major late achievements were depictions of the Archduke in his art gallery and also a series of brilliant tiny copies of works in the archducal collection.

Rocky grottoes appear in a great many of Teniers' paintings as backdrops for saints or genre subjects.[1] His employment of this motif derives from the earlier examples of Joos de Momper the Younger, Paul Brill, and to some extent Pieter Breughel the Elder and Joachim Patinir. The rocky cave-like settings provide properly gloomy spaces to contrast with pious scenes, and the performance of a mass in a grotto shrine was also a subject of the earlier Flemish artists.[2] There are indeed a good number of grotto scenes by Teniers in which he, as here, depicts an isolated roadside Cross.[3] In the present painting, which with its light pastel tonalities seems to date from late in his Antwerp period, the Cross forms the centerpiece of the composition. The dark recess of the grotto encompasses an actual mass performed by a priest and acolytes in the depth of the cave, so that the magnificence of the natural world overwhelms the paltry scale of human activity. But Teniers makes a point of including as participants a wide range of social classes from elegantly attired gentlemen to rustic peasants.

EZ

Oil on canvas, 64 ½ × 90 ⅛ in.

Monogrammed on the rock at the lower right: *DT F*

Gallery Fund by exchange, 1991.3

Provenance: Gunnar Sadolin collection, Copenhagen; sale, Rassmussen, Copenhagen, November 8–9, 1977, no. 279; Trafalgar Galleries, London, by 1978; Imelda Marcos, Manila; seized by U.S. government; sale Christie's, New York, January 11, 1991, no. 84; from whom purchased.

Selected Exhibitions: Brussels, 1980, no. 217.

43. Johannes Jansz. van Bronchorst

Dutch, 1627–56

Aurora

c. 1655

Long attributed to Jan Gerritsz. van Bronchorst (*c.* 1603–61), *Aurora* is now, due to the researches of Thomas Döring, recognized as the masterpiece of his son, Johannes Jansz. van Bronchorst, closely related to the *Jupiter and Juno* (fig. 43A; Utrecht, Centraal Museum), also formerly attributed to the father.[1] Johannes was born in Utrecht and presumably trained under his father, a glass painter and engraver and also an accomplished painter. Through his father Johannes probably knew Gerrit van Honthorst (1592–1656) and Cornelis van Poelenburgh (1594–1667), whose influence can be seen in his paintings.[2] Johannes is documented in Rome between 1648 and 1650. Returning to the Netherlands in 1652, he moved to Amsterdam, where his father was involved with two major decorative projects, the Nieuwe Kerk, which had been damaged by fire, and the new Town Hall.[3]

For the Atheneum's painting, Bronchorst draws on Northern and Southern precedents as well as classical texts and Cesare Ripa's *Iconologia*, (first edition 1593) to create a striking and unique image.[4] Rather than the familiar chariot racing through the sky, Bronchorst employs the two-zone format of sixteenth-century allegorical prints, such as the set of four engravings by Adriaen Collaert after designs by Martin de Vos (fig. 43B; Amsterdam, Rijksprentenkabinet).[5] The upper zone freely follows Virgil's description in the *Aeneid* (IV, 129 and 584), "Dawn rose and left the Ocean," and ". . . [left] the saffron bed of Tithonus . . . sprinkling her fresh rays upon the earth."[6] In this painting, Aurora, a beautiful nude surrounded by

partially draped Horae, sweeps across the sky on a dark cloud, reminiscent of the works of Poelenburgh.[7] Assisted by putti, Aurora lifts the cloak of darkness, drawing the morning light over her. Preceding Aurora, Pegasus strides toward the heavens, accelerating the arrival of dawn, while in the distant left Apollo's sun chariot rises from the ocean. The mood in the lower, earthly zone differs dramatically from the heavenly sphere. Here Bronchorst approaches the manner of Caravaggio and his followers, allowing light to pick out of the darkness the coarse figures of three seated males.

Between the two zones is a complex play of symbolism – death and life, winter and spring, the elements of air and water, and their associated humors, the sanguine and the phlegmatic, the interpretation is enigmatic.[8] Judson interprets the upper zone, where putti and the Horae hold garlands of flowers, as an allusion to the Neo-Platonic association of Aurora with air, spring and the sanguine humor, and the lower zone an allusion to night, water, and the phlegmatic temperament.[9] He points to the bearded man in the pose of Kronos or Saturn and the overturned water jug typically associated with river gods and the phlegmatic temperament. He suggests the old man on the right is Father Time, and the arm gesture of the young man with his back to the viewer a reference to Michelangelo's *Night* in the Medici Chapel, Florence. The ruins, barren trees, decaying plants, and flowing water in the lower zone further refer to the conclusion of the day and year, which are overtaken by dawn/spring.

Rather than Night and Father Time, Saunders identifies the two older figures in the lower zone as Oceanus and Tithonus, Aurora's elderly husband.[10] Most recently, Döring, associates the lower zone with the theme of *vanitas*, observing that there is a progression from left to right of age and sleep that reflects the transition from day to night, spring to winter.[11] The plants – flowering on the left and barren on the right – show the same kind of progression. While Döring's interpretation appears most encompassing, the associations suggested by Judson and Saunders would also have been recognized by Bronchorst's contemporaries and contributed to

their appreciation of the painting.

When the painting was sold in 1687, the sale catalogue noted that Bronchorst's *Aurora* had a pendant. None has ever been identified, but Judson suggested that it would have represented an allegory of afternoon and evening. Saunders, citing print precedents, proposed that the Atheneum's *Aurora* was actually one of a series of four paintings representing the different times of day.[12] Döring, however, contends that if the pendant had been lost, the sale catalogue entry would not have mentioned it and proposes that the pendant was not by Bronchorst but was rather the painting in the preceding lot (no. 11) of the sale, which is identified as *A Bacchanal* by Jacob van Loo.[13] Both paintings are described in similar laudatory terms and brought high prices.[14] Stylistic similarities between the work of the two artists would, furthermore, make such a pairing plausible. For example in van Loo's *Diana and her Nymphs* (Braunschweig, Herzog Anton Ulrich-Museum), he represents nude figures in the clouds of a rose-tinted evening sky. Döring argues, somewhat cautiously, that the subject would also have been acceptable as a pendant, since bacchanals were associated not only with autumn, but also with evening. Döring acknowledges that his proposal remains hypothetical without additional evidence but points out that in 1657 Bronchorst's father was commissioned to paint a pendant for a painting by Jacob van Loo.

ALW

Oil on canvas, 64 ½ × 52 ½ in.

Signed lower right: *IvBronchorst Fec.*

The Ella Gallup Sumner and Mary Catlin Sumner Collection Fund, 1966.10

Provenance:[15] Anonymous sale, Amsterdam, 9 April 1687, lot 12 as "Een Morgenstont van de jonge Bronckhorst, syn alderbeste is een weerga. 160.0;"[16] Arundel family, Wardour Castle, probably since 18th century; sold to Edward Speelman, Ltd., London; from whom purchased in 1966.

References: Judson, 1966, pp. 1–11; Haverkamp-Begemann, 1978, pp. 121–2; Haak, 1984, p. 316, pl. 676; Blankert and Slatkes, eds., 1987, pp. 242, 244, fig. 118; Döring, 1987, pp. 159–60, fig. 202; Klessman, 1987, p. 160; Döring, 1993, pp. 151–6, no. B8; Döring, 2000, p. 61.

Selected Exhibitions: Athens and Dordrecht, 2000–1, no. 15.

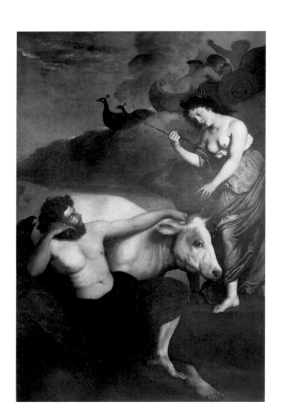

Fig. 43A. Johannes Jansz. van Bronchorst, *Jupiter and Juno*, *c.* 1655, oil on canvas. Centraal Museum, Utrecht

Fig. 43B. Adriaen Collaert after Martin de Vos, *The Four Times of Day: "Aurora,"* engraving. Rijksprentenkabinet, Amsterdam

44. Frans Jansz. Post

Dutch, *c.* 1612–80

Brazilian Landscape

1656

In October 1636 Johann Maurits, Count of Nassau-Seigen, traveled to Brazil as governor general of the Dutch colony. In his entourage were scientists, cartographers and artists to document Brazil. Johann Maurits's publication *Historia naturalis Brasiliae . . .* (Leiden, 1648), the scientific observations of Willem Pies [Piso], medical doctor to Johann Maurits, with illustrations based on the watercolors of George Marcgrave, provided the first account of the natural history of the Americas.[1] The most important artists who accompanied Johann Maurits were Albert Eckhout (*c.* 1610–66) and Frans Post. Whereas Eckhout recorded the animals and people of Brazil, Post, a young landscape draughtsman and painter from Haarlem, represented the overall appearance of the land and of the animals and plants that lived there. Rather than wild, uncultivated land, most of Post's paintings include structures that refer to the colonial rule of the Portuguese and especially to the new rule of the Dutch.

Frans Post devoted his entire career to painting images of Brazil, most of which are fantasies painted from memory and sketches after his return to The Netherlands from the New World in 1644. Only six paintings actually produced in Brazil are known, but many more must have existed. In 1679, in search of financial backing, Johann Maurits sent Louis XIV of France forty-two paintings of Brazil by Frans Post and Albert Eckhout. Among those was *The São Francisco River with Fort Maurits*, 1638 (Louvre). Post's earliest dated painting, it has an abstract simplicity, dominated by the vast sky and broad river that stretches undisturbed from foreground to distant shore. Although once thought to have been painted from life, the Paris painting was undoubtedly based on drawings. The delicate, draughtsmanlike depiction of the fort and the distant, receding shoreline is very similar in character to the series of nineteen drawings of the coastlines of Madeira, the Canaries and Capverdie Islands that Post made enroute to Brazil (Amsterdam, Rijksmuseum Nederlands Scheepvaart Museum). Although a native of Haarlem, Frans Post's crisply defined paintings show no influence of contemporary monochromatic landscapes. Not surprisingly, his work is closest to that of his older brother, the architect Pieter Post (1608–69), and through him to Cornelis Vroom.

The Hartford painting, dated 1656, is typical of the works Post produced after his return to Haarlem. Like the majority of Post's European paintings, it is painted on panel. The simplicity of the early paintings has given way to dense foliage and distant panoramas. Typical of his later paintings, the dark vegetation in the foreground frames the view of the soft, atmospheric distance. The view is from a hill past a clearing to the distant, flat landscape, where meandering rivers reflect the light, drawing the eye toward the horizon as in Koninck's panoramic landscapes of Holland.

The lush vegetation and broad expanse of landscape that dominate the dark-skinned figures gathered to trade and socialize outside a house with a thatched roof suggest that the scene is in the tropical province of Pernambuco, although the exact location is not known and was probably a fantasy based on drawings Post made in Brazil. The figures shown in the Hartford painting are African and Indian slaves who provided the large work force required for the labor intensive and costly production of sugar for export to Europe.

Slaves wear colonial costumes similar to those of their European supervisors rather than the native costumes depicted in Eckhout's series of nine large ethnographic paintings of aboriginal Indians that Johann Maurits presented to King Frederick III of Denmark in 1654 (Copenhagen, National Museum).[2] In some of Post's paintings, such as *The Sugar Factory* (Rotterdam, Boymans van Beuningen Museum), Post portrays the actual activity of the sugar business, while in other paintings he only alludes to it by representing slaves walking to market or relaxing. In the Hartford painting, the figures gather to trade and socialize. Three figures dance. The diminutive size of the figures relative to the landscape and the bucolic mood of the gathering are reminiscent of Claude Lorrain, whose Arcadian prints and paintings Post may have known. Like Claude and other contemporaries, Post in his work reflects an idealized perception of the rustic and primitive man as happy in his innocence and simplicity.

ALW

Oil on panel, 16 ⅜ × 22 in.

Signed and dated on rock at lower left center: *F. Post. 1656*

The Ella Gallup Sumner and Mary Catlin Sumner Collection Fund, 1949.460

Provenance: Sale, Christie's, London, *c.* 1905 (as by David Vinckboons); John M. Thompson, New York; Anonymous sale, Parke-Bernet, New York, 25–6 February 1949, lot 52 (as Vinckboons, *African Landscape with Figures*); Julius Weitzner, New York; from whom purchased in 1949.

References: Larsen, 1962, pp. 112f, no. 34, fig. 35; Sousa–Leão, 1973, p. 77, no. 27; Saunders in Haverkamp–Begemann, 1978, pp. 173–4.

Selected Exhibitions: Washington–Paris, 1975–6, no. 79.

45. Michael Sweerts
Flemish, 1618–64

Boy with a Hat
c. 1655–6

The Flemish painter Michael Sweerts had one of the most unusual careers of any seventeenth artist. Having spent his early creative years, from *c.* 1646 to 1655, in Rome, where he was knighted by the Pope and absorbed influences from the *Bamboccianti* as well as the followers of Caravaggio, he returned to Brussels to found a painting academy. He specialized in portraits and genre subjects, producing an occasional religious or history subject, such as the grandiose *Plague in an Ancient City* (Los Angeles County Museum of Art) inspired by Poussin. In 1661 Sweerts was in Amsterdam in the company of a French Lazarist missionary overseeing the construction of a vessel to take members of the Société des Missions Etrangères to China. Sweerts himself joined this evangelical expedition, which departed from Marseilles under the leadership of François Pallu, Bishop of Heliopolis, in January 1662. This long journey, during which several of the other missionaries died, took them to Palestine and on to Aleppo where Sweerts' paintings (now unknown) were well received, and then to Tabriz in Persia in July 1662. However, by this time the painter had became emotionally disturbed, and so irritated the remaining missionaries, that the Bishop had to dismiss him. Somehow Sweerts made his way, on his own, to Goa, a stronghold of Portuguese Jesuits on the west coast of India, and there he died in 1664.

Perhaps Sweerts' most striking creations are his series of heads of youths of which this one is considered his most brilliant. Neither traditional portraits nor genre subjects, these small scale but detailed works each capture a certain physiognomic type and temperament. The subjects, in this case a shepherd boy, usually look away from the viewer and seem troubled by some highly personal emotion or reflection conveyed by an almost tearful expression. The similarity to works by Johannes Vermeer has been noted, but if anything the master of Delft adopted this poetic approach from Sweerts.

EZ

Oil on canvas, 14 ½ × 11 ½ in.

The Ella Gallup Sumner and Mary Catlin Sumner Collection Fund, 1940.198

Provenance: Lord Northbourne, Betteshanger Park, Kent, since the 18th century; Earl of Hastings; Money-Coutts collection (?); Arnold Seligmann, Rey & Co., New York, by 1940; from whom purchased in 1940.

References: Haverkamp-Begemann, 1978, p. 194, no. 154; R. Kultzen, *Michael Sweerts*, Doornspijk, 1996, no. 98.

Selected Exhibitions: New York et al., 1954, no. 80; Hartford–Sarasota, 1958, no. 75; Rotterdam–Rome, 1958–9, no. 48 and 49; The Hague–San Francisco, 1990, no. 63; Amsterdam–Hartford, 2002, no. 14.

46. Jacob van Ruisdael

Dutch, 1628/9–82

View of the Dunes near Bloemendaal with Bleaching Fields

c. 1670–5

The preeminent Dutch landscape painter of the second half of the seventeenth century, Jacob van Ruisdael was born in Haarlem in 1628/9, the son of Isaack van Ruisdael (1599–1677), a picture dealer, frame maker and minor artist. Jacob probably received his earliest training from his father and his uncle Salomon van Ruysdael, who with Jan van Goyen was one of the innovators of the tonal landscape. By the age of twenty, the year he joined the Guild of St. Luke in Haarlem, Jacob had already produced paintings of high quality. Around 1650 van Ruisdael traveled along the Dutch-German border, probably with Nicholas Berchem, and six years later moved to Amsterdam, where he died in 1682.

View of the Dunes near Bloemendaal with Bleaching Fields is typical of Jacob van Ruisdael's popular *Haarlempjes*, little views of Haarlem. Painted between 1670 and 1675, years after his move to Amsterdam, these panoramic views depict the countryside surrounding Haarlem rather than the city from within.[1] In the Hartford painting the view is from the top of a high dune across green polders with cottages, past church towers to the glistening sea on the distant horizon. In the middle ground linen is stretched out on the grass between the canals. Forming diagonal ribbons of light, the receding canals direct the eye to the sunlit church tower nestled in the dunes. Although the lines of the canals contribute to the perception of depth, van Ruisdael here as elsewhere plays with light and shadow as well as solid masses to construct his composition and suggest both space and depth. The sky, which occupies two thirds of the composition, plays an important role. Billowing clouds blown from the sea rush forward over the land, casting shadows and animating the landscape with patches of light that illuminate significant details that help to locate and define the landscape.

Rather than a view of the city of Haarlem, the Hartford painting depicts the skyline and vicinity of Bloemendaal, northwest of Haarlem. Similar views are found in paintings by van Ruisdael in the Thyssen-Bornemisza Collection, Madrid, the Staatliche Museen Preussischer Kulturbesitz, Gemäldegalerie, Berlin, and in a private collection New York.[2] Comparing the view to contemporary seventeenth-century maps, Pieter Biesboer has demonstrated the topographical accuracy of van Ruisdael's paintings: tucked behind a dune in the distant left of the Hartford painting and its variants is the tower of the Dutch Reformed Church of Bloemendaal and between the trees in the middle ground the country house with two large chimneys is Hartelust.[3] Michiel de Wael who was depicted by Frans Hals, built Hartelust and owned the surrounding bleaching fields from 1631 to 1652. The unusual rounded shape of the bleaching field in the center reappears on a map made by Pieter Wils in 1637, who identifies it as the bleaching grounds De Mol located along the Bloemendaal-weg. As in the Hartford painting, the map shows a half-round field next to five parallel fields separated by narrow canals. The buildings in the middleground at the end of the canals in the Hartford painting also appear on the

map, where they are identified as part of the bleaching operations: the lyeing house, the dairy, the living quarters, and the stables.

During the seventeenth century the bleaching of domestic and imported linen was second only to brewing in economic importance to Haarlem and the surrounding towns of Bloemendaal, Overveen and Heemstede; the industry extended as far north as Alkmaar and south to Leiden. Although the production of linen had been an important industry since the fifteenth century, with the influx of skilled weavers and bleachers from Flanders after the fall of Antwerp in 1585, the industry grew in importance.[4]

The number of views of the bleaching fields painted by Jacob van Ruisdael and represented in contemporary prints and paintings reflects the wide interest in the landmark. The long lines of white linen stretched out on the grassy polders were a popular tourist attraction mentioned in contemporary poems and extolled by Ampsing in his history of Haarlem published in 1628. Maps identified the locations of bleacheries and included vignettes of bleached linen stretched out on polders to identify Haarlem. The bleaching fields were a destination not only for local townsfolk but also for visitors to Haarlem, including Willem III, Prince of Orange, and his mother, Mary Stuart, who were escorted in the summer of 1660 to see "the pleasurable sight of the bleacheries."[5]

Attempts to interpret these popular images as moralizations on purity, either individual or civic, are unconvincing.[6] Although there is no evidence that van Ruisdael painted any of his numerous variations on commission, it is likely that many of his patrons were people involved in the linen industry of Haarlem and her surrounding communities. While local patrons may have found in them expressions of personal or civic pride in the economic prosperity of the linen business, the primary appeal of the paintings was undoubtedly the pleasure of the images themselves. Like Claes Visscher's famous engraved series of seven views of Haarlem, two of which include references to the linen business, van Ruisdael's Haarlempjes were probably intended "for those who have no time to travel far." Like Visscher's prints and modern photographs, van Ruisdael's Haarlempjes appealed to the local populace and to visitors who took pleasure in the actual experience of visiting the bleaching fields. It is perhaps significant that van Ruisdael, who spent his early years in Haarlem, painted the subject only after he had moved to Amsterdam, when he himself may have felt nostalgia for the unusual sight.

ALW

Oil on canvas, 13 ⅜ × 16 ⅜ in.

Monogrammed, lower right:[7] *JVR*

The Ella Gallup Sumner and Mary Catlin Sumner Collection Fund, 1950.498

Provenance: Private collection, England; sale, London, Christie's, 2 June 1950, no. 134; Eugene Slatter, London; from whom purchased in 1950.[8]

References: Possibly Smith, 1835, vol. 6, 1935, no. 139 and Suppl. 1842, no. 6; Possibly Hofstede de Groot, vol. 4, 1912, nos. 83a and 100; Haverkamp-Begemann, 1978, p. 185; Biesboer, 1995, pp. 37–8; Slive, 2001, p. 69, no. 41.

Selected Exhibitions: Hartford, 1950, no. 10; Utica–Rochester, 1963, no. 32.

47. Nicolaes Berchem

Dutch, 1620–83

A Moor Offering a Parrot to a Lady

c. 1665[1]

Born in Haarlem in 1620, Nicolaes Berchem studied drawing with his father, the still life painter Pieter Claesz. (1599–1678) before, according to Houbraken, studying painting with Jan van Goyen (1596–1656), Pieter de Grebber (*c.* 1600–52), Jan Wils, and Jan Baptist Weenix (1621–*c.* 1660/1). Berchem's early paintings of the Dutch countryside reflect the influence of van Goyen's tonal landscapes and the staffage of Pieter van Laer (1599–1642?). After 1650 Berchem adopted a brighter coloration to portray the Italian countryside bathed in warm light and populated by Arcadian shepherds. It is unclear when, if ever, Berchem traveled to Italy. According to Houbraken he made a sea voyage to Italy as a young man, which may have been *c.* 1642, but is more likely to have been between 1651 and 1653.[2] Berchem is documented in both Haarlem and Amsterdam between 1655 and 1670, when he settled permanently in Amsterdam. He continued to paint Italianate landscapes, but histories and allegorical scenes assumed greater importance in his later work.

Berchem probably painted *A Moor Offering a Parrot to a Lady c.* 1665. In contrast to his early coastal scenes (beginning about 1655) in which his focus is the coastline populated by Arcadian shepherds, in the Hartford painting the emphasis is a lively port populated by elegant and exotic folk. The larger scale of the figures and the change in emphasis suggest the influence of his cousin Jan Baptiste Weenix, who specialized in painting port scenes in which exotic figures, classical ruins and statues establish the foreign locale. The Hartford painting is one of a small group of paintings by Berchem in which a beautiful, elegantly dressed woman dominates the composition, drawing the attention of the other figures. The paintings share a theatrical quality created through dramatic lighting and exotic figure types. Here a young, elegant woman dressed in blue and white satin stands on an elevated piazza. Beyond her in the left, misty distance a ship with its sails unfurled and men dressed both in conventional contemporary western clothes and turbans locate the scene in a Mediterranean port. The painting does not, however, depict an actual place or event.[3]

The major protagonist in the painting is a Moor dressed in yellow and gold satins and a turban.[4] On his left wrist sits a scarlet macaw, a bird native to Central and South America. As he steps forward toward the young woman he holds his right hand to his mouth in an Eastern gesture of homage.[5] The strong sunlight falls on his back, casting a sharp shadow against the steps. The barking dogs respond to the activity of the humans. Behind the Moor a man dressed like a member of the papal Swiss Guard, watches with amusement, while above him, under the gaze of the statue of Venus, a man entertains another elegantly dressed woman with a lute. The correct interpretation of Berchem's painting remains elusive. The theatrical quality of the Hartford painting suggested to previous scholars that Berchem may have depicted a scene from a play such as *Othello and Desdemona* or *A Moor sent by Pharaoh for Sarah*.[6] While rejecting these identifications, Christine

Schloss proposes that the painting may represent an unrecognized scene from a contemporary play.[7] Rather than a specific literary subject, however, Berchem may have intended a more general interpretation for which the exotic setting would have appealed to his viewers. The statue of Venus with Cupid and two turtle-doves at her feet establishes the theme of love, which dominates much of the painting.[8] The graceful sway of Venus's pose and the cast sunlight relate her to the woman standing at the top of the steps, whose low-cut décolleté decorated with jewels is both elegant and erotic. The theme of erotic love is also suggested by the presentation of the parrot by the Moor, who was viewed by Berchem's contemporaries as a prototype of everything uncouth, heathenish, and lascivious; at best an exotic phenomenon.[9]

Schloss suggests that Berchem may have perceived his female protagonist as the allegorical figure of Lady World. Like the traditional symbol of the worldly woman, Berchem's woman wears a Greek cross.[10] Comparing the painting to Joachim Wttewael's drawing *The Indian Homage*, Christopher Brown suggests that Berchem's Moor may represent the Pagan East paying hommage to the Christian West, personified by the elegant woman who wears a large cross on her chest.[11]

ALW

Oil on canvas, 36 ⅞ × 35 in.

Signed lower right: *N Berchem / F* [N and B in monogram]

The Ella Gallup Sumner and Mary Catlin Sumner Collection Fund, 1961.29

Provenance: César Gabriel (?) and Renaud de Choiseul-Chévigny, ducs de Praslin; sale, Paris, A.J. Paillet, 18 February 1793, no. 79, (sold for Ffr. 2,001); Pieter Baron de Smeth van Alphen (1753–1809), Amsterdam and De Bilt, from 1793(?); sale, Amsterdam, 1–2 August 1810, no. 11, (sold for Dfl. 1,625 to); Jeronimo de Vries (1776–1853), Amsterdam. for; Lucretia Johanna van Winter (1785–1845) m. 1822 Hendrick Six van Hillegom (1790–1847), Amsterdam [and in 1834, valued at 400 gns]; by descent 1847 to their sons; Jonkheer Jan Pieter Six van Hillegom (1824–99) and Jonkheer Pieter Six van Vromade (1827–1905), Amsterdam; by descent 1905 to Pieter's son; Jonkheer Jan Six Hillegom, Amsterdam, 1926 (from 1922, Stichting Six); sale, Amsterdam, Muller, 16 October 1928, no. 2, (sold for ƒ 3.4000 to); P. de Boer, Amsterdam; Hanns Schäffer, Berlin, *c.* 1930;[11] Private Collection, Germany, sold 1959 to; Hanns Schäffer Galleries, New York, (stock no. 2046 as *Othello and Desdemona* and elsewhere as *Moor and Lady*); from whom purchased in 1961.

References: Smith, 1834, vol. v, pp. 38–9, no. 103; Blanc, 1857–8, vol. II, p. 162; Hofstede de Groot, 1926, vol. IX, p. 70, no. 71; von Sick, 1929, pp. 25–6; Stechow, 1966, pp. 159 and 217, note 70; Haverkamp-Begemann, 1978, pp. 13, 65, and 116–18; Zafran, 1978, p. 245, fig. 8; Schloss, 1982, pp. 12, 19–20, 49, 63–4, and 156, fig. 34; Priem, 1997, pp. 104, 134, 197, no. 1, fig. 6.

Selected Exhibitions: Amsterdam, 1900, no. 6 (as 'Othello and Desdemona"); Cologne, 1930, no. 3; San Francisco–Boston, 1996–7, no. 73; Philadelphia–London, 1984, no. 5; The Hague–San Francisco, 1990–1, no. 6; Dulwich, 2002, no. 32.

Etched by Le Bas.

48, 49. Simon Vouet

French, 1590–1649

Saint Ursula

c. 1620

Saint Margaret

c. 1620

These paintings were first published by Andreina Griseri in 1961, who correctly recognised both works as pictures relatively early in Vouet's years in Rome, associating them with the *Birth of the Virgin* in San Francesco a Ripa, a painting now believed to have been completed just before Vouet's travel to Genoa; therefore, according to recent dating, about 1620 (in earlier literature it is sometimes placed *c.* 1622). Crelly, writing of the Hartford paintings shortly after Griseri, noted that he was also inclined to date the Hartford picture to about 1620, confirming its stylistic connection with the *Birth of the Virgin*. In a memorandum in the Atheneum's files, Charles Sterling, in March 1963, examined the pictures and considered them fine works by Vouet, dating to the years 1620–4. Rosenberg in the 1982 exhibition catalogue, strongly reaffirmed both the attribution to Vouet of the two paintings and their stylistic association with the *Birth of the Virgin*. Brejon and Cuzin had earlier argued the pictures were by an unidentified Roman follower or student of Vouet. Picking up the argument once again in 1982, Cuzin contested that despite the "strongly Vouetesque character" of the works, their deep colours, with strong reds and blues and the creamy impasto of the paint seemed removed from the monumental "and austere" art of Vouet.[1] This argument is unpersuasive, given the rich colorism and thick, loose yet masterly brushwork already evident in the draperies of the series *Angels of the Passion* (Naples, Capodimonte), datable to about 1615,[2] and the half figures of *St. Mary Magdalen* and *St. Catherine of Alexandria* in the Quirinale collection (*c.* 1615). Vouet executed another such pair of *Judith* and *Saint Catherine of Alexandria* for the Doria family shortly after his arrival in Genoa, about 1621.[3]

The Hartford pictures are works in stylistic transition. The Caravaggism of the early Vouet is increasingly influenced by the art of Bologna, as expressed in the idealized softly sculptured, rounded fullness of the figures. The bravura of their draperies the solemn full faces with their distinctive noses and bee-stung, sensual lips are also evident in the Capodimonte series of *Angels of the Passion*, half-figures of about the same dimensions. The compositional bravura and bright facial lighting are also found in the art of Orazio Borgianni, whose works Vouet admired at this time. The Hartford paintings are more suave and controlled in their brushwork, however, than the earlier, Venetian-influenced *Angels of the Passion*, yet less restrained and spatially sophisticated than his *Allegory of the Human Soul* (Rome, Capitoline), of about 1624, and the painting *Angels of the Passion* (Besançon, Musée des Beaux-Arts) of about the same date.[4] As Rosenberg further stated in 1982, "everything points to Vouet's authorship: the long undulating fingers

with fine nails, the ample drapery, the rounded heads seen *da sotto in sù*, the heavily braided hair, and of course the facial features."[5] All these factors confirm that the attribution of the Hartford paintings, and a dating towards 1620 is thus reasonable. While the Vouet attribution of these pictures seems secure, in recent years we have become increasingly aware of the accomplishments of the Vouet "circle" and studio in Rome, including his brother Aubin, Charles Mellin, the Cavaliere Muti, and perhaps most intriguingly Virginia da Vezzo, who became his wife.[6] These Roman years were profoundly influential upon the development of one of France's greatest artists.

Vouet began his career in Paris, executing portraits, but by his early teens had already arrived in Italy, returning from an artistic embassy to Constantinople at the age of twenty-one. In Rome by the end of 1613, he became an early exponent of the style of Caravaggio. In 1620/1, he worked for the Doria family in Genoa, returning to Rome. In Rome his style matured, reflecting many influences, including not only works of the followers of Caravaggio, but increasingly the style of the Bolognese school, especially Annibale Carracci, Guido Reni, and Giovanni Lanfranco. This recasting of Vouet's art in the light of Bolognese painting would mould the style of the artist, and his many prominent pupils, after his return to France, and is evident in Vouet's broad, sculpturally rounded figure types, bright colors, and lyricism. His appointment in 1624 as *principe* of the Accademia di San Luca and a commission for the Vatican culminated his career there. On returning to France in 1627, after his successful Roman career, he was awarded with the position of First Painter to King Louis XIII.

The story of St. Ursula is given in the entry on the Claude painting (cat. no. 52); in both works she holds her banner. St. Margaret, born in Antioch in the third century, was the daughter of a pagan priest, but was secretly baptised. Olibrius, a pagan prefect, wished to marry her, but when she refused, confessing her faith, she was martyred. Her martyrdom, ultimately realised by beheading, was preceded by a remarkable series of tortures and miraculous recoveries. While in prison between her trials, she also was visited by the devil, who assumed several forms including a dragon (with which she is usually, as in the Hartford painting, depicted), that she overcame with the sign of the Cross. Both saints, therefore, are distinguished by their passive acceptance of martyrdom, rejecting pagan marriage, in the firm conviction of their faiths.

HTG

Oils on canvas, 38 ½ × 29 ⅛ in. and 39 × 29 ¼ in.

The Ella Gallup Sumner and Mary Catlin Sumner Collection Fund, 1961.285 and 1961.471

Provenance: Probably private collection, Spain, before 1961;[7] Frederick Mont, New York by 1961; from whom purchased.

References: Griseri, 1961, pp. 322–5; Crelly, 1962, pp. 216–17, no. 141 A and B, fig. 7a; Brejon and Cuzin, in exh. cat. Rome–Paris, 1973–4, p. 250 (Italian edition), p. 257 (French edition); Cuzin, 1982, p. 529.

Selected Exhibitions: Bordeaux, 1966, no. 18 (*St. Margaret*); Paris–New York–Chicago, 1982, nos. 115 and 116.

50. The Le Nain Brothers

French, active mid-seventeenth century

Peasants in a Landscape

c. 1640–5

The Le Nain brothers, Antoine (*c.* 1600–48), Louis (*c.* 1603–48) and Mathieu (1607–77), came from Laon, where their family owned farming properties. Apparently they received their initial training there by an unknown artist, but by 1629 had established themselves in Saint-Germain-en-Laye, just outside Paris (and its guild restrictions), where they lived and worked together. Early attributable works by the individual brothers do not survive. In March 1648, they joined the newly formed Académie Royale de Peinture et de Sculpture, but two months later both Antoine and Louis were dead. Mathieu lived until 1677. Sixteen paintings signed "Lenain" survive, ten of them dated, all in the 1640s and before 1648. We are therefore faced with a situation in which three brothers working together, probably collaborated on the same pictures, with no surviving documented work attributable to a single brother, and no dated work after the deaths of Antoine and Louis.[1] Despite the seemingly insuperable limitations, various art historians, most notably Jean-Pierre Cuzin and Pierre Rosenberg, have isolated three distinctive Le Nain hands (as well as other artists in their circle) and have applied names to them, in part guided by convention.[2] Antoine is associated with small works on copper or panel, genre scenes, and children's portraits in which the figures are painted with a rough, loose brush stroke. Often depicting groups, especially of children, around the table or associated with musical performance, these pictures are also distinguished by their awkwardness in perspective and bright colors. They are not, however, psychologically penetrating. Mathieu is assigned works in which the compositions are structured diagonally, the brushstrokes are more restrained and less nervous and the figures bear a greater monumentality. The controversially attributed Vassar College *Artist's Studio*, which must date after 1652 due to the attire, is placed in this group. The paintings assigned to Louis are, as MacGregor has described them, "subdued in both palette and emotional register . . . In most of these pictures a group of people calmly confronts the spectator, while action is suspended . . . and the figures are neither idealized nor sentimentalized."[3] Rosenberg defines

them as having rounded faces and bearing a more melancholic, introspective air.[4] As MacGregor points out, "These paintings have, again without any supporting evidence, frequently been ascribed to Louis."[5] Indeed, the limitations to our knowledge presented by the slim documentary evidence are daunting. We must further recognize the likelihood that the brothers, working in the same studio, influenced each other, that they collaborated, and that their styles may have evolved in trajectories we can no longer deconstruct. The existence of works done in a similar style by various anonymous masters (e.g. the Maître des cortèges, Maître aux béguins, and Maître des jeux), and the potential existence of studio works (works by the Le Nains were popular and the brothers employed apprentices) are further complications. It is therefore most prudent to assign the name "Le Nain Brothers," following the practice of Thuillier and, more recently, Humphrey Wine.[6] At the same time, the Hartford picture falls within the so-called "Louis" group, as described above.

The paintings of the Le Nain Brothers are distinguished by their charming blend of Italianate currents, the knowledge of Northern genre paintings, especially apparently of the *bambocciati* working in Rome, and Flemish art popular in Paris at the time. To this is conjoined a French abjuring of sentimentality, humor, or derision. The unforgettable result, in a painting such as the Atheneum's, is a study of individuals, each absorbed in his or her own reflections or private activities, set against a landscape which is perhaps most notable for the distancing it creates between the figures. The isolation of each of the foreground figures is palpable: the man with his jug, the youth playing his flageolet (a type of flute), the old woman and the girl standing close to her. In a remarkable way, this melancholic insularity extends to the realistic yet detached presentation of the barrel, various objects and even the dog. In the background, figures are similarly isolated from each other: a cow-maid guides her cow, a shepherd stands by his small flock, and a gentleman has his fortune told. The setting seems bucolic rather than a commentary on the harsh economic realities of French peasant life under Richelieu and Mazarin. The cool, northern light and rolling village landscape of the Le Nains's native Picardy further infuses the subject with a quiet, contemplative air. The painting is stylistically closely tied to others in the "Louis" group, most notably with the *Four Figures at a Table*, at the National Gallery, London (fig. 50A), in which the same old woman and small girl appear, with virtually the same expressions.[7] Noting the costume and collar of the young boy in the latter work, Jamot has dated the London painting to *c.* 1643,[8] a date generally accepted. The Atheneum

painting must date to virtually the same time. Other pictures of peasants in outdoor settings, evidently by the same hand, include the *Peasants in a Landscape* (Washington, National Gallery of Art), *Peasants before Their House* (San Francisco, Fine Arts Museums),[9] *The Cart* (Paris, Louvre), *The Ass* (St. Petersburg, Hermitage) and *Resting Cavalier*, (London, Victoria and Albert Museum).[10]

The Hartford painting has suffered over the years from possible abrasion and an over-aggressive cleaning that removed its glazes and undoubtedly intensified some of the lighting effects within the picture. Nonetheless, it retains the tender, melancholic and haunting poetry characteristic of the best of the paintings in the "Louis" group.

HTG

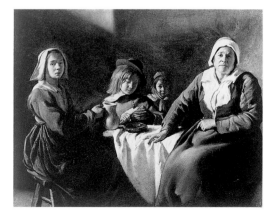

Fig. 50A. The Le Nain Brothers, *Four Figures at a Table*, *c.* 1643, oil on canvas, 17 ½ × 21 ½ in. National Gallery London, NG1425

Oil on canvas, 16 ⅜ × 21 ¾ in.

The Ella Gallup Sumner and Mary Catlin Sumner Collection Fund, 1931.210

Provenance: George Wilbraham, Northwick Castle, Cheshire, by 1839; Wilbraham descendant sale, Christie's, London, 18 July 1930, no. 24; Durlacher Brothers, London, 1930; from whom purchased.

References: Fierens, 1933, pp. 28–30, 62 (Louis); Dorival, 1946, p. 68 (Louis); Bloch 1953, p. 367 (Louis); Dorival, 1953, p. 17 (Louis); Fierens, 1957, p. 550 (Louis); Thuillier, 1964, pp. 15, 21 (Le Nain); Blunt, 1978, p. 873; Cuzin, 1979, p. 70, n. 14; Rosenberg, 1979, p. 96, ill. p. 97; Rosenberg, 1993, p. 80, no. 33 (Louis [?]); Wine, 2001, p. 200.

Selected Exhibitions: London, 1839, no. 158; Hartford, 1931, no. 32; San Francisco, 1934, no. 12; Paris, 1934, no. 68; Pittsburgh, 1936, no. 12; New York, 1936, no. 13; Paris, 1937, no. 92; Toledo, 1947, no. 3; Toledo–New York, 1961, no. 27; Paris, 1978–9, no. 32; Paris–New York–Chicago, 1982, no. 48.

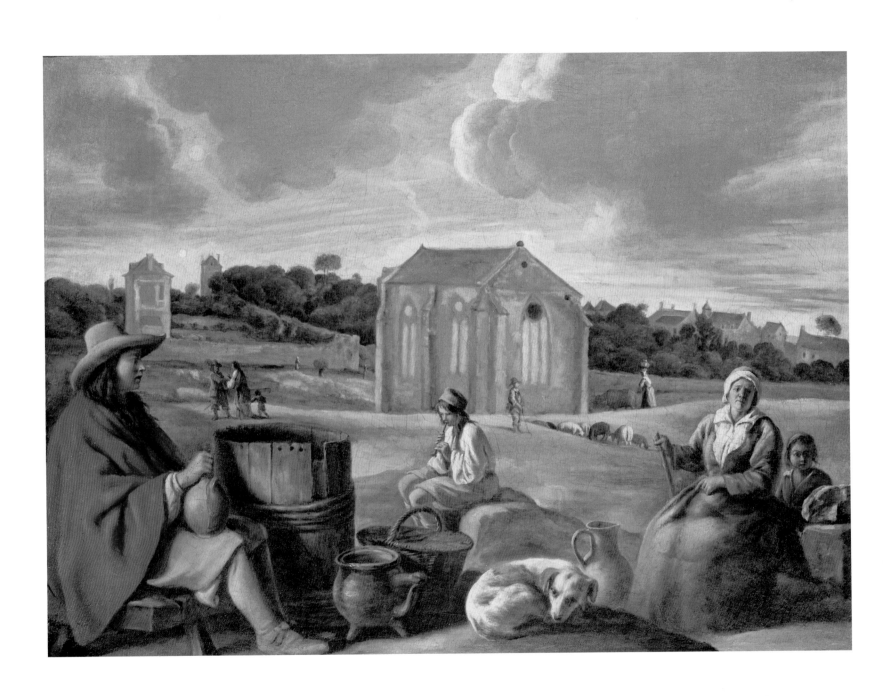

51. Eustache Le Sueur

French, 1616–55

Young Man with a Sword

c. 1645

Although the masterful treatment of both the composition and the brushwork in the Wadsworth Atheneum's portrait of a young man has never been disputed, the attribution has been controversial. The painting was originally published by Anthony Blunt in 1946, as a work by Simon Vouet. Blunt based his attribution on the "livid colouring and certain tricks of drawing, such as the exaggerated size of the eyes," as evidence that the work dated to Vouet's Paris period, characteristics hardly excluding the possibility of Le Sueur, however. He also cites the broad treatment of the drapery, thick impasto of the sleeve, and "loosely defined edge of the collar" as "distant echoes of the treatment of corresponding details in the Italian portraits." Crelly accepted Blunt's attribution, slightly mis-stating its grounds, noting that he had not seen the original work. It was the eminent connoisseur and scholar, Charles Sterling, however, who first attributed the portrait to Le Sueur, dating it towards 1645, and asserting that it is "le chef d'œuvre de Le Sueur portraitiste." Indeed, he compared the Hartford portrait favorably with the "poétique picturale" of Vermeer. Sterling's 1968 article fundamentally defined Le Sueur as a portraitist, the latter's work in that genre having previously been known only through a group portrait at the Louvre, the so-called "Gathering of Friends" of 1640, and a portrait of a "Monsieur Albert" (Guéret, Musée Municipal). Sterling expanded the corpus with four portraits (including a self-portrait only known through a print). He based his attribution on a carefully itemized list of stylistic comparisons with the secure portrait of "Monsieur Albert," and a "Portrait of a Man" (then in a private collection in Duisberg, but its present location unknown),[1] earlier works by his reckoning, but all dating between 1640–5. Sterling's arguments remain persuasive: the shared treatment of the fluidly drawn hands, with their long, flat tips and nails, the accenting of the nose and the eyes and the controlled pose with the head turned from the body. He also pointed to certain idiosyncrasies shared between the three surviving portraits he attributed to Le Sueur, such as the highlighted creased border of the collar resting lightly on the shoulder. In the 1982 Paris exhibition catalogue, Rosenberg accepted without reservation Sterling's re-attribution. When, later that year, Blunt re-iterated his continued support of the Vouet attribution based on the subject's vigorousness and the brilliant coloristic highlights, Rosenberg responded in his 1984 postscript to the exhibition, that "the attribution to Vouet must definitely be dismissed." In an oral communication to Alain Mérot, Jacques Thuillier made note of unspecified "differences importantes de facture" between the Hartford painting and other works cited by Sterling. In his catalogue raisonné, Mérot, while accepting the attribution of the other portraits listed by Sterling, rejected the Wadsworth Atheneum's picture, tentatively returning to Blunt's earlier proposal of Vouet. He adopts Blunt's arguments that the colorism is too brilliant for Le Sueur, the range of whites too refined and unlike the other accepted portraits. He

also questions the meditated pose, although it should be noted that it is virtually the same as Le Sueur's "Portrait of a Man,"[2] in the Louvre, except reversed in orientation. Finally, he suggests comparison with the highly meditative recently rediscovered "Portrait of Mère Marguerite Acarie" by Vouet, the only surviving portrait in oil from his Parisian period.[3] Mérot alludes specifically to the treatment of the whites, as in the sitter's wimple.

We agree with Wintermute's observation that the continued questioning of the portrait to Le Sueur is unjustified, and find that Sterling's arguments remain sound. Regarding the highlighting, it should be noted that, as Sterling first commented, the portrait of "Monsieur Albert" at Guéret is worn and undoubtedly has lost much of the contrast of shadows, and highlighting of the face and hand. Already in his early historical and mythological paintings of the late 1630s and 1640, Le Sueur demonstrated himself to be a brilliant colorist, and the treatment of the white draperies in the early *Sleeping Venus* in San Francisco, dating to the late 1630s, is already a tour de force. When Vouet turns to open brush work in his portraits, evident in his more spontaneous-seeming works from the Roman period, he tends to be far more radical and abstract than Le Sueur. As Wintermute has observed, the Hartford portrait combines something of the *sprezzatura* of Vouet's earlier portraiture with the refinement of his more sophisticated later works and a controlled assurance of Le Sueur's own colorism.

Le Sueur was self-consciously imitating Italian High Renaissance portraits and "bravos," the elegant bust portraits popularised by Titian, Sebastiano and Palma in the earlier sixteenth century, but also visible in portraits by Raphael, most notably in his portrait of Castiglione (whose tonal range the Wadsworth Atheneum portrait shares). The Castiglione portrait had entered the Parisian collection of Alfonso Lopez, a Portuguese marrano, resident in France since 1604. A *créature* of Richelieu, whom he had known since 1617, Lopez was, among his many talents, a diamond merchant and a distinguished collector. In the same 1639 Amsterdam sale in which he acquired the Raphael portrait of Castiglione, he also bought Titian's magnificent *Man with the Blue Sleeve* (National Gallery, London), the so-called "Ariosto." Rembrandt attended the sale and noted the portraits for future use, and both works, whose acquisitions were very much news, could have been seen by Le Sueur in Paris after that date. They evidently influenced the composition and the bravura emphasis on the sleeve. It is also possible that Le Sueur knew the Raphael *Portrait of a Youth* (formerly Cracow, Czartoryski Museum), known in Northern Europe at the time either from the original or a copy.[4] These grandiloquent Italian sources would have led him to the felicitous emphasis on the plasticity of the sleeve, the rougher brushstroke, and the sophisticated exploration of the range of creamy tonalities applied to it. The Wadsworth Atheneum portrait thus brings to mind the assertion of the seventeenth-century French biographer, André Félibien, "que le Sueur ait

égalé Raphaël & le Titien dans la correction du dessein & la beauté du coloris."[5] It should also be noted, however, that there remains in the work a certain awkwardness in the representation of the hands. That on the hilt of the sword reads flatly, and the other hand has a certain claw-like character. While the treatment of the hands is totally consistent with the other Le Sueur portraits, it is distinctive from the masterful three-dimensional conviction of Vouet's painted hands.

Part of the problem in attributing the work undoubtedly can be traced to Le Sueur's training and imitative artistic character. The artist entered Vouet's studio at an early age, and his early painting shows the profound influence of that master on him. However, his direct exposure to works by and after Raphael and Poussin in the 1640s is reflected in a more Raphaelesque treatment, increasingly classicizing, and refined sensibility to more idealized figure types, carefully structured and balanced compositions, clarity of contour, and a classical vernacular in costume. The Hartford painting testifies to this Italianate leaning in its "bravo" figure pose and composition. Distinguished by its luminous yet restrained tones, brilliantly exemplified by the cream-coloured sleeve, with its subtle green-infused shadows, set between the rich, highlighted brown hair and the charcoal cape, the portrait is among the greatest of the French seventeenth century.

HTG

Oil on canvas, 25 ⅛ × 20 ½ in.

The Ella Gallup Sumner and Mary Catlin Sumner Collection Fund 1966.11

Provenance: Tomás Harris,[6] Spanish Art Galleries, London, in 1938; Mme Seligmann,[7] Paris; Edward Speelman, London, 1966; from whom purchased.

References: Blunt, 1946, p. 271, pl. 11A (as Vouet); Crelly, 1962, p. 173, no. 55 (as Vouet); Sterling, 1965, pp. 182–3, fig. 7 (as Le Sueur); Blunt, 1982, p. 530 (as Vouet); Rosenberg, 1984, p. 30 (as Le Sueur); Sapin, 1986, no. 2 (as the Le Sueur; sold in Paris in 1786 under the name of Vouet); Mérot, 1987, R.93, pp. 418–19 (as Vouet?); Chastel, 1995, pp. 130–1 (as Le Sueur?); Wintermute, 1996, p. 19 (as Le Sueur); Mérot, 2000, R.93, pp. 418–19 (as Vouet?).

Selected Exhibitions: Paris–New York–Chicago, 1982, no. 52 (as Le Sueur).

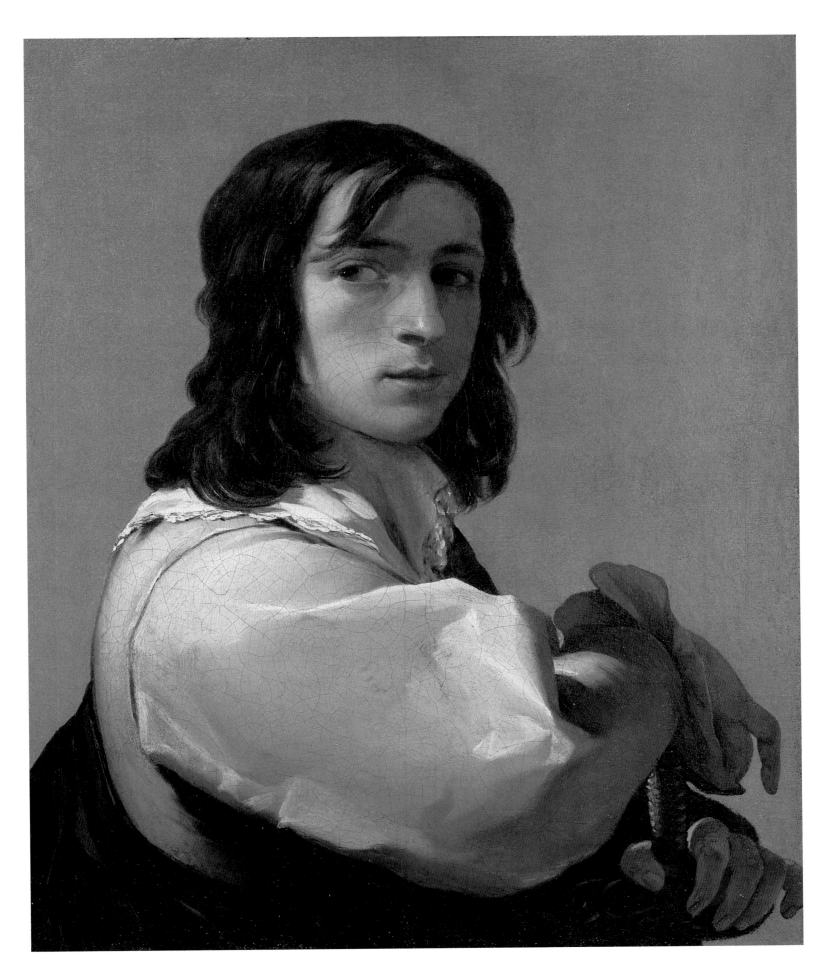

52. Claude Gellée, called Claude Lorrain

French, 1604–82

Saint George and the Dragon

c. 1641

Born in 1604, Claude Gellée arrived in Rome from his native duchy of Lorraine about 1617, and entered the service of Agostino Tassi, a designer of illusionistic landscapes trained by Paul Bril. The earliest influences on Claude's style were dominantly those of Northern European landscape artists working in Rome and Naples, including Sandrart, Wils, Breenbergh, Swanevelt, and Bril. Not an antiquarian by nature, his vision of the monumental nobility of ancient architecture was essentially picturesque, yet, in the later 1630s and 1640s, a more balanced and classical compositional order characterizes his work. Also evident are a softer, more fluid and ambiguous spatial transition and a restrained, subtler use of color to evoke a more sweeping, idealized, nostalgic, elegiacal and atmospheric vision of figures in landscape. It is to this period and the emergence of Claude's mature style – which would make him the most successful landscape painter in Europe – that the Wadsworth Atheneum's picture belongs.

The Hartford painting was originally executed for Cardinal Fausto Poli, the *praefectus domi* (major domo) for Pope Urban VIII and administrator of the Barberini properties and possessions. In 1643 he was made Cardinal, and the execution of this painting, as a pendant to *Seaport with the Embarkation of Saint Ursula*, (National Gallery, London; *Liber Veritatis* 54, fig. 52A) executed about two years earlier, may be

related to this event. The early history of the painting, and the fact that it was done at about the same time as the Cardinal's election are confirmed by Claude himself and by the sequence of the *Liber Veritatis* sheet within the album of drawings and its inscription: "faict per il Cardinale pauly pauli sy ritrova dal Cardinale Antonio." Poli died in 1653 and split the pair of paintings, leaving the Hartford painting to Cardinal Antonio Barberini (d. 1671) and the London picture to the other papal nephew, Cardinal Francesco Barberini (d. 1679).[1]

Although a worldly man, who lived in splendour, Poli chose as subjects for these paintings, themes that are of serious religious import, especially when interpreted together. According to the medieval *Golden Legend* by Jacobus de Voragine, a standard source on the lives of the saints, St. Ursula was a princess, daughter of the British king Notus, who made a pilgrimage to Rome, visiting Pope Cyriacus, prior to her marriage to the pagan king of Anglia, in the company of 11,000 virgins. During their return, they were attacked in Cologne by Huns, and when Ursula refused to marry their chief, she and all her companions were massacred, becoming martyrs to their faith. The painting in London shows their departure from Rome on their fateful voyage. St. George was a Christian Cappadocian and a Roman tribune. Passing by the city of Silene in Lybia, he discovered that each year the city had to surrender a human sacrifice to a local dragon. Saving the daughter of the city's ruler, St. George slew the dragon, thereby converting the king, the princess and the town to Christianity. St. George was eventually martyred by beheading by the Romans at Nicomedia during the persecutions of Emperor Diocletian. The pair of paintings thus contrast two forms of redemption. In the London canvas we are presented with the passive acceptance of martyrdom, as Ursula departs with her own thousands on their spiritual pilgrimage, achieving their salvation through their acceptance of God's will. In the Hartford picture we are witness to the active faith of St. George. By bravely slaying the dragon, he converts thousands of pagans to Christianity. There are other, more material parallels and complementary relationships between the works. In the former painting we are presented with a port opening onto a seascape. In the Hartford painting the artist has depicted a richly verdant landscape. While the placement of figures, even in dramatic narratives, within a panoramic landscape is typical of Claude's work, a direct inspiration for the landscape emphasis in the Hartford painting may have

been a painting of the subject executed about 1610 and attributed to Domenichino, now at the National Gallery, London, as Forte has suggested.[2] The "Embarkation of St. Ursula" is set at sunrise, while the Hartford painting is timed at late afternoon. The general compositional structure of the two paintings is remarkably similar.

The Wadsworth Atheneum's *St. George and the Dragon*, corresponds precisely to Claude's record drawing in *Liber Veritatis* (fig. 52B) except that the latter shows three birds in the sky. None are visible in the painting, and Kitson suggested that they might have disappeared due to a too vigorous cleaning.[3] Both of the pendants were etched in the 1660s by Dominique Barrière, a painter and printmaker from Marseilles, then active in Rome.

HTG

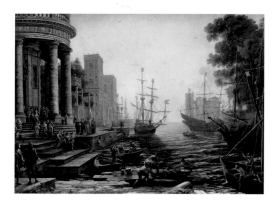

Fig. 52A. Claude Lorrain, *Seaport with the Embarkation of Saint Ursula*, 1641, oil on canvas, 44 × 58 in. National Gallery London, NG30

Fig. 52B. Claude Lorrain, *Saint George and the Dragon*, graphite. From the *Liber Veritatis*, British Museum © Copyright. The Trustees of the British Museum

Oil on canvas, 58 ½ × 44 in.

Signed at the bottom, below the running woman: *CLAUD . . .*

The Ella Sumner and Mary Catlin Sumner Collection Fund, 1937.2

Provenance: Cardinal Fausto Poli, Rome; Cardinal Antonio Barberini (1608–71), Rome; John Lock (according to Earlom); Edmond Antrobus; his sale, London, February 1788; Charles d'Arveley, High Treasurer of France; Charles Alexandre de Colonne, Prime Minister of France; sale, London, Skinner, March 27, 1795, no. 67; William Beckford; possibly with Tomàs Harris,[4] London; Durlacher Bros., New York, by 1936; from whom purchased.

References: Smith, 1837, vol. VIII, p. 230, no. 73; Dullea, 1887, pp. 38, 107; Dillon, 1905, p. 71; Roethlisberger, 1961, no. 29; Vivian, 1969, p. 725; Roethlisberger, 1975, no. 136; Kitson, 1978, under no. 73; Lavin, 1975, p. 302; Forte, 1982, pp. 97–101; Wine, 2001, p. 99.

Selected Exhibitions: New York, 1938, no. 1; New York, 1939, no. 43; New York, 1958; Baltimore, 1961; Washington, 1982–3, no. 29.

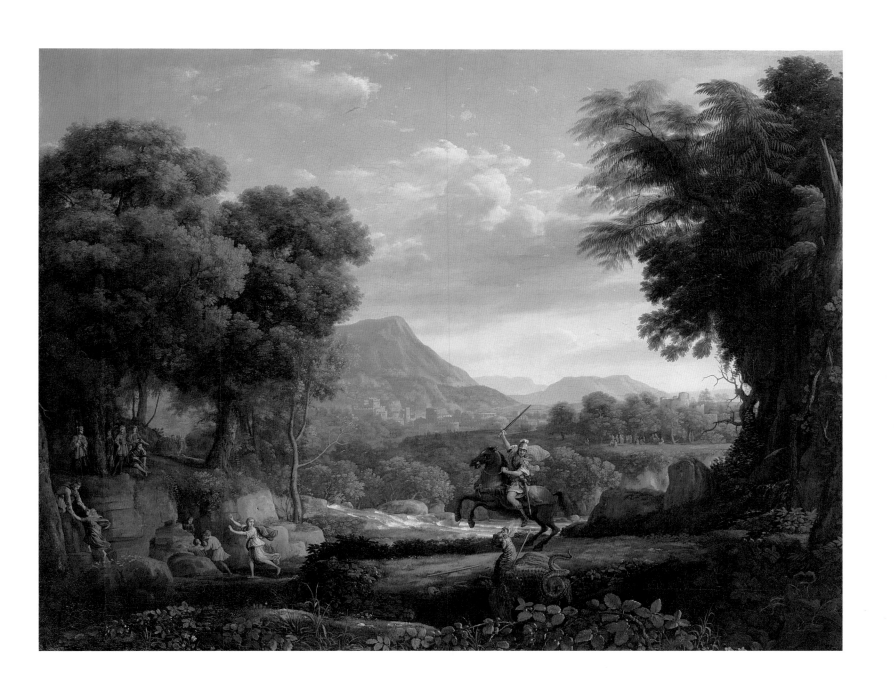

53. Jacques Stella

French, 1596–1657

The Judgment of Paris

1650

Jacques Stella was born in Lyon, a provincial artistic center. Most notable among its artists was the Bolognese-influenced and Paris-born Thomas Blanchet. Earlier in the century Horace Le Blanc had been the leading municipal artist, and Stella may have received initial training in his studio. Lyon, in central France, was a main travel route between Paris and Rome. At the age of twenty, Stella journeyed to Florence, in 1616, where the brilliant Lorraine printmaker Jacques Callot was emerging as a major figure. After the death of Cosimo II, in 1622, Stella continued to Rome. There he earned a reputation both as a painter and designer for prints. A close friendship with Poussin profoundly influenced his art, previously indebted to the counter-maniera (a reformist trend nonetheless working within much of the same vernacular as late mannerist painting in Italy). Stella personally commissioned or owned several important works from Poussin, among them the Wadsworth Atheneum's great *Crucifixion* of 1645 (fig. 22). Leaving Rome in 1634 with the returning French ambassador, the Duke de Crequi, Stella gained the patronage in Paris of Cardinal Richelieu, as well as other prominent collectors. He also continued as a popular graphic designer. His increasingly classicistic compositions, with idealized, yet doll-like figures, retain surprisingly naturalistic details, probably stemming from an early, Italian appreciation of the work of the Dutch genre painters in Italy. In short, Stella was an accessible, intelligent, but less intellectually demanding articulator of Poussin's classical aesthetic in France. He worked in a more lyrical vein at times with rapturous colorism, as demonstrated in the Hartford painting. These integrated talents are amply illustrated in the Wadsworth Atheneum picture by its profound debt to Raphael through Marcantonio's print, its great clarity and compositional balance, crisp contours and its bright, clear color palette. It is, in short, a Poussiniste work in a popular, less challenging vernacular.

According to the ancient story of the Judgment of Paris, the Trojan prince and shepherd of that name, was asked to choose between the three goddesses, Juno, Venus and Minerva (in their Roman nomenclature), which among them was the most beautiful. In Stella's painting of 1650, Mercury, the messenger god, who was sent by Jupiter to ensure that Paris decided the competition, is depicted handing the handsome youth the golden apple bearing the legend "to the fairest," to be presented to the victor. The three contestants await Paris's decision, but hardly passively. A confident Venus directs Cupid's burning arrow towards Paris, and she is already being crowned with a floral wreath by her attendants. Minerva, accompanied by her owl and her back turned to the viewer, points to Fame. Juno gestures towards the figures of Ceres, holding a crown, Time, with a sack of riches, and a putto, bearing a pearl necklace. Each of the three nude goddesses displays her womanly charms from a different angle. In the midst of this activity, Sol rides his chariot on his daily course. At the upper right, Jupiter, who wisely had declined to make the selection, looks on bemusedly from his throne. The scene is further witnessed by a river god, Oeneus, Paris's father-in-law, and by satyrs and other mythological attendants. Paris's choice of love (Venus) over power and wealth (Juno) or wisdom and military prowess (Minerva), will ultimately result in his abduction of Helen and the onset of the Trojan War.

The painting makes imaginative use of Marcantonio Raimondi's celebrated print *The Judgment of Paris*, of about 1517–20 (fig. 53A) after Raphael. The original Raphael design is itself inspired by ancient Roman sarcophagi. As Cuzin has noted, Stella borrowed many motifs from the engraving, as well as the overall compositional structure of the print, but left hardly a single figure unaltered. This Raphaelesque inspiration is entirely in keeping with Stella's work at this mature period of his career.

As Rosenberg has noted, Stella's *Judgment of Paris*, belonged to the distinguished seventeenth-century collector, the remarkable Count of Brienne, in whose inventory it appeared in 1662. Brienne, besides his familiarity with the young Louis XIV, was also secretary to Cardinal Mazarin, whose impressive collection included a large number of contemporary Italian paintings, as well as antiquities, French and Flemish works. At the age of twenty-seven, however, Brienne was placed by his family in an asylum, where he died in 1698. Another notable previous owner of the painting was Alexandre Dumont of Cambrai, who also had in his collection Vermeer's *The Geographer* (now in Das Städel, Frankfurt).

HTG

Oil on canvas, 29 ⅝ × 39 in.

Signed and dated, lower right on river god's oar: *Stella f.1650*

The Ella Gallup Sumner and Mary Catlin Sumner Collection Fund, 1957.445

Provenance: Louis-Henri de Loménie, comte de Brienne (1636–98), 1662; M. Chalut de Verins, Fermier-général to Queen Marie-Antoinette, by inheritance to M. Deville; Deville sale, Paris, March 19, 1816, no. 32; Hypolite Delaroche; Delaroche sale, February 1–2, 1819, lot 26; Féréol de Bonnemaison; Sale, Paris, April 17–24, 1827, no. 98; Alexandre Dumont, Cambrai, 1860; sale, Paris, Hôtel Drouot, June 27–8, 1957, no. 180; Julius Weitzner, London, 1957; from whom purchased in 1957.

References: Félibien, v, 1688, p. 271; Mantz, 1860, pp. 311–12; Thuillier, 1958, 1, 1960, p. 109 (as lost); Rosenberg, 1964, pp. 297–9; Cuzin, 1982, p. 529; Rosenberg, 1984, p. 35.

Selected Exhibitions: Paris–New York–Chicago, 1982, no. 102; Cologne–Munich–Antwerp, 2000–1, no. 66.

Fig. 53A. Marcantonio Raimondi after Raphael, *The Judgment of Paris*, c. 1517–20, engraving, 11 ½ × 17 in.

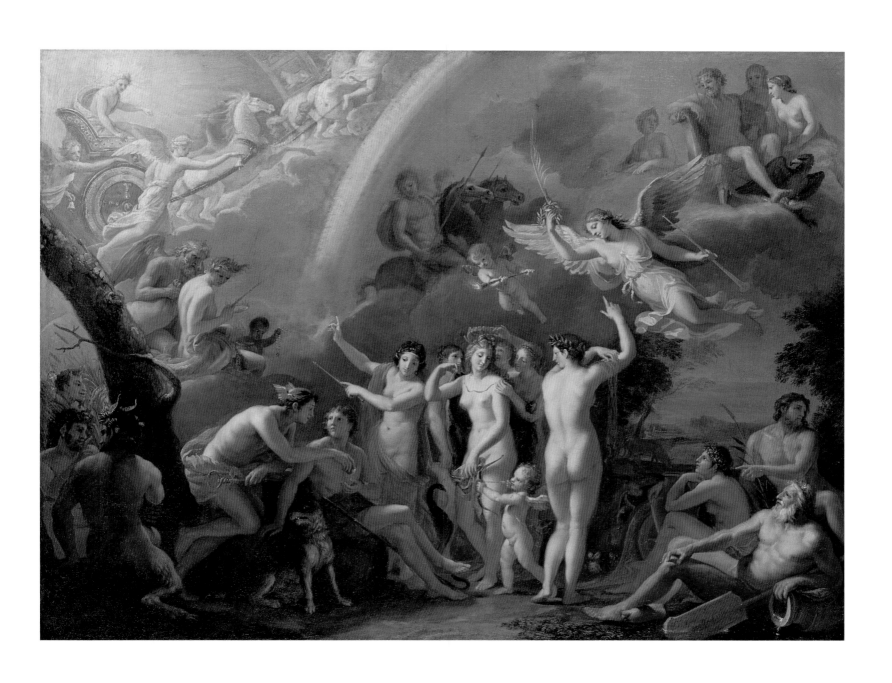

54. François Boucher

French, 1703–70

The Egg Seller

c. 1734–5

The amazingly prolific and versatile François Boucher was the foremost painter, draughtsman, print-maker, book illustrator and designer of tapestries of his generation. He was to achieve fame in the highest ranks of France's official art establishment, and although he was the target of much maligning on the part of art critics who defended a return to the ideals of the Classical tradition, his prestige remained intact as long as the Rococo aesthetic held sway.

Born in Paris, he was the son of Nicolas Boucher, a minor painter. In the early 1720s, the young François attracted the notice of the history painter François Lemoyne, whose elegant painting style he quickly assimilated. In 1724 he won first prize in the painting competition organized by the Académie Royale, but he was only able to depart for Rome in the spring of 1728. Although adept in virtually every genre, he would eventually specialize in painting scenes of amorous dalliance in idyllic settings and the loves, pleasures and adventures of the gods of Roman mythology.

Boucher returned to Paris about 1731. In 1734 he applied for membership in the Académie Royale, into which he was inducted on the strength of his diploma picture, *Rinaldo and Armida* (Paris, Musée du Louvre). The following year he received the first in a long string of royal commissions, when he was asked to produce four camaïeu decorations for the bedchamber of Queen Marie Leczynska at Versailles.

It was at this relatively early stage of his career, i.e. more than a decade before he became the favorite painter of Louis XV's official mistress, the Marquise de Pompadour, with whom his name is often connected, that François Boucher executed the genre painting in the Wadsworth Atheneum. Traditionally titled *The Egg Seller*, it would probably be more appropriately called *The Egg Thief*. The sexual nature

of the incident it portrays requires little explanation. This is clearly a scene of seduction in which hand gestures play a dominant role. A red-cheeked man places his left hand around the shoulders of a considerably younger woman and with the other boldly seizes one of the eggs she has gathered in the basket on which she rests her arm. That she is not playing hard to get is evidenced by the forward thrust of her head, the look of gentle bemusement with which she greets the man's voluptuous smile and the fact that she has gently placed her right hand on his forearm. The theme of eggs as metaphors of the fragility of female virginity has such seventeenth-century Dutch precedents as Frans van Mieris's *Broken Eggs*.[1] In the eighteenth century, it will later be given its ultimate expression by Jean Baptiste Greuze in one of the four paintings "dans le Costume Italien" that he sent to the Salon of 1757, the Metropolitan Museum of Arts' *Broken Eggs* (see cat. no. 56), and in the same artist's *Distributor of Rosaries*[2], in which a maiden dressed in scarlet coyly lifts the cloth covering the basket of eggs she shows to an old hermit monk and his young acolyte.

In August of 1748, Jean Daullé published an engraving of Boucher's composition, with the man replaced by a curly headed youth and the hillock in the background transformed into a stone pedestal overgrown with vegetation (fig. 54A). This engraving bears the printed title by which the Atheneum's painting has traditionally been named, *La Marchande d'Œufs*, and a few lines of moralistic doggerel:

> Dans ce panier tout est fragile.
> D'un Villageois ces Œufs sont le trésor.
> L'Honneur est plus fragile encor:
> Le bien garder n'est pas chose facile.[3]

Although the engraving specifies that the print was based on a painting, in all likelihood Daullé's source was a chalk drawing recorded by Alexandre Ananoff as belonging to the G. de W . . . collection.[4] Daullé also engraved and published as part of the same set three related two-figured oval compositions which also seem to have been inspired by drawings rather than paintings.[5]

In the second half of the nineteenth century, *The Egg Seller* was paired with a painting of identical dimensions and shape which was probably executed at the same time, *Of Three Things, Will You Do One? (De trois choses en ferez-vous une?)* (fig. 54B), the subject of which is an eighteenth-century parlor game known as the *Pied-de-boeuf*.[6] The two pictures were together as pendants in the 1874 and 1877 sales cited in the provenance. They subsequently belonged to Madame C. Lelong, but only the present work was included in the auction sale of her property that was held in 1903. Both Alastair Laing and Colin Bailey have denied the companion status of the two works, but given the obvious similarity in the artist's handling of the oil medium and the significance Boucher has assigned to hand gestures in each of them, one would perhaps be wise not to discard too readily this possibility.

JB

Oil on canvas, oval: 42 ½ × 32 ¾ in.

The Ella Gallup Sumner and Mary Catlin Sumner Collection Fund, 1977.1

Provenance: M. Pillot, "marchand de curiosités," Paris; his sale, Paris, December 6–8, 1858, no. 17; Paris, anonymous estate sale, January 22, 1874, no. 2; Paris, anonymous sale, May 14, 1877, no. 8; Madame C. Lelong; her sale, Galerie Georges Petit, May 11–15, 1903, no. 498; Galerie Cailleux, Paris, by 1974; from whom purchased.

References: Soullié and Masson, 1906, no. 1505; de Nolhac, 1907, p. 144; MacFall, 1908, p. 155, rep. p. 109; Ananoff, 1976, I, p. 223, no. 90; Jean-Richard, 1978, p. 161, under no. 546; Ananoff, 1980, p. 92, no. 90, rep. p. 91; Brunel, 1986, rep. p. 178, fig. 142; New York, 1986–7, pp. 139–40, under no. 19; Ottawa, 2003–4, p. 363, under cat. no. 50.

Selected Exhibitions: Paris, 1897, no. 16; Paris, 1975, no. 3; Williamstown, 1987.

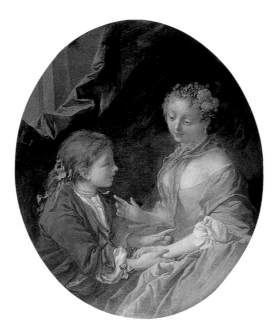

Fig. 54A. Jean Daullé, after Boucher, *La Marchande d'Œufs*, etching, 10 × 8 ¼ in. Photograph courtesy of the Wildenstein Institute, Paris

Fig. 54B. François Boucher, *Of Three Things, Will You Do One? (De trois choses en ferez-vous une?)*, *c.* 1733–4, oil on canvas, oval: 41 × 33 ¼ in. Fondation Ephrussi-de-Rothschild, Académie des Beaux-Arts, Saint-Jean-Cap-Ferrat

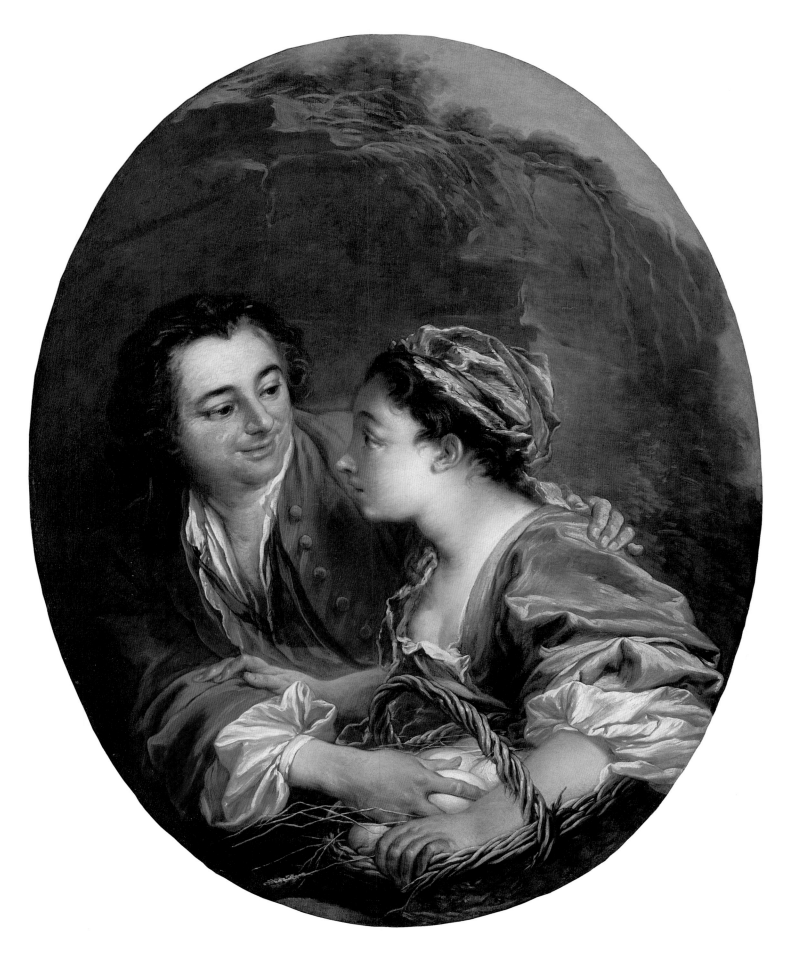

French School * 145

55. Noël Hallé

French, 1711–81

The Holy Family

1753

Both Hallé's father and grandfather were painters, and after first studying architecture, he followed in their footsteps. An important influence on him was the history painter Jean Restout, who became his brother-in-law in 1729. Hallé competed unsuccessfully for the *Prix de Rome* in 1734 but won it in 1736, which enabled him to depart for Rome in 1737. There, under the director of the *Académie de France*, Jean-François de Troy, he pursued the prescribed course, studying ancient works of art as well as those of Raphael and other Renaissance masters. He returned to France in 1744 and commenced a distinguished career as a dedicated academician, being *agréé* in 1746 and *reçu* as a history painter in 1748. He became a professor at the *Académie Royale* in 1755 and was sent to reorganize its Roman branch. Hallé received the *Ordre de Saint-Michel* from the king, who had commissioned works for several of his residences from the painter. In his final year, he became *recteur* of the *Académie*.

Noël Hallé was best known as a painter of scenes from classical history, but even in those grand subjects, he imparted a tender, human quality, and this element became more pronounced in his genre subjects. *The Holy Family* is an outstanding example of this aspect of his art, for under the guise of a religious subject, it is actually a touching depiction of a real family with a mother spoon feeding her child overseen with a protective gaze by a bearded patriarch. In fact the intimacy and lack of obvious divinity in this representation of the Holy Family led to considerable comment by the critics, who wrote about the Salon of 1753 where it was first exhibited. One observed that Hallé, "exprime une idée très basse dans un sujet très noble,"[1] and another noted, "ce n'est point une Sainte Famille, mais c'est une Bambochade des plus agréables."[2] Also found worthy of praise was the figure of the young woman, who may have been modeled after Hallé's own young wife, and the miniaturist quality of the work as well as the brilliant color.[3] Indeed, what strikes us still as so effective is the coloristic richness of the painter's palette, creating a harmonious balance in the triangular figure group of yellow, red, green and muted purple. Hallé made a number of preparatory drawings and also executed several variants and repetitions of this charming work,[4] which had been lost from sight until it reappeared among the other fine pieces in the Gutzwiller collection sale.

EZ

Oil on canvas, 18 × 14 ½ in.

Signed and dated at lower center: *Noël Hallé 1753*

The Ella Gallup Sumner and Mary Catlin Sumner Collection Fund, 1997.21.1

Provenance: Ernest Gutzwiller (d. 1976), L'Hôtel de Beauharmais, Paris; sale, Sotheby's, London, December 11, 1996, no. 12; John Mitchell and Sons, London, by 1997; from whom purchased.

References: O. Estornet, *La famille des Hallé*, Paris, 1905, p. 134; N. Willk-Brocard, *Une dynastie Les Hallé*, Paris, 1995, pp. 125–6, 384–6, no. 52.

Selected Exhibitions: Salon, Paris, 1753, no. 54.

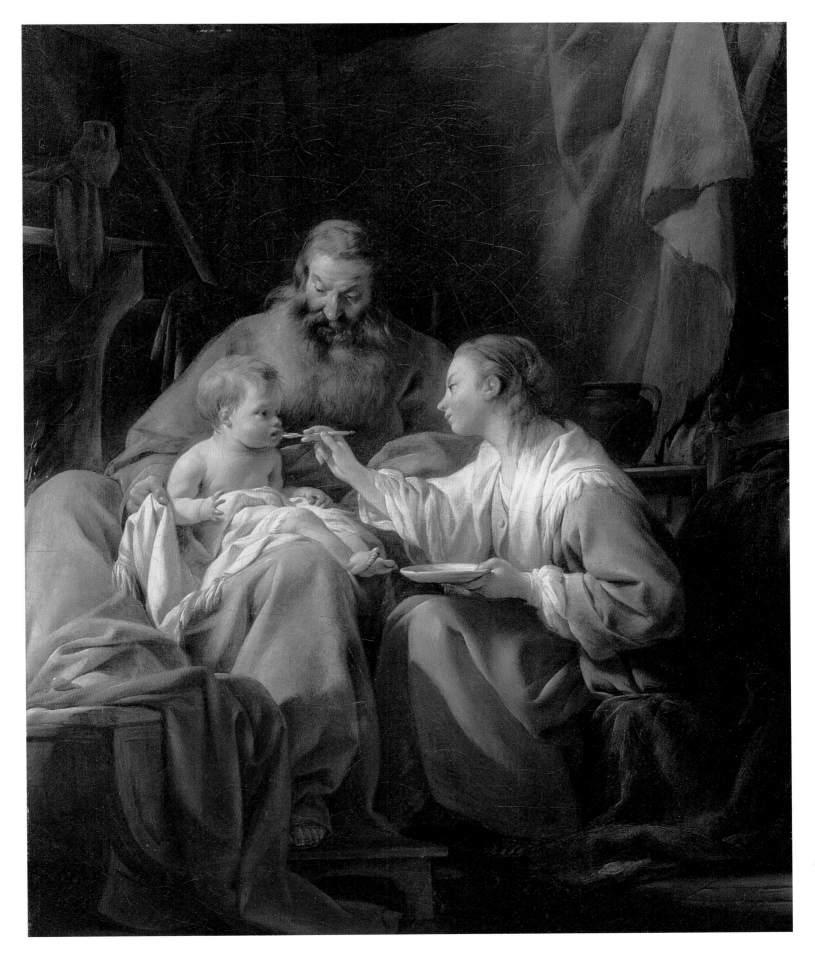

56. Jean Baptiste Greuze

French, 1725–1805

Indolence (La Paresseuse Italienne)

1757

The genre painter and portraitist Jean Baptiste Greuze was born in the Burgundian town of Tournus, the son of a roofer, Jean Louis Greuze and his wife, née Claudine Roch. By the late 1740s he was demonstrating talent as a draftsman and a painter, and he was sent to Lyon to apprentice under the direction of the portraitist Charles Grandon. Around 1750, Greuze accompanied his master to Paris but was soon enrolled as a student of the history painter Charles Joseph Natoire at the school of the Académie Royale de Peinture et de Sculpture. His early progress was so astounding that he was able to gain the support of the sculptor Jean Baptiste Pigalle and the director of the Académie, Louis de Silvestre. On June 28, 1755 he was made an associate member (an *agréé*) of the Académie in the category of genre painting and in late August of that year sent to the Salon six works, all of which were masterful performances that elicited positive critical commentary.

Although Greuze did not compete for the Prix de Rome, he realized that an ambitious artist should travel to Italy to familiarize himself with the masterpieces of Antiquity, the High Renaissance and the Baroque age. He found sponsorship in the person of the historian, collector and honorary member of the Académie, the Abbé Louis Gougenot, in whose company he departed in late September of 1755 for Italy. Along the way, they made sightseeing stops at Turin, Genoa, Parma, Modena, Bologna, Florence and Naples, arriving in Rome by late January of 1756. When Gougenot left, Greuze was given room and board at the Académie de France, whose new director was his master Natoire. News of his progress reached

the ears of Louis XV's director of fine arts, the Marquis de Marigny, brother of the king's mistress the Marquise de Pompadour, for whom he received a commission. While in Rome, Greuze painted a number of major works, among them the two sets of pendant moralizing compositions depicting figures "dans le Costume Italien," which he later sent to the Paris Salon of 1757. Two horizontal paintings, *L'Oeuf cassé* (Metropolitan Museum of Art, New York) and *Le Geste napolitain* (Worcester Art Museum), formed a pair, and the Wadsworth Atheneum's *Indolence* and *The Bird-Catcher* (Muzeum Narodowe, Warsaw) formed another.[1]

Indolence depicts a pretty, plump but unkempt young woman sitting on a chair in a rustic pantry, leaning forward and crossing her hands in her lap. Her swollen breasts protrude from the low cut bodice of her rather plain dress. The only luxurious items of clothing are her bright red shoes, one of which lies discarded on the floor, which is littered with a copper basin, pieces of crockery and tipped-over bowl of water, items she seems too phlegmatic, tired or unwell to pick up. The simple furnishings consist of a tripod wash-stand and cabinet. The wedding band on her left hand signals that she is married, and from the dull, rather sickly expression on her face, one could well imagine that she is either completely inebriated after emptying one of the bottles of wine on the cabinet or suffering from morning sickness, which may well explain her dispirited and lymphatic condition.[2] Neither the staging of the scene nor the almost miraculous handling of paint have undergone an appreciable change since the works Greuze had painted prior to his Italian trip.[3] The warm flesh tones and the creamy whites of the woman's fichu, blouse and apron are beautifully modulated. The crimson of the shoes provides the single note of bright color in an otherwise subdued palette.

It has more than once been noted that the young woman's pose is based on Caravaggio's early *Repentant Magdalen* of *c.* 1595, which Greuze undoubtedly saw in the Palazzo Doria-Phamphilj in Rome. The subject of a slovenly young woman in a rustic interior also has a kinship with the lightly clad female protagonist in *The Flea Hunt (La Pulce)* by the Bolognese genre painter Giuseppe Marie Crespi, which exists in multiple versions,[4] one of which Greuze may well have come across on his way to Rome. What may be a study for the figure in the Atheneum's painting, a black chalk drawing on blue paper depicting a bovine-featured woman facing left and holding her hands cupped in her lap, is in The State Hermitage Museum, St. Petersburg.[5]

The pendant *Bird-Catcher* in Warsaw remained in the Radziwill and Branicki collections until 1944, entering the Muzeum Narodowe in Warsaw only in 1954. As can be seen in the engraving by Moitte (fig.

56A), it depicts a healthy young blade, no doubt the young woman's husband, in a wildly contorted pose. His frenetic energy was meant to contrast with her inertia. The sexual innuendos[6] are obvious: the so-called "lazy" young woman's forlorn state is the result of his rambunctious efforts. He has snared his birds and is now tuning his musical instrument to charm his hapless spouse, whom he has impregnated. Another seicento painting in the Doria Pamphilj collection probably inspired the pose of the young fowler/guitarist, a copy of Caravaggio's *St. John the Baptist with a Ram* in the Pinacoteca Capitolina, Rome, whose dynamic stance echoes that of one of Michelangelo's famous *Ignudi* on the ceiling of the Sistine Chapel.[7]

The spatial relationship of figure to setting are alike in the two compositions: the female and male protagonists loom large and are close to the picture plane, and the rooms are cluttered, almost to a stifling degree, with all sorts of household items and hunting gear. The two pictures were meant to be seen together and their subjects understood as a narrative, and they were thus both engraved by Pierre Étienne Moitte with the titles *La Paresseuse* and *Le Donneur de sérénade*.[8]

JB

Oil on canvas, 25 ½ × 19 ¼ in.

The Ella Gallup Sumner and Mary Catlin Sumner Collection Fund, 1934.11

Provenance: Jean Baptiste Laurent Boyer de Fonscolombe (1716–88), Hôtel Grimaldi-Regusse, Aix-en-Provence, as of 1757; his sale, Paris, *Catalogue d'une collection de Tableaux d'Italie, de Flandre, de Hollande et de France . . . formant le cabinet de feu M. Boyer de Fonscolombe, d'Aix en Provence*, January 18, 1790, lot. 101, sold with its pendant to the dealer Constantin for a bid of 877 *livres*; sometime before 1874 in the collections of the Polish noble families, Radziwill and Branicki, Rome, Paris and Warsaw; acquired in 1922 from the Radziwills in Paris, through the intermediary of J. Bernard, by Wildenstein, Paris and New York; from whom purchased in 1934.

Selected References: Smith, 1837, VIII, no. 96; de Goncourt, n.d., II, pp. 74, 81; Martin and Masson, 1908, p. 16, no. 187; Rivers, 1912, pp. 73, 126, 270; Mauclair, Paris, 1926, p. 81; Wescott, 1935, pp. 7–8; Brookner, 1972, pp. 59, 97, repro. pl. 13; Opperman, 1979, p. 411; Fried, 1980, pp. 35, 37, repro. p. 37, fig. 17; Levey, 1992, p. 221, repro. in col. p. 220, fig. 227; Munahll, 2002, p. 20.

Selected Exhibitions: Paris, 1757, no. 114; New York, 1935–6, no. 31; New York, 1940, no. 204; New York, 1954, no. 13; London, 1968, no. 302; Toledo–Ottawa, 1976, no. 41; Hartford–Dijon, 1976–7, no. 10; Atlanta, 1983, no. 48; Hanover, 1997–8, no. 26; Ottawa–Washington, 2003, no. 66.

Fig. 56A. Pierre Etienne Moitte after Greuze, *The Bird-Catcher*, 1765, engraving. Private collection

57. Elisabeth Louise Vigée Le Brun

French, 1755–1842

The Duchesse de Polignac Wearing a Straw Hat

1782

Elisabeth Louise Vigée was born in Paris on April 16, 1755 near the church of Saint-Eustache where she was baptized. She was the first child of the portrait painter Louis Vigée (1715–67) and his wife, née Jeanne Maissin (1728–1800). Before his death, his father had begun to instruct his young daughter in the art of drawing and pastel painting, arts in which he excelled. His premature death when she was only twelve years of age affected her profoundly, as did her mother's second marriage to the jeweler Le Sèvre. Realizing that Elisabeth Louise had both talent and the ambition to succeed, Madame Le Sèvre allowed her daughter to study painting in earnest. All things considered, the artist must be considered as self-taught, and she trained herself by studying and copying Old Master and modern paintings that she came across in visits she made to various royal and private collections. Following in her father's footsteps, she specialized in portraiture, and she rapidly gained access to a well-paying, mostly upper-middle-class clientele.

Mademoiselle Vigée joined the Académie de Saint-Luc, of which her father had been a member, and she exhibited there some of her early works in 1774. Her family moved to lodgings in a townhouse on the rue de Cléry, the Hôtel de Lubert, which was then occupied by one of the foremost art experts and dealers of the day, Jean Baptiste Pierre Le Brun (1748–1813). He was attracted to the young prodigy and readily lent her paintings from his stock for her to copy. Recognizing in her artistic accomplishments a source of future income, he asked for her hand in marriage. In early 1776, to gain a modicum of independence, she married him, despite the fact that he already had a reputation as a philanderer. In 1780 the artist gave birth to her only child, a girl christened Jeanne Julie Louise.

The Le Bruns lived on an opulent scale. The artist's stylish salon became one of the most popular in Paris and was a gathering place for artists, writers, and prominent figures of the highest echelons of French society. Owing to her connections at Versailles, she could soon boast of a wealthy and high-born clientele. It was in 1778 that Vigée Le Brun painted from life for the Austrian Court a full-length, life-size state portrait of Empress Maria Teresa's daughter, Marie Antoinette, the consort of Louis XVI. Thereafter, she could consistently rely on the Queen's patronage, and she would ultimately paint more than thirty portraits of the Queen and her children.[1]

Thanks to Marie Antoinette's direct intervention in 1783, Madame Le Brun was made a member of the Académie Royale de Peinture et de Sculpture over the objections of the powerful First Painter to the King, Jean Baptiste Marie Pierre, who claimed that her husband's profession as an art dealer in effect disqualified her. Thereafter, she was able to exhibit her works in the Académie's biennial Salon, where they attracted much attention. Her growing fame and the astounding quality of her works at this time was such that she could barely keep up with the portrait commissions that came her way. It was probably her dealer-husband who introduced her to her most important private patron, the Comte de Vaudreuil, the lover of Marie Antoinette's closest friend and confidant, the Duchesse de Polignac.

Madame de Polignac, née Gabrielle Yolande Claude Martine de Polastron, was born in Paris on September 8, 1749 into a family of the impoverished nobility. She was the daughter of Comte Gabriel de Polastron, a former member of the household of Louis XVI's father, the Dauphin Louis, and Grand Sénéchal of the province of Armagnac. Her mother was Jeanne Charlotte Hérault, the daughter of René Hérault, an advisor to the King's privy counsel and an Intendant of the Generality of Paris. On July 5, 1767, Yolande married Jules François Armand, Comte de Polignac (1746–1847), an officer in the Royal Polish regiment.

Marie Antoinette spent much time in the company of the Duchesse de Polignac. Her salon was the meeting place of a coterie of aristocrats who used the influence she could exert on the Queen to advance their own interests. They convinced Marie Antoinette to dispense highly remunerated offices to their cronies and urged her to use her authority over the King to involve herself in matters of state. These abuses which occurred at a time when the royal treasury was on the verge of bankruptcy increased the Queen's unpopularity among all classes of French society.

By 1789, when the French Revolution violently erupted, Madame de Polignac and those who gravitated around her were the main target of the clandestine press. She, the members of her immediate family, the Comte de Vaudreuil, and the King's brother the Comte d'Artois fled France in the first wave of the emigration. In 1790, after a stay in Switzerland, the Polignacs moved on to Venice, where the marriage of one of the Duchesse's sons, Armand, was to be celebrated. At the end of July 1791, the Polignacs and Vaudreuil settled in the outskirts of Vienna, the birthplace of Marie Antoinette. The already compromised state of the Duchesse's health worsened as news of the fate of the royal family was reported to her. She survived the death of Marie Antoinette by only a few months, expiring on December 5, 1793. According to Vigée Le Brun, who was living nearby, ". . . sorrow had changed her so much that her lovely face had become unrecognizable."[2]

In the lists of her sitters that she appended to her memoirs, Vigée Le Brun accounts for eight portraits of the Duchesse de Polignac.[3] The first, which shows her wearing a straw hat, was recently acquired by the Musée national du Château de Versailles from the estate of Prince Guy de Polignac.[4] The composition is based on Vigée Le Brun's exquisite *Self-Portait with a Straw Hat*, a work acquired by the Comte de Vaudreuil. The self-portrait, and by extension the likeness of the Duchesse de Polignac wearing a straw hat, is a pastiche of Rubens' *Portrait of Suzanne Fourment*, called *"The Chapeau de paille,"* which the artist had seen in the Van Havre collection in Antwerp. Both works derive their sensitive handling of light and colored reflections from Rubens'

celebrated prototype.[5] The addition of wildflowers and blades of wheat to the crown of the straw hat was probably inspired by such Dutch seventeenth-century prototypes as Paulus Moreelse's half-length depictions of shepherdesses (fig. 46).[6]

The Atheneum's *Portrait of the Duchesse de Polignac* is undoubtedly the replica of the Versailles painting mentioned in Vigée Le Brun's list of 1782.[7] Its first known owner was a British aristocrat living in France, Henry Seymour, half-brother of the Earl of Sandwich and nephew of the Duke of Somerset.[8] (For a short time he had been the lover of Louis XV's last paramour, the Comtesse Du Barry.) The Wadsworth Atheneum's painting remained in the possession of Henry Seymour's descendents until at least 1912 and was ultimately sold by one of them to Lord Curzon of Keddleston. According to the catalogue of the Curzon sale in 1932, it had been presented by the Duchesse de Polignac to Seymour's French wife, née Louise Thérèse de la Martellière de Chançay. But one can legitimately wonder if this provenance was not just a ruse to obfuscate a collection history that would have included the name of Seymour's next and last mistress, the Comtesse de Canillac, née de Roncherolles, a rather notorious noblewoman who was well introduced into the Polignac circle.

JB

Oil on canvas, 36 × 25 in.

The Ella Gallup Sumner and Mary Catlin Sumner Collection Fund, acquired in honor of Kate M. Sellers, Eighth Director of the Wadsworth Atheneum, 2000–3, 2002.13.1

Provenance: Most likely the Duchesse de Polignac; and given by her to Madame de Canillac who was the mistress of Henry Seymour (1729–1805), Château de Prunay and later Knoyle (Wiltshire); from whom it passed to his son, Henry Seymour (1776–1849); to the latter's second son, Alfred Seymour (1824–88), Knoyle; to the latter's daughter, Jane Margaret Seymour (1873–1943); probably presented by her in her lifetime to her cousin, Henry Hales Pleydell-Bouverie (1848–1925), the son of Jane Seymour (d. 1892), the oldest child of Henry Seymour (1776–1849), and her husband, Philip Pleydell Bouverie; acquired after 1912 by George Nathaniel, 5th Baron Curzon, Earl Curzon of Kedleston and 1st Marquess Curzon of Kedleston (1859–1925); to his second wife, née Grace Elvina Trillia Hinds (d. 1958), (her sale, New York, American Art Association, April 22, 1932, lot 81); sold there for $16,500 to H.E. Russell on behalf of the American diplomat Anthony ("Tony") Joseph Drexel Biddle (1896–1961); private American collection; Jack Kilgore & Co., New York, 2002; from whom purchased in 2002.

References: Vigée Le Brun, Paris, 1835, I, p. 330; Salmon, 2000, fig. 1.

58. Joseph Wright of Derby

British, 1734–97

The Old Man and Death

1773

The inevitable provincial connotation of the designation "Wright of Derby" to distinguish him from the Liverpool painter Richard Wright, is misleading for Joseph Wright of Derby was one of the most accomplished and original talents to emerge in eighteenth-century England. Synthesizing many facets of aesthetic and intellectual culture, including scientific inquiry, emerging interests in native landscape, and long-standing academic concerns for narrative painting, Wright's best work exhibits penetrating representations of human drama, perceptive observation of the natural world, scientific accuracy, and an abstract delight in the art of painting for its own sake. Born in 1734 to a solidly middle class professional family, Wright was educated and raised in Derby where he spent most of his life. His circle of friends, acquaintances and patrons there included wealthy industrialists as well as a group of philosophers and scientists later known as the Lunar Society. After initially teaching himself to draw by copying prints, Wright's formal training began in 1751 when he became a pupil in the London studio of the portrait painter Thomas Hudson. He remained there for two years and returned for a second period *c.* 1756–7. Wright first exhibited in London at the Society of Artists in 1965 and thereafter at the Royal Academy. He settled in Derby after attempts to establish himself in fashionable portrait painting in Liverpool (1768–71) and Bath (1775–7) interrupted by an excursion to study the painting and landscape of Italy (1774–5). Although portrait commissions remained the most reliable source of income throughout his career, Wright became deeply interested in landscape giving it increasing importance in his portrait and narrative compositions but also establishing pure landscape as an independent subject.[1] Although he sold relatively few in his lifetime, Wright's landscapes earned critical acclaim and his accomplishments were instrumental in raising the status of landscape painting.

The Old Man and Death masterfully combines Wright's ability to depict a literary narrative with his skill in rendering a natural setting with accuracy and keenly observed detail. The subject of this painting is based on one of Aesop's Fables or possibly a later re-telling by Jean de la Fontaine.[2] Both were widely known and available in English translation in the eighteenth century. According to the tale, an old man, weary of the cares of life, lays down his bundle of sticks and seats himself in exhaustion on a bank, and calls on Death to release him from his toil. Appearing in response to this invocation, Death arrives. Personified here as a skeleton, Death carries an arrow, the instrument of death. Illustrating the moral of the tale that it is "better to suffer than to die," the startled old man recoils in horror and instinctively waves him off, reaching for the bundle as he clings to life. While some have suggested that the arrow impales the skeleton, others point out that the arrow is in fact resting on Death's shoulder and pointing away from the man thereby indicating that death in this case is a matter of choice and not an infliction.[3]

Wright's decision to paint a didactic subject reflects prevailing academic dogma that privileged serious moralizing narratives. Yet, he skillfully sets the drama in an elaborate and extensive landscape setting reflecting a contemporary shift toward landscape as a worthy pursuit for an ambitious artist. Wright himself excelled at brilliantly observed and rendered compositions of "pure" landscape. In *The Old Man and Death*, the dominant landscape setting is calculated to complement the human drama by effecting mood and enhancing narrative meaning. The defoliated tree branch in the middle ground echoes the confrontation of man with his own mortality and psychological vulnerability. The ruined building in the background is a common allusion to the transience of human life. Many have commented on the "strange" choice to set this macabre scene in broad daylight.[4] Yet, the most forceful element of Wright's landscape is perhaps the brilliant glittering light that illuminates the intensely dramatic scene with startling drama and scrutiny. In fact, Wright's objective recording of a sun-flooded landscape paradoxically underscoring the frightful and unexpected apparition of Death has been compared to the surrealist combination of irrational subject with photographic detachment.[5] Wright is widely known for his experiments in recording a variety of light effects from the artificial light of a candle, forge, or fireworks to the natural illumination of the night by a volcanic eruption or the moon.

The precise detail of Wright's rendering of the landscape in *Old Man and Death* has been variously assessed as too heavy-handed or more favorably compared to the "crystalline exactness of the Pre-Raphelites."[6] Alternatively, it may be presented as one of the finest examples of brilliantly synthesized efforts to represent the artist's fascination with observed effects of glittering light on wide ranging surfaces of foliage, stone, water etc. and the artistic delight in the abstract vocabulary of pure sensual painting of intricate texture, color, and form.

Wright's interest in scientific matters is reflected in the subjects of two of the artist's major paintings, *A Philosopher Giving a Lecture on the Orrery* and *An Experiment on a Bird in the Air Pump* that record the activities of the Lunar Society in their pursuit of scientific truth.[7] Wright himself pursued an intense study of natural scenery enabling him to represent convincing landscape effects in order to record a wide range of scientific inquiry, including his fascination with studying various kinds of natural and artificial light and geographic forms in the landscape. In this landscape, Wright carefully records the play of a strong unforgiving daylight on the variety of foliage and the decaying stone of the ruin. His portrayal of Death, rendered with meticulous anatomical accuracy, likewise reflects his interest in scientific accuracy. For the animated skeleton of Death, Wright turned to the medical illustration of Jan Wandelaar for Albinus's medical text. A sketchbook now in the British Museum records Wrights study of that source.[8]

A letter from Joseph Wright to his sister Nancy written from Italy documents his anxiety over the hanging of the *Old Man and Death* at the Royal Academy exhibition noting that he set a price of 80 guineas.[9] The painting remained unsold in his lifetime. A smaller version (25 × 30 in.) showing only the central portion is in the Walker Art Gallery Liverpool.[10]

CR

Oil on canvas, 40 × 50 ¹/₁₆ in.

The Ella Gallup Sumner and Mary Catlin Sumner Collection Fund, 1953.15

Provenance: Estate sale of the artist, Christie's, London, May 6, 1801, no. 58; bought in; Shaw of Derby sale, October 11, 1810, no. 5; purchased by Sir Robert Wilmot of Chaddesden and by descent until 1952; H.J. Spiller, London; from whom purchased in 1953.

References: Nicolson, 1968, no. 221; Egerton, 1990, no. 38; Cummings and Staley, 1968, no. 29.

Selected Exhibitions: London, 1774, no. 321; Royal Academy, 1886, no. 6 and numerous other occasions; Northampton, 1955, no. 12; Cambridge, 1965, no. 39; Paris, 1972, no. 41; London, 1990, no. 38; New Haven–San Marino, 2001, no. 28; London, 2002, no. 316.

59. Benjamin West

British (born America), 1738–1820

Saul and the Witch of Endor

1777

Born and raised in rural Pennsylvania, Benjamin West first studied painting in Philadelphia with the English portrait painter William Williams (1721–91); he subsequently established himself as a portraitist in that city. In 1759, he traveled to Italy where he spent three years studying classical sculpture and Renaissance and modern Italian painting in preparation for his career as one of the most successful history painters in England. In 1763, he settled in London where he soon established himself as an innovator in the neo-classical movement and a strong advocate for the advancement of an English school of history painting. A founding member of the Royal Academy in 1768, West was appointed historical painter to King George III and, in 1792, he was elected second president of the Royal Academy succeeding Sir Joshua Reynolds. West's extraordinary individual achievement was instrumental in advancing acclaim and patronage in eighteenth century England for history painting—then the most exalted category of fine art.

West's *Saul and the Witch of Endor* depicts an episode from the Old Testament (1 Samuel 28:3–20). According to the Biblical tale Saul visits the Witch of Endor to obtain a prophesy about the outcome of an imminent battle. Using supernatural powers, the grotesque witch, at the far left, summons the ghost of the dead prophet Samuel who emerges from towers of glowing smoke. The prostate Saul, in the foreground, bows in terror at the sight of the ghostly apparition who predicts forthcoming defeat and death. The drama is intensified by the frightened expressions of the two soldiers accompanying Saul who glance back over their shoulders as they flee through a door to the right.

This small-scale painting characterized by a tightly organized composition, with effective gesture, figural interaction, crisply delineated forms, and clearly articulated narrative, favorably demonstrates the accomplishments of West as a painter of history. The narrow-stage-like space and rigidly posed figures exemplify West's paradigmatic neo-classical style, first developed in contact with Anton Raphael Mengs and Gavin Hamilton in Italy who each encouraged West to interpret classical art.[1] Probably inspired by a composition of the same subject (now in the Louvre) by the Italian seventeenth-century artist Salvator Rosa, which was widely available at the time as an engraving by A. Laurentius, West has chosen the most spectacular emotional and visual moment.[2] Exaggerated theatrical gesture and facial expression communicate the narrative in keeping with academic doctrines of history painting. The heightened passion of this frightening supernatural event appealed to the early romantic imagination that West shared with many of his contemporaries. Among others John Hamilton Mortimer, Joseph Wright of Derby, and John Henry Fuseli all embraced current interests in the aesthetics of the sublime, most famously articulated by Edmund Burke in his *Philosophical Inquiry into the Origin of Our Ideas of the Sublime and the Beautiful* (1757).[3] Defined in opposition to the aesthetic of beauty, the sublime was a more powerful emotion of awe prompted by psychological responses to terror.

West was an innovative exploiter of the highly active print market in late eighteenth century England as a source of supplementary income and for the promotion of his historical works. Although never publicly exhibited, his *Saul and the Witch of Endor* was available for wider public consumption through three different engravings. William Sharp, one of the most successful line engravers of the day, executed a large plate (16⅞ × 23¼ in.) entitled "The Witch of En-Dor," that was published in 1788 by J. and J. Boydell. This print bears an inscription indicating that the original painting was in the collection off Daniel Dalby, Esq. of Liverpool.[4] The following lines accompanied the print:

> And he said unto her, what form is he of? And she said, an old man cometh up, and he is covered with a mantle.
> And Saul perceived that it was Samuel, and he stooped with his face to the ground, and bowed himself.
> Vide the 1st Book of Samuel. 28th Chapter & 14th Verse.

A second engraving of West's *Saul and the Witch of Endor* by F. Shipster was published 4 July 1797 by Thomas Macklin who included it in the 1800 second volume of his elegant volumes of the Bible illustrated by prints after important British history painters. Winkes produced a steel engraving in Karlsruhe.[5]

The pessimism of West's portrayal of Saul focusing on a frail and inadequate response to imminent doom rather than some laudable model of civic heroism central to much neo-classical art, recurs in other biblical subjects by West. For example, in *The Cave of Despair* (1772), based on an episode from Spenser in which Una intercedes to prevent the suicide of the Red Cross Knight goaded by Despair, the painter likewise embraces the subject of human despair in the face of higher powers. This narrative shift from heroic action to resigned despair has been linked to the consequence of the war and chaos of the American and French revolutions. More specifically, Staley has suggested that the Biblical tale of an evil king facing defeat and death, painted in the same year as the Battle of Saratoga, implied clear links to contemporary events in the American War of Independence.[6] The pathos of awe and despair were to become mainstays of Romantic painters in the later eighteenth and early nineteenth centuries. Notably, one of West's most promising students, Washington Allston decades later produced his own composition of *Saul and the Witch of Endor* (1820, Amherst College).[7]

CR

Oil on canvas, 19 ¹⁵⁄₁₆ × 25 ¾ in.

Bequest of Mrs. Clara Hinton Gould, 1948.186

Provenance: Private collection, England; Thomas Knowles for Daniel Dalby, Liverpool, England, possibly purchased in 1779; sale, London, Roger Chapman & Thomas, 1935; purchased by Renaissance Galleries, Philadelphia, 1935; Dalzell-Hatfield Gallery, Los Angeles, CA; Mrs. Clara Hinton Gould, Santa Barbara, CA, 1939; bequest to the Wadsworth Atheneum, 1948.

References: Galt, 1820; Evans, 1959; Dillenberger, 1977; Abrams, 1985; von Erffa and Staley, 1986, no. 275; Kornhauser, 1996, no. 485.

Selected Exhibitions: Philadelphia, 1938, no. 31; New York, 1943, no. 206; Hartford, 1948; Chicago, 1949; Detroit, 1957, no. 65; Allentown, 1962, no. 11; Cambridge, 1965, no. 35; New York, 1966, no. 290; Paris, 1972, no. 324; Baltimore, 1989, no. 25.

60. Thomas Gainsborough

British, 1727–88

Woody Landscape

c. 1783–4

Thomas Gainsborough was among the most important British painters of the eighteenth century. He enjoyed a highly successful career as a portraitist, and can be ranked as the greatest rival to founding Royal Academy president Sir Joshua Reynolds. Born in Sudbury, Suffolk, Gainsborough moved to London as a young man and attended the St. Martin's Lane Academy studying under the printmaker Gravelot and the history painter Francis Hayman. He taught himself landscape by imitating and copying seventeenth-century Dutch compositions. Gainsborough returned to Suffolk where he made a living painting portraits and pursued his interest in landscape by painting and sketching the local scenery. He established himself in portrait painting thereafter at Bath and in London. He was patronized by the royal family and exhibited at the Society of Artists and the Free Society of Artists. Invited to become a founding member of the Royal Academy in 1768, he exhibited there intermittently through 1783 when, prompted by dissatisfaction with the hanging of his paintings, he withdrew from the annual exhibitions to show his paintings in his own house and studio at a fashionable address on Pall Mall.

Although his landscapes found few patrons in his day, Gainsborough's achievement as a painter of rustic scenes delineated in his unique painterly style inspired many followers and helped to establish landscape as an important subject for painting in Britain. By his own testimony, landscape was Gainsborough's preferred subject for painting and sketching. A valued respite from portraiture, his time in the countryside afforded careful observation and recording of the scenery. His rustic landscapes, typically featuring woodlands, farmlands, country lanes, and river scenes, are rarely topographically specific but rather evoke generalized and ideal images of rural life in Britain. In the Atheneum's painting, a lone peasant wades through a pool on horseback behind another horse and followed by his dog within a lush wooded landscape dotted with sheep peacefully grazing on the hill beyond. While the absence of particular details suggests that the scene is an imaginary one, the feathery and sketchy rendering of the trees and the rhythmic brush and sweeping line delineating the banks of the pool and hillside convincingly evoke an idyllic pastoral tranquility. Although Gainsborough rooted his immediate experience of landscape in his native Suffolk, the dreamy, immaterial world conjured by the artist's loose paint and translucent glazes suggests a removal from actuality toward a general notion of the landscape and identity of England or Britain, an image of harmony between the rural population and its surroundings. The inventive artifice of Gainsborough's art is highly sophisticated and replete with pictorial allusions to compositions and techniques of old master traditions, especially works by the Dutch artists Ruisdael, Hobbema, and Wynants and the Flemish painter Rubens. In *Woody Landscape*, the central pool at middle distance, the framing trees and the distant hills recall well-established conventions of classical landscape composition.

Describing *Woody Landscape* as an "exceptionally vigorously painted canvas," John Hayes comments with some interpretive judgment that "the placid motion of the figure and horses crossing the pool stand out against the prevailing diagonals, serpentine movement and agitation of the trees."[1] In his description, Hayes suggests the potential meaning of Gainsborough's landscapes as celebrations of agrarian harmony between man and nature evocative of a moral economy of forest commoners, a simple way of life associated with the remote countryside and its humblest inhabitants.[2] Campaigns of accelerated parliamentary enclosure from the second quarter of the eighteenth century, suiting the needs of expanding urban commerce, radically altered the English countryside. Surviving open-field villages and common rights, were rapidly eliminated causing many people to be driven from the land and from the independent status these systems had accorded. Regret for the social and economic transformations engendered by a capitalist economy spurred the emergence of a significant new genre of rustic landscape painting, which is an achievement primarily associated with Thomas Gainsborough.[3] In *Woody Landscape*, the figures slowly wading through the pool in the warm glow of an evening sun seems to recall some nostalgia for the simplicities of rural life for which Gainsborough himself so often yearned.

Reportedly interested in the sensual appeal of color and bravura painting inspired by closely observed experiences of nature, Gainsborough self-consciously distanced his art from aesthetic texts or literary associations. Yet, his painting practices, particularly the unusually loose and sketchy technique so evident in the Wadsworth Atheneum's *Woody Landscape*, became closely aligned with evolving discourses of the picturesque, popularized most notably by William Gilpin in opposition to strictures of Reynolds's academic authority that condemned his "want of precision and finish" as a deficiency.[4] In his 1788 address to the students of the Royal Academy, Reynolds acknowledge the powerful impression of nature that he exhibited in his portraits, landscapes, and beggar subjects. With careful caveat that Gainsborough's non-academic preparation would not have suited him to the high aims of historical painting, Reynolds offered backhanded praise for Gainsborough's "natural sagacity" in his careful observation and reference to nature stating that he preferred "genius in a lower rank of art to feebleness and insipidity in the highest."[5] Moreover, Reynolds's reported possession of *Woody Landscape*, testifies to his appreciation of Gainsborough's supreme achievements as one of the most significant landscape painters of the eighteenth century.

Waterhouse dates *Woody Landscape* to "perhaps about 1786" and connects it stylistically to *Mountain Landscape with Sheep*.[6] Hayes dates the picture to *c.* 1783–4 and suggests that "the handling is uncannily close to the best work of Dupont." Gainsborough's nephew and only close and direct follower, Gainsborough Dupont (1754–96) lived with his uncle from childhood and was apprenticed to him in 1772.[7]

CR

Oil on canvas, 25 3/16 × 30 1/4 in.

The Ella Gallup Sumner and Mary Catlin Sumner Collection Fund, 1957.15

Provenance: Possibly owned by Sir Joshua Reynolds; Charles Meigh, Esq.; his sale, Christie's, London, June 21–2, 1850, lot 133; purchased by James Lenox, New York, 1850; bequeathed by Lenox to the New York Public Library; New York Public Library sale, Parke-Bernet, New York, October 17, 1956, lot 42; purchased by John P. Nicholson, New York, 1956; from whom purchased in 1957.

References: New York Public Library, 1911, no. 45; Waterhouse, 1958, no. 1000; Hayes, 1982, no. 152.

Selected Exhibitions: New York, 1958, p. 99; Columbia, South Carolina, 1957, no. 33.

Notes

A Passion for Paintings

All correspondence referred to, unless otherwise noted, is in the Atheneum Archives and likewise references to newspapers are to the scrapbooks also in the Archives.

1 On the early history of the Atheneum see Richard Saunders and Helen Raye, *Daniel Wadsworth, Patron of the Arts*, Hartford, 1981; and Eugene R. Gaddis, "Foremost upon this Continent," in '*The Spirit of Genius': Art at the Wadsworth Atheneum*, Hartford, 1992, pp. 11–16.

2 See Kornhauser, 1996, vol. I, p. 18 and vol. II, p. 758, no. 468.

3 *Catalogue of Paintings Now Exhibiting in Wadsworth Gallery*, Hartford, 1844.

4 Ibid, no. 38; and Kornhauser, 1996, pp. 17 and 19, fig. 9.

5 Cadogan and Mahoney, 1991, pp. 11 and 274.

6 *Catalogue of Paintings in Wadsworth Gallery*, Hartford, 1850.

7 On the Beresford collection see Haverkamp-Begemann, 1978, pp. 11, 150, and 159; Cadogan, 1991, p. 74.

8 *Catalogue of Original Oil Paintings both Ancient and Modern, The Entire Collection of J. G. Batterson, Now on Exhibition at the Wadsworth Atheneum*, Hartford, 1864. On Mr. Batterson see *Commemorative Biographical Record of Hartford County, CT*, Chicago, 1901, pp. 24–8.

9 Trustees' Minutes of June 4, 1864, vol. I, p. 48 in the Atheneum Archives.

10 Haverkamp-Begemann, 1978, pp. 129, 153, and 156; Cadogan, 1991, p. 228 with the Campidolios now attributed to Spadino.

11 Cadogan, 1991, pp. 45, 159, 167, 219, 287; Haverkamp-Begemann, 1978, pp. 113 and 146. For information on G. Story see *Wadsworth Atheneum Bulletin*, December 1922, pp. 10–11.

12 Gaddis, 1992, p. 18.

13 *Hartford Times*, October 25, 1927; on the Sumner Bequest see F. B. Gay, "Frank C. Sumner Bequest," *Wadsworth Atheneum Bulletin*, October 1927, pp. 32–3.

14 See Nicolas Fox Weber, *Patron Saints*, New York 1992, pp. 135–6.

15 Forbes' recommendation was in a letter to Goodwin of January 19, 1927; and his appointment in a letter from Goodwin to Forbes of May 9, 1927.

16 Forbes to Goodwin, September 20, 1927.

17 Goodwin to Forbes, September 26, 1927.

18 Forbes to Berenson, December 10, 1927.

19 Letter from Berenson to Forbes, December 30, 1927, and cable of December 31, 1927.

20 Forbes to Berenson, January 17, 1928.

21 Austin to Paff, cable of December 14, 1927 and letter of December 15, 1927.

22 Paff to Austin, January 11, 1928.

23 A. E. Austin, "A Painting by Tintoretto," *Wadsworth Atheneum Bulletin*, January 1928, pp. 1–4; "Hartford Makes First Sumner Purchase," *Art News*, XXVI, no. 16, 1928, pp. 1–2; Cadogan, 1991, pp. 247–8.

24 A. E. Austin, "Annual Reception and Exhibition," *Wadsworth Atheneum Bulletin*, January 1929, p. 4.

25 *Hartford Times*, January 4 and 17, 1928.

26 *Hartford Times*, January 10, 1928.

27 *Loan Exhibition of Distinguished Works of Art*, Wadsworth Atheneum, Hartford, January 18–February 1, 1928.

28 Austin to Hartford Police Chief, January 1928.

29 Austin to Paff, January 31, 1928; According to the *Hartford Courant* of February 4, 1928, the final attendance was 35,802.

30 Forbes to Paff, March 17, 1927.

31 According to a cable of January 23, 1928 to Austin.

32 Paff to Firm (Durlacher's, London) January 25, 1929; The Durlacher files from the New York branch are in the Research Library of the J.P. Getty Institute, Los Angeles.

33 "A Fragment of a Thirteenth Century Italian Fresco," *Wadsworth Atheneum Bulletin*, October 1928, pp. 34–6.

34 Sachs to Forbes undated cable and Sachs to Austin, September 6, 1928.

35 Gimpel to Austin, December 2 and 4, 1928. The Avignon *Pietà* is acq. no. 1928.322

36 This and other of the unpublished texts on the collection by Austin are located in the Registrar's files of the Atheneum.

37 Austin, "Annual Reception and Exhibition," *Wadsworth Atheneum Bulletin*, January 1929, p. 4.

38 *Loan Exhibition of French Art of the Eighteenth Century*, January 23–February 6, 1929.

39 Paff to Firm, January 25, 1929 in Durlacher files.

40 JRS, "Two Large Canvases by Luca Giordano," *Wadsworth Atheneum Bulletin*, January 1930, pp. 2–3.

41 Paff to Firm, December 23, 1929; the other code names which can be determined are "gorilla" for Kansas City and "raccoon" for Cincinatti.

42 Henry-Russell Hitchcock, Jr, "Salvator Rosa," in *Wadsworth Atheneum Bulletin*, April 1930, pp. 21–3.

43 Cadogan, 1991, p. 218.

44 Austin to Hurdle, December 28, 1929.

45 Askew to Austin, November 20, 1929.

46 Austin to Ringling, November 19, 1929.

47 Austin to Ringling, December 28, 1929. On the Böhler connection, see Eric Zafran, "John and Lulu," in *John Ringling, Dreamer–Builder–Collector*, Sarasota, 1997, pp. 43–55.

48 Letters from Fuller of Cleveland to Austin, December 30, 1929; Milliken to Austin of January 11, 1930.

49 Harshe to Austin, November 5, 1929 and Valentiner to Austin undated.

50 *Exhibition of Italian Painting of the Sei- and Settecento*, January 22–February 5, 1930.

51 Articles in the *Hartford Times*, January 23, 31 and February 8, 1930; and *Hartford Courant*, January 26 and February 11, 1930.

52 Cables and letters from Austin to Wildenstein of February 2, 18, and 19, 1930 and from Wildenstein to Austin of February 3, 18, and 20, 1930.

53 See Rosenberg in New York, 1982, p. 364, p. 2 and Benedict Nicolson, *Caravaggism in Europe*, Turin 1989, v. I, p. 87, no. 780 as "Master K."

54 Wildenstein to Austin, December 24, 1936.

55 Wildenstein to Austin, January 14, 1939. See Richard Spear, *Caravaggio and his Followers*, New York, 1975, pp. 128–9.

56 Weitzner to Austin, October 5, 1939. Since Weitzner later claimed to have had a role in the Atheneum's purchase of the Caravaggio *St. Francis*, perhaps this was the picture he had in mind.

57 *Hartford Courant*, January 8, 1931.

58 *Retrospective Exhibition of Landscape Painting*, January 20–February 9, 1931.

59 Austin text in Registrar's files.

60 Böhler to Austin, June 25, 1931.

61 Parsons to Austin, February 12, 1930.

62 Austin to Parsons, July 25, 1930.

63 Parsons to Austin, September 1, 1930.

64 See Mahoney in Cadogan, 1991, p. 230; and Eliot Rowlands, *The Nelson-Atkins Museum of Art, Italian Paintings, 1300–1800*, Kansas City, 1996, pp. 261–9, no. 30.

65 Henry-Russell Hitchcock, "The Saint Catherine by Bernardo Strozzi," *Wadsworth Atheneum Bulletin*, April 1931, pp. 14–15.

66 Askew to Austin, November 7, 1932.

67 An undated letter concerning this acquisition from Paul Sachs in London to Austin is in the Durlacher files at the Getty; see also the correspondence Askew to Durlacher, May 10, 133 and Askew to Austin, February 4, 1932.

68 Askew to Austin, May 25, 1933 and Askew in Durlacher files. The Claude was *Liber Veritatis* no. 11.

69 Askew to Austin, May 25, 1933, and Askew to Firm, February 4, 1932 (Durlacher files) and Austin to Askew, October 5, 1934.

70 Letter from Forbes to Duveen, November 17, 1931; A. E. Austin, "Piero di Cosimo," *Wadsworth Atheneum Bulletin*, January, 1932, p. 6.

71 Cadogan, 1991, p. 15.

72 This incident is related in Soby's unpublished autobiography – a copy of which is in the Atheneum Archives. The Panofsky article "The Early History of Man," appears in his *Studies in Iconology*, New York, 1962, pp. 33–67.

73 *Exhibition of Italian Renaissance Art*, Wadsworth Atheneum, Hartford, 1932. Lord Duveen, as revealed by the gallery files on deposit at the Research Library of the Getty Institute, purchased one of Austin's art works and also sent a contribution to support his Friends and Enemies of Modern Music.

74 Henry-Russell Hitchcock, "The Avery Memorial," *Wadsworth Atheneum Bulletin*, January–March, 1934, pp. 12–13.

75 Wehle to Austin, September 4, 1935; and Wescott, 1935, pp. 7–8.

76 Austin to Askew, July 8, 1936; Askew cable to Austin, July 20, 1936; Askew in Durlacher files, October 24 and 27, 1935 and July 8, 1936.

77 See Eugene Gaddis, *Magician of the Modern*, New York, 2000, p. 313.

78 Byk to Austin, April 26 and May 8, 1935.

79 Austin to Byk, October 7, 1935.

80 Byk to Austin, May 14, 1936.

81 See in Cadogan, 1991, pp. 156–7 and 302–5.

82 Letters and cable from M. Knoedler and Co. to Austin, November 27, December 9 and 29, 1936; *New York Times* and "Hartford: Two Masterpieces of the Settecento," *Art News*, January 1937, p. 20; Cadogan, 1991, pp. 171–4.

83 Askew to Durlacher's, September 1936 (in Durlacher files); and Askew to Austin, November 19, 1936; *New York Times* clipping in Atheneum Archives.

84 Cadogan, 1991, pp. 309–13.

85 Interview with A.R. Claflin of October 22, 1974 in Atheneum Archives.

86 Invoice from Galerie Sanct Lucas of July 22, 1937; opinions of Dr. Suida to Cunningham, December 21, 1946; Everett Fahy to Peter Marlow, March 24, 1969; and Robert Simon to Eric Zafran, verbally, May 2003.

87 Cadogan, 1991, pp. 52–5, 134–5, 271; P. de Boer to Austin, December 13, 1937; and Haverkamp-Begemann, 1978, pp. 197 and 200.

88 Carré to Austin, August 7, 1936.

89 E. Howland to Austin, October 5 and 8, 1936.

90 The *Hartford Times,* December 15, 1936 and the *Hartford Courant* of December 16, 1936.

91 Carré to Mrs. Austin, December 16, 1936.

92 Austin's secretary to Knoedler and Co, December 22, 1936.

93 Cables between Austin and Harshe of December 21, 1936.

94 *Hartford Times,* January 9, 1937.

95 Duveen and Austin correspondence of January 2 and 22, 1937.

96 Wintermute, 1996, p. 62.

97 *Hartford Courant,* January 30, 1937.

98 *Hartford Times,* January 1, 1938.

99 Invoice of May 11, 1937.

100 The Valdés Leal was paid for on May 8, 1939; The Campi information was in a letter from Askew to Austin, October 20, 1938; for it and the Archimbaldos see Cadogan, 1991, pp. 266–70.

101 Cadogan, 1991, pp. 75–6 and 168–9.

102 Letter and cables between Wildenstein and Austin of April 4, May 4 and 5, 1939; see Cadogan, 1991, pp. 97–9; the attribution to Carlevarijs has recently been questioned in favor of Richter.

103 Haverkamp-Begemann, 1978, pp. 170, 178–82.

104 Invoice for the Bourdon of October 5, 1939; and for the Vernet of June 9, 1939.

105 Mondschein to Austin, May 6, 1939; see Cadogan, 1991, p. 244.

106 A. E. Austin, "The New Purchases at Hartford," *Art News*, v. 39, no. 7, November 16, 1940, p. 8.

107 Haverkamp-Begemann, 1978, pp. 125–6 and 151–2.

108 See Eric Zafran, "Michael Sweerts in America," in *Michael Sweerts: 1618–1664*, Amsterdam and Hartford, 2002, p. 59.

109 Austin text in Registrar's files.

110 Byk to Austin, November 9 and 27, 1938 and March 20, 1939.

111 Austin to Valentiner, January 18, 1940.

112 The Voss letter is dated 7, VI, 39; Discussion of the Atheneum's fragmentary painting can be found in J.-P. Cuzin and P. Rosenberg, *Georges de La Tour*, Paris, 1997, pp. 216–19, no. 45c.

113 Byk to Austin, February 8, 1940.

114 *Night Scenes*, Wadsworth Atheneum, Hartford, February 15–March 7, 1940, np, no. 5.

115 Byk to Austin, March 7, 1940.

116 Byk to Austin, April 8, 1940.

117 Byk to Austin, April 11 and 30, 1940.

118 Byk to Austin, August 27, 1940.

119 Byk to Austin, October 14, 1940.

120 Byk to Austin, October 21, 1940.

121 Byk to Austin, December 3, 1940.

122 Byk to Austin, January 16, 1941.

123 Byk to Austin, May 29, 1941.

124 Byk to Austin, June 19 and 26, 1941

125 Schaeffer to Austin, December 17, 1941. The exhibition was *Gems of the Baroque*, January 1942; and for the Recco see Cadogan, 1991, p. 207.

126 Vitale Bloch to Austin, March 25, 1938; Koetser to Austin, November 27, 1941; Longhi to Cunningham, March 22, 1960. See *La Natura Morta in Italia*, Milan, 1989, II, pp. 652–4, fig. 772; and also Munich, 2002–3, p. 138.

127 Byk to Austin, April 14, 1941.

128 *Art News*, February 15, 1943, cover and pp. 16–17; Mahon to Cunningham, April 1, 1963.

129 Byk to Austin, November 30 and December 11, 1942; and Austin to Byk, December 2, 1942.

130 Austin to Huntington, June 10, 1943.

131 Byk to Austin, June 14, 1943; Exhibition type-script in Registrar's files gives the dates as June 26, 1943 to January 16, 1944; the review by Marian Murray was in the *Hartford Times*, June 26, 1943.

132 Byk to Austin, June 21, 1943.

133 Byk to the Atheneum, June 15, 1943; Announcement of the director's resignation appeared in the *Wadsworth Atheneum Bulletin*, January–February, 1945, p. 2; see also Gaddis, 2000, p. 367.

134 Gaddis, 2000, pp. 364–5.

135 Cadogan, 1991, pp. 208–9.

136 Ibid, pp. 109–10; and Haverkamp-Begemann, 1978, pp. 157–8.

137 For the *Boy*, 1944.34, see Cadogan, 1991, pp. 194–6; The *Girl*, 1997.22.1, was sold Sotheby's, New York, January 12, 1989, no. 124.

138 See Cadogan, 1991, pp. 202–3; and A. C. Bates, "The Earl of Warwick," *Wadsworth Atheneum Bulletin*, January–February, 1944.

139 *Hartford Times*, April 25, 1945; a typed list of "Exhibition of Dutch Paintings" April 29–May 6, 1945 is in the Registrar's files.

140 *Hartford Times*, April 30, 1945.

141 *Hartford Courant*, May 1, 1945.

142 Constable to Goodwin, October 11, 1946.

143 C. C. Cunningham, "How to Buy," *Art News*, 50, no. 7, November 1951, p. 60.

144 H. and E. Tietze to Cunningham, January 21, 1948.

146 "I am very greatful for the splendid photograph of the new Traversi. It seems to me one of the finest pictures by the master; what character and what composition!" L. Fröhlich-Bume to Cunningham, January 1, 1949.

147 Cunningham to Agnew, September 20, 1950.

148 Vallance to Agnew, August 25, 1950.

149 Geoffrey Agnew to Cunningham, April 5, 1956.

150 Geoffrey Agnew to Cunningham, April 15 and 19, 1956.

151 Cunningham to Agnew, June 8, 1956.

152 Longhi to E. Gregory, Cunningham's secretary, October 30, 1956; and see D. Mahon, "An Attribution Re-Studied," *Wadsworth Atheneum Bulletin*, spring 1958, pp. 1–4.

153 Correspondence between Cunningham and Geoffrey Agnew, April 29 and May 3, 1957.

154 Koetser to Cunningham, February 18, 1949.

155 Koetser to Cunningham, January 17 and February 17, 1951.

156 Harris to Cunningham, undated of late 1950.

157 Harris to Cunningham, cable of December 29, 1950 and letter of March 5, 1951.

158 Weitzner to Cunningham, October 15, 1957.

159 C. Newhouse to Cunningham, November 29, 1957; Cunningham to Mont, February 10, 1958; Newhouse to E. Turner, February 15, 1958; See Cadogan, 1991, pp. 314–19.

160 P. Porzelt to Cunningham, October 29 and November 23, 1953 and Cunningham to Porzelt, November 17, 1953.

161 Panofsky to Cunningham, October 13, 1955 and May 4, 1956.

162 Panofsky to Cunningham, May 4, 1956; P. Askew to Cunningham, February 4, 1961; and see P. Askew, "Fetti's Martyrdom," *The Burlington Magazine*, vol. CIII, June 1961, pp. 248–9.

163 Cunningham to Valentiner, February 2, 1955.

164 Rosenberg to Cunningham, March 18, 1955.

165 C. C. Cunningham, "A Painting by Rembrandt," *Wadsworth Atheneum Bulletin*, April, 1955, pp. 1–2; and W. R. Valentiner, "A Portrait by Rembrandt," *Art Quarterly*, XVIII, 1955, pp. 215–19; and also *Arts*, XXI, February 1957, p. 43.

166 Letter to Members of October 2, 1962 and Press Release of October 3, 1962.

167 See Haverkamp-Begemann, 1978, pp. 154 and 175–8; and press reports in the *Hartford Courant*, January 26, 1978 and the *New York Times*, January 27, 1978.

168 Correspondence between Kaplan and Cunningham of February 24, March 3, and April 24, 1958; see the *Hartford Courant*, *New York Times*, and *New York Herald Tribune*, all of September 21, 1958; and see also Slive, 1958, pp. 13–23. For the Moreelse see Haverkamp-Begemann, 1978, p. 164.

169 Cunningham to Weitzner, December 8, 1949.

170 Weitzner to Cunningham, August 14, 1958; see also Haverkamp-Begemann, 1978, pp. 135, 198–9.

171 Robert Vose, Jr. to Cunningham, May 18 and October 31, 1951.

172 The Gainsborough invoice from John Nicholson Gallery is dated February 18, 1957; correspondence about the Wright of Derby is Spiller to Charles Buckley, October 3, 1952; Cunningham to Spiller, October 17, 1952; and Spiller to Cunningham, December 16, 1952.

173 Atheneum News Release, March 1, 1957; the Vignon is 1956.728 and the Stella 1957.445.

174 Sperling to Cunningham, March 7, 1960.

175 Sperling to Cunningham, April 25, 1960; and the *Hartford Courant*, May 23, 1960.

176 Mont to Cunningham, June 8, 1961; and Manning to Cunningham, June 8, 1961.

177 Correspondence between Anthony Speelman and Cunningham, November 25 and 30, 1964.

178 *Genoese Masters: Cambiaso to Magnasco, 1550–1750* was held at the Atheneum March 19–May 5, 1963; reviewed in the *Springfield News*, March 20, 1963.

179 Cunningham to Mahon, April 8, 1963.

180 "Collections," *Wadsworth Atheneum Bulletin*, Spring 1964, p. 12.

181 Longhi to Cunningham, February 15, 1964; Mrs. Fowles to Cunningham, June 28, 1963; invoice of July 15, 1963; see also Craig Felton, "The Earliest Paintings of Ribera," *Wadsworth Atheneum Bulletin*, Winter 1969, pp. 2–29.

[182] See Pierre Rosenberg in *France in the Golden Age*, New York, 1982, pp. 246–7, no. 29.

[183] Mr. and Mrs. Mont to Cunningham, December 13 and 24, 1963; and Cunningham to Mrs. Mont, December 31, 1963.

[184] Clark to James Elliott, September 21, 1969; see Cadogan, 1991, pp. 118–20.

[185] Mrs. Mont to Peter Marlow, September 17, 1968; the attribution by Spike was made verbally to Jean Cadogan, December 1979.

[186] See Ann Percy, "Magic and Melancholy: Castiglione's *Sorceress* in Hartford," *Wadsworth Atheneum Bulletin*, winter 1970, p. 2.

[187] Hartford–Dijon, *Greuze*, 1976–7.

[188] Cadogan, 1991, pp. 200–2.

[189] Matthiesen to Cadogan, January 25, 1985.

[190] Cadogan,1991, pp. 103, 129, and 216–17.

[191] Frank Rizzo, "New Atheneum Director Director buys first Major Work," *Hartford Courant*, February 21, 1997, p. A3.

[192] P. Sutton, "Curator's Choice," *What's On at the Wadsworth*, May-June, 1997, np.

[193] *Caravaggio and his Italian Followers from the Collections of the Galleria Nazionale d'Arte in Rome*, Hartford, 1998.

[194] *Caravaggio's 'St. John' and Masterpieces from the Capitoline Museum in Rome*, Hartford, 1999.

[195] Simon Schama, "Another Dimension," *The New Yorker*, October 28, 2002, pp. 86 and 91.

[196] Sale Sotheby's, London, December 11, 1996, nos. 12 and 13.

Catalogue 1

[1] The artist was born Piero di Lorenzo di Piero Ubaldini; for his life and death dates, see Geronimus, 2000, pp. 164–70. For Vasari's *Life* see Vasari, 1568, vol. 1, pp. 650–9, and Waldman, 2000, pp. 171–9.

[2] Hartt, 1987, p. 480.

[3] Panofsky, 1937, pp. 19–28; published in revised form in Panofsky, 1939, pp. 33–67.

[4] For further discussion of the subject and its literary sources, see Fermor, 1993, pp. 77–8; Franklin, 2000, pp. 57–8.

[5] Laskin and Pantazzi, 1987, vol. 1, pp. 221–6; Franklin, 2000, p. 53 notes that the paintings are stylistically similar, and both are painted on rough, diamond-weave canvases somewhat unusual for Florentine paintings of this time, and are of comparable dimensions, although the Ottawa canvas has been trimmed at the sides.

[6] Franklin, 2000, p. 63.

[7] Franklin, 2000, p. 54.

[8] Franklin, 2000, pp. 55–6.

[9] Franklin, 2000, p. 61.

Catalogue 2

[1] Vasari, 1568/1996, vol. 2, p. 145; elsewhere he mentioned as being in a de' Nobili collection a portrait "of an armed captain, very much alive," which he attributed to Giorgione (Cadogan, 1991, p. 198, fn. 10). For the various identifications of the sitter, attribution of the painting to Sebastiano, and discussions of date, see Cadogan, 1991, p. 198, fn. 1, 10.

[2] Hirst, 1981, p. 97, fn. 28; Cadogan, 1991, p. 198, fn. 11.

[3] Hirst, 1981, p. 97.

[4] Vasari, 1568/1996, vol. 2, p. 145.

[5] Hirst, 1981, p. 97.

[6] Hirst, 1981, p. 97; Cadogan in Ayres, 1992, p. 40; Anderson, 1997, fig. 34

[7] Sheard, 1994, p. 87.

[8] Anderson, 1997, p. 325, repr. col., now attributed to Paolo Morando, il Cavazzola (1486–1522).

[9] Cadogan, 1991, pp. 197–8, fn. 1.

[10] Vasari, 1568/1996, vol. 2, p. 145; Borghini, 1584, p. 436, cites the same provenance.

Catalogue 3

[1] Humfrey, 1996, pp. 183–4.

[2] Humfrey in Ferrara–New York–Los Angeles, 1998–9, p. 249.

[3] Lucco, 1998, p. 270, as 1528–30; for a critical history of the painting, see Ballarin, 1994–5, vol. 1, pp. 335–6, no. 429, and Humfrey, in Ferrara–New York–Los Angeles 1998–9, pp. 250–3.

[4] Humfrey, in Ferrara–New York–Los Angeles 1998–9, p. 250.

[5] Cadogan, 1991, p. 138; Humfrey in Ferrara–New York–Los Angeles, 1998–9, pp. 250–1.

[6] Humfrey in Ferrara–New York–Los Angeles, 1998–9, p. 251.

[7] For extended discussions of provenance and the existence of possible replicas of the Hartford painting, see Cadogan, 1991, pp. 138–40; Humfrey in Ferrara–New York–Los Angeles, 1998–9, pp. 251–2.

Catalogue 4

[1] Fehl, 1992, pp. 167, 172–3, writes that the paintings were a gift from Tintoretto to Aretino and that he placed the pictures on the ceiling of his *salone* in Palazzo Bollani and moved them to his new quarters in 1551; Nichols, 1999, p. 6, says the paintings were made for the ceiling of the writer's bedroom in Palazzo Bollani.

[2] Cadogan, 1991, pp. 245, 247, fn. 7.

[3] Cadogan, 1991, pp. 245, 247, fn. 8.

[4] Cadogan, 1991, p. 245; Nichols, 1996, p. 7. The visible *pentimenti* include changes in the size of Apollo's lyre, the position of the fingers on Apollo's right hand and Marsyas's fingers on the shawm he holds, and slight alterations to Athena's hands.

[5] Philip Rylands in London, 1983–4, p. 212; Nichols, 1999, p. 38.

[6] Rylands in London, 1983–4, p. 212; Cadogan, 1991, p. 246, fn. 12; Nichols, 1996, p. 7.

[7] Cadogan, 1991, p. 246.

[8] Cadogan, 1991, pp. 246, 247, fn. 15, 17, with further citations; Fehl, 1992, pp. 167–8, describes the ceiling paintings for Aretino as a pictorial celebration of "the victories of the gods over brutishness" and interprets the figure on the extreme right as Tintoretto's reference to "Aretino's pre-eminent role as arbiter of artistic taste in Venice."

Catalogue 5

[1] Rearick, in Fort Worth, 1992, p. 304.

[2] For an approximation of the original appearance of the painting, see the version in a private collection reproduced by Ballarin, 1996, vol. 2, fig. 587 (*c.* 1553).

[3] Rearick, in Fort Worth, 1992, p. 304.

[4] Farmer, 1997, pp. 91–2.

Catalogue 6

[1] See Cappelletti, 1996, pp. 573–5, for a concise summary of the artist's life and work and further bibliography.

[2] *The New Testament of the Jerusalem Bible*, Garden City, NY: Doubleday & Company, 1996, p. 189. For a discussion of the theme and its interest to visual artists, see Ekserdjian, 1997, p. 158.

[3] Orsi painted another version of the theme, now in the Galleria Estense, Modena (repr. Cadogan, 1991, fig. 33) which is a straight-forward adaptation of Correggio's *Noli me tangere* in the Museo del Prado, Madrid.

[4] Vittoria Romani in Bologna–Washington–New York, 1986–7, p. 155.

[5] Romani in Bologna–Washington–New York, 1986–7, p. 155.

[6] Romani in Bologna–Washington–New York, 1986–7, p. 150.

Catalogue 7

[1] Gash, 1996, p. 702; for whom see for an excellent summary introduction to Caravaggio's life and work, working methods and technique, character and personality, influence, and critical reception and posthumous reputation.

[2] Quoted by Richard Spear, "The Critical Fortune of a Realist Painter," in New York, 1985, p. 22–7.

[3] Ibid, p. 24.

[4] Waterhouse, 1962, p. 21.

[5] Askew, 1969, pp. 280–306.

[6] Treffers, 1988, pp. 161–4.

[7] See Spear, 1971, p. 69, fn. 3, 4; Spike, 2001, pp. 55–7, 244, fn. 72; Puglisi, 1998, p. 124.

[8] Puglisi, 1998, p. 124.

[9] The picture's provenance is uncertain and controversial; see Mahoney in Cadogan, 1991, pp. 84–7; Gilbert, 1995, pp. 107, 280, fn. 47; Langdon, 1998, p. 402, fn. 50; and most recently Lorizzo, 2001, pp. 408–9.

Catalogue 8

[1] For example, Wittkower, 1958/99, vol. 1, p. 64.

[2] Chappell, 1996, p. 313.

[3] Baldinucci, 1681/1728, vol. 3 [1846], p. 241.

[4] New York, 1990, pp. 58–61, no. 11 [purchased by the Metropolitan Museum of Art with the assistance of the Gwynne Andrews Fund, 1991.7], and San Miniato, 1959, no. 31, respectively; on representations of the Adoration of the Shepherds, see also Florence, 1992, no. 57.

[5] Wittkower, 1958/99, vol. 1, p. 64.

[6] Ginori Lisci, 1972, vol. 1, p. 329, fig. 263; Civai, 1990, fig. 19.

[7] Florence, 1984, no. 6 (Galleria Palatina, 97 × 78 cm., inv. 1912, no. 475).

[8] Civai, 1990, pp. 43–4, 49, fn. 84–8, cites Martelli family inventories of 1682, 1771, and 1802–13 in the Archivio di Stato, Fondo Martelli, Florence.

[9] *Collezioni private bergamasche*, 1980, vol. 1, fig. 26.

[10] Bonsi, 1767, p. 17.

Catalogue 9

[1] Wittkower, 1958/99, vol. I, p. 66.

[2] For the *Sacri Monti*, see Cannon-Brookes in Birmingham, 1974, pp. 8–10, 20–2.

[3] Wittkower, 1958/99, vol. I, p. 68.

4 For reproductions of these works cited by Wittkower, 1958/99, pp. 67–8, as among the artist's finest, see Varese, 1962 figs. 26–35, 49–62, 74–82, 112–16, 144–9.

5 See note 1.

6 London, Christie's, *Important Old Master Pictures*, December 13, 1996, p. 194.

7 Varese, 1962, pls. 49–62, 90–4, 71; for other representations by Morazzone of the Agony in the Garden, see Varese, 1962, pls. 127b, 132b.

8 Hall, 1979, p. 11.

9 For a brief introduction to the subject, see Steel, in Raleigh, 1984, pp. 122, 124.

10 Published in *Saloon of Fine Arts*, London, 1818, no. 15 as "Christ in the Garden," 3.7½ by 2.9½ in., "pt by Morazzone," engraved by "J Vendramini" [Giovanni (or John) Vendramini, 1769–1839]; Varese, 1962, fig. e.

Catalogue 10

1 Tuyll van Serooskerken, 1996, p. 33; Carel van Tuyll van Serooskerken, in Bologna–Washington–New York, 1986–7, p. 377.

2 Spike, in Princeton, 1980, p. 18, noted the "freshness of [Badalocchio's] Annibalesque impressions in this painting."

3 Tuyll van Serooskerken, 1996, p. 33.

4 Mahon, 1958, p. 3, described the picture as "one of Sisto's best and most attractive works."

5 Badalocchio's paintings were frequently attributed to Lanfranco and various members of the Carracci circle; for example, see the *Virgin and Child with Saints Crispin and Crispiano* and *Deposition* (both Museo e Gallerie Nazionali di Capodimonte, Naples) exhibited in Parma–Naples–Munich, 1995, pp. 323–5, nos. 115, 116.

6 Negro and Pirondini, 1995, fn. 72, p. 100 (Museo e Gallerie di Nazionali Capodimonte, Naples, inv. Q 1930, fn. 584).

7 Jestaz, 1994, p. 114, no. 2862, "*uno in tavola, cornice nera et un filetto dentro d'oro, con la Madonna SS.ma, Bambino in grembo e S. Giuseppe a sedere e paesi.*"

8 Bertini, 1987, p. 196, no. 320.

Catalogue 11

1 Lanzi, 1847, vol. 2, 208.

2 Alessandra Frabetti in Bologna–Washington–New York, 1986–7, p. 200.

3 Frabetti in Bologna–Washington–New York, 1986–7, p. 196.

4 Ripa, 1603, pp. 142–3 ("Fame") and p. 483 ("Time"). Scarsellino painted another personification of Fame (1592–3; Galleria Estense, Modena) as part of a series of decorative friezes in the Palazzo dei Diamanti, Ferrara (Novelli, 1964, p. 37, no. 121, fig. 15b).

5 Mahon, 1937, p. 178.

6 Cited in London, 1984, p. 101, and Cadogan, 1991, p. 224, no. 3, with further references.

Catalogue 12

1 For an introduction to the subject, see Mann in New York–Saint Louis, 2001–2, pp. 82, 186.

2 Spear in Cleveland, 1971, p. 100.

3 Orazio's original design for *Judith and Her Maidservant with the Head of Holofernes* compressed the two figures into a more compact area and would have emphasized the narrative with even more

startling dramatic effect. The original canvas has been "let out" at a later date with the addition of canvas strips 13 centimeters wide at the top and left; see Mann, in New York–Saint Louis, 2001–2, p. 189, fn. 3.

4 Mann, in New York–Saint Louis, 2001–2, pp. 187–8.

5 The literature is voluminous; for a starting point, see Mann, "Artemisia and Orazio Gentileschi," in New York–Saint Louis, 2001–2, pp. 249–61.

6 For discussion of the dating see Spear in Cleveland, 1971, p. 100; Mahoney in Cadogan, 1991, p. 150; Mann in New York–Saint Louis, 2001–2, pp. 188–9.

7 For the painting's provenance in a Genoese collection, where the composition was recorded in Anthony van Dyck's *Italian Sketchbook* of 1621–7, see J. Mann in New York–Saint Louis, 2001–2, pp. 189–90, fn. 9–14.

Catalogue 13

1 Rowlands, 1996, p. 260; Martha Lucy in Baltimore, 1995, p. 15, has suggested the influence of the art of Strozzi's teacher, Pietro Sorri (1556–1622), on "the energetic brushwork which seems to sit on the surface of the canvas." Boccardo, 1995, p. 868, has suggested the importance of Tuscan mannerist paintings in Giovanni Carlo Dori's collection for Strozzi's development.

2 The feast of Saint Catherine was suppressed by the Holy See in 1969.

3 Rowlands, 1996, pp. 266–8, col. pl. 30, fig. 30c; Baltimore, 1995, p. 26, no. 11.

4 Rowlands, 1996, pp. 264–5.

5 For the discovery by means of infared reflectography of the presence of the attributes of Saint Catherine under the present composition see Rowlands, 1996, pp. 261–2, 266.

6 Mahoney in Cadogan, 1991, pp. 230, 232; Mortari, 1995, pp. 108–9; Rowlands, 1996, p. 267, figs. 30d–f; Contini, 2002, pp. 30–3.

7 This early provenance has been suggested by Rowlands, 1996, p. 269, on the basis of seventeenth-century inventories.

Catalogue 14

1 Quoted by David Steel in Raleigh, 1984, pp. 83, 85, fn. 9; for whom see for a brief discussion of the theme of the Holy Family in the Carpenter's Shop, pp. 83, 85, fn. 8, 9.

2 Ottani Cavina, 1968, p. 48.

3 Quoted in New York–Naples, 1985, p. 167.

4 Paris–New York–Chicago, 1982, pp. 246–7, with a bibliography and discussion of the varying arguments by the proponents of the respective attributions; see also Mahoney in Cadogan, 1991, pp. 220–2.

5 For the arguments in favor of the traditional attribution to Saraceni, see Mahoney in Cadogan, 1991, pp. 221–2, fn. 30.

6 Spear in Cleveland, 1971, p. 161.

Catalogue 15

1 Laureati, 2001, p. 68.

2 See Markova, 2000, pp. 53–5, figs. 9–11.

3 Charles Sterling was the first to recognize the Roman and specifically Caravaggesque character of the Hartford still life, which he thought reflected a

lost Caravaggio (Paris 1952, p. 88); for the voluminous literature citing the attribution of the "Master of the Hartford Still-Life" appellation to the Hartford still-life and other anonymous works, see Spike in New York–Tulsa–Dayton, 1983, p. 46; Mahoney in Cadogan, 1991, pp. 92–5, and Berra, 1996, pp. 154–5, fn. 89.

4 Mina Gregori in a letter of February 24, 2003, citing Claudio Strinati in *L'anima e le cose: La natura morta nell'Italia Pontificia nel XVII e XVIII secolo*, exh. cat., ed. Rodolfo Battistini, Modena, 2001, p. 16.

5 Zeri, 1976, pp. 92–103; for a resumé of critical reaction to Zeri's attribution, see Alberto Cottino in *La natura morta in Italia*, 1989, vol. 2, p. 691.

6 Quoted by Laureati, 2001, p. 69; see her brief discussion on the distinctions between Caravaggio's still-lifes and those attributed to the Master of the Hartford Still-Life, p. 72.

7 Mahoney in Cadogan, 1991, pp. 92–5; Laureati, 2001, p. 73.

8 For a discussion of this issue in an analogous Italian still-life painting, see Diane De Grazia in De Grazia and Garberson, 1996, pp. 202, 204, fn. 26.

Catalogue 16

1 Percy 1996, vol. 6, p. 107.

2 See Percy, in Cleveland–Fort Worth–Naples 1984–5, p. 64, for specific derivations.

3 Percy, in Cleveland–Fort Worth–Naples 1984–5, p. 64; for her observations on Cavallino's "neo-Mannerism," see pp. 13, 14; Alfred Moir, in Detroit, 1965, p. 146, on the other hand, described the figure "as Stanzionesque as any in Cavallino's career."

4 Dominici, 1742–5, vol. 3, p. 42, trans. by Percy, in Cleveland–Fort Worth–Naples, 1984–5, p. 5.

5 Dominici, 1742–5, vol. 3, p. 43, trans. by Percy, in Cleveland–Fort Worth–Naples, 1984–5, p. 5.

6 For remarks about the condition of Cavallino's early pictures and on his preparation of the supports, see Percy, in Cleveland–Fort Worth–Naples, 1984–5, pp. 4, 74.

7 Wittkower, 1958/99, vol. 2, p. 163.

8 Mahoney, in Cadogan, 1991, p. 105, fn. 21.

Catalogue 17

1 Scott, 1995, pls. 101, 103, 119.

2 Salerno, 1963, p. 35.

3 For details of their relationship, see Spike in Sarasota–Hartford, 1984–5, p. 156.

4 On the issue of the identification of Lucrezia as the model for the Hartford and Rome paintings, see Mahoney in Cadogan, 1991, pp. 213–14, and Scott, 1995, p. 64, fig. 79.

5 As Spike in Sarasota–Hartford, 1984–5, p. 156, has observed: "It seems most likely that Lucrezia is envisioned as Poetry, which makes a more satisfactory companion than would a sibyl to Rosa's self-portrayal as a philosopher. Rosa's poetic gifts were considerable and a source of pride to him. Indeed, his literary accomplishments greatly facilitated his entry into intellectual circles in Florence." See also Roworth, 1989, pp. 139–41, and Scott, 1995, p. 64, who identifies the Atheneum painting as *Lucrezia as Muse*.

6 For the various interpretations of the National Gallery painting, see London, 1973, no. 9; Roworth, 1989, pp. 137–8; Leuschner, 1994, pp. 278–83; and Scott, 1995, pp. 61, 64, col. pl. 77.

7 Helen Langdon in London 1973, pp. 22, 23.

8 Langdon in London, 1973, p. 23.

Catalogue 18
1 Soprani-Ratti, 1768, p. 342.
2 Soprani-Ratti, 1768, p. 342, cited by Newcome, 1975, p. 27.
3 Newcome 1978, p. 326.
4 Soprani, 1674, p. 236.
5 Labò, 1942, p. 369.
6 Eric Zafran in New York, 1978, p. 17, attempted to reconcile the iconography of the two paintings as "intended to contrast two kinds of love, the unbridled physical aspect in the mythological scene and the triumph of selfless devotion and spiritual love in the St. Geneviève."
7 The subject was identified by Bertina Suida Manning in Portland, 1956, p. 33. See also *Bibliotheca sanctorum*, 1960–70, vol. 6, cols. 156–7.
8 Newcome Schleier, 1997, pp. 150–1, fig. 5, no. 4.
9 Labò, 1942, p. 369: "Un documento servirebbe a datare al 1652 otto grande quadri di Storie profane con figure intere, che egli promise al sig. Pietro Fenoglio di Ventimiglia, ma di cui non si sa niente, neppure s'egli li abbia poi eseguiti."

Catalogue 19 and 20
1 See George Hersey in New Haven–Hartford–Kansas City, 1987, pp. 139–42.
2 Mahoney in Cadogan, 1991, p. 156.
3 J. Patrice Marandel in Los Angeles, 2001–2, p. 360, also believes that "the paintings are not part of an iconographic program, but rather the result of an ingenious, if somewhat obvious, artificial pairing."
4 Ferrari and Scavizzi, 1992, vol. 3, figs. 303, 304, 332, 622.
5 Ferrari and Scavizzi, 1992, p. 371.
6 Mahoney in Cadogan, 1991, pp. 155–6.
7 Joachim and McCullagh, 1979, p. 65, no. 88, pl. 91. The drawing was first published by Walter Vitzthum, who identified the connection with Titian and believed the pen-and-ink sketch to be a preliminary idea for the figure of Europa in the Hartford painting; Ferrari and Scavizzi, 1992, vol. 1, p. 371, no. D106.

Catalogue 21
1 See Spike, "Giuseppe Maria Crespi and the Emergence of Genre Painting in Italy," in Fort Worth, 1986, pp. 13–38.
2 For Crespi's copies after the Guercino painting in the Musée du Louvre, Paris, see Merriman, 1980, p. 265, nos. 116, 117.
3 Dwight Miller in Chicago–Minneapolis–Toledo, 1970, p. 118.
4 Merriman, 1980, p. 299: ". . . there are no works by Crespi from those early years [*c.* 1705] which could correspond in style, subject, and sentiment to the *Artist in his Studio*."
5 Merriman, 1980, p. 299.
6 See note 9.
7 Spike in Fort Worth, 1986, p. 170, fn. 5.
8 Emiliani, 1990, pp. 127–8, no. 64; Bologna–Stuttgart–Moscow, 1990–1, p. 356, no. 33; the painting was sold at London, Sotheby's, July 5, 1989, lot 72, 21 × 15 in. (53.5 × 38.5 cm).
9 Spike in Fort Worth, 1986, p. 168, citing L. Frati, "Quadri Dipinti per il Marchese D'Ormea e per Carlo Emanuele III," *Bollettino d'Arte*, vol 10, 1916, p. 282.

Catalogue 22
1 See Edgar Peters Bowron in De Grazia and Garberson, 1996, p. 30, fn. 4.
2 Beddington in San Diego, 2001, p. 28.
3 Parker, 1948, pp. 29–30, no. 4, fig. 8.
4 Constable, 1989, vol. 1, p. 214; vol. 2, no. 537*; Beddington in San Diego, 2001, p. 28, fig. 29.
5 Beddington in San Diego, 2001, p. 28, 33, fn. 78.
6 Sold with a certificate by Dr. Hermann Voss, Berlin, April 3, 1929.

Catalogue 23
1 For a concise survey of the genre, see Harting, 1996, pp. 352–4.
2 For a brief biographical sketch, see Slive, 1987, pp. 169–71, and Mahoney in Cadogan, 1991, pp. 186–7.
3 For "Salvator Rosa" frames, see Mitchell and Roberts, 1996, pp. 269–74.
4 Olsen, 1951, pp. 90–103.
5 Valenti believed the landscape to be the work of Nicolaes Berchem; see Slive, 1987, pp. 169, 176ff; Slive, 2001, pp. 291–3, repr. col.
6 Arisi, 1986, p. 430; see Kiene, 1990, pp. 281–99, figs. 8–23.
7 Mahoney in Cadogan, 1991, p. 187, figs. 34, 35; Kiene in Paris–Piacenza–Braunschweig, 1992–3, p. 141, no. 39, fig. 56; New York, Christie's, *Old Master Paintings*, May 15, 1996, lot 111.
8 Owen and Brown, 1988, p. 207.

Catalogue 24
1 Heimbürger Ravalli, 1982, pp. 15–42; see also Rowlands, 1996, pp. 436–8.
2 Longhi, 1927, pp. 145–67.
3 Nicola Spinosa in Detroit–Chicago, 1981–2, vol. 1, p. 148.
4 Rowlands citing Antal, 1962, p. 205; Bologna, 1980, pp. 56–8, also raised the possibility of English artistic influences on the artist.
5 Rowlands, 1996, p. 437.
6 Mahoney in Cadogan, 1991, p. 249; Spinosa in Detroit–Chicago, 1981–2, vol. 1, p. 148, identifies the game as checkers.
7 Jan Kelch in Philadelphia–Berlin–London, 1984, p. 325.
8 Heimbürger Ravalli, 1982, pp. 34–8.

Catalogue 25
1 Rowlands, 1996, pp. 429–35, cat. no. 53.
2 Mariuz, 1971, figs. 40–3; Contini, 2002, pp. 232–6, repr., figs. 1, 2.
3 New York, Sotheby's, *Old Master Paintings*, May 23, 2001, lot 49, oil on canvas, 28⅝ × 41¼ in., signed *Domo Tiepolo* and possibly indistinctly dated. The painting was examined by Sack, 1910, p. 323, who noted that it and the Atheneum picture were both dated 1752.
4 Knox, 1980, vol. 1, pp. 306, 315, nos. P 144, P.229; Cadogan, 1991, p. 242, fn. 7.
5 The date has been read variously; see Cadogan, 1991, p. 242, fn. 7.

Catalogue 26
1 The basic reference for the artist's life and work is Viterbo, 1998–9.
2 Lalande, 1769, vol. 5, p. 263.
3 Farmer, 1997, pp. 82, 83.
4 Pansecchi, 1989–90, p. 344; the identification of the saint is confirmed by the features of his death-mask conserved in the Congregazione Generalizia dei Padri Scolopi in Rome.
5 Rudolph, in Philadelphia–Houston, 2000, p. 351.
6 Johns, 1993, p. 202.

Catalogue 27
1 Garberson, 1996, p. 121.
2 See, for example, New York, 1971, p. 80, no. 189.
3 For Canaletto's depiction of this detail, see Bowron, 1996, pp. 25–6, 30, fn. 7; for Guardi's dependence on Canaletto, see Byam Shaw, 1996, pp. 743, 744.
4 For Guardi's painted views of the Piazzetta looking toward San Giorgio Maggiore, see Morassi, 1973, vol. 1, pp. 378–81, nos. 361–78; vol. 2, figs. 391–5, 397–400.
5 Morassi, 1975, p. 137, no. 355, fig. 337; Cadogan, 1991, p. 164, fn. 3–5.
6 For Guardi's painted views, see note 4; for the drawings see Morassi, 1975, pp. nos. 137–8, 335–42.

Catalogue 28
1 Knox, 1980, vol. 1, p. 78; Barcham, 1996, p. 864.
2 Levey, 1971, pp. 238–9, no. 3318.
3 Levey, 1971, pp. 239–40, no. 3319; Mariuz, 1971, fig. 271.
4 Levey, 1971, p. 238.
5 Levey, 1971, p. 238.
6 Knox, 1980, vol. 1, pp. 108 (B 59, B 64), 138 (D 70), 140 (D 98–100), 141 (D 101); vol. 2, pls. 274, 275, 289, 299, 301–4.

Catalogue 29
1 Copies include complete sets in Vienna (Europahaus) and Murcia (ex-collection d'Estoup). There are, in addition copies of single figures, including *Taste*, in St. Petersburg (The State Hermitage), Florence (Rampini collection), Forlì (ex-collection Rossi).
2 "Fece molte cose qui in Roma et in particulare per . . . , spagniolo, quale ha cinque mezze figure per i cinque sensi molto belle. . . ." Mancini, 1614–21, p. 251.
3 A 1624 inventory of paintings belonging to Francesco Cussida (the son of Pietro Cussida) lists "cinque quadri delli cinque sentimenti." Papi, 2002, 34, 42–3.

Catalogue 30
1 The painting is inscribed: FRAN. CO RIBALTA CATALA, LO PINTO EN MADRID, ANO D. MDLXXXII. Kowal, 1985, 217–19, no. F–1.
2 Kowal, 1985, 252–5, nos. F–38, F–40
3 St. Bonaventure, *Legenda Sancti Francisci*, in *Opera Omnia*, 8 (1898): 519. For a discussion of the popularity of the subject in post-Tridentine Italian painting, see Askew, 1969, 298–306. In 1617 Bartolomé González painted the earliest documented representation of the subject in Spain for the Capuchin monastery of El Pardo. Martín González, 1958, 131.

4 For a discussion of the typological parallel between St. Francis and Christ, see Askew, 1969, pp. 289–90.

5 Benito Domenech, 1987, 122–3.

6 A 1604 engraving by Raphael Sadeler the Elder after a work by the Italian Capuchin painter, Paolo Piazza, is often cited as the probable iconographic source of Ribalta's painting.

7 Kowal, 1984, 768–75; Angulo Iñiguez and Pérez Sánchez, 1988, 68–9, nos. 340–4.

Catalogue 31

1 On the Mercedarians, see James William Brodman, *Ransoming Captives in Crusader Spain: the Order of Merced on the Christian-Islamic Frontier*, Philadelphia, 1986.

2 Antonio Ponz recorded two martyr saints by Zurbarán near the door to the refectory, while Ceán Bermúdez specifies a St. Serapion in the *sala De profundis*. Matute's additions and corrections to Ponz state that only one of Zurbarán's two martyrs, St. Serapion, remains in the *sala De Profundis* and that it is installed facing the refectory door. The date of Matute's notes, which were not published until 1887 (fifty-seven years after his death), is unknown. By 1810 the two paintings seen by Ponz had been removed to the Seville Alcázar. Ponz, 1786, 9, pp. 106–7; Cean Bermúdez, 1800, 6, p. 49; Matute, 1887, p. 377; Gómez Ímaz, 1917, p. 141.

Catalogue 32

1 There is no documentary evidence of such a trip and, although Antonio Palomino maintains that he was in Madrid in 1664, the influence of the royal collection upon his style can be detected at an earlier date.

2 Valdivieso, 2002, pp. 37–51. See especially Antonio de Pereda's *Vanitas*, *c.* 1634 (Vienna, Kunsthistorisches Museum).

3 Most of the books have been identified: Juan Eusebio Nieremberg, *De la diferencia de lo temporal y eternal: crisol de desengaños*; Fray Jerónimo Román, *Republicas del mundo*; Antonio de Nájera, *Suma astrológica y arte para enseñar hazer pronósticos de los tiempos*; Alonso de Herrera, *Libro de agricultura*; Vicente Carducho, *Diálogos de la pintura*; Giacomo Vignola, *Le due regole della prospettiva prattica*; Sebastiano Serlio, *Libros de architectura*; Leon Battista Alberti, *De re aedificatoria*.

4 The page is inscribed PO/TENTIA/ADACTUM TAMQUAM/TABULA RASA (on scroll); the verse below reads: En la tabla rasa tanto excede/que vee todas las cosas en portencia/solo el pincel con soberana ciencia/reducir la potencia al acto puede. (The possibility for action is as a blank sheet. The blank sheet, which sees all things as possibilities, is surpassed alone by the brush's sovereign science to turn possibility into action.) The facing page reproduces the royal decree, *Sentencia que dio el Real consejo de hacienda en el pleito de los pintores*. Cadogan, 1991, pp. 325–6; Trapier, 1960, p. 32; Nordström, 1959, p. 135.

5 Juan Eusebio Nieremberg (1595–1658) taught at the Colegio Imperial of Madrid. There are more than fifty Spanish editions of *De la diferencia de lo temporal y eternal: crisol de desengaños*, first published in 1640.

6 The York painting displays the same bibliographic erudition as the Hartford picture; identifiable texts include: Luis de Granada, *Introduccion del símbolo de la fe*; Girolamo Savonarola, *El Triumpho de la Cruz d'xpo alias*; Fray Antonio Alvarado, *Arte de bien vivir y guía de los caminos del cielo*; Alonso de Villegas, *Flos sanctorum*; Alonso de Vascones, *Destierro de ignorancias y aviso de penitentes*; Martin de Roa, *Estados de los bienaventurados en el cielo, de los niños en el limbo, de las almas en Purgatorio, de los condenados en el Infierno y de todo deste universo despues de la Resurreccion y juizio universal*; Antonio del Castillo, *El devoto Peregrino, viage de Tierra Santa*. See Nordström, 1959, pp. 129–32; Trapier, 1960, pp. 33–4.

7 Possibly Henry Solomon Wellcome (1853–1936).

Catalogue 33

1 On the founding of the Madrid Academy, see Bédat, 1989, pp. 27–71.

2 Junquera de Vega, 1965, pp. 12–27.

3 Tomlinson, 1990, p. 84.

4 Ibid, pp. 84–9.

Catalogue 34

1 Tomlinson, 1989, p. 12.

2 Sambricio, 1946, p. 173.

3 Pemán, 1969, pp. 53–72; idem, 1992, pp. 304–20.

4 The portrait, inscribed "Dⁿ Sebastián Martínez / Por su Amigo / Goya / 1792," was evidently painted in Madrid, prior to Goya's trip to Cádiz. Martínez, a wine and textile merchant, was also Treasurer General of the Council of Finances of Cádiz and a member of the Royal Council of the Public Treasury.

5 Cruz y Bahamonde, 1813, p. 340.

6 Trapier, 1964, p. 9; Gudiol, 1970, vol. 1, p. 287.

7 The inventory of the collection of Martínez's son-in-law, Fernando Casado de Torres, lists five paintings by Goya, including: no. 197 "una mujer de Goia, ancho 3 cuartas, alto 2" and its apparent pendant, no. 211 "una mujer dormida de Goia, ancho 3 quartas, alto media vara." The dimensions of both paintings (41.75 × 62.61 cm), which are probably approximate, are close to those of the Dublin painting (44.5 × 76.5 cm). The measurements of the Hartford *Gossiping Women* (59 × 145.5 cm.) and the Madrid *Woman Asleep* (59 × 145 cm) are considerably larger. Baticle, 1978, p. 22.

8 Cruz Valdovinos, 1989, pp. 311–19.

9 Lee, 2001, pp. 3–10.

10 Canellas López, 1981, p. 465; Fernández de Moratín, 1968, pp. 174–5.

11 I am grateful to Jesusa Vega for sharing this observation.

12 The 1803–5 inventory of Sebastián Martínez's property includes only one painting by Goya, his 1792 portrait of Martínez. According to Nicolás de la Cruz, Martínez's collection was divided between his two surviving daughters, Catalina and Josefa. Half of the collection remained with Fernando Casado de Torres (husband of Catalina), while the other half was "sold to the English" by Francisco Viola (husband of Josefa). The inventory of Casado de Torres's property, which probably dates from the 1830s, does not include the Hartford painting. Cruz, 1813, p. 339; Baticle, 1978, pp. 21–2; Glendinning, 1994, pp. 100–1, 109.

Catalogue 35

1 One of high quality is in The Mauritshuis, The Hague. See Sluijter-Seijffert, 1984, no. 25. Another was in 1973 on the London art market. See Alan Jacobs Gallery, *Fine XVII Century Dutch and Flemish Old Masters*, London, 1973, p. 29; and yet another version of this was in 1961 with the dealer G. Cramer at The Hague. Also similar is a *Psyche Conducted to Olympus* at the Kunstsammlung in Basel; while a large copy of the Atheneum's painting on canvas and without the putti was with a restorer in The Hague in 1950.

Catalogue 36

1 The other versions are in the National Museum, Stockholm and in the Centraal Museum, Utrecht. Roethlisberger 1993, cat. nos. 423 (fig. 593) and 514 (fig. 699), respectively.

2 Roethlisberger 1993, cat. no. 562 (fig. 751): "Panel with yellowish-brown ground in oil, drawing in pen, brownish oil paint, white heightening, 18 × 26 cm. Signed at the bottom right *A. Bloemaert fè.*, strengthened (doubled) in the last letters of the name."

3 The 1904 sale catalogue calls the painting "Neptune and Salacis." Haverkamp-Begemann, 1978, p. 119, accepts the title and explains that the story of the Triumph of Neptune and Amphitrite involves an ancient conflation of the Greek gods Poseidon and Amphitrite and the Roman gods Neptune and Salacia. See also de Bosque 1985, pp. 274ff.

4 Roethlisberger 1993, p. 277 where he also notes other treatments of the theme by Bloemaert.

5 See Roethlisberger 1993, T173, p. 391. The drawing is part of the *tekenboek*, drawings made by Abraham Bloemaert, probably copying other drawings in preparation for the printed version of the book published by Cornelis Bloemaert. Haverkamp-Begemann, 1978 also mentions drawings in Dresden, Gemäldegalerie, inv. no. 1235 and a drawing with E. Burg-Berger, Berlin, in 1936. Neither is mentioned by Roethlisberger.

Catalogue 38

1 Gemäldegalerie, Dresden, inv. Nr. 1257, panel, 29 × 37 cm, not signed; Museum Boymans van Beuningen, Rotterdam, inv. Nr. 2173, panel, 30 × 47 cm, signed lower middle: *B.vander. Ast*; The Mauritshuis, The Hague, inv. Nr. 399, copper, 7.8 × 12.5 cm, not signed or dated.

2 The identifications were made by Willard D. Harman of the Yale University Department of Zoology and published in Haverkamp-Begemann, 1978, p. 114, footnote 1 of the Van der Ast entry (nr. 7).

Catalogue 39

1 See Washington *et al.*, 2001, nos. 51–3.

2 Reiss, 1975, p. 104.

Catalogue 40

1 Biographical data regarding the Coymans family was first published by Johan E. Elias, *De Vroedschap van Amsterdam, 1578–1795*, Haarlem, 1905, vol. 2, p. 762; and recently expanded by Biesboer 2001, p. 278.

2 In 1625 Balthazar and Joan commissioned the young architect Jacob van Campen to build an elegant double house on the Keizersgracht.

3 Slive, 1974, no. 166.
4 Slive, 1974, no. 189 and 188 respectively.
5 Biesboer, 2001, pp. 278–9.
6 For a discussion of the identity of the sitter and additional bibliography, see Wheelock, 1995, pp. 76, 78.
7 Biesboer, 2001, inventories 79 and 86. On p. 278 Biesboer suggests the connection to the portraits in Baltimore and Hartford.
8 According to inscription by Sir James Carnegie on the stretcher: "Franck Hals pinx – 1644/ (Bought from M.r Forrest (strand / Oct. 1850 / James Carnegie." Sir James also put his initials, "J.C." in monogram, on the stretcher.

Catalogue 41
1 Baldinucci, 1681/1728, VI, p. 367. For a full discussion of the identification of the Hartford painting and that commissioned by Raggi as well as of the attribution of the five paintings, see Kren 1979, vol. 3, cat. A15, pp. 26–9.
2 Kren 1979, pp. 28–9 notes that the group is attributed to Miel and Cerquozzi in 1710 but in 1701 mentions only Cerquozzi.
3 Quoted in translation in Kren 1979, p. 27. The original is found in *Catalogue Raisonné des 215 Tableaux les plus capitaux du Cabinet de M.r le Comte de Sellon d'Allaman, en Suisse Pays de Vaud . . .*, 1795, no. 113 and reads: "Sur toile, hauteur 2 pieds 10 pouces, largeur 5 pieds 6 pouces. Une place de Rome ornée de la colonne Antoine. On voit sur cette place une infinité de scènes de carnaval, groupes de masques de toutes espèces, des soldats de la garde Suisse du Pape en grand costume: un d'entr'eux recevant le supplice de l'estrapade. Ces différens groupes sont dessinés et composés avec tout plein d'esprit, et ont bien du piquant. Les caractères de tete sont nobles et gracieux, les attitudes pittoresques. Le coloris et la composition ne laissent rien à désirer." Le nos. 112–19 in the catalogue are listed as by Miel and nos. 113–17 all have the same dimensions.
4 Kren 1979, p. 28.
5 Ibid, 1979, pp. 94–5, notes that the painting must date before 1650 because in *Roman Carnival* (Vienna, Kunsthistorisches Museum) Johannes Lingelbach (1622–74) employs a massing of buildings and centralized column and figures similar to the Hartford painting, which he must have seen before his departure from Rome in 1650.
6 Regarding the Raggis as art patrons, see Kren 1979, pp. 153–64, and regarding Giovanni Battista Raggi, Venanzio Belloni, *Scritti e Cose d'Arte Genovese*, Genoa, 1988, pp. 149–51. A large collection was formed in Genoa by Giovanni Battista Raggi. Many of the pictures were auctioned January 22, 1659, but some pictures were sent to Rome on the Gallera Diana and were probably inherited by Cardinal Lorenzo Raggi, Giovanni Battista's brother.
7 Kren 1979, p. 155.
8 According to Haverkamp-Begemann, 1978, p. 164, the manuscript "Quadri delle case dei principi in Roma," compiled by Giuseppe Ghezzi from receipts for paintings exhibited by the Sodalizio dei Piceni in Salvatore in Lauro, lists for the exhibition of 1701 "cinque quadri bellissimi bislunghi tutti d'unna misura di Michel.o delle Battaglie, Bambocciate," and for the exhibition of 1710 "cinque quadri bislunghi di Michel.o e Gio. Miele rappresentatnti Bambocciate" as in the possession of Marchese Raggi. "Michel.o delle Battaglie" refers to Michelangelo Cerquozzi. The manuscript is preserved in the Museo di Roma and was published in part in *Paesisti e vedutisti a Roma*, p. 43.

Catalogue 42
1 See for example the pair at Dulwich reproduced in Antwerp, 1991, nos. 8A and B; as well as one at the Prado, no. 1817; and others sold at Christie's, London, November 29, 1974, no. 83 and December 11, 1992, no. 78.
2 See for example a work by Joos de Momper recently at Christie's, South Kensington, July 11, 2003, no. 3.
3 One in Lord Tollemache's collection, Helmingham Hall, photo in the Frick Art Reference Library; one sold at Parke-Bernet, New York, March 28, 1946, no. 74; another at Sotheby's Parke-Bernet, London, December 12, 1979, no. 192.

Catalogue 43
1 The painting was sold in Amsterdam in 1687 as a work by "the younger Bronchorst." The attribution to the younger artist was confirmed by the discovery of a signature on the Hartford painting in 1986 by Thomas Döring and Stephen Kornhauser, conservator of paintings at the Wadsworth Atheneum. See Döring, 1993, cat. no. B 8.
2 Jan Gerritsz. made etchings after paintings by van Poelenburgh and under his influence turned to painting, joining the St. Luke's Guild in Utrecht in 1639.
3 Jan Gerritsz. moved to Amsterdam in 1651 after receiving the commission for four stained glass windows for the Nieuwe Kerk, Amsterdam, for which he was paid the handsome fee of 12,400 guilders. He became a citizen of Amsterdam in 1652 and during the following years fulfilled a number of important painting commissions: the organ shutters in the Nieuwe Kerk, completed in 1655; ceiling pieces and overmantels for the new Town Hall and a portrait of the regents of the Oudezijds Huiszittenhuis (1657). He died in Amsterdam in 1661, outliving his son Johannes, who died in 1656. Another son Gerrit (c. 1636–73) was also a painter.
4 In Rome Johannes would have seen the famous ceiling frescos painted by Guido Reni (1613/14, Rome, Palazzo Rospigliosi, Casino dell'Aurora) and Guercino (1621–3, fresco, Rome, Casino Ludovisi), and in the Netherlands Jacob van Campen's adaptations for the Huis ten Bosch, completed in 1649, and for the Town Hall in Amsterdam.
5 Judson, 1966, p. 4, fig. 6. Saunders in Haverkamp-Begemann, 1978, p. 122, no. 2 notes similarities between the Hartford painting and Poussin's *Diana and Endymion*, (See Anthony Blunt, *The Paintings of Nicolas Poussin" A Critical Catalogue*, London, 1966, p. 63.)
6 Judson 1966, p. 4ff.
7 Judson, 1966, p. 7 and Haak, 1984, p. 316.
8 Haak, 1984, p. 316.
9 Judson 1966, p. 6.
10 Saunders in Haverkamp-Begemann, 1978, p. 121. On page 122, fn. 6, Saunders notes that Guercino included Tithonus in *Aurora* as having been left behind under the curtain of darkness as Dawn travels across the sky toward night. Poussin also represents a sleeping river god in his two versions of *Aurora and Cephalus*. Blunt 1966, p. 105 sees this as a double reference to Tithonus and Oceanus.
11 Döring 1993, p. 154 notes that the figure Judson identifies as Father Time bears none of the traditional attributes and that Saunders does not provide an explanation for the younger man.

12 Saunders in Haverkamp-Begemann, 1978, pp. 121–2 notes that in the Hartford painting there is actually only the one clearly identifiable allegorical figure of Dawn.
13 Döring, 1993, p. 155.
14 Described as "Een Bachgenaal van van Loo, het capitaalste en beste." The sale price of 234 guilders was more than seventy guilders over that paid for the *Aurora*.
15 Döring, 1993, cat. no. B 8, dismisses any association of an *Aurora* sold in Ghent, Hôtel Kervy-Van den Hecke, lot. 10, as "Bronckhorst (dit Lange Jan)" with Johannes Bronckhorst. "Lange Jan" was the nickname of another artist, Jan Boeckhorst, who was from Münster and a student of Jacob Jordaens. He was also known by his contemporaries as "Bronckhorst."
16 Hoet, 1752, vol. 1, p. 6.

Catalogue 44
1 F. Guerra, "Medicine in Dutch Brazil 1624–1654," in *Johann Maurits van Nassau-Siegen 1604–1679*, E. van Boogaart, ed., The Hague, 1979, p. 484 ff.; E.W. Gudger, "George Marcgrave, The First Student of American Natural History," *Popular Science Monthly* 81 (1912), pp. 250–74.
2 Under the Portuguese, Indians had been brought togetheIïr in villages under the supervision of the Jesuits.

Catalogue 46
1 For an extended discussion of the subject, see Slive, 2001, pp. 51–60, and Linda Stone-Ferrier, *From Cloth to Clothing: Depictions of Textile Production and Textiles in Dutch Seventeenth-Century Art*, Ann Arbor, Michigan, 1984, and Linda Stone-Ferrier, "Views of Haarlem: A Reconsideration of Ruisdael and Rembrandt," *Art Bulletin*, 67 (September 1985), pp. 417–35. Slive, 2001, pp. 51 citing a private communication from Pieter Biesboer, notes that the latter has found a reference to a *Haarlempje* by Jacob van Ruisdael in a Haarlem inventory dated 1663.
2 Slive, 2001, nos. 50, 37, and 55, respectively.
3 See Biesboer, 1995, pp. 36–9. The following discussion is based on his pp. 37–8 and figs. 5 & 6.
4 Regarding the linen business during the seventeenth century, see S. C. Regtdoorzee Greup-Roldanus, *Geschiedenis der Haarlemmer Bleekerijen*, The Hague, 1936, and for the depiction of the linen industry during the seventeenth century, see Stone-Ferrier 1984 and 1985, note 3 above.
5 Slive, 2001, p. 59.
6 Wilfried Wiegand, *Ruisdael-Studien: ein Versuch zur Ikonologie der Landschaftsmalerei*, Hamburg, Ph.D. diss., 1971, p. 105, drew attention to the emblem of a bleacher and concluded that van Ruisdael's *Haarlempjes* extolled the purified soul. R.H. Fuchs, "Over het landscap. Een verslag naar aanleiding van Jacob van Ruisdael, *Het krenveld*," *Tijdschrift voor Geschiedenis* LXXXVI (1973), p. 285, rejecting Wiegand's emblematic interpretation of the bleaching-field paintings, suggests that because the view of Haarlem is also prominent, the paintings were visual metaphors of Haarlem's purity as a city. See discussion in Stone-Ferrier 1985, who argues that the paintings were expressions of civic pride in the prosperity of the linen business and its importance for the region. Slive, 2001, p. 60 rejects these interpretations in favor of an aesthetic appreciation for the views as reminders of the actual scene.

7 The "R" has been overpainted, but examination of the monogram under ultra-violet light confirms that it is original.

8 Slive, 2001, p. 64, cat. no. 37, fn. 1, considers the possibility that the Hartford painting or the versions in Berlin (Slive, no. 37), or Madrid (Slive, no. 50), "which are similar in size and motif, are possibly identical with one or more of the pictures that appeared in the following auctions: Sale, Ménageot, Paris (Chariot), 17 March 1778, no. 221; sale, Mme. De Cossé, Paris (Lebrun), 14 November 1778, no. 43 (Lebrun); sale, Paris (Paillet), 17ff. January 1809, no. 104 (fr. 520; with reversed dimensions?); sale, Villiers, Paris (Lebrun), 30 March 1812, no. 53 (fr. 1402, Constantin; cited in Smith 139 and HdG 100). One of them also may be identical with a painting that was in the collection Leonardus Pietr de Reus, The Hague, by 1842; the collection was sold en bloc in 1845 to Carl Mayer, Freiherr von Rothschild, or his son Mayer Carl, Freiherr von Rothschild, Frankfurt-am-Main (Smith Suppl. 6; HdG 83a)."

Catalogue 47

1 Kren in Haverkamp-Begemann, 1978 incorrectly states that the painting is dated.

2 In 1649, probably in anticipation of his prolonged absence, Berchem and his wife drew up a will. Berchem's presence in Italy at some date is supported by the listing of paintings by him in the 1714 inventory of the collection of the Colonna family as well as in the 1724 biography by Nicola Pio.

3 See Schloss, 1982, pp. 31–46.

4 Ibid., p. 20, notes that in Netherlandish art blacks in eastern costume with parrots often symbolized Africa.

5 Ibid., 1982, p. 19.

6 In 1900 Jan Six named the painting "Othello and Desdemona." In 1919 he identified the subject as "The King of Egypt sends a Negro for Sarah." He believed that the painting was a pendant to Berchem's *Abraham Receiving Sarah from King Abimelech* (Geneva, Musée d'Art et d'Histoire), an association Hofstede de Groot rejected because of the difference in dimensions. Kren in Haverkamp-Begemann, 1978 dismisses both identifications.

7 Schloss, 1982, p. 20.

8 Broos in The Hague, 1991, p. 157, sees hidden symbolism in the details of the painting: in addition to Venus, the music-making couple at her feet, and the glass of wine refer to the pleasures of life, wine, women and song. The still life of an orange and lemon reminds the viewer that love can be both sweet and sour.

9 Broos in The Hague, 1991, p. 158.

10 As Schloss, 1982, p. 63, notes, Northern paintings and prints from the middle ages to the seventeenth century represented Lady World with a cross and globe on her head. Eddy de Jongh has suggested that a map on the wall could replace the globe in some instances.

9 Brown in Philadelphia–London, 1984, no. 5.

11 Listed as the lender to an exhibition in Cologne in 1930. However, the business records of Hanns Schaeffer, Getty Research Institute, Los Angeles, make no reference to the gallery having owned the painting prior to 1959, suggesting that Schaeffer was representing the owner and not himself the owner.

Catalogue 48 and 49

1 Cuzin, 1982, p. 529.

2 These works are discussed and well reproduced in color in Paris, 1990, nos. 2, 3, 4 repr. pp. 185–8. See also Rome, 1991, nos. 4, 5, repr. pp. 86–7.

3 Paris, 1990, p. 98. Also, E. Schleier, "Nouve proposte per Simon Vouet, Charles Mellin et Giovanni Battista Muti," *Poussin et Rome, Actes du colloque del'Académie de France à Rome*, 16–18 November 1994, 1996, p. 154.

4 The latter paintings are reproduced in Crelly, 1962, figs. 21–2, 23.

5 Paris–New York–Chicago, 1982, p. 335.

6 See Paris, 1990, pp. 26–36 on the Roman studio of Vouet. Olivier Michel has recently published a half-figure painting of *Judith* identical to a print by Claude Mellan that attributes the composition to her. While accomplished, the painting lacks the rounded sculptural presence, fineness of rendering the hands and fingers, and convincing, suave handling of the brush to convey the natural folds of drapery. See O. Michel, "Virginia Vezzi et l'entourage de Simon Vouet à Rome," *Simon Vouet: actes du colloque international*, Galeries nationales du Grand Palais, 5–7 February 1991, ed. Stéphane Loire, Paris, 1992, pp. 127–9, repr. p. 129.

7 According to Griseri, 1961, pp. 322–5, the painting (speaking of the *St. Ursula*) "seems to have come from the dispersal of a Roman collection such as that of Dal Pozzo . . ." According to a *Hartford Times* clipping, dated October 23, 1961, "The St. Ursula is one of a pair of paintings (the other is of St. Martha [sic]) found in a relatively unknown, uncatalogued Spanish collection." A note with accompanying photograph presumably from Mont also suggests a previous private Spanish owner, which has been confirmed by Juan Luna, a curator at the Prado. Rosenberg, in his entry in Paris–New York–Chicago, p. 335, states that the works were "Discovered in Spain by José Milicua . . ."

Catalogue 50

1 The situation is well summed up by Neil MacGregor in his essay on the Le Nain brothers in "Le Nain," *The Dictionary of Art*, ed., J. Turner, vol. 19, London and New York, 1996, pp. 146–50. As MacGregor points out, the only work datable after 1648, indeed after 1652, because of the breeches worn by the artist in the painting, is the *Artist's Studio* (Poughkeepsie, NY, Vassar College Art Gallery), but the attribution of the painting is disputed. MacGregor also well summarizes the general characteristics of the three "hands" distinguished primarily by Rosenberg and Cuzin. These characteristics as presented by MacGregor are outlined in this entry.

2 Cuzin, 1978, pp. 875–6; Rosenberg, 1993. Also see Rosenberg's entry on the Hartford painting in Paris–New York–Chicago, 1982, no. 48.

3 MacGregor, op. cit., p. 149.

4 Rosenberg's defines the three artists' stylistic characters, admitting that the names of Antoine and Louis could be interchanged, in Paris–New York–Chicago, 1982, pp. 263–9.

5 MacGregor, op. cit., p. 149.

6 Wine, 2001, pp.194–211.

7 Ibid., pp. 198–201.

8 For full references and Wine's commentary on the difficulties in dating Le Nain paintings from costumes, see Wine, op. cit., p. 201, fn. 13, 14.

9 These two paintings reproduced in Paris–New York–Chicago, 1992, nos. 47, 46. Also Paris, 1978, nos. 35, 36.

10 The Louvre painting is in Paris, 1978, no. 34, the St. Petersburg painting, Paris, 1978, no. 33. The Victoria and Albert picture in MacGregor, 1996, p. 149, fig. 4.

Catalogue 51

1 Both works are reproduced in Sterling, 1965, figs. 2 and 4. The reproduction of the painting formerly in Duisberg is particularly helpful, as the more recent reproduction in Mérot's *catalogue raisonné* is significantly inferior.

2 Sterling, 1965, fig. 3, then in a private collection. Mérot, 2000, no. 24, p. 175.

3 The work, signed and dated 1630, is in a French Carmelite collection. See *L'Art du XVIIe siècle dans les Carmels de France*, Paris, Petit-Palais, 1982–3, no. 51, repr. p. 23.

4 On knowledge of the work in Northern Europe in the first half of the seventeenth century, see L. Dussler, *Raphael, A Critical Catalogue of his Pictures, Wall-Paintings and Tapestries*, London and New York, 1971, pp. 41–2, pl. 90.

5 Félibien, 1688, v, p. 35.

6 According to Blunt, 1946, pp. 268–71.

7 According to a letter dated March 8, 1966 from Edward Speelman in the Museum's object file, he purchased the painting from Mrs. Seligmann of Paris, who inherited the painting from her husband. Speelman insists that they were of no direct relation to Arnold Seligmann, the art dealer.

Catalogue 52

1 The inscriptions and discussion of the early provenance history are presented by Michael Kitson in Kitson, 1978, LV73 (Hartford painting), p. 97, and LV54 (London painting), pp. 85–7. Further information in Vivian, 1969, p. 725.

2 See Spear, 1982, vol. I, no. 4, as "attributed to Domenichino." Spear suggests the possibility that the painting alternatively might be by Giovanni Battista Viola, p. 127, repr. vol. II, pl. 6. Also, Forte, 1982, p. 100, repr. p. 99.

3 Kitson, 1978, p. 98.

4 In the Museum's object file, there is a hand-written annotation on a typed object sheet indicating this.

Catalogue 54

1 The State Hermitage, Saint Petersburg.

2 Today in a private collection. For that work, see exh. cat., Paris, Grand Palais, *De David à Delacroix: la peinture française de 1774 à 1830*, 1974–5, no. 59.

3 In this basket all is fragile.
For a country lad these eggs are a treasure.
Honor is still more fragile.
To keep it intact is not an easy chore.

4 Ananoff, 1976, p. 224, fig. 95/1 bis.

5 *La Souffleuse de Savon (The Bubble Blower), La Vendangeuse (The Grape Picker)* and *Le Marchand d'oiseaux (The Bird Seller)*. For those works, see Ananoff, 1976, pp. 224–5, nos. 92–4 and Jean-Richard, 1978, pp. 160–2, nos. 542, 544 and 548.

6 The most extensive discussions of this painting are to be found in Alastair Laing's entry for it in New York, 1986–7 and Colin Bailey's text in Ottawa–Washington, 2003–4.

Catalogue 55

1 Le Père Laugier, *Jugement d'un amateur sur l'exposition des tableaux. Lettre à M. le marquis de Vxxx*, Paris, 1753, p. 42.

2 L'Abbé Leblanc, *Observations sur les ouvrages de MM de l'Académie*, Paris, 1753, p.22.

3 M. Estève, *Lettre à un ami sur l'exposition des tableaux . . .* , Paris, 1753, p. 13.

4 See Willk-Brocard, 1995, nos. 52a, 55, 332, 333.

Catalogue 56

1 The young male and female models for these two pictures also appear in the larger pair of pictures.

2 Richard Rand in Hanover, 1997–8, p. 148, has noted the similarity of the pose of *La Paresseuse* and that of the young woman in Greuze's *Le Malheur imprévu (The Broken Mirror)* (Wallace Collection, London) of *c.* 1763, which is clearly an allegory of lost innocence.

3 For good illustrations, see Thomas E. Crow, *Painters and Public Life in Eighteenth-Century Paris*, New Haven and London, 1985, p. 139, fig. 57 and Edgar Munahall, 2002, p. 21, fig. 9 (color).

4 Gallerie degli Uffizi, Florence; Musée du Louvre, Paris; Museo Nazionale, Pisa; and Museo di Capodimonte, Naples.

5 See François Monod and Louis Hautecoeur, *Les Dessins de Greuze conservés à l'Académie des Beaux-Arts de Saint-Petersbourg*, Paris, 1922, p. 32, no. 70, repro. pl. XXVII.

6 Opperman, 1979 suggests that the two figures symbolize two of the seven deadly vices, *desidia* (sloth) and *luxuria* (lust).

7 On the two paintings in the Doria Pamphilj collection, see Eduard A. Safarik and Giorgio Torselli, *La Galleria Doria Pamphilj a Roma*, Rome, 1982, figs. 227 (*Repentant Magdalen*) and 229 *(St. John)*. On the autograph and non-autograph status over the centuries of the Doria *St. John*, consult Maurizio Marini, *Caravaggio – Michelangelo Merisi da Caravaggio "pictor Praestantissimus,"* Rome, 1987, pp. 444–5, under no. 42.

Catalogue 57

1 See Joseph Baillio, "Le Dossier d'une œuvre d'actualité politique: *Marie-Antoinette et ses enfants* par Mme Vigée Le Brun," *L'Oeil*, no. 308, March 1981, pp. 34–41, 74–5 and no. 310, May 1981, pp. 53–60, 90–91.

2 Vigée Le Brun, 1835, vol. II, p. 229.

3 These eight portraits can be itemized as follows: an original and the Atheneum's replica of the *Portrait with a Straw Hat*; a portrait in which the subject is shown wearing another type of plumed hat, standing before a piano forte and holding a musical score (National Trust, Waddesdon Manor; Aylesbury, Bucks; possibly the paiting presented to the Comte d'Adhémar, French ambassador to the Court of George III and seen in his London residence by Sir Joshua Reynolds and the Comte de Tilly), which was painted in 1783 but featured in the artist's list of 1787; two portraits "with a hat" in the list of 1787; another portrait of the sitter in the list of the same year (possibly the pastel profile now in the collection of one of Madame de Polignac's descendents); and two other unidentified portraits in the list of 1789. Not mentioned in Vigée Le Brun's lists are a profile drawing she did of of the Duchesse in Rome *c.* 1792 (private collection) and a posthumous likeness that was engraved in Vienna by Josef Fischer and later in London by John Smith.

4 It should be noted that the same relationship exists between the Polignac portrait in Versailles and the Atheneum's replica and the two autograph versions of Vigée Le Brun's *Self-Portrait with a Straw Hat*, the prime version and its look-alike in the National Gallery, London.

5 See Joseph Baillio, "Vigée Le Brun and the Classical Practice of Imitation," *Paris, Center of Artistic Enlightenment* (Papers in Art History from The Pennsylvania State University, IV), 1988, pp. 96–7 and notes 8–10.

6 A prime example of this type of picture is Paulus Moreelse's *Shepherdess* of 1633 in the Wadsworth Atheneum (fig. 46). An earlier version of 1622 is now preserved in the Kunsthaus, Zurich as part of the Betty and David M. Koetser Foundation. See Christian Klemm, *The Paintings of The Betty and David M. Koetser Foundation*, Zurich, 1988, pp. 90–1, no. 37, repro. in color. Consult also Chapter Four of Alison McNeil Kettering's *The Dutch Arcadia: Pastoral Art and its Audience in the Golden Age*, Montclair, N.J., 1983, pp. 44–62.

7 "1 Copie de la meme." Versions of the *Portrait with a Straw Hat*, which may or may not be autograph, were recorded in the Vaudreuil and Baron Edmond de Rothschild collections; and in the catalogue of an anonymous auction sale: Paris, January 17, 1803, lot 96. A number of anonymous copies have also been traced.

8 On Henry Seymour and his sometimes troublesome progeny, consult Bernard Falk, *The Naughty Seymours: Companions in Folly and Caprice*, London and Melbourne, 1940.

Catalogue 58

1 Egerton, 1990, pp. 9–11 and 15.

2 Buckley, 1953, p. 2.

3 Rosenblum, 1960, p. 27; Cummings and Staley, p. 71.

4 Egerton, 1990, p. 84.

5 Rosenblum, 1960, p. 27.

6 Egerton, 1990, p. 84; Rosenblum, 1960, p. 27.

7 Nicolson, 1968, p. 113–15.

8 Kemp, 2000, cat. no. 315.

9 Nicolson, 1968, p. 243.

10 Nicolson p. 243.

Catalogue 59

1 Abrams, 1985, p. 75.

2 Staley, 1986, no. 275.

3 Ibid.

4 A letter from West to Daulby dated October 15, 1779 indicates that Daulby may have acquired *Saul and the Witch of Endor* at that date for 30 guineas.

5 Kornhauser, no. 485; Staley, 1986, no. 220.

6 Staley, 1986, pp. 82–3.

7 Dillenberger and Taylor, no. 21.

Catalogue 60

1 Hayes, pp. 524–5, no. 153.

2 Rosenthal, 1999, Chapter 8, "Figuring Landscape;" Bermingham, 1986, p. 40.

3 Williams, p. 100; Bermingham, 1986, chap. 1, "The State and Estate of Nature."

4 Brenneman, 1997.

5 Reynolds, 1789.

6 Waterhouse, 1958, no. 1001a.

7 Hayes, p. 152, no. 152; Waterhouse, 1958, p. 41.

BIBLIOGRAPHY
Abbreviated references

Abrams, 1985: Ann Uhry Abrams, *The Valiant Hero: Benjamin West and Grand-Style History Paintings*, Washington, D.C.

Ananoff, 1976: Alexandre Ananoff, *François Boucher*, Lausanne and Paris, vol. 1.

Ananoff, 1980: Alexandre Ananoff, *L'opera completa di Boucher*, Milan.

Anderson, 1979: Jaynie Anderson, "The Giorgionesque Portrait: from Likeness to Allegory," in *Giorgione: Atti del Convegno Internazionale di studi per il 5° centenario della nascita* [1978], Venice, pp. 153–70.

Anderson, 1997: Jaynie Anderson, *Giorgione: The Painter of "Poetic Brevity,"* Paris and New York.

Angelis, 1974: Rita de Angelis, *L'opera pittorica completa di Goya*, Milan.

Angulo Iñiguez, 1971: Diego Angulo Iñiguez, *Pintura del siglo XVII. Ars Hispaniae*, vol. 15, Madrid.

Antal, 1962: Frederick Antal, *Hogarth and His Place in European Art*, London.

Arisi, 1961: Ferdinando Arisi, *Gian Paolo Panini*, Piacenza.

Arisi, 1986: Ferdinando Arisi, *Gian Paolo Panini e i fasti della Roma del '700*, Rome.

Ayres, 1992: Linda Ayres, ed., *"The Spirit of Genius": Art at the Wadsworth Atheneum*, New York.

Askew, 1969: Pamela Askew, "The Angelic Consloation of St. Francis of Assisi in Post-Tridentine Italian Painting," *Journal of the Warburg and Courtauld Institutes*, vol. 32, pp. 280–306.

Baker, 1994: Christopher Baker, *Canaletto*, London.

Baldinucci, 1681/1728: Filippo Baldinucci, *Notizie de' professori del disegno da Cimabue in qua*, 6 vols. (Florence, 1681–1728); 4 vols., ed. Ferdinando Ranalli (Florence, 1845–7).

Ballarin, 1994–5: Alessandro Ballarin, *Dosso Dossi : La pittura a Ferrara negli anni del Ducato di Alfonso I*, [Register of documents by Alessanda Pattanaro; catalogue by Vittoria Romani], 2 vols., Cittadella.

Ballarin, 1995: Alessandro Ballarin, *Jacopo Bassano I. Scritti 1964–1995*, ed. Vittoria Romano, 2 vols, Padua.

Ballarin, 1996: Alessandro Ballarin, *Jacopo Bassano II. Tavole*, 3 vols., Padua, 1996.

Barcham, 1996: William L. Barcham, "Giandomenico Tiepolo," in *Dictionary of Art*, vol. 30, pp. 863–4.

Barclay, 2000: Marion H. Barclay, "Piero di Cosimo's 'Vulcan and Aeolus' and 'The Finding of Vulcan on the Island of Lemnos' Reunited". Part II. "Materials and Technique of Piero di Cosimo's 'Vulcan and Aeolus,'" *National Gallery of Canada Review*, vol. 1, pp. 66–75.

Baticle, 1978: Jeannine Baticle, "Les Amis 'norteños' de Goya en Andalousie. Ceán Bermúdez, Sebastián Martínez," in *Actas del XXIII congreso international de historia del arte, España entre el Mediterráneo y el Atlántico, Granada, 1973*. 3 vols. Granada: Universidad de Granada, 3, pp. 15–30.

Baticle, 1987: Jeannine Baticle, *Zurbarán*, Metropolitan Museum of Art, New York.

Bean, 1995: Thomas Bean, "Richard Ford as Picture Collector and Patron in Spain," *The Burlington Magazine*, vol. 137, pp. 96–107.

Bédat, 1989: Claude Bédat, *La Real Academia de Bellas Artes de San Fernando (1744–1808)*, Madrid.

Bergström, 1956: Ingmar Bergström, *Dutch Still-Life Painting in the Seventeenth Century*, London.

Bergström, 1970: Ingvar Bergstrom, *Maestros españoles de bodegones y floreros del siglo XVII* (trans. Matica Goulard de Westberg), Madrid.

Bermingham, 1986: Ann Bermingham, *Landscape and Ideology: the English rustic tradition, 1740–1860*, Berkeley.

Berra, 1996: Giacomo Berra, "Arcimboldi e Caravaggio: 'diligenza' e 'patienza' nella natura morta arcaica," *Paragone*, vol. 47, pp. 108–161.

Bertini, 1987: Giuseppe Bertini, *La Galleria del Duca di Parma: storia di una collezione*, Bologna.

Bibliotheca sanctorum 1960–70: *Bibliotheca sanctorum*, 12 vols., Rome.

Biesboer, 1995: Pieter Biesboer, "Topographical Identifications for a Number of "Haerlempjes" by Jacob van Ruisdael," in *Shop Talk, Studies in Honor of Seymour Slive, presented on His Seventy-Fifth Birthday*, Cambridge, Mass.

Biesboer, 2001: Pieter Biesboer, *Collections of Paintings in Haarlem, 1572–1745*, ed. Carol Togneri, Los Angeles.

Bissell, 1981: R. Ward Bissell, *Orazio Gentileschi and the Poetic Tradition in Caravaggesque Painting*, University Park and London.

Bissell, 1999: R. Ward Bissell, *Artemisia Gentileschi and the Authority of Art: Critical Reading and Catalogue Raisonné*, University Park.

Blanc, 1857–8: Charles Blanc, *Les trésors de la curiosité tire des catalogues de vente . . .* (5 vols.), Paris.

Blankert and Slatkes, eds., 1987; Albert Blankert and Leonard J. Slatkes, eds., *Holländische Malerei in neuem Licht, Hendrick ter Brugghen und seine Zeitgenossen*, exh. cat. Braunschweig, Herzog Anton Ulrich-Museum.

Bloch, 1953: Vitale Bloch, "The Le Nains, on the Occasion of the Exhibition at Reims," *Burlingon Magazine*, vol. XCV, pp. 366–7.

Blunt, 1946: Anthony Blunt, "Some Portraits by Simon Vouet," *The Burlington Magazine*, vol. LXXXVIII, pp. 268–71.

Blunt, 1978: Anthony Blunt, "The Le Nain Exhibition at the Grand Palais, Paris: 'Le Nain Problems,'" (review), *The Burlington Magazine*, vol. CXX, pp. 870–5.

Blunt, 1982: Anthony Blunt, (note to review by J.P. Cuzin), *The Burlington Magazine*, August, p. 530.

Boccardo, 1995: Piero Boccardo, "Bernardo Strozzi [exh. rev.]," *The Burlington Magazine*, vol. 137, pp. 868–70.

Bode and Binder, 1914: W. von Bode and M. J. Binder, *Frans Hals: sein Leben und seine Werke*, Berlin.

Bologna, 1980: Ferdinando Bologna, *Gaspare Traversi nell' illuminismo europeo*, Naples.

Bonsi, 1767: Bonso Pio Bonsi, *Il trionfo delle Bell'Arti In occasione, che gli Accademici del Disegno . . . fanno la solenne mostra delle Opere antiche di più eccellenti Artefici nella propria Cappella, e nel Chiostro secondo de' PP. della SS. Nunziata in Firenze l'anno 1767*, Florence.

Borenius, 1938: Tancred Borenius, "An Allegorical Portrait by Valdés Leal," *The Burlington Magazine*, vol. 73, pp. 146–51.

Borghini, 1584: Raffaele Borghini, *Il Riposo*, Venice.

Borroni Salvadori, 1974: Fabia Borroni Salvadori, "Le esposizioni d'arte a Firenze dal 1674 al 1767," *Mitteilungen des Kunsthistorischen Institutes in Florenz*, vol. 18, pp. 1–166.

Borys, 2001: Stephen D. Borys, "Giuseppe Maria Crespi's *Allegory of the Arts* Rediscovered," *National Gallery of Canada Review*, vol. 2, pp. 1–80.

Bowron, 1996: Edgar Peters Bowron, "[Canaletto's] *The Square of Saint Mark's, Venice*, and *Entrance to the Grand Canal from the Molo, Venice*," in De Grazia and Garberson, pp. 24–31.

Brejon and Cuzin, 1974: Arnauld Brejon de Lavergnée and Jean-Pierre Cuzin, *"Vouet" in Valentin et les caravagesques français*, Paris, Grand Palais, Rome, Accademia di Francia, Villa Medici

Brenneman, 1997: David A. Brenneman, "Thomas Gainsborough and the picturesque sketch," *Word and Image*, vol. 13, no. 4, pp. 392–404.

Brookner, 1972: Anita Brookner, *Greuze: The Rise and Fall of an Eighteenth-Century Phenomenon*, Greenwich, Connecticut.

Brown, 1974: Jonathan Brown, *Francisco de Zurbarán*, New York.

Brown, 1991: Jonathan Brown, *The Golden Age of Painting in Spain*, New Haven and London.

Brown, 1998: Jonathan Brown, *Painting in Spain 1500–1700*, New Haven and London.

Brunel, 1986: Georges Brunel, *Boucher*, Paris.

Buckley, 1953: C.E. Buckley, "An Eighteenth Century English Painting," *Wadsworth Atheneum Bulletin*, series 2, no. 40, April.

Byam Shaw, 1996: James Byam Shaw, "Francesco Guardi," in *Dictionary of Art*, vol. 13, pp. 742–6.

Cadogan and Mahoney, 1991: Jean K. Cadogan and Michael R. T. Mahoney, *Wadsworth Atheneum Paintings II: Italy and Spain, Fourteenth through Nineteenth Centuries*, Hartford.

Camón Aznar, 1980–2: José Camón Aznar, *Francisco de Goya*, 4 vols., Zaragoza, Instituto Camón Aznar.

Canellas López, 1981: Ángel Canallas Lopez, ed., *Diplomatario de Francisco de Goya*, Zaragoza: Institución Fernando El Católico.

Cantelli, 1983: Giuseppe Cantelli, *Repertorio della pittura fiorentina del Seicento*, Florence.

Cappelletti, 1996: Francesca Cappelletti, "Lelio Orsi," in *Dictionary of Art*, vol. 23, pp. 573–5.

Cardi, 1628: Giovanni Battista Cardi, *Vita del Cigoli* [1628], ed. Guido Battelli and Kurt Heinrich Busse, San Miniato, 1913.

Caturla, 1994: María Luisa Caturla, *Francisco de Zurbarán*, trans. Odile Delenda, Paris.

Cean Bermúdez, 1880: Juan AntonioCean Bermudez, *Diccionario histórico de los más ilustres profesores de las Bellas Artes en España*, 6 vols., Madrid, Real Academia de San Fernando.

Chappell, 1981: Miles L. Chappell, "Missing Pictures by Lodovico Cigoli. Some Problematical Works and Some Proposals in Preparation for a Catalogue," *Paragone*, vol. 31 (no. 373), pp. 54–104.

Chappell, 1996: Miles L. Chappell, "Lodovico Cigoli," in *Dictionary of Art*, vol. 7, pp. 310–14.

Chastel, 1995: André Chastel, *L'Art français, III, Ancien régime 1620–1775*, Paris.

Cherry, 1999: Peter Cherry, *Arte y naturaleza. El Bodegón Español en el siglo de oro*, Madrid.

Civai, 1990: Allesandra Civai, *Dipinti e sculture in casa Martelli. Storia di una collezione patrizia fiorentina dal Quattrocento all'Ottocento*, Florence.

Cohen, 1995: Ronald Cohen, "Jusepe (or Gioseppe) de Ribera: An Alternate View." *Storia dell'arte*, 85, pp. 445–58.

Collezioni private bergamasche, 1980: *Collezioni private bergamasche: Monumenta Bergomensia LV*, ed. Banca Provinciale Lombarda, 4 vols.

Constable, 1989: W. G. Constable, *Canaletto: Giovanni Antonio Canaletto, 1697–1768*, 2nd ed. revised by J.G. Links, Oxford.

Contini, 2002: Roberto Contini, *The Thyssen–Bornemisza Collection: Seventeenth and Eighteenth Century Italian Painting*, London.

Crelly, 1962: William R. Crelly, *The Painting of Simon Vouet*, New Haven and London.

Cruz Valdovinos, 1989: José Manuel Cruz Valdovinos, "Inquisidores e ilustrados: Las pinturas y estampas 'indecentes' de Sebastián Martínez," in *El Arte en tiempo de Carlos III*, pp. 311–19, Madrid.

Cruz y Bahamonde, 1813: Nicolás de la Cruz y Bahamonde, *Viage de España, Francia e Italia*, 14 vols., Madrid.

Cummings and Staley, 1968: Frederick J. Cummins, Allen Staley and Robert Rosenblum, *Romantic Art in Britain; paintings and drawings, 1760–1860*; Falcon Press.

Cunningham, 1951; Charles C. Cunningham, "Saint Serapion by Francesco de Zurbarán." *Wadsworth Atheneum Bulletin*, October, p. 1.

Cuzin, 1978: Jean-Pierre Cuzin, "A Hypothesis Concerning the Le Nain Brothers," *The Burlington Magazine*, vol. CXX, pp. 875–6.

Cuzin, 1979: Jean-Pierre Cuzin, "Les Frères Le Nain : la part de Mathieu," *Paragone*, 349–351, pp. 58–70.

Cuzin, 1982: Jean-Pierre Cuzin, "New York. French Seventeenth Century Paintings from American Collections," (review) *The Burlington Magazine*, vol. CXXIV, pp. 526–30.

Dandelet, 2001: Thomas James Dandelet, *Spanish Rome, 1500–1700*, New Haven and London.

de Bosque, 1985: Andrée de Bosque, *Mythologie et Maniérisme: Italie, Bavière, Fontainebleau, Prague, Pays Bas, Peinture et Dessins*, Paris.

de Mirimonde, 1964/5: A.P. de Mirimonde, "Une Nature morte allégorique de Balthasar van der Ast," *La Revue du Louvre et des Musées de France*, 3–4.

de Nolhac, 1907: Pierre de Nolhac *François Boucher, premier peintre du roi*, Paris.

Desparmet Fitz-Gerald, 1928: Xavière Desparmet Fitz-Gerald, *L'oeuvre peint de Goya: catalogue raisonné*, Paris.

De Grazia and Garberson, 1996: Diane De Grazia and Eric Garberson, *The Collections of the National Gallery of Art Systematic Catalogue: Italian Paintings of the Seventeenth and Eighteenth Centuries*, Washington, D.C.

Dictionary of Art, 1996: *The Dictionary of Art*, ed. Jane Turner, 34 vols., London.

Dillenberger and Taylor, 1972: Jane Dillenbergber and Joshua C. Taylor, *The Hand and the Spirit, Religious Art in America, 1700–1900*, Berkeley.

Dillenberger, 1977: John Dillenberger, *Benjamin West: The Context of his Life's Work with Particular Attention to Paintings with Religious Subject Matter*, San Antonio, Texas.

Dillon, 1905: Edward Dillon, *Claude*, London.

Dominici, 1742–5: Bernardo de' Dominici, *Vite de' pittori, scultori ed architetetti napoletani*, 3 vols., Naples. Reprinted, Bologna, 1971.

Döring, 1987: Thomas Döring, "Caravaggeske Aspekte im Werk Johannes van Bronchorsts," in Döring, 1993: Thomas Döring, *Studien zur Künstlerfamilie van Bronchorst*, Alfter.

Döring, 2000; Thomas Döring, "Johannes (Jansz.) van Bronchorst," in *Dictionary of Art*, vol. 4, pp. 846–7.

Dorival, 1946: Bernard Dorival, *La Peinture française*, Paris.

Dorival, 1953: Bernard Dorival, "Expression littéraire et expression picturale du sentiment de la nature au XVIIe siècle français," *La Revue des Arts*, no. 1, Paris, pp. 45–52.

Dullea, 1887: Owen J. Dullea, *Claude Gellée*, London.

Egerton, 1990: Judy Egerton, *Joseph Wright of Derby, 1734–1797*, Tate Gallery, London.

Ekserdjian, 1997: David Ekserdjian, *Correggio*, New Haven and London.

Emiliani, 1990: Andrea Emiliani, ed., *Giuseppe Maria Crespi, 1665–1747*, Bologna.

Erffa and Staley, 1986: Helmut von Erffa and Allen Staley, *The Paintings of Benjamin West, with catalogue raisonné*, New Haven.

Evans, 1959: Grose Evans, *Benjamin West and the Taste of his Times*, Carbondale, Illinois.

Fantozzi, 1842: Federico Fantozzi, *Nuova guida, ovvero, Descrizione storico–artistico–critica della città e contorni di Firenze*, Florence.

Farmer, 1997: David Hugh Farmer, *The Oxford Dictionary of Saints*, 4th edition, Oxford and New York.

Fehl, 1992: Philip Fehl, "Tintoretto's Homage to Titian and Pietro Aretino," in *Decorum and Wit: The Poetry of Venetian Painting. Essays in the History of the Classical Tradition*, Vienna.

Félibien, 1688: André Félibien, *Entretiens sur les vies et sur les ouvrages des plus excellens peintres anciens et modernes*, 5 vols., Paris, (reprint ed.: Minkoff Reprints, Geneva, 1972.)

Felton and Jordan, 1982: Craig M. Felton and William B. Jordan, *Jusepe de Ribera, lo Spagnoletto, 1591–1652*, exh. cat., Fort Worth, Kimbell Art Museum.

Felton, 1969: Craig M. Felton, "The Earliest Paintings of Jusepe de Ribera," *Wadsworth Atheneum Bulletin*, 5, pp. 2–29.

Felton, 1976: Craig M. Felton, "More Early Paintings by Jusepe de Ribera," *Storia dell'Arte*, 26, pp. 31–43.

Felton, 1991: Craig M. Felton, "Ribera's Early Years in Italy: the *Martyrdom of St. Lawrence* and the *Five Senses*," *The Burlington Magazine*, 133, pp. 71–81.

Fermor, 1993: Sharon Fermor, *Piero di Cosimo. Fiction, Invention, and Fantasia*, London.

Fernández de Moratín, 1968: Leandro Fernández de Moratín, *Diario (mayo 1780–marzo 1808) de Leandro Fernández de Moratín*, ed. René and Mireille Andioc, Madrid.

Fernández Rojas, 2000: Mathilde Fernandez Rojas, *El Convento de la Merced Calzada de Sevilla*, Seville.

Ferrara, 1933: *Catalogo della esposizione della pittura ferrarese del rinascimento*, Palazzo dei Diamanti, Ferrara.

Ferrari and Scavizzi, 1966: Oreste Ferrari and Giuseppe Scavizzi, *Luca Giordano*, 3 vols., Naples.

Ferrari and Scavizzi, 1992: Oreste Ferrari and Giuseppe Scavizzi, *Luca Giordano. L'opera completa*, 2 vols., Naples.

Fierens, 1933: Paul Fierens, *Les Le Nain*, Paris.

Fierens, 1957: Paul Fierens, "La vie paysanne au XVIIe siècle. Louis Le Nain," *Le Jardin des Arts*, no. 33, July, pp. 547–54.

Forlani Tempesti and Capretti, 1996: Anna Forlani Tempesti and Elena Capretti, *Piero di Cosimo*, Florence.

Forte, 1982: Joseph C. Forte, "In Detail: Claude Lorraine's 'St. George and the Dragon,'" *Portfolio*, IV, no. 5, pp. 96–101.

Franklin, 2000: David Franklin, "Piero di Cosimo's *Vulcan and Aeolus* and *The Finding of Vulcan on the Island of Lemnos* Reunited. Part I. A Historical

Perspective," *National Gallery of Canada Review*, vol. 1, pp. 53–65.

Frati and Gregori, 1973; Tiziana Frati and Mina Gregori, *L'opera completa di Zurbarán*, Milan.

Fried, 1980: Michael Fried, *Absorption and Theatricality: Painting and Beholder in the Age of Diderot*, Berkeley and Los Angeles.

Garberson, 1996: Eric Garberson, "Francesco Guardi," in De Grazia and Garberson, pp. 120–121.

Gállego, 1968: Julián Gállego, *Vision et symboles dans la peinture espagnole du siécle d'or*, Paris.

Gállego and Gudiol, 1977: Julián Gallego and José Guidol, *Zurbarán, 1598–1664*, New York.

Gallo, 1997: Marco Gallo, *Orazio Borgianni pittore romano (1574–1616) e Francisco de Castro, conte di Castro*, Rome.

Galt, 1820: John Galt, *The Life Studies and Works of Benjamin West, Esq.*, London.

Gash, 1996: John Gash, "Michelangelo Merisi da Caravaggio," in *Dictionary of Art*, vol. 5, pp. 707–22.

Gassier and Wilson, 1971: Pierre Gassier and Juliet Wilson, *Goya. His Life and Work with a catalogue raisonné of the paintings, drawings and engravings*, New York.

Gaya Nuño, 1958: Juan Antonio Gaya Nuño, *La pintura española fuera de España*, Madrid.

Geronimus, 2000: Dennis Geronimus, "The Birth Date, Early Life, and Career of Piero di Cosimo," *The Art Bulletin*, vol. 82, March, pp. 164–170.

Gilbert, 1995: Creighton Gilbert, *Caravaggio and His Two Cardinals*, University Park.

Ginori Lisci, 1972: Leonardo Ginori Lisci, *I palazzi di Firenze nella storia e nell'arte*, 2 vols., Florence.

Glendinning, 1989: Nigel Glendinning, "Nineteenth-century British Envoys in Spain and the Taste for Spanish Art in England," *The Burlington Magazine*, vol. 131, pp. 117–26.

Glendinning, 1994: Nigel Glendinning, "Spanish Inventory References to Paintings by Goya, 1800–1850: Originals, Copies and Valuations," *The Burlington Magazine*, vol. 126, pp. 100–10.

Glück, 1931: G. Glück, *Van Dyck, des Meisters Gemälde*, Stuttgart, 1931.

Gómez Ímaz, 1896: Manuel Gomez Imaz, *Inventario de los cuadros sustraidos por el gobierno intruso en Sevilla en el año de 1810*, 1896 (ed. of 1917, Seville)

De Goncourt, nd: Edmond and Jules de Goncourt, *L'Art du dix-huitieme siecle*, Paris.

González de León, 1844: Felix Gonzalez de Leon, *Noticia artística, histórica y curiosa de todos los edificios públicos, sagrados y profanos de esta muy noble, muy leal, muy heroica, e invicta Ciudad de Sevilla y de muchas casas particulares; con todo lo que les sirve de adorno artístico, antigüedades, inscripciones y curiosidades que contienen. 2 vols., Seville.

Grimm, 1972: Claus Grimm, *Frans Hals*, Berlin.

Grimm, 1990: Claus Grimm, *Frans Hals: The Complete Work*, New York.

Griseri, 1961: Andreina Griseri, "La période romaine de Vouet : deux tableaux inédis," *Art de France*, I, pp. 322–5.

Gudiol, 1970: Josep Gudiol i Ricart, *Goya, 1746–1828*, 4 vols., Barcelona.

Guinard, 1947: Paul Guinard, "Los conjuntos dispersos o desaparecidos de Zurbarán. Anotaciones á Cean Bermúdez (II)," *Archivo español de arte 20*, pp. 161–201.

Guinard, 1960: Paul Guinard, *Zurbarán et les peintres espagnols de la vie monastique*, Paris.

Haak, 1984: Bob Haak, *The Golden Age, Dutch Painters of the Seventeenth Century*, trans. by Elizabeth Willems-Treeman, New York.

Hall, 1979: James Hall, *Dictionary of Subjects & Symbols in Art*, rev. ed., New York.

Harris, 1996: Ann Sutherland Harris, "Orazio Gentileschi," in *Dictionary of Art*, vol. 12, pp. 304–6.

Harting, 1996: Ursula Harting, "Cabinet picture, 2: Picture of Collections," in *Dictionary of Art*, vol. 5, pp. 352–4.

Hartt, 1987: Frederick Hartt, *History of Italian Reniassance Art: Painting, Sculpture, and Architecture*, 3rd ed., New York.

Haverkamp-Begemann, 1978: *Wadsworth Atheneum Paintings, Catalogue I, The Netherlands and the German-speaking Countries, Fifteenth–Nineteenth Centuries*, Hartford.

Hayes, 1982: John Hayes, *The Landscape Paintings of Thomas Gainsborough*

Heimbürger Ravalli, 1982: Mina Heimbürger Ravalli, "Data on the life and work of Gaspare Giovanni Traversi (1722?–1770)," *Paragone*, vol. 32, pp. 15–42.

Hibbard, 1983: Howard Hibbard, *Caravaggio*, New York.

Hirst, 1981: Michael Hirst, *Sebastiano del Piombo*, Oxford.

Hoet, 1752: G. Hoet, *Catalogus of Naamlijst van schilderyen . . . in het openbaar verkogt*, 2 vols., The Hague.

Hofstede de Groot, 1910: Cornelis Hofstede de Groot, *Beschreibendes...der hervorragendsten holländischen Maler...*, Esslingen.

Jaffé, 1964: M. Jaffé, "The Resurrection of Christ by Anthony van Dyck," *Wadsworth Atheneum Bulletin*, no. 18, Winter, pp. 1–7.

Jean-Richard, 1978: Pierrette Jean-Richard, *L'Oeuvre gravé de François Boucher dans la Collection Edmond de Rothschild*, Paris.

Jestaz, 1994: Bertrand Jestaz, ed., *L'inventaire du palais et des propriétés Farnése à Rome en 1644*, Rome.

Joachim and McCullagh, 1979: Harold Joachim and Suzanne Folds McCullagh, *Italian Drawings in the Art Institute of Chicago*, Chicago and London.

Johns, 1993: Christopher M. S. Johns, *Papal Art and Cultural Politics: Rome in the Age of Clement XI*, Cambridge.

Jordan and Cherry, 1995: William B. Jordan and Peter Cherry, *Spanish Still Life from Velázquez to Goya*, London.

Judson, 1966: J. R. Judson, "Allegory of Dawn and Night," *Wadsworth Atheneum Bulletin*, 6th ser., II, pp. 1–11.

Junquera de Vega, 1965: Paulina Junquera de Vega, "Los libros de coro de la Real Capilla," *Reales sitios 2*, pp. 12–27.

Kiene, 1990: Michael Kiene, "Giovanni Paolo Panninis Expertisen für Marchese Capponi und sein Galeriebild für Kardinal Valenti Gonzaga," *Römisches Jahrbuch der Bibliotheca Hertziana*, vol. 26, pp. 257–301.

Kinkead, 1978: Duncan T. Kinkead, *Juan de Valdés Leal (1622–1690). His Life and Work*, London and New York.

Kitson, 1978: Michael Kitson, *Claude Lorrain: Liber Veritatis*, London.

Klessman, 1987: Rüdiger Klessman, *Hendrick ter Brugghen und die Nachfolger Caravaggios in Holland*, Brunswick.

Knox, 1980: George Knox, *Giambattista and Domenico Tiepolo. A Study and Catalogue Raisonné of the Chalk Drawings*, 2 vols., Oxford.

Konečný, 1973: Lubomír Konečný, "Another 'Postilla' to the *Five Senses* by Jusepe de Ribera," *Paragone*, no. 285, pp. 85–92.

Kornhauser, 1996: Elizabeth Mankin Kornhauser, *American Paintings Before 1945 in the Wadsworth Atheneum*, New Haven and London.

Kren, 1979: Thomas John Kren, "Jan Miel (1599–1664), A Flemish Painter in Rome," 3 vols., Ph.D. diss., Yale University, New Haven, Conn.

Kubler and Soria, 1959: George Kubler and Martin S. Soria, *Art and Architecture in Spain and Portugal and Their American Dominions, 1500 to 1800*, Baltimore.

Labò, 1942: M. Labò, "Valerio Castello," *Emporium*, vol. 96, pp. 368–78.

Lalande, 1769: Joseph Jérome Lalande, *Voyage d'un françois en Italie, fait dans les années 1765 & 1766*, Paris.

La natura morta in Italia, 1989: ed. Francesco Porzio, 2 vols., Milan.

Langdon, 1996: Helen Langdon, "Salvator Rosa," in *Dictionary of Art*, vol. 27, pp. 149–55.

Langdon, 1998: Helen Langdon, *Caravaggio: A Life*, London.

Lanzi, 1847: Luigi Lanzi, *The History of Painting in Italy: From the Period of Revival of the Fine Arts to the End of the Eighteenth Century*, trans. by Thomas Roscoe, 3 vols., London.

Larsen, 1962: Erik Larsen, *Frans Post: Interprète du Brésil*, Amsterdam and Rio de Janeiro.

Larsen, 1980: Erik Larsen, *L'opera completa di Van Dyck, 1626–1641*, Milan.

Larsen, 1988: Erik Larsen, *The Paintings of Anthony van Dyck*, 2 vols., Freren.

Laskin and Pantazzi, 1987: Myron Laskin, Jr., and Michael Pantazzi, eds., *Catalogue of the National Gallery of Canada: European and American Painting, Sculpture, and Decorative Arts*, 2 vols., Ottawa.

Laureati, 2001: Laura Laureati, "Painting Nature: Fruit, Flowers and Vegetables," in London–Rome, 2001, pp. 68–87.

Lavin, 1975: Marilyn Aronberg Lavin, *Seventeenth-Century Barberini Documents and Inventories of Art*, New York.

Lee, 2001: Simon Lee, "Goya's *Santa Cueva* Revisted," *Apollo*, 154, pp. 3–10.

Leuschner, 1994: Eckhard Leuschner, "The Pythagorean Inscription on Rosa's London 'Self-Portrait,'" *Journal of the Warburg and Courtauld Institutes*, vol. 57, pp. 278–83.

Levey, 1971: Michael Levey, *National Gallery Catalogues: The Seventeenth and Eighteenth Century Italian Schools*, London.

Levine and Mai, 1991: David A. Levine, Ekkehard Mai, et al., *Bamboccianti, Niederländische Malerrebellen im Rom des Barock* (exh. cat., Wallraf Richartz Museum, Cologne and Centraal Museum, Utrecht), Cologne and Milan.

Links, 1994: J. G. Links, *Canaletto*, 2nd ed., London.

Links, 1998: J. G. Links, *The Soane Canalettos*, London.

Longhi, 1927: Roberto Longhi, "Di Gaspare Traversi," *Vita artistica*, pp. 145–67.

Longhi, 1966: Roberto Longhi, "I *Cinque sensi* del Ribera," *Paragone*, no. 193, pp. 74–8.

Lorizzo, 2001: Loredana Lorizzo, "Cardinal Ascanio Filomarino's purchases of works of art in Rome: Poussin, Caravaggio, Vouet, and Valentin," *The Burlington Magazine*, vol. 143, pp. 404–11.

Lucco, 1998: Mauro Lucco, "Battista Dossi and Sebastiano Filippi," in *Dosso's Fate: Painting and Court Culture in Renaissance Italy*, ed. Luisa Ciammitti, Steven F. Ostrow, and Salvatore Settis, Los Angeles.

Lukehart, 1998: Peter M. Lukehart, "A Paradoxical Priest: Bernardo Strozzi (1581/82–1644)," *Elvehjem Museum of Art Bulletin/ Biennial Report 1995–97*, pp. 7–24.

Luna and Moreno de las Heras, 1996: Juan J. Luna and Margarita Moreno de las Heras, *Goya: 250 Aniversario*, Madrid, Museo del Prado.

MacFall, 1908: Haldane MacFall, *Boucher, The Man, His Times, His Art, and His Significance, 1703–1770*, London.

MacGregor, 1996: Neil MacGregor, entry on "Le Nain," in *Dictionary of Art*, vol. 19, pp. 146–50.

Mahon, 1937: Denis Mahon, "Notes on the Young Guercino. II—Cento and Ferrara," *The Burlington Magazine*, vol. 70, pp. 176–189.

Mahon, 1958: Denis Mahon, "An Attribution Re-studied: Sisto Badalocchio's 'Holy Family'," *Wadsworth Atheneum Bulletin*, pp. 1–4.

Mallory, 1985: Nina Ayala Mallory, "Luis Meléndez: Pintor de bodegones del siglo XVIII," *Goya*, 186, pp. 355–60.

Mallory, 1990: Nina Ayala Mallory, *El Greco to Murillo: Spanish Painting in the Golden Age, 1556–1700*, New York.

Mancini, (1614–21) 1956–7: Giulio Mancini, *Considerazioni sulla pittura*, eds. A. Marucchi and L. Salerno, Rome.

Mantz, 1860: Paul Mantz, "Le cabinet de M. A. Dumont à Cambrai," *Gazette des Beaux-Arts*, VIII, pp. 303–13.

Manzitti, 1972: Camillo Manzitti, *Valerio Castello*, Genoa.

Marandel, 1990: J. Patrice Marandel, "A Painter Without Metaphors," *Journal of Art*, vol. 3, December 1990, pp. 16–19.

Mariuz, 1971: Adriano Mariuz, *Giandomenico Tiepolo*, Venice.

Markova, 2000: Vittoria Markova, "Il Pomo del Mistero," *Quadri & Sculture*, vol. 8, pp. 50–61.

Martin and Masson, 1908: Jean Martin and Charles Masson, *Catalogue raisonné de l'oeuvre peint et dessiné de J.-B. Greuze*, Paris.

Matteoli, 1980: Anna Matteoli, *Lodovico Cardi-Cigoli, pittore e architetto: fonti biografiche, catalogo delle opere, documenti, bibliografia, indici analitici*, Pisa, 1980.

Matute y Gaviria, 1887: Justino Matute y Gaviria, "Adiciones y correcciones de D. Justino Matute al tomo IX. del *Viaje de España* de D. Antonio Ponz, aumentadas nuevamente," *Archivo hispalense*, 3, pp. 361–88.

Mauclair, 1926: Camille Mauclair, *Greuze et Son Temps*, Paris.

Mayer, 1923: August L. Mayer, *Francisco de Goya*, Munich.

McCorquodale 1979: Charles McCorquodale, *The Baroque Italian Painters*, London.

Mérot, 1987 and 2000: Alain Mérot, *Eustache Le Sueur (1616–1655)*, Paris, (2nd edition, with additions, 2000).

Merriman, 1980: Mira Pajes Merriman, *Giuseppe Maria Crespi*, Milan.

Milicua, 1952: José Milicua, "El centenario de Ribera: Ribera en Roma, el manuscrito de Mancini," *Archivo Español de Arte*, 25, pp. 309–22.

Mitchell and Roberts, 1996: Paul Mitchell and Lynn Roberts, *Frameworks: Form, Function & Ornament in European Portrait Frames*, London.

Moir, 1994: Alfred Moir, *Anthony van Dyck*, New York.

Morales y Marín, 1994: José Luis Morales y Marín, *Goya. Catálogo de la pintura*. Zaragoza, Real Academia de Nobles y Bellas Artes.

Morassi, 1973: Antonio Morassi, *Antonio e Francesco Guardi*, 2 vols., Venice; reprinted as *Guardi: I dipinti*, 2vols., Venice, 1975 and 1984.

Morassi, 1975: Antonio Morassi, *Guardi: Tutti i disegni di Antonio, Francesco e Giacomo Guardi*, Venice.

Mortari, 1966: Luisa Mortari, *Bernardo Strozzi*, Rome.

Mortari, 1995: Luisa Mortari, *Bernardo Strozzi*, Rome.

Munhall, 2002: Edgar Munhall, *Greuze the Draftsman*, Frick Collection, New York.

Negro and Pirondini, 1995: Emilio Negro and Massimo Pirondini, *La scuola dei Carracci. I seguaci di Annibale e Agostino*, Modena.

Newcome, 1975: Mary Newcome, "The Drawings of Valerio Castello," *Master Drawings*, vol. 13, pp. 26–40.

Newcome, 1978: Mary Newcome, "Valerio Castello: A Genoese Master of the Seicento," *Apollo*, vol. 108, pp. 322–6.

Newcome Schleier, 1997: Mary Newcome Schleier, "Other Drawings by Valerio Castello," in *L'arte del disegno: Christel Theim zum . . . 3. January 1997*, ed. Gunther Thiem, Munich, pp. 145–52.

Nichols, 1996: Tom Nichols, "Jacopo Tintoretto," in *Dictionary of Art*, vol. 31, pp. 5–18.

Nichols, 1999: Tom Nichols, *Tintoretto: Tradition and Identity*, London.

Nicolson, 1968: Benedict Nicolson, *Joseph Wright of Derby: Painter of Light*, London and New York.

Nordström, 1959: Folke Nordström, "The Crown of Life and the Crown of Vanity. Two Companion Pieces by Valdes Leal," *Figura*, n.s. 1, pp. 127–37.

Novelli, 1964: Maria Angela Novelli, *Lo Scarsellino*, Bologna.

Olsen, 1951: Harald Olsen, "Et Malet galleri af Pannini: Kardinal Silvio Valenti Gonzagas samling," *Kunstmusseets Aarsskrift*, vol. 38, pp. 90–103.

Opperman, 1979: Hal N. Opperman, "review of Greuze exhibition," *Eighteenth Century Studies*, XII, no. 3, Spring.

Ottani Cavina, 1968: Anna Ottani Cavina, *Carlo Saraceni*, Milan.

Owen and Brown, 1988: Felicity Owen and David Blayney Brown, *Collector of Genius: A Life of Sir George Beaumont*, New Haven and London.

Pallucchini and Rossi, 1982: Rodolfo Pallucchini and Paola Rossi, *Tintoretto: Le opere sacre e profane*, 2 vols., Milan, 1982; reprinted, 1990.

Panofsky, 1937: Erwin Panofsky, "The Early History of Man in a Series of Paintings by Piero di Cosimo," *Journal of the Warburg and Courtauld Institutes*, vol. 1, pp. 19–28.

Panofsky, 1939: Erwin Panofsky, "The Early History of Man in Two Cycles of Paintings by Piero di Cosimo," in *Studies in Iconology*, Oxford, pp. 33–67.

Pansecchi, 1989–90: Fiorella Pansecchi, "Domenico Corvi, l'apparato della Basilica Vaticana del 1767 e San Giuseppe Calasanzio," *Prospettiva*, vols. 57–60, pp. 340–45.

Paoletti, 1968: John Paoletti, "The Italian School: Problems and Suggestions," *Apollo*, 88, pp. 420–9.

Papi, 2002: Gianni Papi, "Jusepe de Ribera a Roma e il Maestro del Giudizio di Salomone," *Paragone*, no. 44, 21–43.

Parker, 1948: Karl T. Parker, *The Drawings of Antonio Canaletto in the Collection of His Majesty the King at Windsor Castle*, London.

Peladan, 1912: J. Peladan, *Frans Hals*, Paris.

Pemán, 1949: César Peman, "Nuevas pinturas de Zurbarán en Inglaterra." *Archivo español de arte*, 22, pp. 207–13.

Pemán, 1978: Medina, María Pemán, "La Colección artística de Don Sebastián Martínez el amigo de Goya," *Archivo español de arte*, 51, pp. 53–72.

Pemán, 1992: Medina, María Pemán, "Estampas y libros que vió Goya en casa de Sebastián Martínez," *Archivo español de arte*, 65, pp. 304–20.

Percy, 1996: Ann Percy, "Bernardo Cavallino," in *Dictionary of Art*, vol. 6, pp. 107–10.

Pérez Sánchez and Spinosa, 1978: Alfonso E. Pérez Sanchez and Nicola Spinosa, *L'opera completa del Ribera*, Milan.

Pérez Sánchez and Spinosa, 1992: Alfonso E. Pérez Sánchez and Nicola Spinosa, *Jusepe de Ribera, 1591–1652*, Metropolitan Museum of Art, New York.

Ponz, 1794: Antonio Ponz, *Viage de España*, 18 vols., Madrid.

Priem, 1997: Ruud Priem, "The 'most excellent collection' of Lucretia Johanna van Winter; the years 1809–22, with a catalogue of the works purchased," *Simiolus* 25, no. 2/3.

Puglisi, 1998: Catherine Puglisi, *Caravaggio*, London.

Rave, 2003: A.B. Rave, *Gaspare Traversi*, Stuttgart.

Repetti, 1841: Emanuele Repetti, *Notizie e guida di Firenze e de' suoi contorni*, Florence.

Reynolds, 1789: Joshua Reynolds, *A Discourse, delivered to the Students of the Royal Academy on the Distribution of the Prized, 10th December 1788 by the President*, London.

Ripa, 1603: Cesare Ripa, *Iconologia*, Rome, 1603.

Rivers, 1912: J. Rivers, *Greuze and His Models*, London

Roethlisberger, 1961: Marcel Roethlisberger, *Claude Lorrain, The Paintings: Critical Catalogue*, New Haven.

Roethlisberger, 1975: Marcel Roethlisberger, *Tout l'œuvre peint de Claude Lorrain*, Milan (repr. Paris, 1977).

Roethlisberger, 1993: Marcel G. Roethlisberger, *Abraham Bloemaert and His Sons, Paintings and Prints*, biographies and documents by Marten Jan Bok, 2 vols., Doornspijk, The Netherlands.

Rosenblum, 1960: Robert Rosenblum, "Wright of Derby: Gothick Realist," *Art News*, LIX, no. 1, March.

Rosenberg, 1964: Pierre Rosenberg, "Quelques tableau inédits du XVIIe siècle français par Jacques Stella, Charles Mellin, Jean Tassel et Sébastien Bourdon," *Art de France*, IV, pp. 297–9.

Rosenberg, 1979: Pierre Rosenberg, "L'exposition Le Nain : une proposition," *Revue de l'Art*, 43, pp. 91–100.

Rosenberg, 1984: Pierre Rosenberg, "France in the Golden Age: A Postscript," *The Metropolitan Museum Journal*, vol. 17, pp. 23–46.

Rosenberg, 1993: Pierre Rosenberg, Tout l'œuvre peint des Le Nain, Paris.

Rosenthal, 1999: Michael Rosenthal, *The Art of Thomas Gainsborough*, The Paul Mellon Centre for Studies in British Art, New Haven and London.

Rowlands, 1996: Eliot W. Rowlands, *The Collections of The Nelson-Atkins Museum of Art: Italian Paintings 1300–1800*, Kansas City.

Roworth, 1989: Wendy Wassyng Roworth, "Salvator Rosa's Self-Portraits: Some Problems of Identity and Meaning," *The Seventeenth Century*, vol. 4, pp. 117–47.

Rudolph, 1982: Stella Rudolph, "Primato di Domenico Corvi nella Roma del secondo Settecento," *Labyrinthos*, vol. 1, pp. 1–45.

Rudolph, 1984: Stella Rudolph, *La pittura del '700 a Roma*, Milan.

Ruggeri, 1996: Ugo Ruggeri, "Scarsellino," in *Dictionary of Art*, vol. 28, pp. 38–9.

Sack, 1910: Eduard Sack, *Giambattista und Domenico Tiepolo, ihr Leben und ihre Werke; ein Beitrag zur Kunstgeschichte des achtzehnten Jahrhunderts*, Hamburg.

Salerno, 1963: Luigi Salerno, *Salvator Rosa*, Milan.

Salmon, 2000: Xavier Salmon, "Le portrait de la duchesse de Polignac: un nouveau chef-d'oeuvre de Madame Vigée Le Brun entre dans les collections du château de Versailles," in exh. cat. Versailles, Musée national du Château, *Château de Versailles, deux acquisitions exceptionnelles*, Versailles.

Sambricio, 1946: Valentín de Sambricio, *Tapices de Goya*, Madrid.

Sánchez Cantón, 1922: Francisco Javier Sanchez Canton, "La vida de San Pedro Nolasco: Pinturas del claustro del refectorio de la Merced Calzada de Sevilla." *La Merced*, 5/42 (January 24, 1922), pp. 209–16.

Sapin, 1986: Marguerite Sapin, "Précisions sur l'histoire de quelques tableaux d'Eustache Le Sueur," *B.S.H.A.F.*, pp. 53–88.

Schleier, 1968: Erich Schleier, "Una postilla per i 'Cinque sensi' del giovane Ribera," *Paragone*, no. 223, pp. 79–80.

Schloss, 1982: Christine S. Schloss, *Travel, Trade, and Temptation. The Dutch Italianate Harbor Scene, 1640–1680*, Ann Arbor, Michigan.

Scott, 1995: Jonathan Scott, *Salvator Rosa. His Life and Times*, New Haven and London.

Seelig, 1997: Gero Seelig, *Abraham Bloemaert (1566–1651), Studien zur Utrechter Malerei um 1620*, Berlin.

Sheard, 1994: Wendy Stedman Sheard, "Le Siècle de Titien [exh. rev.]," *Art Journal*, vol. 53, Spring, pp. 87–89.

Sick, 1929: Ilse von Sick, *Nicolaes Berchem, ein Vorläufer des Rokoko*, Cologne.

Simo, 1988: Melanie Louise Simo, *London and the Landscape: From Country Seat to Metropolis*, New Haven and London.

Slive, 1958: Seymour Slive, " Frans Hals' 'Portrait of Joseph Coymans,'" *Wadsworth Atheneum Bulletin*, Winter, pp. 12–23.

Slive, 1970 and 1974: Seymour Slive, Frans Hals, London, 3 vols.

Slive, 1987: Seymour Slive, "Dutch pictures in the collection of Cardinal Silvio Valenti Gonzaga (1690–1756)," *Simiolus*, vol. 17, pp. 169–190.

Slive, 2001: Seymour Slive, *Jacob van Ruisdael, A Complete Catalogue of his Paintings, Drawings and Etchings*, New Haven and London.

Sluijter-Seijffert, 1984: Nicolette C. Sluijter-Seijffert, *Cornelis van Poelenburch (ca. 1593–1667)*, diss. Leiden.

Smith, 1837: John Smith, *A Catalogue Raisonné of the Most Eminent ... Painters*, vol. VIII, London.

Soprani, 1674: Raffaele Soprani, *Le vite de' pittori, scultori ed architetti genovesi*, Genoa.

Soprani-Ratti, 1768: Raffaele Soprani, *Le vite de' pittori, scultori ed architetti genovesi*, enlarged, ed. Carlo Giuseppe Ratti, 2 vols., Genoa.

Soria, 1953: Martin S. Soria, *The Paintings of Zurbarán*, London.

Soullié and Masson, 1906 : L. Soullié and C. Masson, "Catalogue raisonné de l'oeuvre peint et dessiné de François Boucher," in André Michel, *François Boucher*, Paris.

Sousa-Leão, 1973: J. De Sousa-Leão, *Frans Post: 1612–1680*, Amsterdam.

Spear, 1971: Richard E. Spear, *Caravaggio and His Followers*, Cleveland.

Spear, 1972: Richard E. Spear, "Unknown Pictures by the Caravaggisti," *Storia de l'arte*, 14, pp. 149–61.

Spear, 1982: Richard Spear, *Domenichino*, 2 vols., New Haven and London.

Spike, 2001: John T. Spike, *Caravaggio*, New York and London.

Stechow, 1966: Wolfgang Stechow, *Dutch Landscape Painting of the Seventeenth Century*, London.

Sterling, 1965: Charles Sterling, "Eustache Le Sueur peintre de portraits," *Walter Friedlaender zum 90. Geburtstag. Ein Festgabe seiner europäischen Schüler, Freunde und Verehrer*, Berlin, pp. 181–4.

Stoppa, 2003: Jacopo Stoppa, *Il Morazzone*, Milan.

Sullivan and Mallory, 1982: Edward J. Sullivan and Nina A. Mallory, *Painting in Spain 1650–1700 from North American Collections*, Princeton.

Sullivan, 1982: Edward J. Sullivan, *Goya and the Art of his Time*, Dallas, Meadows Museum.

Sutton, 1965: Denys Sutton, "A Master of Austerity: Francisco de Zurbarán." *Apollo* 81, pp. 322–25.

Thuillier, 1958: Jacques Thuillier, "Poussin et ses premiers compagnons français à Rome," in *Colloque Nicolas Poussin*, I, Paris, pp. 71–116.

Thuillier, 1964: Jacques Thuillier (and Albert Châtalet), *La Peinture française II. De Le Nain à Fragonard*, ed. Albert Skira, Geneva.

Tomlinson, 1989: Janis A. Tomlinson, *Francisco Goya: The Tapestry Cartoons and Early Career at the Court of Madrid*, Cambridge, Cambridge University Press.

Tomlinson, 1990: Janis A. Tomlinson, "The Provenance and Patronage of Luis Meléndez's Aranjuez Still Lifes," *The Burlington Magazine*, vol. 132, pp. 84–9.

Tomlinson, 1991: Janis A. Tomlinson, "Burn It, Hide It, Flaunt It: Goya's Majas and the Censorial Mind," *Art Journal*, 50/4, pp. 59–64.

Tomlinson, 1992: Janis A. Tomlinson, *Goya in the Twilight of Enlightenment*, New Haven and London.

Tomlinson, 2002: Janis A. Tomlinson, in *Goya, Images of Women*, Washington, D.C., National Gallery of Art.

Trapier, 1956: Elizabeth du Gué Trapier, *Valdés Leal; Baroque Concept of Death and Suffering in his Painting*, New York.

Trapier, 1960: Elizabeth du Gué Trapier, *Valdés Leal Spanish Baroque Painter*, New York.

Trapier, 1964: Elizabeth du Gué Trapier, *Goya and his Sitters*, New York.

Treffers, 1988: Bert Treffers, "Il Francseco Hartford del Caravaggio e la spiritualità francescana alla fine del XVI secolo," *Mitteilungen des Kunsthistorischen Insitutes in Florenz*, vol. 32, pp. 145–72.

Tufts and Luna, 1985: Eleanor Tufts and Juan J. Luna, *Luis Meléndez: Spanish Still-Life Painter of the Eighteenth Century*, Meadows Museum, Dallas.

Tufts, 1969: Eleanor Tufts, "Still Life with Pigeon by Luis Meléndez," *Wadsworth Atheneum Bulletin*, 6th series, 5, pp. 60–72.

Tufts, 1985: Eleanor Tufts, *Luis Meléndez: Eighteenth-Century Master of the Spanish Still Life, with a Catalogue Raisonné*, Columbia, Miss.

Tuyll van Serooskerken, 1996: Carel van Tuyll van Serooskerken, "Sisto Badalocchio," in *Dictionary of Art*, vol. 3, pp. 32–3.

Valdivieso, 1988: Enrique Valdivieso, *Juan de Valdés Leal*, Seville.

Valdivieso, 1991: Enrique Valdevieso, *Valdés Leal*, Madrid, Museo del Prado.

Valdivieso, 2002: Enrique Valdivieso, *Vanidades y desengaños en la pintura española del Siglo de Oro*, Madrid.

Valentiner, 1922–3: W. R. Valentiner, *Frans Hals (Klassiker der Kunst)*, Berlin.

Valentiner, 1936: W. R. Valentinger, *Frans Hals Paintings in America*, Westport, CT.

Vasari, 1568/1996: Giorgio Vasari, *Lives of the Painters, Sculptors and Architects*, Florence, 1568; trans. by Gaston du C. de Vere, with notes by David Ekserdjian, 2 vols., London.

Vigée Le Brun, 1835: Elizabeth Louise Vigée Le Brun, *Souvenirs*, Paris.

Viñaza, 1889–94: Conde de la Vinaza, *Adiciones al diccionario de los más ilustres profesores de las Bellas Artes en España*, Madrid.

Vivian, 1969: Frances Vivian, "Poussin and Claude Seen from the Archivio Barberini," *The Burlington Magazine*, vol. CXI, pp. 719–26.

Volpe, 1972: Carlo Volpe, "Annotazioni sulla mostra Caravaggesca di Cleveland," *Paragone*, no. 263, pp. 72–3.

Waldman, 2000: Louis Alexander Waldman, "Fact, Fiction, Hearsay: Notes on Vasari's Life of Piero di Cosimo," *The Art Bulletin*, vol. 82, March, pp. 171–9.

Waterhouse, 1958: Ellis Waterhouse, *Gainsborough*, London.

Waterhouse, 1962: Ellis Waterhouse, *Italian Baroque Painting*, London.

Wescott, 1935: Glenway Wescott, "Poor Greuze," in *Wadsworth Atheneum Bulletin*, January–June, cover and pp. 7–8.

Wheelock, 1995: Arthur Wheelock, *Dutch Paintings of the Seventeenth Century, National Gallery of Art Systematic Catalogue*, Washington, D.C.

Whitfield and Martineau, 1982: Clovis Whitfield and Jane Martineau, eds., *Painting in Naples, 1606–1705* (exh. cat.), Royal Academy of Arts, London.

Wilk-Brocard, 1995: Nicole Wilk-Brocard, *Une dynastie Les Hallé . . .* , Paris.

Williams, 1973: Raymond Williams, *The Country and the City*, New York.

Wine, 2001: Humphrey Wine, *National Gallery Catalogues: Seventeenth Century French Paintings*, London.

Wintermute, 1996: Alan Wintermute, *The French Portrait 1550–1850*, Colnaghi, New York.

Wittkower, 1958/1999: Rudolf Wittkower, *Art and Architecture in Italy 1600–1750*; rev. by Joseph Connors and Jennifer Montagu, 3 vols., London and New Haven.

Zafran, 1978: Eric Zafran, "The Northern School at Hartford," *Apollo*, 108/200, October.

Zeri, 1976: Federico Zeri, "Sull'esecuzione di 'natura morte' nella bottega del Cavalier d'Arpino, e sulla presenza ivi del giovane Caravaggio," *Diario di lavoro 2*, Turin, 1976, pp. 92–103.

Zueras Torrens, 1989: Francisco Zueras Torrens, *Goya en Andalucía: Córdoba, Sevilla y Cádiz*, Córdoba.

Exhibitions references

Allentown, 1962: *The World of Benjamin West*; Allentown Art Museum.

Allentown, 1971: *The Circle of Canaletto*; Allentown Art Museum.

Amsterdam, 1900; *Verzameling schilderijen en familie-portretten van de Heeren Jhr. P.H. Six van Vromade, Jhr. Dr. J. Six en Jhr. W. Six, wegens verbouwingt*; Stedelijk Museum.

Amsterdam–Hartford, 2002: *Michael Sweerts (1618–1664)*; Rijksmuseum, Amsterdam; Fine Arts Museums of San Francisco; Wadsworth Atheneum, Hartford.

Antwerp, 1991: *David Teniers the Younger*; Koninklijk Museum voor Schone Kunsten, Antwerp.

Athens–Dordrecht, 2000–2001: *Greek Gods and Heroes in the Age of Rubens and Rembrandt*; National Gallery, Athens; Dordrechts Museum.

Atlanta, 1983: *The Rococo Age: 18th Century French Paintings and Drawings*; High Museum of Art, Atlanta.

Atlanta, 1996: *Rings: Five Passions in World Art*; High Museum of Art, Atlanta.

Baltimore–Saint Louis, 1944: *Three Baroque Masters: Strozzi, Crespi, and Piazzetta*; Baltimore Museum of Art; St. Louis Museum of Art.

Baltimore, 1961: *French Paintings of the 17th Century*; The Walters Art Gallery, Baltimore.

Baltimore, 1971–2: *World of Wonders*; The Walters Art Gallery, Baltimore.

Baltimore, 1989: *Benjamin West: American Painter at the English Court*; Baltimore Museum of Art.

Baltimore, 1995: *Bernardo Strozzi: Master Painter of the Baroque (1581/2–1644)*; The Walters Art Gallery, Baltimore.

Bilbao, 1999–2000: *El Bodegón Español [De Zurbarán a Picasso]*; Museo de Bellas Artes de Bilbao.

Birmingham, 1974: *Lombard Paintings, c. 1595–1630: The Age of Federico Borromeo*; City Museums and Art Gallery, Birmingham.

Bologna, 1935: *Mostra del settecento bolognese*; Palazzo Comunale, Bologna.

Bologna–Washington–New York, 1986–7: *The Age of Correggio and the Carracci: Emilian Painting of the Sixteenth and Seventeenth Centuries*; Pinacoteca Nazionale, Bologna; The National Gallery of Art, Washington; Metropolitan Museum of Art, New York.

Bologna–Stuttgart–Moscow, 1990–1: *Giuseppe Maria Crespi, 1665–1747*; Pinacoteca Nazionale, Bologna; Staatsgalerie Stuttgart; State Pushkin Museum of Fine Arts, Moscow.

Bordeaux ,1966: *La Peinture française. Collections américaines*; Musées des Beaux-Arts, Bordeaux.

Brussels, 1910: *Exposition d'art ancien: l'art belge au XVIIe siecle*; Brussels.

Brussels, 1980: *Bruegel: Une dynastie de peintres*; Palais des Beaux-Arts, Brussels.

Cambridge, 1965: *Sublimity and Sensibility*; Fogg Art Museum, Cambridge.

Chicago, 1949: *From Colony to Nation*; Art Institute of Chicago.

Chicago–Minneapolis–Toledo, 1970: *Painting in Italy in the Eighteenth Century: Rococo to Romanticism*; Art Institute of Chicago; Minneapolis Institute of Arts; Toledo Museum of Art.

Cleveland, 1971: *Caravaggio and His Followers*; Cleveland Museum of Art.

Cleveland–Fort Worth–Naples 1984–5: *Bernardo Cavallino of Naples, 1616–1656*, cat. ed. Anne T. Lurie and Ann Percy; Cleveland Museum of Art; Kimbell Art Museum, Fort Worth; Museo Pignatelli Cortes, Naples.

Cologne, 1930: *Meisterwerke älterer Kunst aus dem deutscher Kunsthandel*; Kunstverein, Cologne.

Cologne–Munich–Antwerp, 2000–1: *Faszination Venus*; Wallraf-Richartz-Museum, Cologne; Alte Pinakothek, Munich; Koninklijk Museum voor Schone Kunsten, Antwerp.

Columbia, 1967: *Landscape in Art—Its Origin and Development*; Columbia Museum of Art.

Dallas, 1983: *Goya and the Art of his Time*; Meadows Museum, Dallas.

Dayton–Sarasota–Hartford, 1962–3: *Genoese Masters: Cambiaso to Magnasco*; Dayton Art Institute; John and Mable Ringling Museum, Sarasota; Wadsworth Atheneum, Hartford.

Detroit, 1957: *Painting in America: The Story of 450 Years*; Detroit Institute of Arts.

Detroit, 1965: *Art in Italy, 1600–1700*, cat. ed. Frederick Cummings; Detroit Institute of Arts.

Detroit–Chicago, 1981–2: *The Golden Age of Naples: Art and Civilization Under the Bourbons 1734–1805*, 2 vols; Detroit Institute of Arts; Art Institute of Chicago.

Detroit, 1986: *Romantic Art in Britain; paintings and drawings, 1760-1860*; Detroit Institute of Arts.

Dulwich, 2002: *Inspired by Italy, Dutch Landscape Painting 1600–1700*; Dulwich Picture Gallery.

Ferrara, 1933: *Catalogo della esposizione della pittura ferrarese del Rinascimento*, cat. by Nino Barbantini; Palazzo dei Diamanti, Ferrara.

Ferrara–New York–Los Angeles, 1998–9: *Dosso Dossi, Court Painter in Renaissance Ferrara*; Galleria d'arte Moderna e Contemporanea, Ferrara; Metropolitan Museum of Art, New York; and The J. Paul Getty Museum, Los Angeles.

Florence, 1767: Florence, *Santissima Annunizata* [see Bonsi 1767].

Florence, 1922: *Mostra della pittura italiana del sei e settecento*; Palazzo Pitti, Florence.

Florence, 1984: *Cristofano Allori, 1577–1621*; Palazzo Pitti, Florence.

Florence, 1986–7: *Il Seicento fiorentino. Arte a Firenze da Ferdinando I a Cosimo III*, 3 vols; Palazzo Strozzi, Florence.

Florence, 1992: *Disegni di Lodovico Cigoli (1559–1631)*; Gabinetto Disegni e Stampe degli Uffizi, Florence.

Fort Worth, 1982–3: *Jusepe de Ribera, lo Spagnoletto, 1591–1652*; Kimbell Art Museum, Fort Worth.

Fort Worth, 1986: *Giuseppe Maria Crespi and the Emergence of Genre Painting in Italy*, Kimbell Art Museum, Fort Worth, 1986.

Fort Worth, 1993: *Jacopo Bassano c. 1510–15 92*; Kimbell Art Museum, Fort Worth.

Frankfurt, 1992: *Kunst in der Republik Genua 1528–1815*, cat. ed. Mary Newcome Schleier; Schirn Kunsthalle, Frankfurt.

Genoa, 1995: *Bernardo Strozzi, Genova 1581/1582–Venezia 1644*, cat. ed. Ezia Gavazza, Giovanna Nepi Sciré, and Giovanna Rotondi Terminiello; Palazzo Ducale, Genoa.

Haarlem, 1962: *Frans Hals*; Frans Hals Museum, Haarlem.

The Hague–San Francisco, 1990–1: *Great Dutch Paintings from America*; The Mauritshuis, The Hague; The Fine Arts Museums of San Francisco.

Hartford, 1930: *Exhibition of Italian Painting of the Sei- and Settecento*; Wadsworth Atheneum, Hartford.

Hartford, 1938: *The Painters of Still Life*; Wadsworth Atheneum, Hartford.

Hartford, 1948: *Gould Bequest of American Paintings*; Wadsworth Atheneum, Hartford.

Hartford, 1949: *Pictures within Pictures*; Wadsworth Atheneum, Hartford.

Hartford, 1950–1: *Life in Seventeenth-Century Holland, Views and Vistas–Pastimes, Pantomimes and Peep Shows*; Wadsworth Atheneum, Hartford.

Hartford–Sarasota, 1958: *A. Everett Austin, Jr., A Director's Taste and Achievement*; Wadsworth Atheneum, Hartford; John and Mable Ringling Museum of Art, Sarasota.

Hartford–Dijon, 1976–7: *Jean-Baptiste Greuze 1725–1805*; Wadsworth Atheneum, Hartford; California Palace of the Legion of Honor, San Francisco; Musée des Beaux-Arts, Dijon.

Hanover, 1997–8: *Intimate Encounters: Love and Domesticity in Eighteenth-Century France*; Dartmouth College, Hood Museum of Art.

London, 1774: *The Society of Artists of Great Britain*; Spring Gardens, London.

London, 1839: British Institution, London

London, 1892: *Old Masters*; Royal Academy of Arts, London.

London, 1893: *Exhibition of the Work of Luca Signorelli and His School*; Burlington Fine Arts Club, London.

London, 1909–10: *National Loan Exhibition*; Grafton Galleries, London.

London, 1925: *Exhibition of Italian Art of the Seventeenth Century*; Burlington Fine Arts Club, London.

London, 1930: *Exhibition of Italian Art, 1200–1900*; Royal Academy of Arts, London.

London, 1932–3: *Winter Exhibition*; Burlington Fine Arts Club, London.

London, 1938: *Exhibition of Seventeenth-Century Art in Europe*; Royal Academy of Arts, London.

London, 1938a: *From Greco to Goya*; London, Spanish Art Gallery.

London, 1950–1: *Exhibition of Works by Holbein and Other Masters of the Sixteenth and Seventeenth Centuries*, London, Royal Academy of Arts.

London, 1968: *France and the XVIII Century*, cat. by Denys Sutton; Royal Academy of Arts, London.

London, 1973: *Salvator Rosa*; Hayward Gallery, London.

London, 1980: *From Tintoretto to Tiepolo*; Heim Gallery, London.

London–Washington, 1982–3: *Painting in Naples, 1606–1705*; Royal Academy of Arts, London; National Gallery of Art, Washington, D.C.

London, 1983–4: *The Genius of Venice, 1500–1600*, Royal Academy of Arts, London.

London, 1984: *From Borso to Cesare d' Este: The School of Ferrara 1450–1628*; Matthiesen Fine Art Ltd., London.

London–Paris–New York, 1990: *Wright of Derby*; Tate Gallery, London; Grand Palais, Paris; Metropolitan Museum of Art, New York.

London, 1995: *Spanish Still Life from Velázquez to Goya*; The National Gallery, London.

London, 2000: *Spectacular Bodies: the art and science of the human body from Leonardo*

to now; Hayward Gallery, London.

London–Rome, 2001: *The Genius of Rome 1592–1623*, cat. ed. Beverly Louise Brown; Royal Academy of Arts, London; Palazzo Venezia, Rome.

Los Angeles, 1936: *Dutch, Flemish and German Old Masters*; Los Angeles County Museum of Art.

Los Angeles, 1946: *Loan Exhibition of Paintings by Rubens and Van Dyck*; Los Angeles County Museum of Art.

Los Angeles, 1979–80: *The Golden Century of Venetian Painting*; Los Angeles County Museum of Art.

Los Angeles, 2001–2: *Luca Giordano 1634–1705*; Los Angeles County Museum of Art.

Madrid, 1964–5: *Exposición Zubarán en el III centenario de su muerte*; Casón del Buen Retiro, Madrid.

Madrid, 1996: *Goya: 250 Aniversario*; Museo del Prado, Madrid.

Milan, 1951: *Mostra del Caravaggio e dei Caravaggisti*; Palazzo Reale, Milan.

Monte Carlo, 1997: *Genua Tempu Fà*, cat. ed. Tiziana Zennaro; Maison d'art, Monte Carlo.

Munich, 2002–3: *Stille Welt, Italienische Stilleben: Arcimboldo, Caravaggio, Strozzi . . .*; Kunsthalle der Hypo-Kulturstiftung, Munich.

Naples, 1979–80: *Civiltà del '700 a Napol i*, 2 vols.; Museo e Gallerie Nazionali di Capodimonte, Naples.

Nashville, 1977: *Treasures from The Chrysler Museum at Norfolk and Walter P. Chrysler, Jr.*, cat. by Mario Amaya and Eric Zafran; Tennessee Fine Arts Center at Cheekwood, Nashville.

New Haven–Sarasota–Kansas City, 1987: *A Taste for Angels. Neapolitan Painting in North America 1650–1750*; Yale University Art Gallery, New Haven; John and Mable Ringling Museum of Art, Sarasota; Nelson-Atkins Museum of Art, Kansas City.

New Haven–San Marino, 2001: *Great British Paintings from American Collections: Holbein to Hockney*; Yale Center for British Art, New Haven; Huntington Library, Art Collections; Botanical Gardens, San Marino.

New York Public Library, 1911: *Catalogue of Paintings in the Picture Galleries*.

New York, 1931: *An Exhibition of Italian Paintings and Drawings of the Seventeenth Century*; Durlacher Bros., New York.

New York, 1932: *Italian Baroque Painting and Drawing, XVI, XVII, and XVIII Centuries*; Kleinberger Galleries, New York.

New York, 1934: *An Exhibition of Venetian Painting, 1600–1800*; Durlacher Bros., New York.

New York, 1935–6: *French Painting and Sculpture of the XVIII Century*; Metropolitan Museum of Art, New York.

New York, 1936: *Georges de la Tour and the Brothers Le Nain*; Knoedler Galleries New York.

New York, 1936a: *Francisco Goya; his paintings, drawings and prints*; Metropolitan Museum of Art, New York.

New York, 1937: *Paintings by Giuseppe Maria Crespi*; Durlacher Bros., New York.

New York, 1938: *An Exhibition of Paintings and Drawings*; Durlacher Bros., New York.

New York, 1938a: *Piero di Cosimo*; Schaeffer Galleries, New York.

New York, 1939 and 1940: *Masterpieces of Art*; World's Fair, New York.

New York 1943: *Romantic Painting in America*; Museum of Modern Art, New York.

New York, 1954: *French Eighteenth-Century Painting*; Wildenstein & Co., New York.

New York *et. al*, 1954: *Dutch Painting–The Golden Age*; Metropolitan Museum of Art, New York; Toledo Museum of Art; The Art Gallery of Toronto.

New York, 1958: *Masterpieces from the Wadsworth Atheneum, Hartford*; Knoedler Galleries, New York.

New York, 1964–5: *Genoese Masters: Cambiaso to Magnasco*, cat. ed. Robert L. Manning; Finch College Museum of Art, New York.

New York, 1966: *Art of the United States, 1670–1955*; Whitney Museum of American Art, New York.

New York, 1971: *Drawings from New York Collections III: The Eighteenth Century in Italy*; Metropolitan Museum of Art and Pierpont Morgan Library, New York.

New York, 1978: *Veronese to Franz Kline: Masterworks from the Chrysler Museum*, cat. by Mario Amaya and Eric Zafran; Wildenstein, New York.

New York–Tulsa–Dayton, 1983: *Italian Sill Life Paintings from Three Centuries*; National Academy of Design, New York; Philbrook Art Center, Tulsa; Dayton Art Institute.

New York–Naples, 1985: *The Age of Caravaggio*; Metropolitan Museum of Art, New York; Museo Naionale di Capodimonte, Naples.

New York, 1986–7: *François Boucher 1703–1770*, cat. by Alastair Laing; Metropolitan Museum of Art, New York.

New York–Paris, 1987–8: *Zubarán*; Metropolitan Museum of Art, New York; Galeries Nationales du Grand Palais, Paris.

New York, 1989: *Old Master Paintings*; Newhouse Galleries, New York.

New York, 1989a: *Important Old Master Paintings: Devotion and Delight*, cat. ed. Robert Simon and Frank Dabell; Piero Corsini, New York.

New York, 1990: *Important Old Master Paintings: Within the Image*; Piero Corsini, Inc., New York.

New York, 1992: *Jusepe de Ribera, 1591–1652*; Metropolitan Museum of Art, New York.

New York–Saint Louis, 2001–2: *Orazio and Artemisia Gentileschi*, cat. ed. Keith Christiansen and Judith Mann; Metropolitan Museum of Art, New York; The Saint Louis Art Museum.

Norfolk, 1967–8: *Italian Renaissance and Baroque Paintings from the Collection of Walter P. Chrysler, Jr.*; Norfolk Museum of Arts and Sciences.

Northampton, 1955: *Joseph Wright of Derby, 1734–1797*; Smith College Museum of Art, Northampton.

Notre Dame–Binghamton, 1970: *The Age of Vasari*; University of Notre Dame Art Gallery, Notre Dame; State University of New York, Binghamton.

Oberlin, 1952: *Italian Seicento Painting*; Allen Memorial Art Museum, Oberlin.

Ottawa, 2000: *Piero di Cosimo's "Vulcan and Aeolus" and "The Finding of Vulcan on Lemnos" Reunited*; National Gallery of Canada, Ottawa.

Ottawa, 2001: *Giuseppe Maria Crespi: The Art of Allegory*; National Gallery of Canada, Ottawa.

Ottawa–Washington, 2003–4: *The Age of Watteau, Chardin, Fragonard: Masterpieces of French Genre Painting*; National Gallery of Canada, Ottawa; National Gallery, Washington, D.C.

Paris, 1757: *Observations périodiques sur la physique…et les arts*; Paris.

Paris, 1897: *Portraits de femmes et d'enfants*; École des Beaux-Arts, Paris.

Paris, 1934: *Les peintres de la Réalité en France au XVIIe siècle*, cat. by Charles Sterling; Musée de l'Orangerie, Paris.

Paris, 1937: *Chefs d'œuvre de l'art français*; Palais National des Arts, Paris.

Paris, 1952: *La Nature morte de l'antiquité à nos jours*; Orangerie des Tuileries, Paris.

Paris, 1972: *British Romantic Painting and the Pre-Raphaelites*; Petit Palais, Paris.

Paris, 1975: *Éloge de l'ovale, peintures et pastels du XVIIIe siècle français*; Galerie Cailleux, Paris.

Paris, 1978–9: *Les frères Le Nain*; Grand Palais, Paris.

Paris–New York–Chicago, 1982: *La Peinture française du XVII siècle dans les collec-tions américaines* [English version, *France in the Golden Age. Seventeenth–Century French Paintings in American Collections*]; Grand Palais, Paris; Metropolitan Museum of Art, New York; The Art Institute of Chicago.

Paris, 1990: *Vouet*, Galeries nationales du Grand Palais, cat. by Jacques Thuillier; Paris.

Paris, 1993: *Le Siècle de Titien: L'âge d'or de la peinture à Venise*; Grand Palais, Paris.

Paris–Piacenza–Braunschweig, 1992–3: *Pannini*, Musée du Louvre, Paris; Museo Civico, Piacenza; Herzog Anton Ulrich Museum, Braunschweig.

Parma–Naples–Munich, 1995: *I Farnese: Arte e Collezionismo*; Palzzo Ducale di Colorno, Parma; Gallerie Nazionale di Capodimonte, Naples; Haus der Kunst, Munich.

Philadelphia, 1938: *Benjamin West*; Philadelphia Museum of Art.

Philadelphia–Berlin–London, 1984: *Masters of Seventeenth-Century Dutch Genre Painting*; Philadelphia Museum of Art; Gemäldegalerie Berlin; Royal Academy of Arts, London.

Philadelphia–Houston, 2000: *Art in Rome in the Eighteenth Century*, cat. ed. Edgar Peters Bowron and Joseph J. Rishel; Philadelphia Museum of Art; Museum of Fine Arts, Houston.

Pittsburgh, 1954: *Pictures of Everyday Life, Genre Painting in Europe 1500–1900*; Carnegie Institute, Pittsburgh.

Portland, 1956: *Paintings from the Collection of Walter P. Chrysler, Jr.*, cat. ed. Bertina Suida Manning; Portland Art Museum.

Poughkeepsie, 1970, *Dutch Mannerism: Apogee and Epilogue*; Vassar College Art Galleries, Poughkeepsie.

Princeton, 1979: *Van Dyck as Religious Artist*; Princeton Art Museum, Princeton.

Princeton, 1980: *Italian Baroque Paintings from New York Private Collections*, cat. by John T. Spike; The Art Museum, Princeton University.

Princeton–Detroit, 1982: *Painting in Spain 1650–1700 from North American Collections*; The Art Museum, Princeton University; The Detroit Institute of Arts.

Raleigh, 1984: *Baroque Paintings from the Bob Jones Univesity Collection*; North Carolina Museum of Art, Raleigh.

Raleigh–Dallas–New York, 1985: *Luis Meléndez: Spanish Still-Life Painter of the Eighteenth Century*; North Carolina Museum of Art, Raleigh; Meadows Museum, Dallas; National Academy of Design, New York.

Reggio Emilia, 1987–8: *Lelio Orsi;* Teatro Municipale, Reggio Emilia.

Rome, 1959: *Il Settecento a Roma;* Palazzo delle Esposizione, Rome.

Rome, 1991: *Vouet,* cat. by Jacques Thuillier; Palazzo delle Esposizioni, Rome.

Rotterdam–Rome, 1958–9: *Michael Sweerts en Tijdgenoten;* Museum Boijmans-van Beuningen, Rotterdam; Palazzo Venezia, Rome.

San Diego, 2001: *Luca Carlevarijs: Views of Venice,* cat. by Charles Beddington; Timken Museum of Art, San Diego.

San Francisco, 1940: *Golden Gate International Exposition;* California Palace of Fine Arts, San Francisco.

San Francisco, 1941: *Exhibition of Italian Baroque Painting, Seventeenth and Eighteenth Centuries;* California Palace of the Legion of Honor, San Francisco.

San Francisco–Boston, 1966–7: *The Age of Rembrandt;* California Palace of the Legion of Honor, San Francisco; Toledo Museum of Art; Museum of Fine Arts, Boston.

San Miniato, 1959: *Mostra del Cigoli e del suo ambiente;* Accademia degli Euteleti, San Miniato.

Sarasota–Hartford, 1958: *A. Everett Austin, Jr.: A Director's Taste and Achievement;* John and Mable Ringling Museum of Art, Sarasota; Wadsworth Atheneum, Hartford.

Sarasota–Hartford, 1984–5: *Baroque Portraiture in Italy: Works from North American Collections;* John and Mable Ringling Museum of Art, Sarasota; Wadsworth Atheneum, Hartford.

Springfield,1937: *Francesco Guardi, 1712–1793;* Springfield, Museum of Fine Arts.

St. Petersburg, 2001: *Abraham Bloemaert (1566–1651) and His Time;* St. Petersburg.

The Hague, 1970: *Goya;* The Mauritshuis, The Hague.

The Hague, 1991: *Great Dutch Paintings from America,* cat. ed. Ben Broos; The Hague.

Toledo, 1913: *Paintings from the Collection of John North Willys;* Toledo Museum of Art.

Toledo, 1941: *Spanish Painting;* Toledo Museum of Art.

Toledo, 1947: *Works of the Brothers Le Nain;* Toledo Museum of Art.

Toledo–New York, 1961: *The Splendid Century–French Art: 1600–1715;* Toledo Museum of Art; Metropolitan Museum of Art, New York.

Toledo–Chicago–Ottawa, 1975–6: *The Age of Louis XV: French Painting from 1710 to 1774;* Toledo Museum of Art; Art Institute of Chicago; National Gallery of Canada, Ottawa.

Toronto, 1960: *Titian, Tintoretto, Paolo Veronese, with a Group of Sixteenth-Century Venetian Drawings;* Art Gallery of Ontario, Toronto.

Toronto–Ottawa–Montreal 1964–5: *Canaletto,* cat. ed. W. G. Constable; Art Gallery of Ontario, Toronto; National Gallery of Canada, Ottawa; Museum of Fine Arts, Montreal.

Turin–Montreal–Washington–Marseille, 1999–2001: *The Triumph of the Baroque: Architecture in Europe 1600–1750;* Palazzina di caccia di Stupinigi, Turin; Montreal Museum of Fine Arts; National Gallery of Art, Washington, D.C.; Centre de la Vielle Charité, Marseille.

Utica–Rochester, 1963: *Masters of Landsape: East and West;* Munson-Williams-Proctor Institute, Utica; Rochester Memorial Art Gallery.

Varese, 1962: *Il Morazzone;* Villa Mirabello, Varese.

Venice, 1951: *Mostra del Tiepolo,* cat. by Giulio Lorenzetti; Venice.

Viterbo, 1998–9: *Domenico Corvi,* cat. ed. Valter Curzi and Anna Lo Bianco; Museo della Rocca Albornoz, Viterbo.

Washington–Paris, 1975–6: *The European Vision of America;* National Gallery of Art, Washington D.C.; Cleveland Museum of Art; Grand Palais, Paris.

Washington, 1982–3: *Claude Lorrain. 1600–1682,* cat. by H. Diane Russell; National Gallery of Art, Washington, D.C.

Washington *et al,* 2001: *Aelbert Cuyp,* National Gallery of Art, Washington, D.C.; National Gallery, London; Rijksmuseum, Amsterdam.

Washington, 2002: *Goya, Images of Women;* National Gallery of Art, Washington, D.C.

Williamstown, 1987: *A Glimpse of Rococo France;* Sterling and Francine Clark Art Institute, Williamstown.

Index